Berenice Abbott
American Photographer

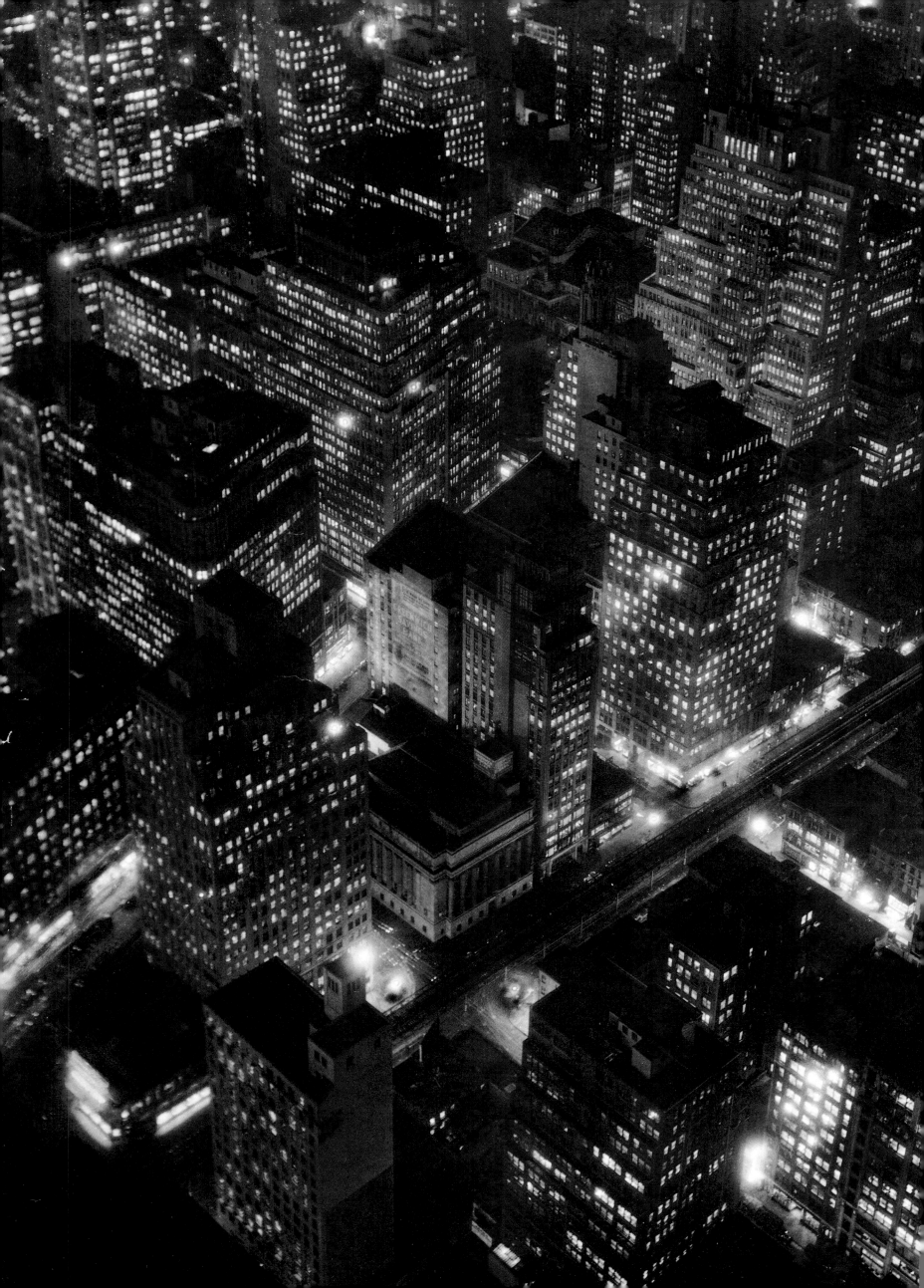

Berenice Abbott American Photographer

by Hank O'Neal

Introduction by John Canaday

Commentary by Berenice Abbott

McGraw-Hill Book Company
New York
St. Louis
San Francisco
Toronto

An Artpress Book

(Page 2)

Nightview

I took this early in the evening; there was only one time of year to take it, shortly before Christmas. I started in at about 4:30 p.m. and didn't have much time. But I had done a good deal of prior planning on the photograph, going so far as to devise a special soft developer for the negative. This was a fifteen-minute exposure and I'm surprised the negative is as sharp as it is because these big buildings do sway a bit. I knew I had no opportunity to make multiple exposures because the lights would start to go out shortly after 5:00 p.m. when the people began to go home, and so it had to be correct on the first try. In this case I was at a window, not at the top of the building; there would have been too much wind outside. It was, of course, hard to get permission. They always thought you wanted to commit suicide and superintendents were always tired, lazy and annoyed. They usually had to be bribed.

Library of Congress Cataloging in Publication Data
O'Neal, Hank.
 Berenice Abbott, American photographer.
 (An Artnews book)
 1. Photography, Artistic. 2. Abbott, Berenice, 1898– . I. Title. II. Series.
 TR654.0724 1981 770'.92'4 82-9887
 ISBN 0-07-047551-2 AACR2

Printed and bound in Japan by Dai Nippon Printing Co.
Composition by Dix Type Co., Syracuse, New York

Table of Contents

Introduction

As a super-eye the modern camera makes the human eye seem so inefficient that we might have bumbled through all the ages of history until the twentieth century with defective vision. The camera freezes action to show us things never seen before—the wings of a hummingbird in flight. It captures fleeting realities that we see so briefly that they are remembered inaccurately. It can even see in the dark. As a scientific tool it verifies theories by recording facts, and has revealed unexpected facts that have inspired new theories. Artist-photographers and photographer-documentarians, in their different ways, capitalize on these capacities of the super-eye, but the camera has another talent, the most valuable of all to the documentarian, that the artist must somehow circumvent.

When it is allowed to, the camera registers instantaneously the totality of a scene (or an object, or a face, or any other fragment of the visible world), an ability denied even the sharpest eye. At first sight we perceive only the salient aspect of a subject; we must travel over it bit by bit to see all of it, and even then, unless it is very small and simple, we can never see all of it at once. The camera can, but the trouble is that this wondrous all-seeing super-eye has no power of selection, which in terms of picture-making means it has no esthetic or interpretive sense. It cannot edit its own reflections of the world in order to capture their visual quintessence or intensify their psychological impact as the human eye has been conditioned to do. Experience has taught us how to reject the documentary clutter of details extraneous to what we expect from a subject. Everyone who has ever been disappointed in a snapshot taken in expectation of its yielding a souvenir of a precious occasion knows the difference between the camera's true-to-facts reflection of what was really in front of the eye and what the eye chose to see there at the behest of the mind or spirit.

Photography that combines the camera's acute unselective veracity with another kind of truth—the expressive truth that makes the difference between a document and a work of art—demands a give-and-take between camera and photographer by which the super-eye is served with the highest degree of technical expertise in order that it in turn may serve an eye and mind of extraordinary perception, visual and psychological, behind the lens.

Berenice Abbott is a photographer gifted with these perceptions, perhaps the one among them all today who has been most insistent on the legitimacy of the camera's documentary genius as a basic expressive resource. She consistently respects her camera's implacably objective vision unmodified by tricky exposures or eccentric angle shots; she rejects every device, subterfuge, or small deceit that would reduce the clarity and exhaustiveness of the camera's documentary power upon which her art is based. Except in her portraits, which are necessarily posed, she rejects set-ups for the natural state of a subject at the moment of the click of the shutter. And if this is also true of any number of first-rate photographers and a handful óf great ones, Berenice Abbott is exceptional in her determined avoidance of subjects whose inherent interest—their unfamiliarity, their bizarre nature, their startling juxtapositions, their exceptional beauty—would arrest the observer's attention even without benefit of the isolation and emphasis that a good photographer can supply. Berenice Abbott's inexhaustible subject is the familiar daily world, and her achievement is that she reveals its fascination without modifying its documentary truth. She becomes in effect a camera endowed with sensitive intelligence or, to put the same idea the other way around, an artist whose eye is miraculously the super-eye of the camera. Exactly how she has attained these mutual identities without sacrificing one to the other is not easy to explain.

A preliminary glance through this book should show that there are appropriate degrees of balance between documentation and interpretation from one set of subjects to another, whether it is a matter of the portraits, the analyses of physical phenomena, or the exploration of New York City, where the interaction was most demanding. Too easily thought of primarily as documents, the New York photographs may be, in truth, documentary in that they preserve for the record the visual aspect of a city that was entering a period of drastic change when the series was begun in 1929. But these factual records preserve as well the mood of the city, which until recently combined excitement with stability, and majestic scale with intimacy. The 1936 photographs of Pennsylvania Station (pp. 102–105) are among the great historical photographs of the century in this double sense of record and interpretation. Since the razing in 1963 of this supreme architectural monument, Berenice Abbott's photographs have become poignant recalls of the city's lost elegance and an accusation against the forces that destroyed it.

Aside from such subjective associations, the Pennsylvania Station photographs are abstract studies in values of light and spatial volume that hold their own in the most demanding company of others in any pictorial medium—and have inspired imitations in the most fluid of them. Yet it is precisely this "fluid," manipulable character of painting and the other graphic arts that most drastically differentiates them from photography. And

it is the recognition of this difference on the part of photographers that has made their medium an independent art. No photographer worthy of the name these days goes in for soft-focus effects, retouching, artistic setups in a painterly mode, or any of the other studio manipulations by which photographers not too long ago violated their medium's honor in efforts to synthesize pseudo-paintings. Whatever painterly qualities the Pennsylvania Station photographs may have are coincidental to their photographic impact—to our knowledge that this picture is the record of a momentary aspect of the real world, that this was a real place, that this light was the light of that moment.

By one chance in thousands, a combination of lucky accidents yields a first-rate expressive photograph instead of a snapshot, but in legitimate photography the lucky moment is the province of the photojournalist, the candid camera, the seeker after telling bits and pieces, and is usually marked by sharp focus on the central element (with background and foreground blurred) rather than on the totality of a scene. The primary source of Berenice Abbott's artistry is her insight and patience in analyzing her subject rather than catching it unawares. The moment to be preserved is preceded by study of the subject from different angles, in different lights, in different phases of its normal daily life, until the right combination of multiple interlocking aspects can be anticipated. Then, within the limitations imposed, the right moment may be waited for and seized—almost as if a trap had been set. Among the Abbott photographs that stick most firmly in my memory are General View Looking Southwest to Manhattan from Manhattan Bridge (p. 101), Willow Place, Nos. 43–49, Brooklyn (p. 131), and El at Columbus Avenue and Broadway (p. 78), in which figures of men, women and children are spotted along the streets as if designed by a genius in pictorial composition, but with their natural life intact. Another is House, Belfast, Along Route 1 (p. 235), in which the play of personalities between the house and the tree would have been interrupted by the presence of any human figure whatsoever.

It always comes as a surprise to me to remember that Berenice Abbott, the most American and realist of photographers, served her apprenticeship (if a photographer who seems to have known all about her craft from the beginning can be said to have served an apprenticeship) in Paris under Man Ray, the American expatriate dadaist and surrealist, as his assistant from 1923, when she gave up sculpture for photography, to 1925. In a general way, with multiple overlappings, photographers are divisible into the romantics, for whom personal expression is the goal, no matter how eccentric or nihilistic the means, and the realists, who believe that the world is intrinsically meaningful and that the artist's assignment is to discover and clarify that meaning, rather than to impose his or her personality on it. As a corollary, the romantic is free to violate conventional techniques (Man Ray was the wittiest juggler the camera has ever known) while the realist accepts their disciplines. Of course we get into all kinds of semantic trouble here. The Pennsylvania Station photographs always had undertones of romantic mood, and these have surfaced and been strengthened now as nostalgic evocations of a lost era. But the mood was created in the first place by the most disciplined means, with direct unmodified reference to the familiar world.

In 1978, John Szarkowski, Director of the Department of Photography at the Museum of Modern Art in New York, assembled a large exhibition, "Mirrors and Windows," on the romantic-and-realist theme, "Mirrors" referring to photographs in which the artist reflects his own image by proxy, with "Windows" giving access to the world outside himself. All the photographer-artists represented had achieved recognition since 1960, more than a generation later than Man Ray and his experimental romantic followers, and Berenice Abbott and her realist colleagues. By comparison with these earlier realists, this conscientiously selected exhibition was overwhelmingly romantic even in the "Windows" section, with hardly more than half a dozen photographs among the 127 in which the camera's realism was not subjugated (which is not the same thing as disciplined) to serve the intimate personality of the artist.

It is foolhardy to venture very far into the semantic labyrinth, but it seems to me that we now have a third classification for photographers, as we long have had for other types of artists, and that Berenice Abbott is one of an eminent group who can properly be called classicists, in the sense of the word that connotes adherence to traditionally authoritative standards of form, balance and restraint, standards that she herself took part in establishing, all of this opposed to romanticism and leaving realism to the world of reportage as a vital art in itself. But let us stop here. Semantics and classifications aside, Berenice Abbott is a great photographer, and this is her book, beyond words.

John Canaday

Berenice Abbott American Photographer

I

Photography in America underwent great changes at the turn of the century, when the long-standing realist tradition was seriously challenged by "artistic" photographers. The painterly overtones of these photographers succeeded in creating a polarization in American photography that exists to this day. The work of the realists Mathew Brady, William Henry Jackson and Timothy·H. Sullivan, and that of the countless men and women who produced daguerreotypes from the earliest days of photography, was in eclipse. A few serious photographers working at the time, such as Henry Holmes Bennett, Alice Austin, Darius Kinsey and Frances Benjamin Johnson, rejected the soft-focus, painterly school, but their photographs were little appreciated.

Berenice Abbott, whose work links the realist traditions of the nineteenth and twentieth centuries, was born in Springfield, Ohio, on July 17, 1898. Abbott's childhood in the Midwest was unhappy; her parents were divorced shortly after she was born and she was raised alone by her mother, separated from her sister and two brothers until the age of six. She rarely saw her father. These lonely circumstances perhaps contributed to the development of her independent nature, and she left home as soon as she could, in 1917, to attend Ohio State University.

At the university she soon decided that the compulsory freshman courses offered there would not help her realize her goal of becoming a journalist. She also rebelled against the dullness of the classes and the lack of dedication on the part of the faculty and chafed at the suffocatingly structured life. A friend and classmate, Sue Jenkins, had left the university and gone to New York where she was working with Jimmy Light, a young director at the famed Provincetown Playhouse in Greenwich Village. She and Light, who were planning to get married, were living in a large apartment in the Village, to which they invited Abbott. With a twenty dollar loan from Jenkins for the train fare, Abbott made the trip to New York in February of 1918, arriving in the middle of a raging blizzard and an epidemic of Spanish influenza. It was a move she never regretted.

Abbott found the vastness of New York and the open, bohemian life of Greenwich Village initially unsettling. Her shyness did not prevent her, however, from enjoying meeting the budding literary figures and Village luminaries of the day, who gathered at the Lights' apartments, first on MacDougal Street and then on Greenwich Avenue. Older than she, many of these people provided her with support and guidance and, in several cases, with what turned out to be lifelong friendship. The writer Djuna Barnes and the critics Malcolm Cowley and Kenneth Burke were fellow roomers in the spacious apartment on Greenwich Avenue, for which she raised her share of the rent, six dollars a month, by working at a number of odd jobs including waitress and yarn dyer.

Abbott's initial plan had been to enroll at Columbia University and study journalism. Enroll she did; study she did not. After a week of witnessing what she considered to be assembly-line education and overcrowded conditions, she quit. She continued casting about, doing odd jobs and, in her spare time, helping out at the Provincetown Playhouse where she even appeared in a minor role in Eugene O'Neill's play *The Moon of the Caribbees.*

Among those friends who exerted the greatest influence on the young woman from Ohio during this period were Hippolyte Havel, Terry Carlin and Sadakichi Hartmann who were all, in a way, surrogate fathers. Havel, a jovial anarchist who was the model for a character in O'Neill's *The Iceman Cometh,* would claim there were three women in his life: his wife, his sweetheart and his "daughter" Berenice Abbott. He even managed to get his "daughter" into McSorley's saloon (then a male stronghold in New York City) to take photographs in the mid-1930s. Hartmann, a writer and poet, was to her "an exotic, dancing butterfly" (she did not know of his interest in photography). Carlin, also an anarchist, was simply a friendly, benign philosopher.

A few others took special notice of her. In her book *Part of a Long Story* Agnes Boulton, who was at one time married to Eugene O'Neill, provided a rare description of Abbott during those early days in New York:

"I climbed the stairs at MacDougal Street. . . . The room was very crowded. . . . The air was full of cigarette smoke and as I stood by the door, someone got up and opened a window—for in spite of the depressed people there was such warmth and talking and humidity and enthusiasm that it seemed something must be done to let some of it out into the night and out over the city. . . . No one noticed me. Then a thin, interesting, pallid and dazed young girl, who seemed for the moment as out of things as I was, who seemed indeed to belong to another world, said, 'You can put your coat outside.'

"There was a long table in the outer room which was in semidarkness. The table was piled with coats and wraps and I laid my coat there, thinking the girl was beside me, for she had followed me outside. I turned to thank her but she had pulled a chair up at the far end of the table and was just silently sitting there, her gaze fixed like the eye of a dazed camera on the open door of the crowded room. There was nothing for me to do but go back, for she did not see *me* any longer, and in truth I was not interested in her then, though later on in the year, before she suddenly and mysteriously disappeared, she had become of great interest to me (though all this time I never had any conversation with her, for few people did) and I became one of her silent allies.

"I often thought of her later; but not for some years did I know that this girl whom I admired and even defended (for there was a certain conspiracy among the women against her) had become the brilliant photographer Berenice Abbott, whose photographs for many years have been on exhibition in New York and Paris."

Her "sudden and mysterious disappearance" was sudden but not very mysterious. After *The*

Moon of the Caribbees closed, she got another part at the Provincetown, in a now long-forgotten play that had a larger role for her. During rehearsals the entire cast came down with Spanish influenza; Abbott was stricken so abruptly she had to be carried by stretcher from her room on Greenwich Avenue across the street to St. Vincent's Hospital where for six weeks she lay close to death. Some of her associates at the theater did not survive. Recalling the experience, Abbott wonders how she managed to endure it; her work and diet had resulted in poor health even before she became ill and the influenza weakened her to such an extent that on her release from the hospital she found it difficult to walk. She regained her strength at the home of a prosperous cousin, Guy Morgan, in Dobbs Ferry, New York.

After a lengthy recuperation, Abbott returned to the city, determined to live alone and develop her talents in sculpture. She rented a small two-room apartment in "Clothesline Alley," a short block off Christopher Street, near Sixth Avenue. The rent was thirteen dollars a month and the two rooms provided a space for sleeping and a studio for sculpting. The move proved beneficial; her early explorations in her studio absorbed her creative energies and she also acquired new friends, primarily artists and writers.

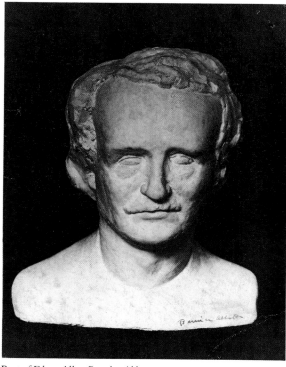

Bust of Edgar Allan Poe, by Abbott

Among the first of these artists to encourage Abbott in her sculpture was Marcel Duchamp, who commissioned her to cast a set of chessmen. Later he provided an introduction to the artist Man Ray, and the three would often visit one another, dine out together or go dancing in a Greenwich Village restaurant. The two men were influential friends (Man Ray was to have greater significance in her life in Paris) but an even more important figure for her at the time was the Baroness Elsa von Freytag-Loringhoven, known simply as The Baroness.

The Baroness, who was sometimes a poet (she was regularly published in *The Little Review*) and sometimes an artist (her portrait of Berenice Abbott is owned by the Museum of Modern Art), was a character in the finest sense of the word. She would wear kitchen pots on her often shaved head and appear scantily clothed at important functions. She was nonetheless a brilliant, if eccentric, artist. She lived for the moment, completely unconcerned with conventional mores, and led her

life as she pleased (her life was her art). The impressionable young Abbott found Baroness Elsa fascinating and visited her frequently, and it was she who instilled in Abbott a desire to go to Europe. The Baroness was ultimately reduced to selling newspapers on the streets of Berlin and she died alone in Paris (by accidental gas poisoning) in 1927. Man Ray made a death mask of her and a few people came to her funeral; the bulk of her poems remain unpublished.

Although by early 1921 Abbott had not developed any specific goals, her outlook, stimulated by the intellectuals and artists she had met and by her sense of independence, had matured. She had also become disenchanted with America. Knowing she could not earn a living from her sculpture, she nevertheless rejected the kinds of employment that might have given her a regular income. She wanted to grow and discover her potential in sculpture. Her lack of success in New York (where she had no real roots) and her carefree nature made the decision to go to France a simple one. She had no carefully thought-out plan; she just felt that it would probably be as easy to scrape by in Paris as it was in New York—and that she might perhaps develop further as an artist in a different environment.

With a one-way ticket in hand, she set sail for France on March 21, 1921, on the *Rochambeau*. Some days later, possessing six dollars, a slight knowledge of French and few friends, she stepped off the Paris train from Le Havre into the vibrant city that would be the focal point of one of the brightest (and most thoroughly documented) decades of creative achievement of the century.

Among the numerous expatriates in Paris "being geniuses together" (the title of the American writer and editor Robert McAlmon's history of the period), there were almost no photographers when Abbott arrived. When Man Ray came later in the year he found he could earn a living making photographic portraits. It is possible that without the early efforts of Man Ray the art of photography in Paris would have been greatly retarded and Berenice Abbott might never have taken a photograph. But in Paris in 1921 the photograph was not considered a serious artistic statement. It attracted some converts by the end of the decade but nearly fifty years would pass before it was accepted as anything more than a stepchild of the arts by French galleries, museums and critics.

Abbott's first two years in Paris were full of uncertainty. She supported herself meagerly by doing odd jobs, often posing for sculptors and painters. Her circle of friends came largely from the American and English colonies, but as her French became fluent her acquaintanceship widened. Her sculpting ability improved modestly but not sufficiently to provide her with a steady income and so during the winter of 1923, faced with an increasingly bleak situation, she felt a change was in order and moved to Berlin.

Her brief sojourn in Berlin—less than a year—was unsuccessful. She studied sculpture and drawing briefly and tried her hand at teaching dancing, but then happily returned to Paris and her old friends. One of the first of these she met on her return was Man Ray, who was now making a good living taking photographs. When he had first come to Paris he had made his portraits in his hotel room, building up a clientele. Now he was in a studio with good north light, but he had a problem with his assistant, a young man who thought he knew everything. When Man Ray mentioned that he wanted someone who knew nothing about photography, someone he could train and mold in a sensible fashion, Abbott asked, "How about me?" Indeed she knew nothing about photography and had no interest in it, but she

needed a job and had always appreciated Man Ray's work as an artist. Man Ray hired her on the spot. At the time, Abbott's intention was to be no more than a faultless darkroom assistant. The job, in fact, proved to be the turning point in her life.

Man Ray provided basic instruction in darkroom work and Abbott took to it instantly. She became excited about what she was doing, working long hours at the studio mastering the craft of developing and printing. Her salary started at fifteen francs a day, barely a living wage, but was soon increased to twenty-five; Man Ray confessed surprise at her rapid success after just a few weeks in the darkroom.

Abbott worked with him for months without ever thinking of taking a photograph herself, if for no other reason than that she was kept so busy in the studio and darkroom. Man Ray was the rage for portraits in Paris and had all the business he could handle, in fact it got to the point where he was looking for someone to help Abbott.

The workload forced Abbott to function efficiently and become a skillful technician. Additionally, her background in sculpture (which she had now given up) enabled her to master printing quickly because her sense of the "sculptured" aspect of the image helped her get as much of a three-dimensional effect as possible from a flat surface. As most of her work was in making enlargements, she printed for those effects and emphases which to her were akin to sculpture.

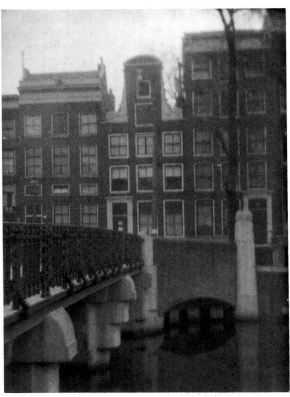

View of Amsterdam, *Abbott's first photograph*

About the middle of her second year with Man Ray, at his instigation, she began to make photographic portraits. The photography had started earlier innocently enough on a brief holiday to Amsterdam. Man Ray had previously lent Abbott a small Brownie-type camera, which she had never used but somehow took along on the trip. Fascinated by the city, she made some photographs and they "turned out." She soon found herself becoming a proficient photographer. Years later she reminisced:

"Man Ray did not teach me photographing techniques. He took the portraits on the balcony in his studio while I was in the darkroom. One day he did, however, suggest that I ought to take some myself; he showed me how the camera worked and I soon began taking some on my

lunch break. I would ask friends to come by and I'd take pictures of them. The first I took came out well, which surprised me. I had no idea of becoming a photographer, but the pictures kept coming out and most of them were good. Some were very good and I decided perhaps I could charge something for my work. Soon I started to build up a little business and I paid Man Ray out of the money I made for the supplies I used, but eventually I was paying him more than he was paying me and that's when it started to become a problem."

It was now 1926. The frantic pace at the studio continued. Abbott worked for Man Ray all day, took photographs on her lunch break and worked into the night on her own material or on rush orders for him. There was still no extra help at the studio. Abbott did not have sufficient time to devote to her own work as well as to Man Ray's and it soon became apparent she had to make a change. But the situation with Man Ray made a move awkward and her use of his equipment made it even more complicated. The matter was finally brought to a head when the art patron and collector Peggy Guggenheim requested a portrait session with Abbott; Man Ray intervened, saying that clients who could afford to pay his prices should be taken by him. Greatly upset by Man Ray's attitude, Abbott, after much soul-searching, resigned. She was devoted to Man Ray and on a personal level deeply regretted leaving him, but she believed, as she does now, that it was the right move from the artistic standpoint. She later recalled: "He changed my whole life; he was the only person I ever worked for and I was extremely grateful to have the job, to have the opportunity to learn. It is too bad it ended the way it did. He was a good friend and a fine photographer."

After leaving Man Ray, Abbott made the decision to set up her own studio. She started looking for work space and photographic equipment. Money was a problem; she had saved a little, but not enough to equip a studio. Three friends came to the rescue: Robert McAlmon, his wife, Winifred Bryher, the English poet and novelist, and Peggy Guggenheim, who provided her with modest loans to purchase the needed equipment. Abbott found studio space at 44 rue de Bac that was small but elegant. There was no skylight but one big room with large windows served the same purpose. A darkroom was constructed off the bathroom in a hallway and a new 5″ x 7″ view camera with a reducing back was installed. Friends became clients and Berenice Abbott's career as a photographer was launched. She recalls:

"I had a lot of friends who just took me at face value; a crazy kid, a crazy American kid. I had little money and I didn't care. These people who became my friends and clients saw something in me and the word of mouth got around pretty fast. When I found out I could take good photographs I was really amazed and Man Ray was actually a little worried because neither of us expected me to catch on so quickly. He took some fantastic portraits of men, but his women are mostly pretty objects. I didn't think about the male-female thing at the time, but it just turned out the photographs I took were different from his, particularly the women. I didn't see it at the time; then it was a bit confusing, but looking back on it now it is much easier to see objectively and it makes sense. All the while I was getting started I made certain not to try and compete with Man Ray. I even went so far as to charge the same price and use completely different equipment."

Recognition came quickly; finding she had accumulated a modest amount of work, Abbott made plans for an exhibition. Her first one-man show, *Portraits Photographiques,* at Jan Slivinsky's

gallery Au Sacré du Printemps, opened on June 8, 1926, and ran for two weeks, with good attendance and reviews. Included in the show were her earliest portraits, among which were those of James Joyce, Jean Cocteau, Sylvia Beach, André Tardieu, Djuna Barnes, Alexander Berkman, Marie Laurencin and André Gide. These first portraits are straightforward, uncluttered, spontaneous and well composed; they do not differ in form from the photographs taken three or four years later in New York. It is virtually impossible to date her earliest work in terms of artistic growth for it was exceptional from the beginning.

exposition
Bérénice Abbott
portraits photographiques

juin 8-20-1926

au-sacre-du
printemps

5, rue du cherche-midi

Mlle Abbott porte un nom moitié ombre, moitié lumière : Bérénice. Elle expose sa mémoire délicieuse. Elle est le lieu d'une partie d'échecs entre la lumière et l'ombre.

Elles d'oiseau, oiseau des îls ; Bérénice, oiseleur sans sexe, apprivoise l'ombre des oiseaux.

Jean Cocteau.

Invitation to Abbott's first show, designed by Jean Cocteau

At this early stage in her career, Abbott established some guidelines for herself which, with very few exceptions, she has followed to this day. These were: not to advertise, seek out clients or take photographs for free. On very rare occasions she has not charged for photographs she has taken of people whose cooperation she has solicited, such as, for example, Eugène Atget.

As a result, her income was modest, but sufficient, and she supplemented it by doing fashion work for Paris *Vogue*. On occasion *Vogue* published her portraits, as did a few other magazines. She was not, however, satisfied with the type of work she was requested to do in fashion photography and was disturbed by some of the *Vogue* staff photographers' attitudes toward women. Her career as a fashion photographer was, therefore, short-lived.

Abbott grew quickly as a photographer, but she was not without influences. Man Ray was certainly her first important influence. Another was Eugène Atget, whose great dedication to photography inspired her. Atget came into her life in 1925 when Man Ray showed her a few of Atget's photographs he had recently acquired. Abbott remembers being deeply impressed, and in 1926, when she was on her own, she visited Atget at his home. Her regard for him increased. She found that he lived simply and sold his photographs for very little. She purchased a few and tried to encourage her friends to do the same.

Few cared about Atget in 1926; even Man Ray tried to discourage Abbott from helping him, saying it was useless to try to do anything with or for him, that it was best he be left alone. What she admired in Atget was his dedication to excellence and his sense of fulfillment in the work itself—work that was free of technical tricks and of any subservience to trends. Though Man Ray took portraits, as Abbott did, much of his other work —what he called "rayographs" and assorted solarizations—resulted from experimentation. Atget left nothing to chance; the extent to which he experimented with his negatives appears to have been minimal and he made no enlargements, working exclusively within printing frames. It was from Atget that Abbott first learned she might have to walk alone. In 1951 she delivered an address in Aspen, Colorado, titled "It Has to Walk Alone," a statement that was her credo.

Atget's solitary figure was to become a major influence in Abbott's photography. In 1929, when she could look back on Atget from a fresh perspective, she wrote in her diary:

"It is not profitable to discuss whether or not photography is an art. Results will speak in due time. Indeed the expression that this medium affords is so utterly new that some time must elapse before we conquer our surprise. The work of Eugène Atget opens up a new world in the realm of creative expression as surely as the cotton gin awoke a sleepy world to the vista of industrialism. We behold a new giant, a gentle brute who quietly and unostentatiously came presenting us with new riches.

"Nadar is probably the only early photographer of significance, but the work of Atget has been of far greater importance in revolutionizing photography. He is the modern forerunner in the sense that hitherto that medium had been used as a small trade for limited purposes. Photographers were petty tradespeople eking out an existence from the daily, sordid tasks of making all men look important and all women look beautiful, and in doing press photography. A few pathetic souls engaged their spare time in making 'artistic pictures'—girls languid under trees, water lilies reflected, towers and arches in dim soft lights, these pictures the most offensive of all. No less tiresome are the numerous freak experimentations, the easiest kind of photography.

"Atget was not 'aesthetic.' His was a dominating passion that drove him to fix life. With the marvelous lens of dream and surprise he 'saw' (that is to say photographed) practically everything about him, in and outside of Paris, with the vision of a poet. As an artist he saw abstractly and I believe he succeeded in making us feel what he saw. Photographing, recording life, dominating his subjects, was as essential to him as writing is to James Joyce."

Eugène Atget, *by Abbott*

Abbott's recognition of Atget's dedication to his art was at the root of her own philosophy of photography. He may not have realized the tremendous influence he had on her or even that she was a photographer; she did not tell him she was a photographer until the day, in 1927, when she asked whether she could take his photograph. It was one of the few times in her career she ever sought permission to take a portrait; fortunately

Atget agreed or we would otherwise have no likeness of him, except for a snapshot as a young man.

The old man posed for Abbott in her studio; three exposures were made. The side view (p. 64) is extremely well known and has been widely reproduced in books and folios of prints. The front view (p. 65) is less well known and the third version, with Atget standing, is scarcely known at all; the glass plate appears to be lost.

At the time she was disappointed with the results of the sitting; Atget had worn a formal coat and she had expected him to be dressed in his more casual fashion. After she had processed the plates and made a few prints, she went to his apartment to show them to him. She arrived to find the small sign on his building advertising "documents for artists" missing and upon inquiry learned of his death.

Abbott stood in shock, faced with the terrible irony of the event. She thought of his great work, of the thousands of glass plates and prints that had filled his workroom. Fortunately she had the presence of mind to ask the concierge about Atget's possessions and learned that they had been entrusted to André Calmettes, who lived on the rue Saint Guillaume. Calmettes' exact address was unknown, but by going to every door on the street Abbott finally located him. Calmettes, who was the director of the municipal theater in Strasbourg and an old friend of Atget's, did, in fact, have all his plates and prints.

Calmettes was not certain what to do with the material. Atget had previously given—in rare instances sold—his photographs to various museums in Paris. Calmettes had therefore considered the possibility of donating the remainder of his friend's work to one of these institutions, but it soon became apparent that none had any interest in obtaining any additional Atget photographs.

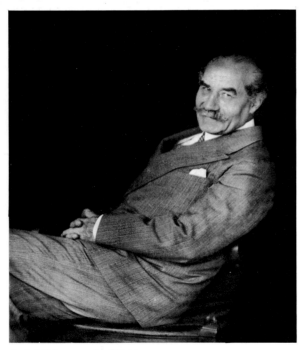

André Calmettes, *by Abbott*

Abbott decided to make an effort to acquire the entire collection. After nearly a year of correspondence and discussions she managed in the fall of 1928 to purchase the almost fifteen hundred glass plates and eight thousand original prints. There was little competition for the collection; only the French art critic Florent Fels made any sort of real effort to obtain it. Abbott has said she feels she was successful because Calmettes thought her the more genuinely interested of the two in his friend's work. There is little doubt his judgment was correct; she was to spend more than forty

years in attempting to secure a place for Atget in the world of photography. She started her campaign to gain recognition for him, in fact, long before she had even purchased the collection.

Every time Abbott wrote to a museum or gallery about exhibiting her own work she always pleaded with them to show Atget as well. For a year or more every show that she appeared in also included a selection of Atget's prints. Soon it became increasingly difficult, however, to interest anyone in him, and with the final acquisition of the collection her struggle truly began. Years later she was to comment that if took two lives to build Atget's reputation, "his and mine."

Though she did not have as much work as she would have liked, and in fact had been forced to move to a smaller studio at 18 rue Servandoni in January, 1928, her reputation continued to grow. One of her sitters, Sylvia Beach, in her book *Shakespeare and Company* (named after her bookstore in Paris) wrote in 1959: "The artist Man Ray and his pupil, Berenice Abbott, who assisted him for a while, were the official portraitists of 'the crowd.' The walls of my bookshop were covered with their photographs. To be 'done' by Man Ray or Berenice Abbott meant you rated as somebody."

In April, 1928, Abbott was invited, along with Man Ray, André Kertesz and a few others, to exhibit at the First Salon of Independent Photographers, organized by, among others, Lucien Vogel of Paris *Vogue,* René Clair, the film director, and Florent Fels. It was the first serious group show of photographs in Paris, scheduled to run from May 24 through June 7. She submitted twelve photographs and the selection was a success. One review, in *Chantecler,* stated:

"We come now to Berenice Abbott. Her simple portrait of a woman transcends Holbein. I want to say with the most naked, the most modest, the least pretentious truth, this human representation evokes a spiritual emotion. It is a bare countenance, bathed by the morning light, which stands out, which presents itself. In simplicity here is her soul to gaze at, given as simply as a handshake. One can have great hopes for the photographer. Berenice Abbott knows perfectly how to let her emotions go in order to present her characters according to their own actions. Maurois is waiting to get up and Mauriac, the author of tragedy, is a little embarrassed by his hands, feeble hands marked by voluptuousness."

All the reviews were not so helpful or perceptive. One critic damaged her relationship with Man Ray further by praising her and blasting him. Abbott has commented:

"The show at the First Salon was most troublesome, not because it was not well liked, but because of the poor review for Man Ray. It was this review that finally separated us. I was praised and he was panned. I was so upset I hid from everyone for a week. I was not in any way competing with Man Ray, but the papers made out I was. The fact that we both took portraits was just the way things were. It's too bad things worked out that way, particularly with that show. It was, in fact, a small show, simply hung down the staircase in a theater."

The First Salon of Independent Photographers helped widen her reputation. Requests came from magazines and newspapers to publish her portraits and galleries throughout Europe asked to exhibit her photographs. Only two years after launching out on her own, she was now no longer considered merely Man Ray's pupil but was becoming as important as the luminaries who sat before her lenses. In the farewell issue of *The Little Review,* a major periodical of the era, for example, more photographs are credited to her than to any

other photographer. She was the most active American photographer in Paris, filling, with Man Ray, a void that had existed until then in the documentation of the period. Her faces of the 1920s look out at one and through studying them one can experience the times even without knowing the identity of the subject. For scholars of the period, Abbott's portraits are true representations of those figures. A portrait that survives long enough to become a part of our heritage, regardless of its subject, is a work of art. Abbott's photographs have achieved that distinction. Her best-known portrait of James Joyce *is* James Joyce; it has been reproduced with such regularity for the more than fifty years since it was taken that it is the image most associated with the writer and his work.

salon de l'escalier
Valentin MARQUETTY et Jules KOLBERT

15, av. montaigne ∅ tél.: élysées 72-46
comédie des champs-élysées

du 24 mai au 7 juin

Ier
SALON INDÉPENDANT
DE LA
PHOTOGRAPHIE

Berenice Abbott ▪ Laure Albin Guillot
Hoyningen Huene ▪ André Kertesz
Germaine Krull-Ivens ▪ Man Ray
Nadar ▪ d'Ora ▪ Paul Outerbridge
Adget (retrospective)
VERNISSAGE
∅ le 24 Mai à 15 heures ∅

Poster for First Salon of Independent Photographers

A question that is often asked, justifiably, of Abbott is why she restricted herself to portraits in her early work. Responding to this same question from an American reporter in June, 1928, she wrote:

"Lack of funds led me into more practical fields and I became interested in photography. I have willingly abandoned sculpture, finding in photography a new, if not finished, art, and one that at least has equally great possibilities—and a form better adapted to the times. So far I have preferred going slowly, occupying myself solely with portrait photography. This is profoundly different from other kinds of photography. A portrait can have the most spectacular lighting effect and can be perfect technically, but it fails as a document (which every photograph should be) or as a work of art if it lacks the essential qualities of expression, gesture and attitude peculiar to the sitter.

"A quick eye for drawing and a mountain of intuition are principal factors for a portraitist. Personally I strive for a psychological value, a simple classicism in portraits."

Events and temperament thus made portraiture a necessity and the wisdom of her decision was confirmed by her immediate critical and commercial success. She was not tempted to venture outside the studio and document Paris; she had seen the work of Atget and knew the city was not in her soul. Abbott stayed indoors and made portraits, straightforward and unadorned. More than

fifty years later she feels she would take the photographs the same way. "Why not?" she asks. "The portraits I made in 1927 still look the way these people looked."

The accounts of life in Paris in the 1920s always depict a time of vigorous, sometimes outrageous, behavior. Abbott's life was not all work and no play, but the social side of her life during this period—and during all other periods of her life as well—is minimized by her. She is reluctant to discuss her contemporaries except in terms of their work, which to her has always been the most important aspect of the people around her.

Abbott's major interests outside photography were reading—Joyce was her favorite; movies—for her Charlie Chaplin and Buster Keaton reigned supreme; and dancing—in which, as far as she was concerned, *she* reigned supreme.

In February, 1929, Abbott returned to the United States for a short visit. She had left America full of rebellion and bitterness, but since then she had been studying the country from afar and had read *America Comes of Age* by the French scholar André Siegfried. In 1928, in an interview in Paris on November 18 with the *Cleveland Plain Dealer,* she had said, "Yes, I am eager to go back. When I came here seven years ago I ran away. But I guess those who rebel most against it [the United States] love it best."

She was not prepared for New York in 1929 any more than she had been in 1918 as a frightened teenager from Ohio. She looked—and was overwhelmed; the city appeared to her like one gigantic subject for a photograph that needed to be taken. Her excitement with the city demanded that she shift her focus to an entirely new field.

In Paris in 1929 Abbott's work had never been better and her friends were there; she was torn, but her mind was made up. She had to photograph New York. There was no reason why she could not set up a new portrait business there; she had received good notices in the New York press and she felt she could easily build up a reputation and a clientele. In her spare time she would photograph the city.

A quick return to Paris was necessary to sell or trade everything she owned—with the exception of her photographic equipment, art objects, personal papers and the Atget Collection. Max Ernst traded some of his paintings for her furniture. She made arrangements to have special containers made for Atget's glass plates. Just before she left Paris she purchased a small Kurt-Benzin camera and began to take photographs in cafés and on the street. With the first pack of film still in the camera she set sail for New York.

II

"When Poussin arrived in Italy he found the Carracci and their followers lauded to the skies—dictators of glory. No artist's education was considered complete without the visit to Italy, but this did not mean a study of such true models as the Antique, or the Sixteenth Century masters. The Carracci and their pupils had the monopoly of fame, that is to say they praised what resembled their own work and used all the authority of their position as the leaders of the reigning fashion to plot against anything that tended to break out of the ordinary rut."
—Eugène Delacroix, Paris, April 28, 1853

The New York to which Abbott returned in 1929 was enchanting, exhilarating and ever changing, but it was also full of pitfalls she had failed to foresee. In her innocence she was eager to photograph the city and its people and to document its constantly renewing appearance. She soon discovered, however, that the task was more difficult than she had imagined. She was unprepared for many things: the increased cost of living, the prejudice against women in photography, the outright competitive hostility among many American photographers and the preoccupation with strictly commercial values, which were foreign to her. Serious photographers tended to be dominated by Alfred Stieglitz and the group around him, and she immediately found herself at odds with their work and their philosophy. In addition, the commercial work in New York while paying more than in Paris presented her with a conflict between creative integrity and the demands of the trade. But this difference in outlook did not deter her. Within a month of her arrival she took a studio at the Hotel des Artistes, just west of Central Park, and set about establishing herself as a portrait photographer.

Abbott had brought with her to New York a modest reputation, and if she had possessed even the slightest business acumen, life might have been much easier. She reckoned her expenses to be five times what they were in Paris and so she quintupled her fees, making her one of the most expensive portraitists in the city. She did not advertise, hoping to gain a reputation by word of mouth as she had done in Paris. But New York was not Paris; her modest reputation, the absence of advertisements and her high fees resulted in few clients. Even among her American friends there were few requests for portraits and she was reluctant to suggest that she be commissioned.

The absence of work discouraged her from carrying out her original plan of working at portraits part of the time to earn expenses and devoting the rest to roaming New York, familiarizing herself with every aspect of the city. Now she could allow herself only one day a week for exploring New York. She was diligent in her search for work, however, and soon Abbott portraits and occasional photographs of the city were appearing in such magazines as *Vanity Fair, The Saturday Review of Literature, The Saturday Evening Post, Theater Guild Magazine* and *Fortune* (which proved to be her best client).

The few portrait commissions and magazine sales helped to keep her studio solvent, but Abbott's passion remained the city. She lived for Wednesday, the day she let herself wander the streets of New York. With no specific plan, she followed wherever her instinct led her, compiling a photographic notebook of locations and subjects she would document more ambitiously at a later date.

It was also a time to experiment, to try to make things look new and exciting in her photographs. One evening a friend took her to the Savoy Ballroom, probably the most popular place in Harlem then, and she was captivated. Abbott thought the dancers were the best she had ever seen and wanted to photograph them. Permission to take a photograph was granted and she returned to the Savoy a few nights later. She set up her camera, guessed at the exposure, set off a magnesium flash and froze a moment of time at the Savoy, almost starting a riot in the process. She had taken what is probably the first live photograph of a jazz band, in this instance Chick Webb's.

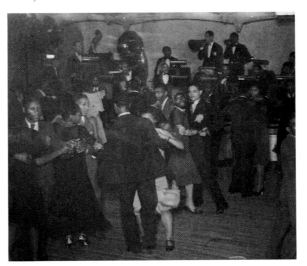

Chick Webb's Orchestra, Savoy Ballroom, 1929, *by Abbott*

Shortly after returning to New York, Abbott called on Alfred Stieglitz. She knew of Stieglitz only by reputation and had never seen any of his photographs, but she was interested in the work he was exhibiting and wanted to discuss the possibility of an Atget show. An exhibition of Paul Strand's photographs was in progress at the Intimate Gallery, a room in the Anderson Galleries, when she arrived, and although Stieglitz was generally complimentary to Strand he spent what Abbott felt was an inordinate amount of time criticizing certain aspects of his work as well as scolding a small child who had touched a photograph on the wall. He expressed a moderate interest in Atget, but Abbott decided right there and then that she did not want Stieglitz to present Atget's photographs in New York; she was afraid he might criticize Atget's work to strangers as he had Strand's to her, and thus do more harm than good. Besides, the two did not hit it off on a personal level and they had little to do with one another after that first meeting. Years afterward Abbott commented:

"He criticized Strand and showed me his own 'Equivalents,' small, dull photographs of clouds. Thinking my first impression of his photography could be wrong, I later went to the Met to see his work. The photographs of O'Keeffe's hands on a Ford seemed static and dull to me. Later still I went to see another large show of his, again hoping I was wrong about him. I was not; there were four or five truly fine photographs, but the rest did not speak to me.

"I felt there was something negative about the man, spiritual America was not of the low breed he had described. To judge America by European standards is foolish and a mistake. There was a new urgency here, for better or worse. America had new needs and new results. There was poetry in our crazy gadgets, our tools, our architecture.

They were our poems, and Hart Crane, perhaps our finest poet, recognized this. Stieglitz did not recognize it."

This initial encounter with Stieglitz was prophetic. Abbott still regards him as a profoundly negative influence on American photography. Yet contrary to what one might expect, she is not nearly as hostile to his photographs or to him personally as she is opposed to what he stood for. Abbott recognized then, as now, that Stieglitz and most of the photographers in his group considered themselves serious artists with a camera. Many of them, in fact, did not work at photography for a living. She regarded them as elitists—overly precious about their work and conspicuously arty. She considered herself to be a truly professional photographer, something she felt was not the case with Stieglitz and those who hovered about him.

The lack of rapport with Stieglitz and his circle isolated Abbott from a major portion of the photographic community. But this merely strengthened her resolve to pursue her own goal and maintain her standards of excellence.

Abbott had been trying to arrange to have a book of Atget's photographs published since 1928. Approaching both French and American publishers, she had met with little initial success. Finally the French firm of Henri Jonquières agreed to do a book but they wished to have a co-publisher in the United States. Long negotiations with Alfred A. Knopf proved fruitless. In late 1929, Abbott was introduced to the gallery owner and publisher Erhard Weyhe by Julien Levy, a young man of independent means she had known briefly in Paris.

Weyhe agreed in March, 1930, to distribute an American edition of the Atget book and to have a show of his original prints at the time of publication—in the fall of the same year. One thousand copies of *Atget: Photographer of Paris* were published bearing the Weyhe imprint and the show was mounted in November. Even though the Literary Guild advertised it through its regular mail order channels, sales were slow. The American edition did not sell out for many years and neither did the French.

Abbott's financial situation deteriorated in the early months of 1930 immediately after the 1929 Wall Street crash. Desperate for funds, she sold an interest in the Atget Collection to Julien Levy for one thousand dollars. The contract for the sale, dated May 2, 1930, was arranged by his attorneys and was much to his advantage. The understanding was that Abbott would make reprints from the glass plates and Levy would sell them in the gallery he planned to open. They were to undertake a campaign to publicize Atget to the best of their combined abilities.

The arrangement was never successful. A letter dated May 8, six days after the date of the contract, outlined the proposed division of profits from the Weyhe show and, presumably, future sales at Levy's gallery. Abbott was to be paid $1.10 for each print sold, plus expenses for materials. One year later a letter dated April 24, 1931, shows a balance due her of $31.06 for work up to that time.

Levy did mount shows in his new gallery featuring both Atget and Abbott, but in time he became more interested in showing the surrealist painters. The last letter from Levy in Abbott's file is dated October 22, 1934, when an accounting of the collection was made for the benefit of one Mme. Blackman, who was apparently interested in purchasing the entire collection of plates and prints. At that time there were 4,218 original prints of different subjects, 3,681 duplicate original prints and 1,415 original plates. From then on, there was almost no contact between the two.

Portraits were an early luxury to fall by the wayside after the 1929 crash—but fortunately the content of Abbott's portraits had been changing. No longer was it limited to the people sitting before her camera but was becoming New York itself.

Her first New York photographs, done with a small view camera, were published quickly, the earliest appearing in the May, 1930, issue of *Architectural Record*. Soon European magazines, mindful of her reputation as a portrait photographer, were also eager for her work. She was grateful for the old ties; the fees were small but it was gratifying to see her new work published.

Although these early outdoor photographs were certainly adequate, the kind of photographs Abbott wanted to take required a larger camera. She bought an 8" x 10" Century Universal view camera (because it was then the lightest and most flexible on the market) and a 9½" Goertz Dagor lens. She took to the streets with the camera but was immediately faced with a critical problem: she had never worked with a large-format camera outdoors and the Century Universal was far more complicated than her small studio view camera. She did not know anyone who could teach her how to use it, and was forced to teach herself and make mistakes along the way. It was the best way to learn because once she made an error she never made it again, and eventually she developed a masterly technique.

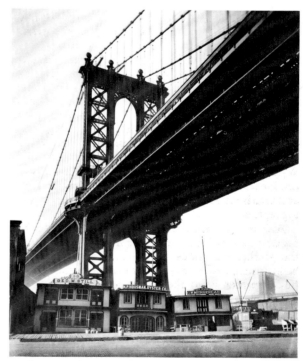

Manhattan Bridge,
Abbott's first photograph with Century Universal camera

By early 1931 Abbott had a plan. It had been two years since her first photographic encounter with the city, and to photograph New York had become an obsession, for the city was changing daily as she studied it. Locations were filed away carefully; two years of searching for good photographs had built up a reserve, and each trip onto the street to take a photograph usually resulted in finding two more to be done. Recognizing even then the scope of her project—her notebooks clearly reveal this—she often found it hard to follow her original plan because there were so many photographs to be taken. She would note a location and return with her camera the following Wednesday, only to find the view altered or a building ripped down altogether. But she soon developed a sense for those parts of the city that were about to change and attempted to cover them rapidly, leaving the documentation of new or less threatened locations for another day.

All this early large-format work in New York was totally self-supported. Aside from the few magazine sales and occasional encouragement from friends, she had no financial aid of any kind. One of her profoundest regrets today is that in these early days, when she was at her most energetic and ablaze with eagerness, she had almost no money.

But to photograph the city properly she needed money. Her first attempt to obtain outside funding was an application to the Guggenheim Foundation. She was rejected. In fact her request was not even considered because the trustees felt they should continue "the international character of the Foundation's fellowships."

Undaunted, in November, 1931, she approached the Museum of the City of New York with a lengthy proposal, for the first time putting the entire plan on paper. The museum's director, Hardinge Scholle, was sympathetic but said that lack of funds made it impossible for the museum to become involved.

In 1932 she went to the New-York Historical Society, now calling the project Changing New York. Part of her proposal reads as follows:

"Old New York is fast disappearing. At almost any point on Manhattan Island the sweep of one's vision can take in the dramatic contrasts of the old and the new and the bold foreshadowing of the future. This dynamic quality should be caught and recorded immediately in a documentary interpretation of New York City. The city is in the making and unless this transition is crystallized now in permanent form, it will be forever lost. Such documents would be of increasing historical value for the archives of this city. Posterity should have a pictorial record of this era's characteristics, which typify New York's present unique personality in regard to social and human aspects, types of people, manner of dress, architecture and interiors. There is no such record except in the poorly reproduced and inferior photographs in yellowing and crumbling files of the newspapers. The camera alone can catch the swift surfaces of the cities today and speaks a language intelligible to all. Photography can supply several sets of the same document, making obliteration by fire or accident almost impossible.

"I am overwhelmed by the importance of American material so often ignored by our native artists. Neglecting our own material, we are leaving open a very rich field to foreign artists who will interpret the American scene too much from the European standpoint. I had very good occasion to see an example of this when I recently helped a French cinematographer make a documentary moving picture of New York City. My attitude as an American whose appreciation is tempered by long residence abroad and whose observation has been made more acute by a truer perspective not only makes my viewpoint critically selective but gives me an unspoiled appreciation of what to others might appear commonplace. Since my return I have been consumed with one aim, one desire: to catch and record this inimitable city. My chief regret is that I have not the money to plunge into the work with the concentrated penetration and sequence that such work demands."

There followed an outline of needs, financial and otherwise, and a description of the product that would be delivered to the Society. It was useless; the idea was rejected in a letter stating, "It would be unwise at this time to find resources to finance your work of photographing the City of New York." Abbott continued her fight in 1933 to obtain adequate funding for her project. In an effort to raise money through private subscription, she enlisted the help of Hardinge Scholle and

the architect Philip Johnson, who was at that time chairman of the department of architecture at the Museum of Modern Art. On January 25, 1933, Scholle drafted a letter on behalf of the Museum of the City of New York praising Abbott's talent and endorsing her project. One week later Johnson prepared a similar letter on Museum of Modern Art letterhead. Both museums provided lists of the names of their major contributors, who were among the most prominent people in New York, and by early summer she had drafted nearly two hundred personal letters to the "friends" of the two museums from whom she hoped to raise fifteen thousand dollars. The mailing was made on June 5; on June 6 the first rejection came from one Rex Cole and on July 10 the last arrived from a member of the Dodge family on holiday in the Near East. In between these two rejections were thirty-three others; most people had not bothered to respond at all. She recalls that one individual wrote offering fifty dollars, but the letter has been lost. Not a single dollar was collected for the New York project through private subscription.

While she was attempting to raise money for the project, Abbott did not abandon her photographic work on Changing New York. In fact, because her portrait business was nonexistent, more of her time than previously was occupied in taking new photographs of the city. Even though lack of funds limited the scope of her work, she managed to take some of her finest New York photographs during the first years of the decade. Critical recognition for this work was quick in coming and the photographs were shown at the Museum of Modern Art and at a variety of galleries.

The constant stream of letters rejecting subscription to Changing New York was discouraging, however. After the thirty-fifth letter arrived she was glad to accept an offer of a job from the architectural historian Henry-Russell Hitchcock. In July, 1933, Abbott and Hitchcock left New York to begin work on two projects, one to record American cities as they existed before the Civil War and the other to document the buildings of Henry Hobson Richardson.

Hitchcock knew exactly what he needed; the locations were on file and he had prepared an elaborate itinerary as well. The two made their way north to Boston, west to Buffalo and south to Savannah. Along the way they worked in Philadelphia, Baltimore, Charleston and a number of other cities. The plan was simple: Hitchcock selected the buildings or a group he wanted to record and from that point on Abbott was in charge. A number of interesting photographs were made —some were even exhibited—but the chief usefulness of the trip to Abbott was in the way the photographs pointed up the differences between the cities—between, for example, the energy of New York and that of Boston. Abbott became even more acutely aware of the importance of her New York work.

Changing New York carried on into 1934, gathering a bit of momentum in the process of which Abbott received some much needed encouragement. She had amassed a significant body of work by this time and the Museum of the City of New York felt a show was in order. They exhibited forty-one of her New York photographs in October and the critical response was favorable and extensive. The most important comment came from an unexpected source, *The Springfield Republican,* a small newspaper published in Massachusetts. The review was written by Elizabeth McCausland, who was to emerge as one of America's foremost art critics. From the time of that first review she was a champion of Berenice Abbott's work. Indeed, she wrote the first thorough-

going appraisal of it shortly after they met in 1935; it was published in the March-April issue of *Trend*. Their friendship was to become an enduring one.

In early 1935 Marchal Landgren of the New York State Municipal Art Committee suggested that Abbott apply to the Federal Art Project for help to underwrite Changing New York. The FAP, part of the Works Progress Administration, was a federal government organization responsible for funding a variety of art projects during the 1930s. Abbott had tried everything else, and so she dug out all her old proposals and updated them. In February, 1935, she submitted a concise three-page outline to Audrey McMahon, the Regional Director of the FAP. Supporting letters were provided by Hardinge Scholle and I. N. Phelps Stokes, the author of *Iconography of Manhattan Island*. A passage from the new proposal gives a vivid picture of New York and is eloquent testimony to her aim:

"To photograph New York City means to seek to catch in the sensitive and delicate photographic emulsion the spirit of the metropolis, while remaining true to its essential fact, its hurrying tempo, its congested streets, the past jostling the present. The concern is not with an architectural rendering of detail, the buildings of 1935 overshadowing everything else, but with a synthesis which shows the skyscraper in relation to the less colossal edifices which preceded it. City vistas, waterways, highways, all means of transportation, areas where peculiarly urban aspects of human living can be observed, crowds, city squares where the trees die for lack of sun and air, narrow and dark canyons where visibility fails because there is no light, litter blowing along a waterfront slip, relics of the age of General Grant or Queen Victoria where these have survived the onward march of the steam shovel; all these things and many more comprise New York City in 1935 and it is these aspects that should be photographed.

"It is important that they should be photographed today, not tomorrow; for tomorrow may see many of these exciting and important mementos of eighteenth- and nineteenth-century New York swept away to make room for new colossi. Already many an amazing and incredible building which was, or could have been, photographed five years ago has disappeared. The tempo of the metropolis is not of eternity, or even time, but of the vanishing instant. Especially then has such a record a peculiarly documentary, as well as artistic, significance. All work that can salvage from oblivion the memorials of the metropolis will have value. Something of this purpose has been carried out as the exigencies of a busy life and the physical difficulties of the undertaking have permitted, but more could be done with ample leisure to devote wholly to the project and with more systematic assistance."

Would anyone at FAP be truly interested? Nothing was immediately forthcoming.

In the spring of 1935 the New School for Social Research asked Abbott to give a course in photography, an unusual opportunity for a photographer at that time. She was terrified of teaching, but the prospect of a modest salary tempted her and the FAP had given no sign that it was going to provide funding for Changing New York. Feeling that she needed a period of time to prepare good class outlines, she agreed to begin teaching in September.

Summer arrived and still no word had come from the FAP. Abbott therefore planned a trip to look at rural America with Elizabeth McCausland, who was likewise a devotee of the American scene. They went to St. Louis and into the Deep South, and Abbott faithfully documented rural and small-town America. Her work is reminiscent of that done for Roy Stryker's Resettlement Administration/Farm Security Administration unit, though hers predates that of Stryker's unit. The subject matter characteristic of her rural photographs is inevitably comparable to the best of the RA/FSA work, although, as she says, she found it difficult to "stick a camera in the face of someone burdened with such poverty." Almost as soon as she returned from the trip some of the photographs were reproduced in a large spread in *The New York Times Magazine*. They have been largely neglected since that time; the negatives were even misplaced and not rediscovered until 1978 (pp. 171–179).

These photographs of the rural South are not typical of Abbott's work of the time but they demonstrate her capability of handling unfamiliar subjects with sensibility and compassion. Had she not been so enthralled with her work in New York she could easily have found a place on Roy Stryker's team.

In early September Abbott reported for her first classes at the New School, not knowing that she

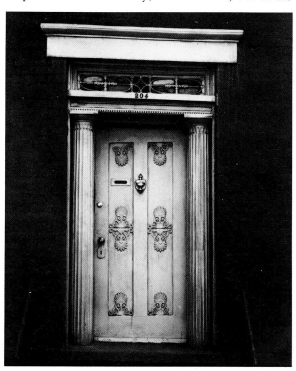

Doorway, 204 West 13th Street, 1931, *by Walker Evans*

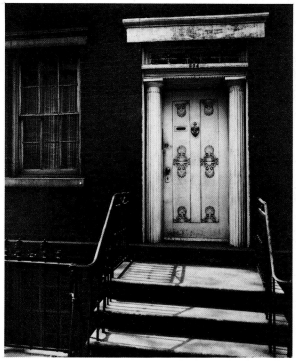

Doorway, 204 West 13th Street, 1937, *by Abbott*

would teach there for the next twenty-three years. She would also go on to establish one of the finer academic photography departments in the United States. She recalls:

"When I began I was the only photographic instructor at the New School and I was frightened to death. I really thought I would faint and have to be carried out but I had prepared my lectures carefully and managed to get through the first class. Then slowly and gradually it became easier. I had some problems; I was used to calling chemicals by their French names, but I soon got over that.

"There were a few talented students but not too many. The best you can do in a course like that is help students find themselves. I tried to teach them to be themselves; to have the courage to be themselves. I never showed them any of my photographs, I didn't want to influence them. I wanted them to find their own way."

Meanwhile she had become increasingly apprehensive about whether the FAP would approve Changing New York. Finally, late in September, the proposal was approved. Berenice Abbott became #235905, a project supervisor with a grade of GS-11 ($145 per month), and Changing New York became Official Project No. 265-6900-826. There had even been room in the budget for her 1930 Ford roadster. After six years she had finally found funding.

The project was structured nearly exactly the way she had outlined it in her last proposal. She took all the photographs and had control of a staff that included a driver, a darkroom helper and a person to spot and file. She also had two history researchers, but she selected her own subject matter. Initially at least she was not caught up in government bureaucracy, although a senior official of the FAP, looking at some of her photographs taken on the Bowery, once told her that a nice girl should not go into such neighborhoods. Abbott replied, "I'm not a nice girl, I'm a photographer." She was never bothered again.

Her work plan required her either to visit a subject area she had previously selected and recorded or to comb the streets until she discovered a potential subject.

She then studied it carefully, determining the best time of day for the proper lighting; if she was lucky and the time was right she would take a photograph of the subject on the spot, otherwise she would return when the light was best.

Her main territory was the borough of Manhattan, with secondary emphasis on Brooklyn and the Bronx; she also took a few photographs of Queens and Staten Island. She was interested in all types of subject matter—for their own qualities and for their relationships to their surroundings. The city was full of change, of contrasts, of contradictions and she attempted to render them all together in one critical moment in each of her photographs. She tried to find locations where all the elements of change could best be documented: "I went down to Coenties' Slip many times but was never satisfied with the photographs. You could see almost every stage of New York City at that location, from the squat little Federal houses, to the awkward 1890s buildings, to higher and higher. I went right out to the end of the pier but the photographs were always underexposed because of the strong sea breezes blowing the camera and shaking the tripod." There was a special, usually immediately apparent, relationship in her photographs between one building and another, between the old and the new: between, for example, the sign of the gun shop and Police Headquarters (p. 106). Her good friend Walker Evans photographed the doorway at 204 East Thirteenth Street as an American artifact; Abbott, unaware of Evans' photograph, took the same subject showing the doorway more in relation to its surroundings.

After a full year of work it was obvious to Abbott that Changing New York was a never-ending job. The more she did the more she realized there was to do. Many of the photographs were also shown in galleries and museums and reproduced in various government publications. She wanted to make all her own prints but it was soon impossible; the demands were simply too great and so she had to turn most of the darkroom work over to assistants. If she had not done so she would have had no time to be on the street producing new photographs.

An unexpected aspect of Changing New York was the publicity it brought Abbott herself. She had never lacked critical acclaim, but the interest in her was now on a more popular level with newspapers, magazines and radio all approaching her on a regular basis. She was asked to judge shows and to serve as the photography advisor to various groups. Magazines such as *U.S. Camera, Popular Photography* and *Coronet* not only requested photographs but published articles on her. In some instances the magazine staff writers prepared the pieces, in others Abbott wrote them herself. To her surprise, even *Life* magazine, which had ignored her up to that time and resumed doing so thereafter, published an extensive feature on Changing New York in 1938.

In December, 1937, a high point in the project's history was reached when the Museum of the City of New York assembled a show featuring 110 of Changing New York's best photographs. It was the greatest number of Abbott photographs ever shown before and the reception was enthusiastic. The writer and photographer Carl Van Vechten wrote her: "I went to see your New York pictures yesterday and you wouldn't need to be told they were all completely magnificent. They all compose. They have clarity and sympathy. Technically they are flawless. Most of all they definitely are lacking in any strain after novelty or angle. I must say I find you are pretty much the master (or mistress) of all living photographers. Would you have time someday to let me try to make a *PHOTOGRAPH* of you?"

In 1938 E. P. Dutton and Company expressed their desire to the Federal Art Project to publish the New York photographs in a book to be entitled *Changing New York*. Abbott was initially pleased, until she learned she would have absolutely no connection with how the book was made: with how the photographs were selected or with any part of the design. She would also receive no royalties or payments of any kind (they would all go to the FAP). The only saving grace for Abbott was the fact that the captions for the photographs were to be written by McCausland.

Despite this unpleasant situation, Abbott went about her work. By the end of the year, however, indications were that all was not well with her project, at least in the eyes of the FAP. There was intense rivalry within the organization and other photographers continually expressed their annoyance that Abbott not only had her own project but worked out of her own studio on Commerce Street as well (she had persuaded the FAP to move the project there in 1936). In December, 1938, she took what was to be the last photograph for the book and the following day she was demoted to assistant project supervisor.

Although *Changing New York* was issued in 1939 to great praise, the book would have been much more comprehensive had Abbott been allowed to participate in its production. After its publication her staff was cut repeatedly until, by August, 1939, she had no staff at all. For nearly a

year every request she made to the FAP had been rejected; her final request, to properly document the World's Fair, was turned down as well. A few weeks later she was told she could remain with the FAP only as a regular staff photographer and that she would have to abandon Changing New York. She resigned. The bureaucracy of the FAP and the jealousy of other staff members had killed the project. From that point on she produced very few New York photographs and only if they were required for a specific purpose.

With the end of Changing New York a significant phase of her career was concluded. In the eyes of some, particularly of those New Yorkers who now look at the photographs taken between 1935 and 1939 with nostalgia, this work forms the most important part of her oeuvre. But this is a narrow view. She does not regard one part of her work as any more significant than another, and she feels that sentimental judgments based on nostalgia miss the point altogether. Her point was graphically to capture the times—to make a record, in as artistic a fashion as possible, that would be of use to historians, sociologists and even art critics.

The values of the New York work are complex. Because the photographs express the spirit of the age rather than simply show a specific location at a specific moment, they transcend time and exist as permanent statements. Abbott's New York photographs can be viewed on two levels: on a deeper level as the particular vision of a major artist of the twentieth century and on a more practical one as a permanent research source for social and architectural historians interested in reconstructing the nature of the city as it existed before World War II. Changing New York was funded for only four years but these few years showed what can be accomplished when the U.S. Government aids artists and has the good sense to leave them alone. During the entire ten-year period of the project—six years of which she was on her own—Abbott produced the finest record ever made of an American city.

The New York project absorbed almost all of Abbott's energies during the second half of the decade, but she was also involved in other matters. There were shows to be arranged, articles to write and, of course, there was Atget. She was overjoyed when Beaumont Newhall agreed to exhibit nineteen Atget prints at the Museum of Modern Art in 1937. After that, prospects for Atget looked a little brighter. Several small shows in other museums were scheduled and a flow of magazine articles appeared, including one by Abbott herself in a 1940 issue of *U.S. Camera*. One of her more important projects in the late 1930s, however, involved another photographer, Lewis Hine.

She first came to know Hine's work through a 1938 article by Beaumont Newhall in *Parnassus*. She wrote to Hine and arranged to meet him at his home at Hastings-on-Hudson, north of New York. It was not a good time to meet Hine; his kind of social documentary photography was not fashionable then and he had no work. Overburdened with financial cares, he was worried and distraught but nonetheless willing to discuss his life and work. Abbott decided she should try to do something to help him. Recalling Hine she says:

"When someone is good it is your obligation to help, even if you are very busy yourself. You can always find time if it really matters. The first person I interested in Hine was Elizabeth McCausland and together we tried to do what we could. We took his work around and tried to convince people to buy it but no one was interested. McCausland wrote two articles about him that

year; one for the *Survey Graphic* and the other for the *Springfield Union and Republican*.

"We finally managed to secure a show for him at the Riverside Museum in January, 1939. Hine did not have an enlarger so I made the enlargements for him. The same month McCausland wrote another article for *U.S. Camera* but there was little more we could do; he died the following year, largely unrecognized.

"Hine's real greatness was his eye. Whatever his assignment was he knew how to see, where to put his camera and how to get a living image. In this sense he was an affirmative photographer. It may very well be that Hine did not have a great social consciousness, in fact, I suspect, based on our meetings, that he did not. His assignments happened to put him in a position to take the kind of photographs he did. He might have done just as well with buildings or interiors, but obviously he liked taking photographs of people and he took them very well, better than almost anyone. His work was probably never fashionable, but it was particularly unfashionable in the years before his death. The people who found his work most unfashionable were those who gravitated around the various cults and the editors of magazines who could have offered him employment.

"I didn't really know him very well and when I did the circumstances were unhappy. I was not even personally fond of him; perhaps he would have been a dearer person to know as a friend if lack of work had not made him so distraught. Nevertheless, he was an important photographer in every sense and I wondered whether to take him on as I had Atget. I made the decision not to at the time and it was the right decision."

The fact of the work of a great photographer like Lewis Hine being summarily rejected—coupled with the loss of her own Changing New York project and her underemployed status—had a profound effect on Abbott. She had worked singlemindedly at documenting the city and had gained consummate professional skills and a superb reputation as an artist, yet she remained without a job and without direction.

She was later to reminisce:

"When Changing New York was finished, it was just over. I didn't want to sacrifice any more; I didn't want any more agony. The project was not ideal, but it was perhaps as good as was possible given the circumstances, and if I had had some encouragement I might have gone on, but I did not, so it was finished.

"Then I thought, 'What do I do now?' I always thought the subject was the important thing; I had to have a subject that could be probed, explored, a subject of significance. The taking of photographs as such never meant much to me; I had to have a reason and I thought to myself, 'Where is all the gutsy stuff these days that is not commonplace?' I kept thrashing around. After all, this was the scientific age. Most of us were woefully ignorant of science yet we were caught up in its tentacles. Of course, it was like a flea attacking a giant, but I gave it a try."

Changing New York had been a ten-year struggle. What Abbott did not know at the time was that her decision faithfully to photograph science, to attempt to link science and art, would involve her in a much more difficult struggle, which would take twice as long even partially to complete. In choosing science as a subject she would soon find herself at odds with virtually everything that was in fashion in photography.

III

Abbott had no formal training in any scientific discipline, but she was endowed with an inquiring mind, a prophetic sense and the perseverance with which to push into the largely unexplored field of scientific photography. She bought secondhand texts on physics and electricity and though she lacked the background to understand them fully she saw how poor most scientific photographs were. The majority of them looked as though they had been taken by the author of the textbook or an assistant or, worse, had been simply stock items. They seemed to rely entirely on captions for explanations and were anything but visually alive.

In late 1939, after her initial study, Abbott drafted a simple statement outlining her beliefs. Written as much for herself as for anyone else, she nevertheless hoped it might find its way into the hands of people who could use or support her work.

"We live in a world made by science. But we—the millions of laymen—do not understand or appreciate the knowledge which thus controls daily life.

"To obtain wide popular support for science to the end that we may explore this vast subject even further and bring as yet unexplored areas under control there needs to be a friendly interpreter between science and the layman.

"I believe that photography can be this spokesman, as no other form of expression can be; for photography, the art of our time, the mechanical-scientific medium which matches the pace and character of our era, is attuned to that function. There is an essential unity between photography, science's child, and science, the parent.

"Yet so far the task of photographing scientific subjects and endowing them with popular appeal and scientific correctness has not been mastered. The function of the artist is needed here, as well as the function of the recorder."

Abbott's ideas about science and photography sounded good; they looked good on paper but they met with no response. She managed to convince Harper and Brothers to publish a new book on electricity using her photographs, but the project subsequently fell through. The many scientists she contacted as possible collaborators scoffed at her ideas. Chemistry courses at New York University improved her own knowledge and the studying involved reinforced her observation that diagrams and even poor photographs helped one to understand the intricacies of science. But she was unable to convince anyone else of the importance of these visual materials as educational tools. After two years she still could find no way to implement her ideas and her quest for work in scientific photography was at an impasse.

Scientific photography provided no income and in her search for work Abbott considered other possibilities. She felt she had sufficient reputation as a photographer to interest a publisher in a how-to book on the subject and she was correct; the first publisher she approached immediately commissioned her to prepare *A Guide to Better Photography*.

Writing the book was not difficult. She followed her New School class notes and the guide fell quickly into place; as it did, she asked Elizabeth McCausland to "polish it up." The book would never have been completed so rapidly nor so well without McCausland's assistance.

A Guide to Better Photography was published in 1941 and proved to be an artistic and commercial success. It stayed in print well into the 1950s and was reprinted many times. The book was not only adeptly written but handsomely illustrated with photographs by Abbott's personal favorites, among them, Nadar, Atget, Hine, Evans, Ansel Adams, Margaret Bourke-White and Lisette Model—photographers not particularly popular at the time. Most of the illustrations in the book are now recognized as classics, while those in other how-to books of the period generally appear hopelessly old-fashioned.

The text, however, is the most important part of the guide. In it Abbott set forth for the first time her basic philosophy of photography: "Photography is a new vision of life, a profoundly realistic and objective view of the external world." Her belief in realistic photography is the primary theme of the book, and she advises the serious photographer to use a camera with ground glass and adjustments, and to avoid manipulative processes that deny photography's realistic character.

Two essays in the book entitled " 'Straight' Photography" and "Documentary Photography" succinctly summarize her philosophy. In " 'Straight' Photography" she repudiates arty and manipulated photographs:

"As I see straight photography, it means using the medium as itself, not as painting or theater. Straight photography should be understood, I believe, not as the product of a group of photographers but as a historical movement expressing the interplay of forces. It was a necessary revolt from the worst follies of pictorialism—manipulation of prints, toning, double printing, fuzzy imitation of inferior Corots. . . . All subject matter is open to interpretation, requires the imagination and intelligent objectivity of the person behind the camera. The realization comes from selection, aiming, shooting, processing with the best technique possible to project your comment better. But devious manipulation into the falsified, 'arty prettiness' of petty mind sis certainly not a photographic function."

In "Documentary Photography" she states her case for this form of photography:

"The reason I emphasize the content of documentary photography . . . is that I believe content to be the *raison d'être* of photography, as of all methods of communication. . . . The potentiality of the camera for communication is almost unlimited. . . . In other words, [documentary photography] is real life, the life you see every day. . . . In this crisis of world history, it is important to understand clearly the potential function and value of the photographer as the historian of human life. . . .

"The photography which best expresses the interplay of forces in our period will be a synthesis of straight and documentary, in which the intelligent photographic technique of the former school and the human emphasis of the latter will be fused."

A Guide to Better Photography was one of the first books to provide insights into the thinking of a great photographer of our era. At the time the book was written, more than forty years ago, the only other photographer who had attempted to make such a statement had been Ansel Adams in his short monograph *Making a Photograph* (1935). None of the other major photographers had committed their philosophy to print for the general reader. A few, like Stieglitz, had published their pronouncements mainly for the benefit of their followers and for historians of photography.

The book was Abbott's sole appearance before the public in the nearly five years following the Changing New York project. There were no

major exhibits of her work and other than occasional portraits, few commercial assignments. In the early 1940s, she produced a photo essay for *Life* magazine on slaughtering chickens, worked a few days on Roy Stryker's Standard Oil Project in the winter of 1945 (she became ill and had to withdraw) and carried out some modest industrial assignments that lasted one or two days at most. She had only one commercial assignment in the 1940s involving more than two days and that was to document the operations of the Red River Logging Company in California (pp. 200–201). This was Abbott's only work west of the Mississippi, and for ten days in August, 1943, she took hundreds of photographs with her Rolleiflex. The work is outstanding and proves what a good photojournalist she could be, given the opportunity.

Red River Logging Company project

Abbott's rejection by commercial outlets forced her to dedicate herself with even firmer resolve to scientific photography and to discovering how science could aid photography. As she acquired sufficient working knowledge of physics, mechanics, chemistry and electronics she began to combine basic scientific principles with her own common sense and practical photographic technique. Gradually another life for Abbott began to emerge. For nearly two decades she concentrated on the photography of science and on inventions and the development of photographic apparatus. This phase is one of the most fascinating of her career but is virtually unknown except to a few close associates. It sets her apart from her contemporaries, placing her, unique among photographers, in the tradition of the self-taught, inventive American craftsman.

In 1944 Abbott stated in an interview in *Popular Photography* magazine, "For two years I have been working on a secret lighting process. My new process is in the stage of evaluation and needs time and money before it can be hatched in full bloom." This was the only public comment she ever made on one of her earliest and most interesting scientific endeavors. She had, however, made the following entry on the subject in her notebook in 1942 and had sent herself a registered letter containing the identical information.

"The problem of photographing real objects so as to obtain greater definition and roundness has led me to make a number of experiments. Through these I have evolved a method which I believe to be unique and which is entirely of my own devising. For convenience I call this method *Projection Photography*.

"In my opinion this method has commercial as well as technical possibilities. Therefore I am setting down the facts about its evolution to protect my interest in patent and manufacturing rights.

"The basic idea came to me on March 9, 1942. I had previously projected objects in my enlarger, but only transparent objects can be so treated. While considering how to make photographs which possess greater definition and roundness and so are more faithful to their real appearance, I suddenly thought: Can I not project opaque objects if they are lit from the front? I immediately made an experiment with my assistant, Miss Wilkinson, to test the idea.

"I sat her in back of my 8″ x 10″ camera, the ground glass first having been removed—this in the darkroom. Then I took two portable lights and lighted her face, draping the focusing cloth, etc., over her head, the camera and lights to shut out light from everything except her face. Thus I was able to project her image through the camera's lens onto a white cardboard on the wall. The image thus projected was startlingly vivid, real and exciting. I then placed a sheet of normal sensitive projection paper over the cardboard and, exposing it, got a very interesting negative photograph.

"But many problems arose. Paper is so slow that a long exposure is needed to make these direct pictures. The subject's head inevitably moved during the twenty-second exposure. The image was in reverse. I questioned if it would be possible to find a way to eliminate the negative altogether, since present-day film is unsatisfactory in many respects.

"Since March 9 I have carried out experiments with paper negatives, autopositive paper, superspeed positive paper, etc. As strong lights cannot come near a person's eyes, all of these were discarded because of their slowness.

"The method I evolved experimentally is to project the image of the object behind the camera onto 16″ x 20″ film in a totally dark room, the object being lighted from the front. This setup creates a new kind of photography, *Projection Photography*. Its prime advantage is greater realism, the *raison d'être* of photography.

"This is possible because the object itself is enlarged instead of a negative. A greater range of tones results; for the real object has more tones than film registers, and paper registers even fewer tones than film. Loss of tones—by which we mean shapes, forms and hence facts—means loss of truth to the real object. This, I am certain, makes an important addition to photography."

The first photographs Abbott made by this new system were of her assistant, Pat Wilkinson, and of Elizabeth McCausland in early April, 1942. She had no large pieces of sheet film so she used regular 8″ x 10″ film. She put four pieces together and then projected an image on the film. The idea worked; these photographs are still tucked away in a file drawer in her darkroom. But if the camera was to aid in photographing science, as she initially hoped, it had to be significantly improved.

She tinkered with the system for nearly four years but lighting remained the major problem. Searching for a stronger light she contacted the pioneer in stroboscopic photography, Harold E. Edgerton, at the Massachusetts Institute of Technology. But he advised her that the lighting she required was at least five years and many thousands of dollars away. Twelve years later, when she began her own work at MIT with the Physical Science Study Committee, the lighting she needed was still not available. In fact forty years later it is still not adequate for the large-format Polaroid system that in many ways is amazingly similar to Abbott's projection system.

Even without the proper illumination Abbott managed to construct a prototype camera, which

stood nearly five feet tall and three feet square. An object inside the camera was projected through the lens onto sensitized film. What Abbott was doing, in effect, was creating a camera obscura in reverse; it was really a very simple process, so simple in fact that, fearing the idea might be stolen, she kept everything related to the project a secret. Construction and work on the camera disrupted the normal activity of her studio for months and she allowed only her most trusted friends to come there.

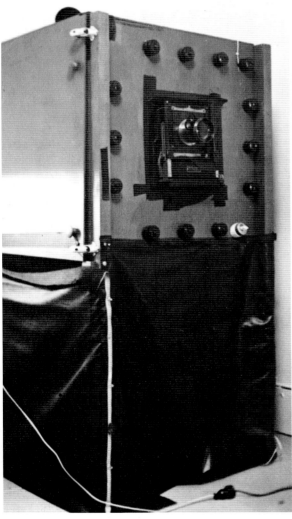

Abbott's Projection-Supersite camera

The 16″ x 20″ contact prints that resulted from her projection process are of three types: portraits (the best known that of Philip Evergood, p. 186), natural objects (insects, leaves) and inanimate objects. They all have the qualities she had outlined in her original notebook: clarity, lack of grain, and greater plasticity and dimensionality; and there is a full range of tones in the negatives and hence a greater tonal range in the prints.

These photographs have rarely been seen by anyone. In the late 1940s Doubleday and Company offered to publish a small portfolio of the photographs, with captions by Muriel Rukeyser, on condition that the Museum of Modern Art exhibit them as experimental photographs. But the director of the Museum's photography department at the time, Edward Steichen, was not interested; he considered the photographs inconsequential and thus the publication did not result.

Although the projection-supersight system, as she called her invention, was not fully realized, it gave Abbott the confidence to move on and she increased the scientific entries in her notebooks; the crude little drawings entered in 1943, in fact, emerged a few years later as patented devices. She began to make her way, designing equipment, developing new processes and inventing gadgets, in the course of which she butted headlong into the

massive, powerful commercial interests that controlled this field. She was ahead of her time, as her notebooks show, and it was inevitable that she be regarded by the commercial outlets as a meddlesome female. The photochemists, optics experts and scientists specializing in camera design knew little about what went on in the minds of serious photographers. They (or more specifically the corporations for which they worked) were only interested in the needs of amateur photographers, who used the bulk of their products, not in those of serious photographers. This situation continues to this day.

Nevertheless Abbott's activity on the fringes of the scientific community began to bear results. In searching for an outlet for her scientific photographs she met Gerald Wendt, the distinguished lecturer and author and popularizer of science, and Jack Catell, the publisher. In mid-1944 Catell took over a little magazine called *Science Illustrated* with the idea of improving it and hired Wendt, the science editor of *Time,* to edit it. In the September, 1944, issue an editorial introduced Berenice Abbott as the photography editor: "She is convinced that a whole new branch of photography needs to be developed—the intimate human portrayal of scientific thought and practice, the analysis of complex science into picture simplicity, and, above all, the imaginative yet realistic atmosphere of scientists and the world they live in."

This was Abbott's first foothold in the scientific world after five years. She would have her scientific photographs published and the job would pay her twenty-five dollars a week. Her main duty for the magazine was to read most of the articles and make certain they were suitably illustrated. In many instances existing photographs were used, but quite often new photographs were needed and this was where Abbott's special skills came into play. Her notebooks indicate her plans for potential projects: the evolution of the light bulb, the laws of science, high-speed subjects, visual manifestations of the changing seasons, among many others. Some of these projects were realized, including the publication of her earliest experiments with wave forms, which she photographed without a camera. Sophisticated variations on Man Ray's work in the 1920s, these wave-form photographs were more fully developed in the late 1950s when Abbott worked for the Physical Science Study Committee (pp. 226–229). They evolved from experiments done as early as 1940 utilizing a small flash bulb, 1/200th of a second in duration (point source light), to expose wave motion in a developing tray that was slowly rocked.

In mid-1945 *Science Illustrated* was sold to McGraw-Hill and the magazine was revamped. Abbott continued to be used, but only on a part-time basis. Though she created her famous soap bubble photograph during this period (p. 231), Abbott found the new publication uninteresting and resigned within a few months.

Seven years had passed since she made the decision to pursue science and Berenice Abbott was nearing fifty. Highly respected as a photographer, she was invited to judge shows and to lecture. Articles were written about her in magazines; on occasion inquiries were made to her about Atget. But with the demise of her position at *Science Illustrated* she was again a master photographer out of work. Forced by her desperate situation to think about alternatives, she hit on an idea for the one truly commercial venture of her long career, a venture that would combine her inventiveness, scientific skills and knowledge of the kind of equipment needed by photographers.

With Hudson Walker, the gallery owner, and Muriel Rukeyser she raised sufficient funds to launch a small business called the House of

Photography. Incorporated on January 29, 1947, the company had a board of directors, a paper worth of $20,000 and 200 shares of stock of which Abbott owned 102 shares.

Scattered through her spacious attic workroom in Maine are the remains of the House of Photography: models of inventions, stock certificates, the corporation seal, bundles of the registered letters (which remained sealed until well into the 1970s) she wrote to herself in order to date ideas, publicity fliers for the products marketed, reams of correspondence with patent attorneys and model makers (to whom were paid the bulk of the company's modest resources), and a file of patents for devices never marketed. Although the House of Photography proved to be a financial failure, Abbott's incredible flood of ideas during its existence distinguished her among twentieth-century American photographers as a photographic equipment designer.

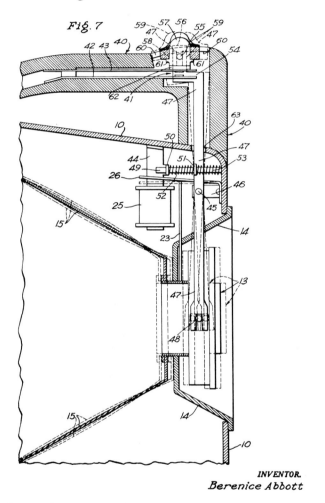

INVENTOR.
Berenice Abbott

Diagram from Abbott's patent for candid camera, 1958

Her notebooks for this period are fascinating. Though Abbott faced numerous problems—mostly financial—and increasing commercial rejection, her notes reflect only a constantly probing mind at work. Some entries simply raise questions, others present ideas that are more fully developed later on; some are dated, many are not. The range of ideas in these notations is broad, the majority of them relating to photography but a number dealing with matters as diverse as metal detectors for protection against assassins, which resemble those used in today's airports, and lighting fixtures. The more evolved ideas were set forth in the letters she mailed to herself, which dated the progress of their development. Four of these ideas were developed extensively with models and ultimately patented.

Abbott began to market one of her inventions, the distortion easel, before she received a patent for it, through the New York firm, Caradell Products, which also manufactured the device. A

prototype of the invention gained favorable publicity and was covered in newspapers and popular magazines; fliers were printed. But sales were few and Caradell's initial surge of enthusiasm for the easel diminished. The House of Photography was soon floundering for lack of a hit invention and many of the stockholders began to lose interest in it. Though the company existed on paper for fifteen more years, its failure with the distortion easel was indicative of the troubles that lay ahead.

The House of Photography and science may have dominated Abbott's work during the last half of the decade, but she still found time to organize photographic shows and lecture, and at one point she increased her teaching load to include courses at Brooklyn College and Sarah Lawrence College.

It was in books, however, that she made her greatest contribution in the 1940s. In 1944 she furnished photographs of nude models for the book *Drawing and the Human Figure* by Arthur Zaidenburg. In 1948 her scientific photographs first appeared in book form in the textbook *American High School Biology*. In the same year her second how-to book, *The View Camera Made Simple,* was published. It covers the use of large-format view cameras and is a detailed extension of the view camera section in *A Guide to Better Photography*. Besides offering general technical advice, the book provided instruction on portraiture, architectural photography and, of course, scientific photography.

A book that would contrast with *Changing New York* was Abbott's next project, a book on Greenwich Village, the part of the city she had long regarded as exceptional. In return for a publishing contract, Abbott agreed to Harper and Brothers' preference for a longer text (which Henry W. Lanier wrote) than she had envisioned, and in late 1948 she set about making the photographs. For the first time she had a contract to produce photographs of her own choice for a book that would bear her name.

Published in 1948 as *Greenwich Village Today and Yesterday,* the book records the row houses, streets and shops of Greenwich Village at the time, and many of the artists who lived there, including Edward Hopper, Chaim Gross, John Sloan and Isamu Noguchi. The seventy-two illustrations include obviously commercial work and some of the finest photographs Abbott had ever done. Among her great images in the pages of this book are the portraits of Hopper (p. 191) and Sloan (p. 181), the repair shop on Christopher Street (p. 193), and the white deer suspended in a designer's window on Bleecker Street (p. 192). This charming book bespeaks serenity in contrast with the dynamism of *Changing New York*.

These books were the positive elements in a decade that ended for Abbott much as it had begun—with uncertainty, little work and no firm commitments. She was not easily classifiable as this or that kind of specialist and she still had no agent. If in the eyes of those responsible for hiring photographers Abbott had seemed "old-fashioned" in 1940, she appeared far more so in 1950, at the age of fifty-two. Early in the decade when she had asked a colleague, "I wonder when it is you get old?" the answer had been: "Don't worry, they'll let you know."

She neither felt nor acted old, but when she made a final attempt to get work with magazines, any kind of work, "they" let her know. She found most of the magazines staffed with bright young college graduates, some of whom had never heard of her: young men who glanced at her work, listened to her half-heartedly and then asked her to leave her name and address. These young—and occasionally even older—editors let her know. She was never given an assignment by any

commercial publication after 1950 and she stopped seeking work from them. The entries in her notebooks indicate almost no commercial work at all after that date, no portraits, no architectural assignments. She did a few scientific studies for herself, but except for work related to a book, an exhibition, Atget or the House of Photography, little else.

Edward Steichen made an offer to show Atget at the Museum of Modern Art in early 1950; he wished to mount an exhibition combining the work of Atget and Stieglitz. Abbott was secretly annoyed with the proposal and thought it was a poor idea. Steichen also made it clear that a condition for having the exhibition would be that the museum own the Atget prints shown. He proposed, therefore, that he purchase the original prints for five dollars each and then "donate" them to the museum. She reluctantly agreed to both proposals and sold the prints to Steichen; they are still exhibited in the museum as having been part of his collection.

A show with more promise took place in February, 1952, at the Metropolitan Museum of Art, where A. Hyatt Mayor was head of the print department. One hundred Atget prints were selected and a brave attempt to show them in a basement gallery was made. The prints were badly framed and hung in such a way that they were barely visible. When Abbott saw this she offered to rehang the show herself but was refused permission. This potentially exciting exhibition, the first major show of Atget's work in a public institution in the United States, received no reviews and advanced Atget's cause in no way.

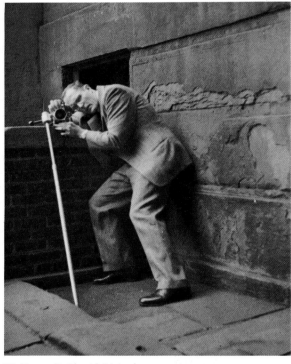

W. Eugene Smith with Unipod

It was through words, not photographs, that Abbott made among her finest contributions to the world of photography in the early 1950s. Always a woman of strong views and high principles, she may strike the less dedicated as harsh and opinionated, but she has unfailingly substantiated her views and stood on her principles, regardless of the consequences. One of the most famous of her statements was made on October 6, 1951, before a group of renowned photographers.

She had been invited to speak at a photography conference at the Aspen Institute for Humanistic Studies in Colorado. Among the photographers invited were Ansel Adams, Dorothea Lange, Eliot Porter and Minor White. Also attending the conference were photo historians and critics including

Paul Vanderbilt and Beaumont Newhall. Abbott was happy to go; it would be a chance to see her colleagues, and although she disagreed with many of their ideas she was fond of them. She also welcomed the conference as an opportunity to make what she felt was an important statement of principles, which she knew would run counter to the accepted standards of the photography world and certainly to those of the photographers present. She planned to make a vigorous attack on pictorialism and what she called "superpictorialism." There were far worse types of photography, she knew, but they were limited for the most part to the color pages of camera annuals and to minor camera clubs. No one took that work seriously. The work of the superpictorialists, however, was taken very seriously. Legions of devoted followers paid homage to Alfred Stieglitz and his disciples.

Abbott's fundamental convictions had already caused her to be at odds with the superpictorialists Stieglitz, Strand and Steichen. She had always regarded Stieglitz as a pompous man who had taken a few good photographs and who was more highly regarded for what he thought about photography than for his actual work. But his disciple Paul Strand was another matter, and she thought him superior to his mentor. Their relations were strained, however, when Strand referred to her once in public as a minor disciple of Atget. She had responded by suggesting that he retreat to his icebox and photograph his cabbages. Highly insulted, Strand had demanded a written apology, which he obviously never got. Steichen was a different kind of problem. Abbott deplored his officious conduct in the photography department of the Museum of Modern Art and regarded him simply as a good commercial photographer.

Thus at variance with three of the most renowned superpictorialists, Abbott planned to give the reasons for this state of affairs at the Aspen meeting. Photography in America had been for too long a slave to the Stieglitz cult, she felt, and it was her duty to say so, even if it hurt. It was the final day of the conference. Some of the remarks that had preceded hers had been made, as she described, "by people who took little scraps of things, pasted them together, got dead serious about them and then photographed them." She had heard a great deal about spirit and emotion but little about intelligence. She had heard people say that artists were not postage stamps and so did not have to communicate. The more she had heard the more incensed she had become. She had no use for artists with a capital A—to her an artist was as integral a part of the community, as organic and as essential as a plumber. She also had no respect for people who were more concerned with being "artistic" than with being simply a photographer. On the last day of the conference, the day of her talk, she prefaced her remarks by commenting that she would feel it a lack of courtesy to the Aspen Institute if she did not present her true beliefs:

"The greatest influence obscuring the field has been pictorialism. . . . Pictorialism means chiefly the making of pleasant, pretty pictures in the spirit of certain minor painters. What is more, the imitators of painting imitate the superficial qualities of painting. . . . The only relationship [between photography and painting] is that of a two-dimensional image on a flat surface within a certain area. . . . Photography can never grow up and stand on its own two feet if it imitates primarily some other medium. It has to walk alone. . . .

"[Stieglitz'] work was spiked with mystical and subjective overtones, with fluent intellectualities. Terms like Equivalents, Hand of Man, etc. were used to bewilder and impress laymen. Art was by

the few, for the few, and cultural America was represented by the back end of a horse to people who did not know they were being insulted. . . . In Stieglitz' time, what was unquestionably an advance in pictorialism is not an advance in 1951. These latter-day pictorialists did not know they were pictorialists. They were what I can only call, for want of a better word, the advanced, or super-pictorialist, school. The tendency here was to be very precious, very exclusive, very jealous of authority, exclude all others who would enter the sanctified portals of art. The individual picture like a painting was the thing—above all the perfect print. Subjectivity predominated. . . . The imitators of abstract painting, the pure design, the cracked window pane or the cracked paint: I think this represents the end. . . . In desperation they might yet resort to stripping emulsion off the paper or spattering the print with hypo."

Abbott left the conference right after her remarks and returned to New York. No one had made a comment in Aspen on her talk, positive or negative. No comments reached her after she returned to New York, but she was not surprised. Weeks, months passed. With time she knew she had benefited greatly by that meeting. In later years she reflected: "I didn't think I knew anything about photography until that conference, until I heard the 'experts.' From that point on I knew I was pretty good. I had a whole new confidence in myself. Half the time you don't really know whether or not your photographs are any good, but the people at that meeting certainly boosted my confidence."

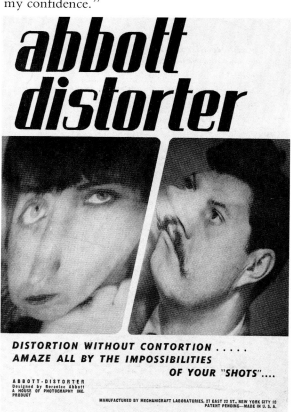

abbott distorter

DISTORTION WITHOUT CONTORTION
AMAZE ALL BY THE IMPOSSIBILITIES
OF YOUR "SHOTS". . . .

ABBOTT·DISTORTER
Designed by Berenice Abbott
A HOUSE OF PHOTOGRAPHY INC.
PRODUCT

MANUFACTURED BY MECHANICRAFT LABORATORIES, 27 EAST 22 ST., NEW YORK CITY 10
PATENT PENDING—MADE IN U.S.A.

Advertisement for Abbott's Distortion Easel

The House of Photography, though in no way successful, continued to occupy her time. She still believed in it, particularly after patents for three consumer-oriented devices—the distortion easel, the composition guide and the mounting system —were granted in 1951 and 1953. The easel was used in the darkroom to distort prints in an amusing manner; the composition guide aided in darkroom printing or composing pictures in the field; and the mounting system was a new way to hang prints. Abbott decided she needed a skilled designer and hired Robert Farkas, a design specialist who was interested in the company's products. After a good start Farkas became ill and his asso-

ciation with the company ceased almost before it had started. She searched for someone to take his place and approached Alexander Kostellow, the head of the department of industrial design at Pratt Insititute in New York. He was interested and a business arrangement was made. Abbott was thrilled. Besides being a skilled designer, Kostellow had many industrial contacts who might help in the marketing end. Tragedy struck again, however, with Kostellow's sudden death in 1954.

Printing with the Distortion Easel

At about the same time a key invention was stolen by an unscrupulous acquaintance. The invention was the first working prototype of a lighting system that became very popular in the 1960s —a floor-to-ceiling hollow metal pole, with springs inside each end and lights that could be attached at any level. Abbott lacked the funds to mount a legal attack on the man who had stolen her device and she was not in a position to manufacture it herself and so the "cat-pole" project was abandoned.

The momentum that had gathered with Farkas and Kostellow dissipated quickly and a majority of the stockholders decided to abandon the corporation. Some turned in their stock for tax losses; the final blow came when Hudson Walker, the primary stockholder besides Abbott, turned in his stock for one dollar.

Although the House of Photography officially remained in existence, it hung by a thread. In early 1955, when Abbott learned that she could expect a patent to be granted on a candid-camera invention, she decided to make one final attempt to stimulate business. She wrote to Edwin Land at Polaroid, advising him that she expected a patent momentarily on her new system and suggested a meeting. In September, 1955, she made her presentation.

Like the projection-supersight system, the candid camera was deceptively simple. It was designed to be a truly instantaneous candid camera that could be aimed and operated without a viewfinder, focusing knobs or other impediments to the seizing of an action shot. It could be focused, sighted and the shutter released all with one hand, at any level and at any moment. A slightly wide-angle lens, a grip with a shutter release and a simple focusing device combined with an ingenious sighting system made up the novel elements of the camera. The sighting system was the real key. Abbott had found that the human thumb was related directly to the eyes and the brain and, if used properly, could be used as the fastest sighting device. How Abbott linked this knowledge to the camera is beyond the scope of this book, but she was correct and the patent was granted in 1958.

The prototype camera worked well and the negatives made good 8″ x 10″ enlargements. It was truly a candid system; no noticeable movement

was required for operation, no conspicuous sighting, no need to focus. Polaroid, however, was not interested in it and the camera never advanced beyond the prototype. This was the death knell for the House of Photography, which Abbott abandoned shortly thereafter.

If the company had had one success it might have been able to continue. But Abbott was attempting to run what was essentially a cottage industry in a small apartment in Greenwich Village, in direct competition with industrial giants who could not be bothered with unproven ideas or ideas not initiated by themselves. Her concepts, however—entered in notebooks some four decades ago—have almost all proven viable.

Abbott's Low-pod

Book projects were turned down as well. No publisher was interested in an updated version of *Changing New York,* and her approach to the Guggenheim Foundation in connection with the project in 1950 was also rejected, as it had been twenty years earlier. Another idea she hit upon, in 1953, was to document in photographs the first fifty years of the century, decade by decade. She wanted to edit the book herself, drawing upon the finest photographs available. But the pattern held: all those she approached declined the idea as uncommercial. Yet another idea, tentatively called *Faces of the Twenties,* with a text by either Djuna Barnes or Janet Flanner, was also abandoned because of lack of interest. The only book that got off the ground was the updating of *A Guide to Better Photography.* It was reissued in 1953, with some additional text (but fewer illustrations), as *A New Guide to Better Photography.*

In spite of all these failures, Abbott was occupied with a project in the early 1950s that produced a massive body of work and that, while unrecognized at the time, is today acknowledged as a significant part of her oeuvre.

In the summer of 1952 Abbott traveled to Florida by train to work on a second ill-fated book on electricity. From the train window on the way down and back she noticed how the local color still changed perceptibly from town to town and state to state even while the perpetual flow of automobiles appeared to be altering the countryside and softening the differences between one locality and another. It would be a challenge, she felt, to document what remained of authentic America along the highways. She imagined a project of great scope: Route 1 from Fort Kent, Maine, to Key West, Florida. However, without money, sponsor or automobile, she could not start it. But the project finally got under way, by chance, two years later.

In 1953 Abbott met a young man named Damon Gadd who ran a ski lodge in Vermont. He was interested in photography and offered to drive her along Route 1 in exchange for her teaching him the craft of photography. In early June, 1954, after her New School classes were over, Abbott met Gadd and his wife in New York and the three headed south, reaching Key West in August. At the end of Route 1 they turned around and drove north, arriving in Fort Kent, Maine, at the end of September. In this way they covered most of Route 1 twice and Abbott took nearly four hundred 8″ x 10″ photographs with the Century Universal and two thousand with the Rolleiflex.

The new photographs captured the native character of the small towns and cities along Route 1, revealing the existence of a fundamentally American spirit not found in cosmopolitan New York. Abbott reveled in her discoveries, in the bizarre and the commonplace, in the people of every sort at work and play along the great national route.

Gadd returned with her to her studio in New York (darkroom training was part of the exchange) and they began to print up the summer's work. She continued printing alone well into 1955, long after Gadd returned to the ski slopes. When she had enough prints to make a logical layout she prepared a prospectus. With layout and prospectus in hand she began to call on publishers, but one after another rejected the proposal; none could see any merit in it. She tried until the end of 1956 and then gave up.

The Route 1 photographs represent the largest and most important body of "unknown" work by Berenice Abbott. Only one photograph from it has ever been published, the potato farmers (p. 243), in *A Portrait of Maine.* This major segment of her work has remained unappreciated by publishers, museum curators and dealers alike. Yet her images of racks of tacky postcards, motels made from old buses, rows of ancient automobiles and hot-dog stands on beaches speak as eloquently of the 1950s as her incomparable New York photographs do of the 1930s and deserve to be published alongside them.

In 1956 Abbott tried to publicize Atget by publishing a folio of his prints. She decided on twenty images to give a sense of the range of his work, and envisioned a total of one hundred folios. She knew printing would be difficult; Atget's negatives were meant to be printed on printing-out paper, a paper that had a great total range but because it was made by hand was generally unavailable. Exceptional darkroom skills would be required to make good prints in quantity. The price for the folio, which was entitled *Eugène Atget Portfolio, Twenty Photographic Prints from His Original Glass Negatives,* was $100 if purchased in advance and $150 if paid for upon delivery. The initial orders were few and by the end of 1956 no more than twenty had been sold. A few completed but unsold folios were traded to book dealer George Wittenborn for art books or retained by Abbott. There was no critical comment whatsoever when the set was issued; Abbott did not finish the remainder of the folios until well into the 1970s.

The future did not look bright for Abbott in 1957. Virtually every proposal she had made over a number of years had been rejected and in twelve months she had received only one commercial assignment. For the first time in her life she was beginning to feel depressed. She had managed the hard times in the past, but now she was one year from being sixty, her health was indifferent and there was little work; she had not saved a penny and could not envision a dependable future of any sort.

On October 4, 1957, an event occurred that to Abbott's mind saved her life: she saw a newspaper headline announcing the successful launching of

Sputnik on that day by the USSR. According to the article that followed, the Soviet success indicated that the United States was falling behind in science, and she remembers thinking, "I wonder if anyone would be interested in scientific photographs now?" She did not have to wonder very long.

The first telephone call she made was the right one—to an old friend and long-time champion, Robert C. Cook. Cook was then head of the Bureau of Population Reports in Washington, D.C., and she thought he might know the proper people to contact. He told her that the Physical Science Study Committee of Educational Services, Inc., in Cambridge, Massachusetts, planned a new book reorganizing the study of high school physics and that he felt her photographs would convincingly illustrate its scientific principles. A call from Cook put her in touch with an editor at Doubleday and Company, the publishers of the book. The editor was impressed with her work and suggested that she talk with Dr. E. P. Little of the PSSC directly, but to wait a week until he could get off a letter of introduction.

It was a week of anticipation. Would they think she was too old for the job? Did they even want a photographer? Finally, after the long wait, she called Dr. Little and though he had not received the letter from Doubleday he urged her to visit him anyway, saying he was well aware of her work and welcomed the opportunity to meet her.

On the appointed day in February, 1958, the PSSC headquarters, across the street from the Massachusetts Institute of Technology campus, was snowed in by a raging blizzard. Abbott managed to get there on time; Dr. Little, coming through the snowdrifts, was late, but it was a perfect meeting. For the first time in her life, perhaps because she was fighting for it, Abbott did a successful sales job on her wares. She showed him her best work. He looked carefully at the photographs and said, "This is just what we want. When can you start?"

His response made the past twenty years worthwhile. Her work with scientific photography had been virtually ignored. She had been forced to make do under trying circumstances, with inadequate equipment and no help from the scientific community. Now she would have access to the best equipment available—specially made for her needs, if necessary—and would be working with professional scientists under the direction of a man who respected her abilities, toward a special goal. Moreover, she was offered a salary of more than twelve thousand dollars a year. This day, like the momentous day thirty-five years before when Man Ray offered her a job, changed her life.

The PSSC was founded in 1956 by Dr. Jerrold R. Zacharias of the MIT Physics Department. The group consisted of university and secondary-school physics teachers who were working to improve the teaching of high school physics. Funding for the committee was provided by the National Science Foundation, with some assistance from the Sloan and Ford foundations, to create study material presenting physics "not as a mere body of facts but basically as a continuing process by which men seek to understand the nature of the physical world." Abbott joined the group officially on March 1, 1958.

The PSSC made it possible for her to begin work almost immediately by providing her with funds to commute to New York to finish her term of weekly classes at the New School. She could have easily resigned in the middle of the semester but felt a loyalty to her students and to the school, which had provided her only steady income for more than two decades.

Although some of the scientists on the project did not like to work with women and one scientist who had been assigned to take photographs before her arrival was outrightly hostile, she soon won the support of the staff. It became apparent to them that complicated photographs could not be "made with a Brownie," as one of the staff members had earlier suggested. As a member of the team, she assisted in designing models and discovering new ways to illustrate age-old scientific principles photographically. Some of the photographs were made without cameras, directly on sensitized paper; precise pinhole cameras were devised for other experiments. It was mandatory to be adept at using floodlights and a stroboscope as well as moving lights. The photograph of the thrown wrench (pp. 216–217), for example, required a moving light so that the background would remain black.

Within a year she had compiled an impressive body of work, and to the surprise of her colleagues the photographs took on a life of their own apart from the PSSC. Clara Mayer arranged a show of some of the photographs at the New School in May, 1959; at the same time the *New York Times Magazine* ran a feature story using five of them. Then, at the urging of Beaumont Newhall, who was the photography editor at *Art in America,* an article by Abbott on her scientific photographs was accepted by them for publication in the 1959 Winter issue. In his biography of Abbott accompanying the article, Newhall wrote: "In her approach to photography as an ally of physics, all the drama, beauty and arresting suspense of the physical laws and the natural phenomena are excitingly presented."

Abbott photograph on cover of Science Illustrated, *1944*

Abbott commented in the article on the potential unity of art and science:

"Scientists are working with dedication and, yes, even joy at the Physical Science Study Committee organized in 1956 at the Massachusetts Institute of Technology and now at its own organization called Educational Services, Inc. This includes a group of men and women, among them some of the nation's foremost physicists and high school physics teachers, who have banded together with other specialists in many areas of communication, including the photographer, to present physics to high school students in as effective a way as possible.

"Some of the scientists are often 'artistic' and quite poetic although these very ones may be the most apathetic about, even disdainful of, art to say nothing of fearful—or just plain untrained. Yet, their intuition can match the artist's any day. I cannot altogether blame them for their fear. However, it cannot be denied that the visual image is a powerful tool in educational matters or that science sorely needs all the visual clarification at its disposal. And what other medium can potentially surpass photography in this mission?

"Often when people speak of science and art, little or no mention is made of photography, the medium preeminently qualified to unite art with science. Photography was born in the years which ushered in the scientific age, an offspring of both science and art. While unbelievably young as a medium it, too, will mature. My interest at Educational Services, Inc., is to explore the possibility of this partnership.

"Such an exploration is like a voyage between Scylla and Charybdis. What course should be taken? Where is the emphasis placed? Can Science and Art unite?

"My own conviction is that not only is this possible—it is necessary. We have all seen pretty enough designs abstracted more or less from scientific subjects, but this is mere byplay. This should not be confused with an accurate portrait of scientific phenomena nor should it be the unimaginative record so often used in the field. However, emphasis is inescapably on scientific clarity, at the expense of poetic license if necessary.

"Indeed, the more clearly the photographer expresses the scientific truth involved, sometimes in its most unesthetic facet or most unattractive homeliness, the better he succeeds in his mission, and the nearer he approaches the goal of communication and, perhaps, art. A simple *statement* of science in visual terms should not be confused with the idea of a mere abstract design.

"The subject of physics with its order and infinite reality does not blink at the realistic image, nor does the scientist. But to today's artist 'the realistic image' is a many-headed demon which sends him into headlong flight. Why? Here in physics is primal order and balance; its universal implications extend limitlessly. Both must know above all also how to let the subject speak for itself.

"Surely scientific truth and natural phenomena are as good subjects for art as are man and his emotions, in their infinite variety."

With the PSSC project, Abbott proved that photography—art, if you will—and science could go hand in hand, in the proper hands. The virtue of her work was so clear that members of the MIT faculty began to seek her out, suggesting joint collaborations. The astrophysicist Albert V. Baez suggested a book that would have taken Abbott into the realm of his discipline. The timing was wrong and the book did not materialize, but the offer signified the faculty's recognition of her work.

Recogniton of her scientific work came in many forms. In July, 1959, Abbott was voted one of the Top Ten Women photographers in the United States by the Professional Photographers of America and in December of the same year her photographs were exhibited at the MIT Faculty Club. In January, 1960, Abbott was on television in Boston explaining her work in a show called "The Camera Looks at Science." Her scientific photographs appeared in galleries throughout New England and the entire scientific collection was taken over by the Smithsonian Institution in 1960 and circulated in museums and schools throughout the United States. Magazines, news-papers, foreign publications, corporations, the United States Information Agency, the Department of Commerce, the U.S. Army—all wanted prints for their use.

The aim of the PSSC project was reaching culmination. The large textbook *Physics* was published in 1960 by D. C. Heath with many Abbott photographs. On its publication, the new leadership of Educational Services, Inc., advised her they no longer had any need for photographs. She accepted this and resigned, grateful for having had nearly three years of fulfilling work. She learned only later that more photographs were needed when she had to return to her old workspace unexpectedly and found that her job had been given to her much younger male assistant. It was a blow, but insignificant by comparison with the whole wonderful experience.

The three-year period of science photography was pivotal in Abbott's work of the next twenty years and the key to the increased recognition that brought her financial success in the 1960s and 1970s. She never regretted the decision she had made to photograph science in 1939, stating in 1978:

"I took the subject because it was important. I practiced what I preached. But I did pick a subject that was too big for me; I was not a scientist. It was a new field for me and I had to explore it, but I could not convince anyone of its importance. I wanted to combine science and photography in a sensible, unemotional way. Some people's idea of scientific photography is just arty design, something pretty. That was not the idea. The idea was to interpret science sensibly with good proportion, good balance and good lighting, so that we could understand it. Someday someone will do it right, will add substantially to what I did and surpass it. It's too bad I had only three years; if I'd had twenty it might have made a difference."

The scientific photographs produced by Berenice Abbott, beginning with the earliest examples in the mid-1940s and culminating with the extraordinary body of work created for the PSSC, may well be viewed in future years as her outstanding contribution to photography. Though largely uninfluenced, her portraits of people can be compared in many ways with the work of others, as can her documentary portraits. The scientific photographs, however, stand alone. They are the most complex photographs she ever made in her evolution from a portraitist and they set her apart from all twentieth-century photographers. Other photographers may have considered doing similar work but none who attempted to do so succeeded. They made scientific photographs, often incredibly exciting ones with sophisticated equipment. They stopped bullets in flight, created abstractions and worked with extreme magnification. Scientific subject matter did provide, much as Abbott had suggested it would in the early 1940s, a new esthetic base for photography, but it remained in the hands of individuals who were for the most part indifferent photographers.

Today the array of scientific photographs taken inside the body, under the sea, on the moon and with electron microscopes is awesome. Obviously the sophistication of these photographs in terms of subject matter and equipment used dwarfs the rather simple, straightforward work of Abbott. A wildly colorful subject basking in polarized light and photographed with the aid of an electron microscope will, obviously, rivet one's attention more rapidly than will a simple black-and-white study of a spinning wrench. But most of the exciting magazine photographs that made Abbott's seem so old-fashioned in the 1930s and 1940s are now forgotten, and her work survives on virtually every level of excellence. The same is true of her

later scientific work; there is little room for comparison between it and the work done by people who are primarily scientists, who use an array of sophisticated equipment to produce images that are often as startling as they are informative.

Abbott's images endure, and will continue to endure, as supreme artistic statements because of their integrity and vision. They stand up not only as photographs—exciting, well-composed, exquisitely printed visual images—but as illustrations of scientific phenomena. They make no effort to startle, only to reveal—in as simple and as beautiful a way as possible. Art and science are combined, and every photograph works on two levels. The photograph of the parabolic mirror (p. 215) could have demonstrated the same scientific principle just as adequately by showing only the reflecting eyes, but to be a well-composed photograph it had to include the base of the stand. This meant two extra days of work, twisting and bending the old Century Universal camera to its limits, making certain that everything that needed to be in the photograph was there. Illustration of the scientific principle alone was not sufficient; form and content had to be there as well.

The photographic principles of Abbott are revealed in a purer form in her scientific photographs than in most of her other work. In them is distilled the vision of a confident realist in full command of all her resources. When photographing a crowded city street or even an unknown client, time and emotion by necessity play a part in the creative process. Regardless of strength of character or determination of intellect, there are bound to be external influences. But with the scientific studies this was not the case. A clear-cut purpose coupled with the necessary skill and intellect allowed her the freedom to create these monumental photographs, photographs that exist simply as images, apart from time or outside stimulus.

IV

Abbott's association with the PSSC had given her financial security for the time, renewed public exposure and a great body of work she knew would be fruitful in a variety of ways. She was also aware that she had to manage her affairs more carefully; as she grew older she would be unable to endure the hardships she had in the past.

In 1956, purely on impulse, Abbott had purchased a dilapidated, vintage-1810 stagecoach inn in Blanchard, Maine, for one thousand dollars. Living frugally in Cambridge, she had saved every penny she could and put it into the property. Her plan was to make the building habitable and to use it eventually as a full-time residence. It was slow going; women her age simply were not given bank loans in provincial Maine (the Township of Blanchard had a population of fifty-two and her "inn" had not been lived in for as long as anyone could remember). But by 1961 the house was comfortable in the summer; winters were still virtually impossible.

Pre-reconstruction view of Abbott's house in Blanchard, Maine

In late 1961 Abbott's health, never robust, deteriorated. She had always had lung problems and now the consequences of smoking, thirty years of New York's polluted air, and several bouts with pneumonia linked to youthful emphysema caught up with her. Early in 1962 part of a lung was removed; cigarettes were forbidden and she was told to spend as much time out of New York as possible. Maine was now essential for her survival and the refurbishing of the inn became more than a diversion.

More improvements continued to be made to the house in Blanchard and the studio on Commerce Street became just a place to have in New York when Abbott needed to process photographs or work on a scientific book. In 1963 she began to transfer some of her studio and darkroom equipment from New York to Maine and by 1966 the move was complete. She gave up her New York studio to begin a totally new life in Maine.

Abbott was now viewed in a different light by the general public and by those in a position to make use of her work. More people came to see the exhibits of her scientific photographs than had come to all her previous shows put together.

Naturally enough all this activity spurred interest in her other photographs, and the almost continuous series of shows that started at this time remains unabated to this day.

Publishers took her scientific work seriously and began to incorporate it into their books on science. As this happened they also regarded her nonscientific work with increased respect. Her greater fame and the need for recuperation after her operation made working on books utilizing existing photographs not only possible but practical. In the 1960s Abbott was involved with many books, seven of which were published. Her first project was providing twenty-two photographs for Leonard Louis Levinson's book *Wall Street: A Pictorial History,* which was published in 1961.

Her next project, an idea she had had since the 1950s but never had found the time to implement, was a book that would combine the photographs of Atget with the words of Marcel Proust. In 1960, while she was still working with the PSSC, she had been visited by Arthur D. Trottenberg, a foundation executive interested in the work of Atget. She told him of her idea and a few weeks later he asked to work on the project. Trottenberg proposed to write the introduction and select the photographs and quotations; all Abbott would have to do would be to supply the prints for reproductions. Profits were to be divided evenly.

The arrangement seemed equitable and she was happy to see the work proceed, although when *A Vision of Paris* reached the final stages of production there was a disagreement. Trottenberg, not being a photo historian, had taken much of his background material for the introduction from sources that heaped praise on Alfred Stieglitz and he made the same mistake Steichen had made in drawing a relationship between Atget and Stieglitz that did not exist. There was no place in an Atget/Proust book for Steiglitz, and so he was eliminated from the text, except for one brief mention. *A Vision of Paris,* which was published in 1963, was visually magnificent, affording the finest reproduction of Atget's work up to that time—and the photographs worked well with the quotations from *Remembrance of Things Past.*

In early 1963, Abbott met Ben Raeburn, the erudite head of Horizon Press. She suggested that he publish a book on Atget and Raeburn was delighted with the notion, but only on condition that she write the introduction herself. In her words: "I came back to Maine in February, 1964, sat down at my rolltop desk and wrote the introductory essay. It was like getting blood out of a stone. McCausland had always read my writing before, but this time I was on my own. She said she would not read my Atget piece, she didn't want to. She told me she wished I'd never heard of Atget, that I spent too much time on him." But she completed the essay and *The World of Atget* was published in 1964. To many her essay on Atget is viewed as the finest piece of writing by one photographer on another. The book was a critical and commercial success, and almost twenty years later is still in print.

She continued to push forward with books on science. In 1964 *Magnet* was issued with photographs by Abbott and text by E. G. Valens, a writer with a good grasp of basic scientific principles. Aimed at high school and junior high school readers, the book contains photographic studies made by Abbott before and after she went to Cambridge as well as new material created especially for it. *Magnet* was reprinted and translated into several languages.

The Abbott-Valens team published *Motion* in 1965 and *The Attractive Universe: Gravity and the Shape of Space* in 1969. The latter, their final collaboration, was considerably more ambitious than the previous two books; directed at more sophisticated readers, it was the most visually interesting of the three.

In 1966 Macmillan asked Abbott to do a book on Maine and gave her carte blanche. *A Portrait of Maine,* with text by Chenoweth Hall, was published in 1968. It is, naturally, not at all characteristic of the many picture books of Maine, which concentrate on the seacoast and the quaint villages. Abbott made no effort to produce a book of "beautiful" photographs of Maine. To her the seacoast was not the only Maine; and so she aimed her camera inland and concentrated on people and industry, producing photographs that are the essence of Maine. There is nothing quaint, no "art"; her photographs are straight and stark, capturing the Maine known to those who live there, not the one advertised to vacationers.

A Portrait of Maine is divided into four sections: nature, work, play and towns. The nature section depicts inland lakes, swamps, streams, woodland areas and parts of the seacoast (some of it taken from the air); the work section concentrates on lumbering, fishing, lobstering and potato farming; the play section deals with hiking, canoe racing (down a snowy hill) and mitten-knitting contests; and the towns pictured are the villages of Dexter, Brunswick, Stonington and a few others —a portrait of the state that would strike anyone who has spent time in Maine as typical.

Houses, Stonington *by Abbott*

Of the many photographs she took, primarily with a Rolleiflex, 128 were chosen for the book. Other than these, her Maine photographs have not been widely circulated; they were, in fact, not taken with any exhibition in mind. Considering the physical endurance needed to photograph logging camps in the middle of harsh Maine winters, lobster fishermen in their bouncing little boats, and inland lakes from tiny, wind-blown planes, the book was a courageous achievement on the part of an indomitable seventy-year-old woman.

At the time *A Portrait of Maine* was published, Abbott was approached by Ben Raeburn with an offer to produce a volume tracing her career from Paris through her accomplishments in science. In December, 1970, *Berenice Abbott: Photographs* was published. It included portraits of writers and artists, portraits of New York and scientific studies. Muriel Rukeyser wrote the foreword and David Vestal provided the introduction.

As the decade drew to an end another event of more immediate importance occurred, In 1969 Abbott had the good fortune to become involved with Lee Witkin, a young man who planned to open a gallery devoted exclusively to photographs. Witkin combined a true interest in photography with a good eye and sound business

sense; he represented Abbott exclusively until the mid-1970s. Success for dealer and artist came quickly. While many other galleries followed in Witkin's footsteps, his can be given much of the credit for starting the boom in photography that resulted in the recognition of photography as an art form and provided financial security for many long-ignored photographers, including Abbott herself.

Housing the Atget Collection in Maine presented problems that had not been present in New York, where the glass plates had been stored in the relatively fireproof building on Commerce Street. Abbott was concerned about the physical safety of the plates, which were becoming increasingly fragile. To make matters worse there had been an extremely unpleasant incident with Julien Levy in 1964, when he returned to New York after thirty years' absence in Europe and asserted his interest in the collection.

The description of the encounter between Abbott, Levy and Levy's new wife written by Elizabeth McCausland reads somewhat like a comic opera, but it was anything but amusing to Abbott. The major demands made by Levy and his wife (who seemed to McCausland to be the moving force in the discussion) were that the collection should be divided immediately to allow Levy's children an opportunity to enjoy the prints and plates since they were "fans of photography," and that there should be an accounting of what had been done with the collection for the past thirty years. The argument was so heated that McCausland called the police. The unpleasantness of the situation was distressing to Abbott and she began seriously to consider how best to dispose of the collection.

The University of Texas was the first public institution to express an interest in the collection and in 1965 preliminary discussions began. In November, 1967, the university mounted the largest Atget exhibition to date, but funding for the purchase of the collection did not materalize.

In 1968 a bid was made for the collection by the George Eastman House of Photography in Rochester, New York, which sent a representative, Nathan Lyons, to Maine to inspect Abbott's holdings. Lyons arrived early one afternoon, flipped through a small portion of the prints, made a token bid and left the same afternoon. Abbott is still at a loss to explain why he bothered to come all the way to Maine only to glance casually at a few prints.

Another perplexing situation involving Atget had occurred two years earlier when Abbott was visiting Paris. In an attempt to find someone in France even moderately interested in Atget, she had written an urgent letter to André Malraux, France's Minister of Culture. He had referred her to someone in another department who was concerned with athletics and had never heard of Atget, resulting in a meaningless meeting. Abbott took a snapshot of Atget's doorway before she went home.

After extensive negotiations, the Atget Collection was finally sold to the Museum of Modern Art on September 29, 1968. The museum proudly announced the acquisition, which was made possible with the aid of a gift from Shirley C. Burden. At the last moment the museum brought Julien Levy into the negotiations and, to Abbott's annoyance, he was given a large percentage of the sale price, which, incidentally, was not much better on a per-print basis than what Steichen had paid in 1950. Abbott feels she was treated badly and that Levy's participation was totally improper.

The museum has, however, been able to care for the collection properly. The prints are mounted, overmatted and indexed, and the plates are stored under the finest possible conditions, though nearly two hundred fewer plates exist today than when Abbott purchased the collection, breakage and deterioration having taken their toll. The museum has also taken steps to perpetuate Atget's work by planning to publish four volumes of its holdings. In 1979 a folio of reprints from the original plates was issued. The prints, on specially made albumin paper, were outstanding.

With the sale of the Atget Collection, Abbott's involvement with Atget ought to have ended. But the interviews about him continue as do the requests to serve on panels to discuss his work and to preside at openings of exhibitions devoted to it. She was particularly pleased with one held at the International Center of Photography in New York in 1980, not so much for the photographs exhibited but for the large banner with Atget's name on it that flew in front of the museum. Atget's photographs have been widely exhibited since the 1960s, but this was the first time he had rated a banner.

Abbott photographing on Wall Street, 1977

In 1977 the controversy with Levy erupted again when Levy published his book *Memoir of an Art Gallery*. In it he made a number of claims, ranging from his having given Abbott money in Paris to buy the Atget Collection, to his convincing Erhard Weyhe to underwrite the Jonquières book, to his showing Atget's work to Stieglitz well in advance of Abbott. She rejects all the claims made by Levy, stating:

"Levy had nothing whatever to do with the sending or lending of money to buy the collection in Paris. My dealings were entirely with André Calmettes. I never visited Atget with Levy; this is entirely false. When I showed some Atget photographs to Stieglitz he never mentioned he had seen them before. The contract between us was made

31

on May 2, 1930, some months after the 1929 crash, a year after I had returned to New York with the entire collection. Levy's subsequent claims are either due to a loss of memory or a deliberate lie."

Documents in Abbott's files fully substantiate this statement, but it is not surprising that with Atget's importance in the history of photography finally recognized, efforts are made to take credit for one or another aspect of the rise of his reputation. People still go so far as to try and link him with Alfred Stieglitz. It is easy to make all kinds of farfetched claims now; it was not so easy, nor so profitable, to do so when no one cared, during the forty years Abbott first tried to make his greatness known. That she remained dedicated to him for so long, in the face of such adversity, is testimony not only to the genius of Atget but to the resolve of another great artist.

Abbott has been actively involved with photography for almost sixty years. She has witnessed many trends and fashions and known most of the twentieth-century masters. Although they have had an influence on her, her realistic approach to photography has remained unaltered. She is convinced her initial vision was correct not only for her photography but for her life as well. She remains a realist in every sense, viewing her first ten years in photography as exciting—learning the craft, discovering Atget, producing portraits and beginning Changing New York—but no more exciting than the last ten have been in Maine. She continues to live for the moment and for tomorrow, unfettered by the past.

In the last decade Abbott has enjoyed almost undreamed-of success. Her photographs have been widely reproduced and exhibited and have provided her with a fine income. Many of the museums and galleries that only a few short years—in some cases months—before had snubbed her now accepted Abbott as a distinguished photographer (and marketable commodity). Universities offering honorary degrees, students seeking advice or criticism of their work, filmmakers proffering documentaries, scholars working on oral history projects, dealers old and new (mostly new), hoping to squeeze themselves into the rapidly filling photography market, and a wide assortment of budding young amateur photographers—all make their way to the comfortable cottage nestled deep in the woods on the shores of a northern lake.

At eighty-four Berenice Abbot is creatively active at least five days a week, printing her work, overseeing the preparation of portfolios issued by the Parasol Press, writing introductions for books she feels are worthy or contemplating new projects. Her most recent major undertaking is a motion picture about her work, directed by the Swiss-based filmmaker Erwin Leiser and scheduled for release in the fall of 1982.

Abbott's accomplishments are wider ranging than anyone else's in the history of American photography. Other photographers have produced more, or better, portraits, but portraiture has been their primary focus. Some have produced a larger body of fine documentary work, but, again, this has been their primary focus. Abbott has done both portraiture and documentary work and done them well; her best stands up with the best of any photographer's. Her scientific photographs are unique. Her inventions are hardly comparable to those of Edwin Land, but name another major American photographer who has invented anything.

Has any curator or photo historian found a talent of the magnitude of Arget's and then made certain the world knew of it? As for teaching, Abbott retired in 1958 after teaching for nearly twenty-five years when there were no photography programs at colleges and universities as there are today. Perhaps there have been better teachers, but Abbott was good at it and she continues to train serious students in her darkroom. Perhaps there have been better printers, but not many, and at eighty-four she remains a printer of uncommon abilities in an age where many photographers require others to do their printing for them. She has done all this for almost sixty years and is still doing it. She has walked alone, oblivious of trends and outside the mainstream, her own master, unique in the sum of her accomplishments.

When in the future photo and social historians look back objectively on twentieth-century photography, there is no doubt that Berenice Abbott will be judged among the dominant photographic forces of the century. She will be seen as the figure who most completely mastered the totality of the photographic discipline and who worked successfully in every aspect of it. Abbott and the photographers she has championed—and the photographers who will undoubtedly follow them in the tradition of realism—will be remembered as the *American* photographers. The photographers who made the equivalents, montages and mysteries will be little more than footnotes to a great seminal period.

When asked many years ago what she considered her best photograph, Abbott replied, "The one I will take tomorrow." Her vision is still clear, her passion for photography undiminished. There are American photographs that need to be made. As Abbott says, perhaps tomorrow the light will be right to do the cathedral pines up near the Canadian border.

Abbott playing ping pong in Maine

Berenice Abbott
American Photographer

Berenice Abbott, ca. 1925

Paris Portraits

Berenice Abbott's first photographs date from 1925 and were taken at Man Ray's Paris studio. At the start of her career she made a conscious decision, dictated by artistic and commercial considerations, to pursue portraiture. She enjoyed immediate critical and financial success and within a year had her own studio and gallery showings. The output of this first phase of her career is often referred to as "Paris Portraits"; but in reality some of these photographs were taken in New York between 1929 and 1931, and it is impossible to differentiate stylistically between those made in one city or the other. All these portraits were made on medium to large glass plates. Abbott's career as a portraitist waned when the economic pressures of the Depression forced her to give up her studio in 1931, by which time she was devoting her time to photographing New York.

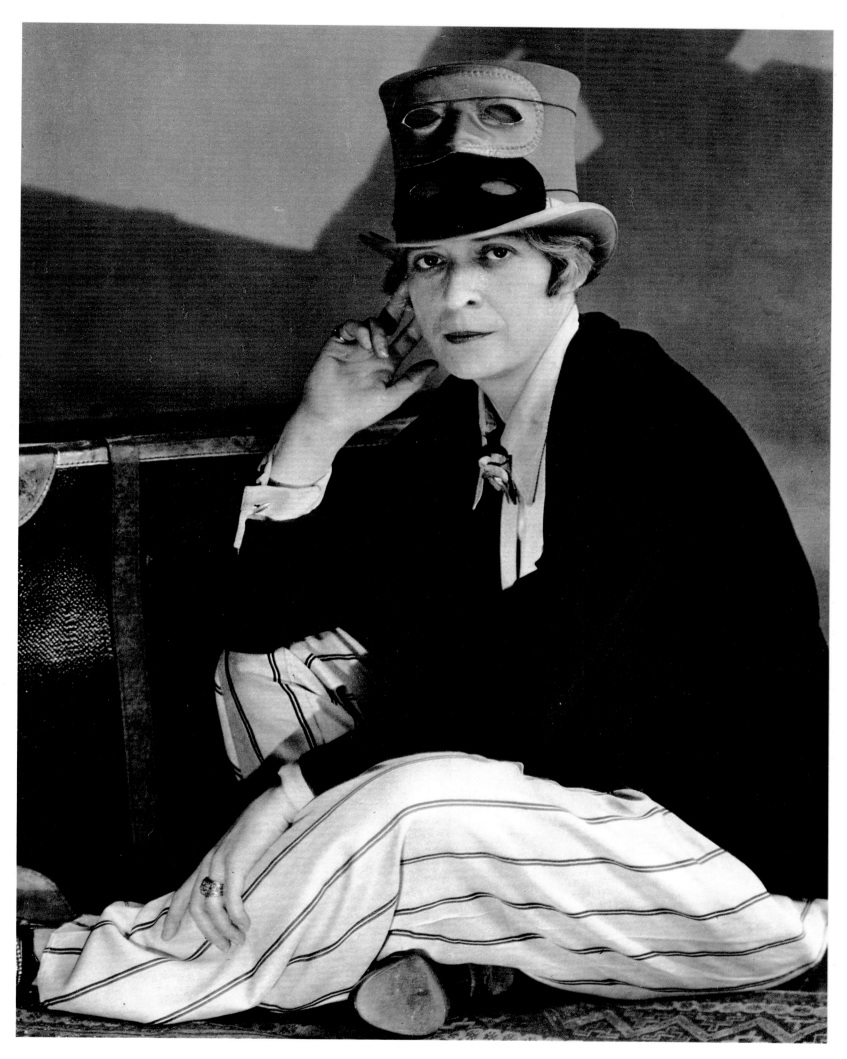

Janet Flanner

This photograph of the American writer is cropped; three quarters of the negative is used. Sometimes I just use the face. I never tried to take portraits that would use the entire negative; I was much more interested in spontaneity and expression and didn't want to fool *around too much with mechanics that might make a sitter uneasy or bored. I always attempted to make a sitting as relaxed and informal as possible, using as little light as I could get by with. This was my whole system and it captured Flanner in this portrait.*

René Crevel
*The men dressed as well as the women then and this is
what shows in the photograph. He was a writer, who
was ill; it caused him to kill himself.*

Isamu Noguchi
This was taken in New York, shortly after I returned from Paris, in 1929. It was a by-product of a job I did for him photographing his sculpture. He did a bust of me at the time and it was exhibited. I went to his studio to do the job with my view camera. The negatives from this assignment have been lost and I have forgotten why I was asked to do the job, other than that I was simply taking photographs to earn a living.

George Antheil
Antheil, a young American composer, had a great deal of recognition in Paris and was helped by a number of people. He was a very interesting man, and I loved his Ballet Méchanique, *with the airplane motor. I am very sympathetic to the idea of that piece. The backdrop here is a funny old map I had put on the wall and purposely kept out of focus.*

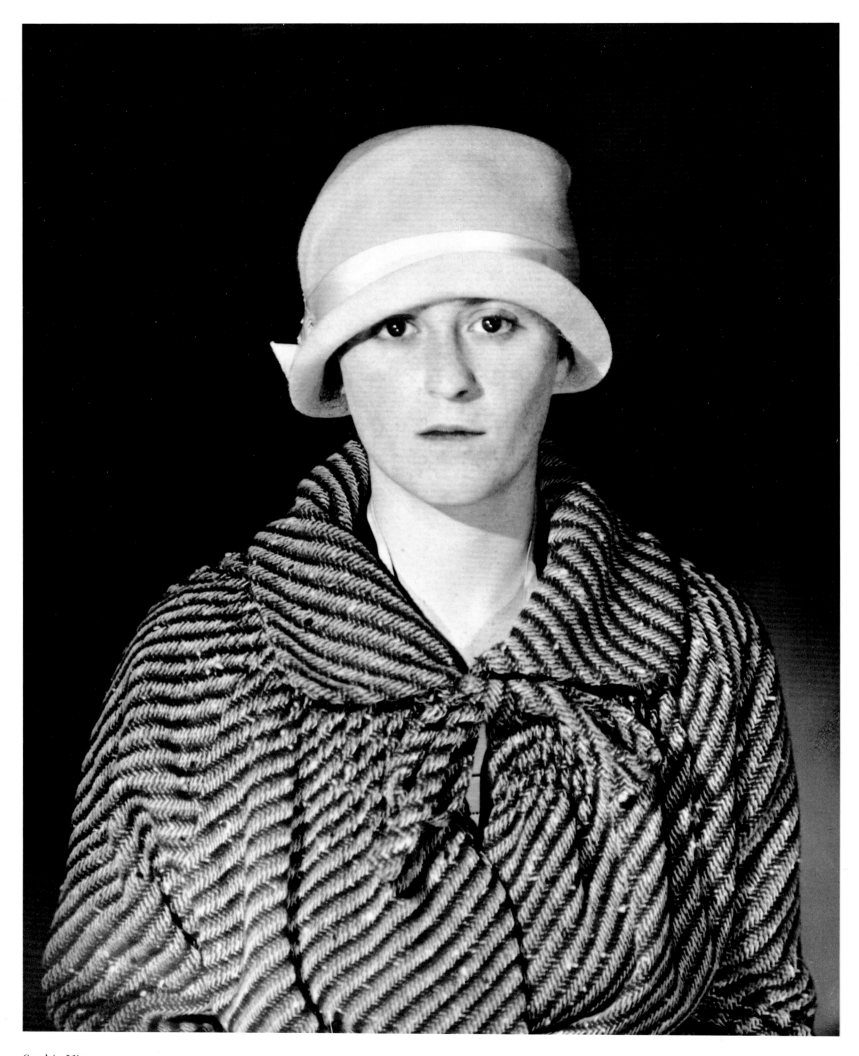

Sophie Victor
A good likeness of Sophie, who was married to the socially prominent Stephen Green. She never laid claim to doing anything in particular, but lived graciously and had a nice time. She currently lives with her husband in Morocco.

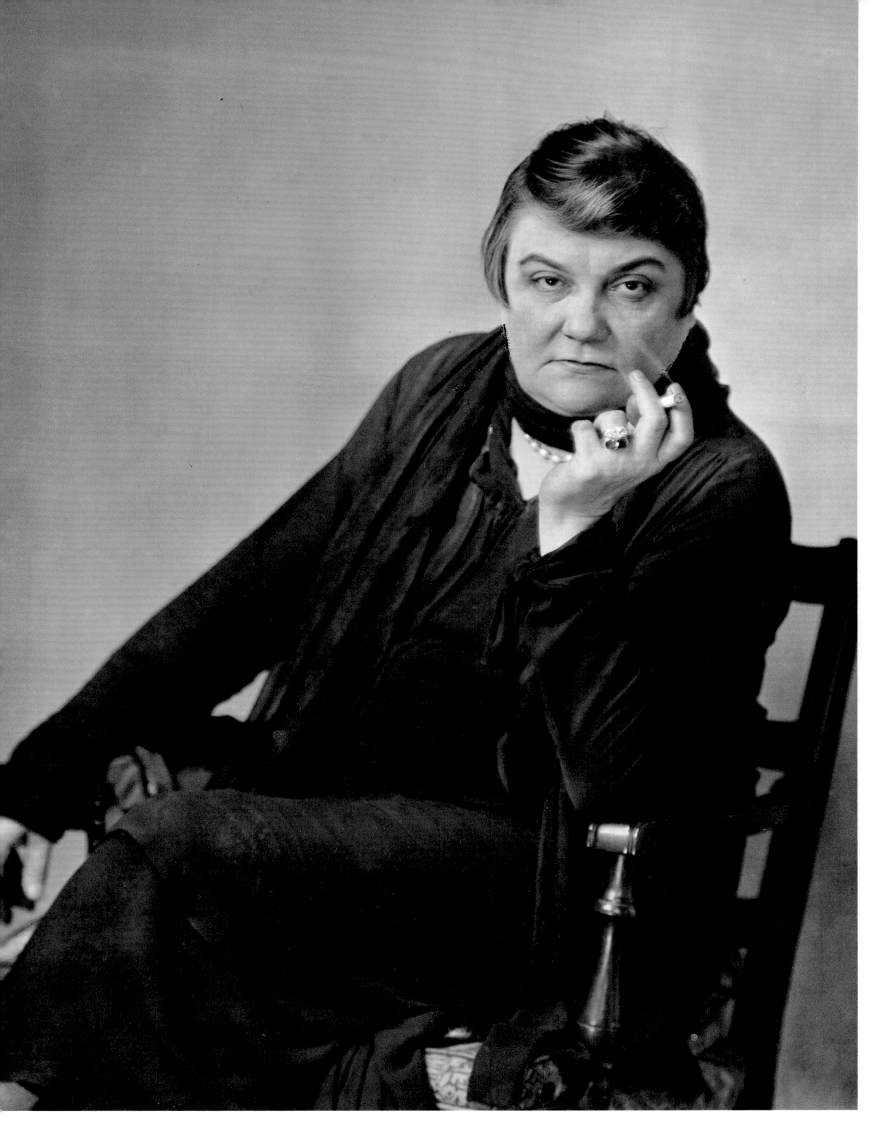

Princess Eugène Murat

This is a strong woman; a strong portrait taken in New York in 1930. I had met her briefly in Paris (she was the granddaughter of Napoleon III) but got to know her better in New York. She was responsible for introducing me to Harlem and the dancing at the Savoy. She *was simply smoking the cigarette when I took this; there was another negative but it has been lost. I should have taken more of her. She was a good subject and I don't know why I didn't, except that I rarely went back to photograph the same people again.*

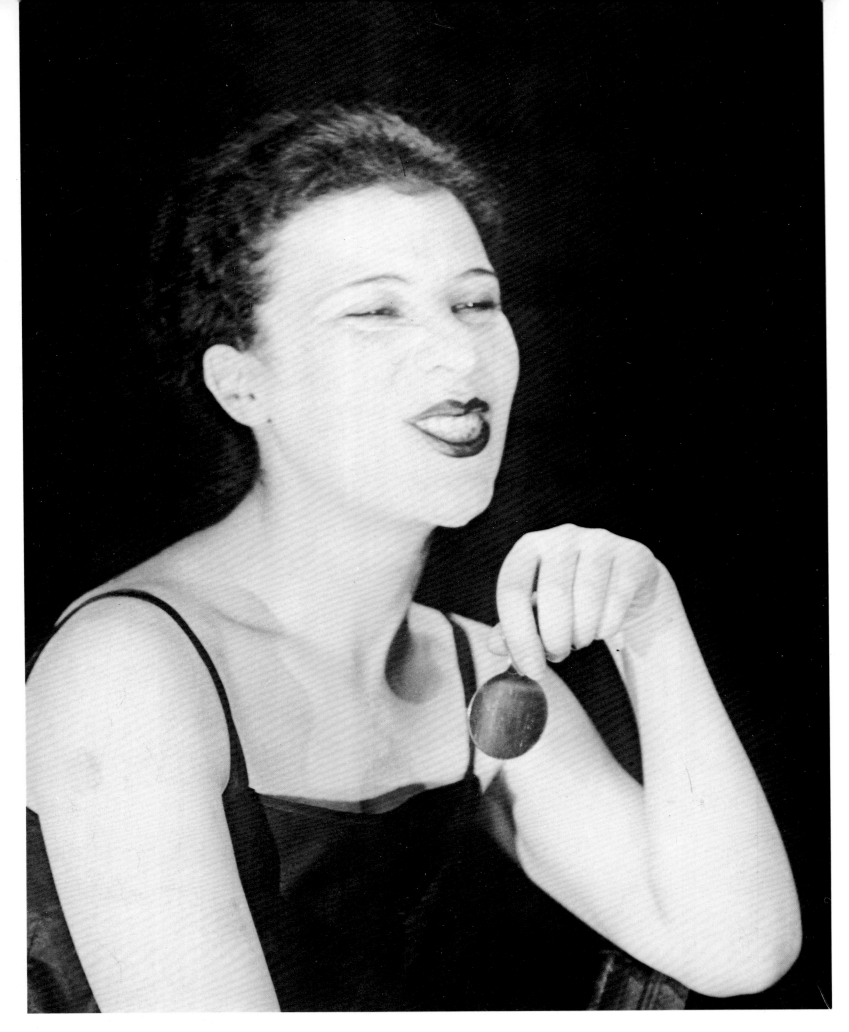

Caridad de Laberdeque

A beautiful, exotic-looking creature with deep red hair and very white skin. She was part Cuban and part something else. She could have been a great success in Paris music halls. She had the talent and the appearance, but she only wanted to start at the top. I saw her bring down many a house but she demanded the best role or none at all and it just didn't work out that way. She was a dear person and a good friend, but eventually someone got her started with drugs and she was finished. This was a happier day—a very spontaneous portrait.

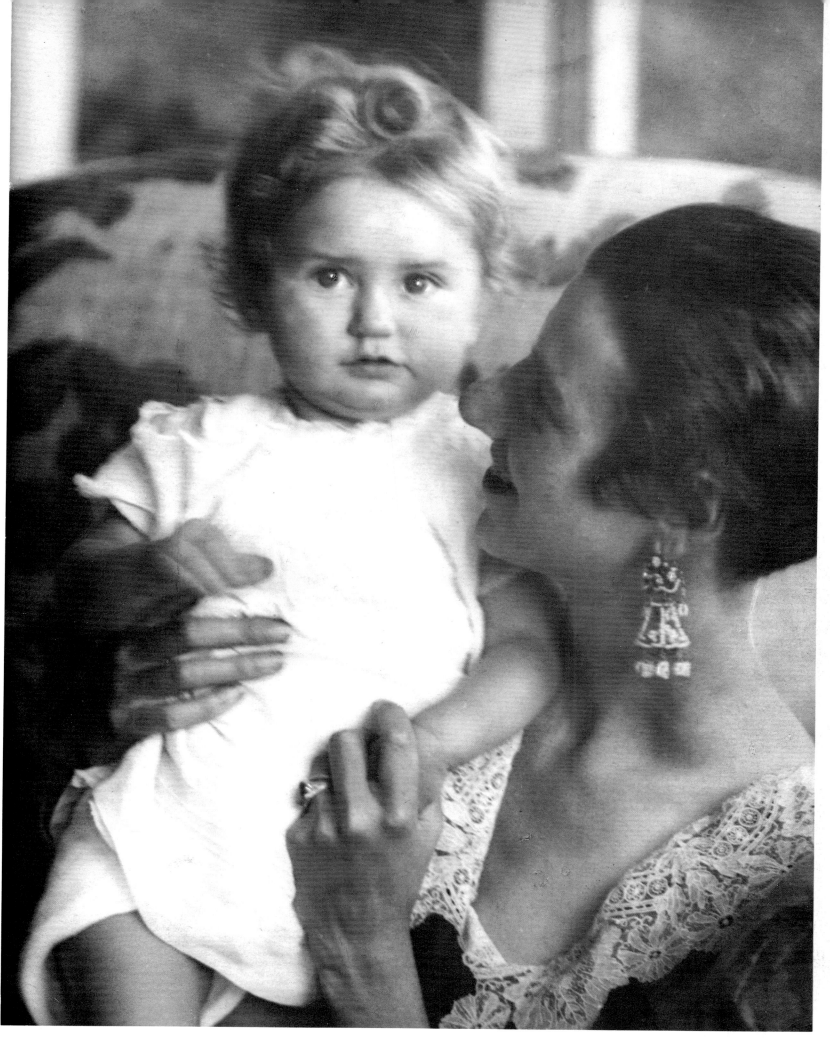

Peggy Guggenheim and Pegeen

Peggy was a great help in providing a loan to get my first studio started. She offered the money and fortunately I had the good sense to accept it; I would never have thought to ask. There has never been as bad a business person as I was then. This photograph was taken in the South of France where I had gone to visit her; I photographed Peggy and her children as partial repayment of the loan. It was one of the first times I photographed children, particularly with a parent.

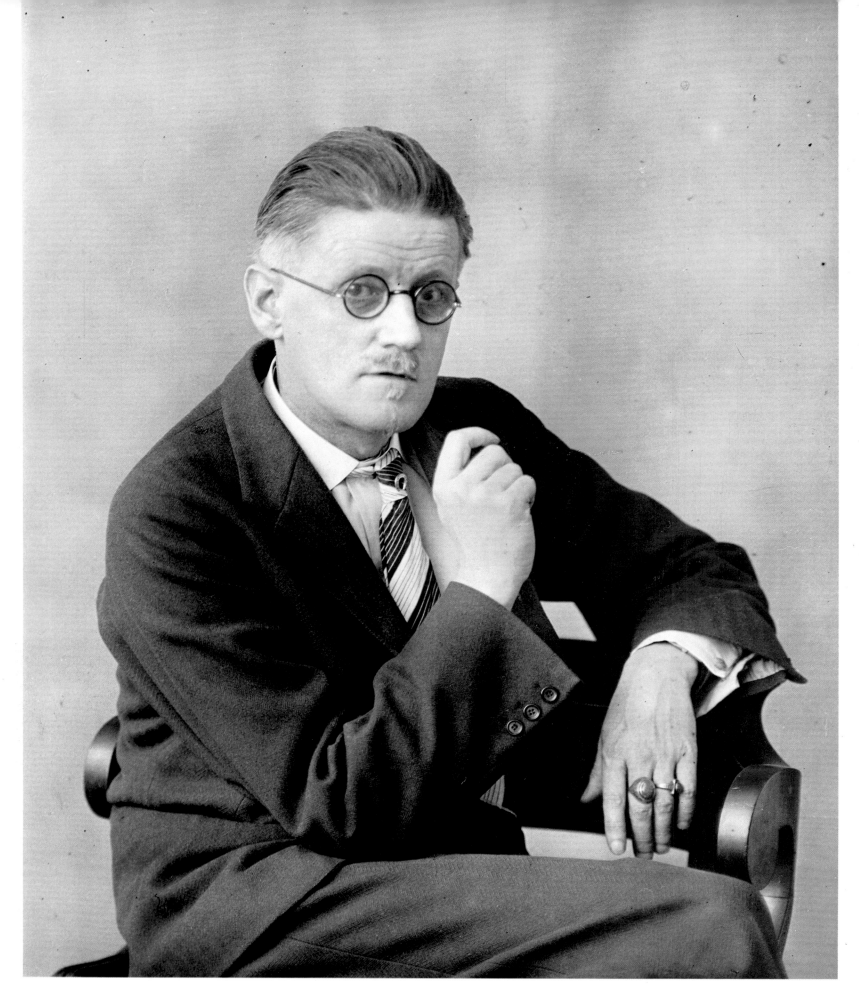

James Joyce
I photographed James Joyce on two occasions. The earlier sitting with the patch on his eye was at his home in 1926, one of the few times I ventured outside to make a portrait. Later, he came to my studio, in 1928. That was when he told me about the severe trouble he had with his eyes. I used only natural light from my skylight, but he still had to wear his hat to shade his eyes. I enjoyed him a great deal and was very fond of his work. He was a very amusing and animated man and it was a good session. Afterward we looked at Atget photographs and he liked them a lot, particularly the one of the dummies without heads in the clothing store window.

James Joyce

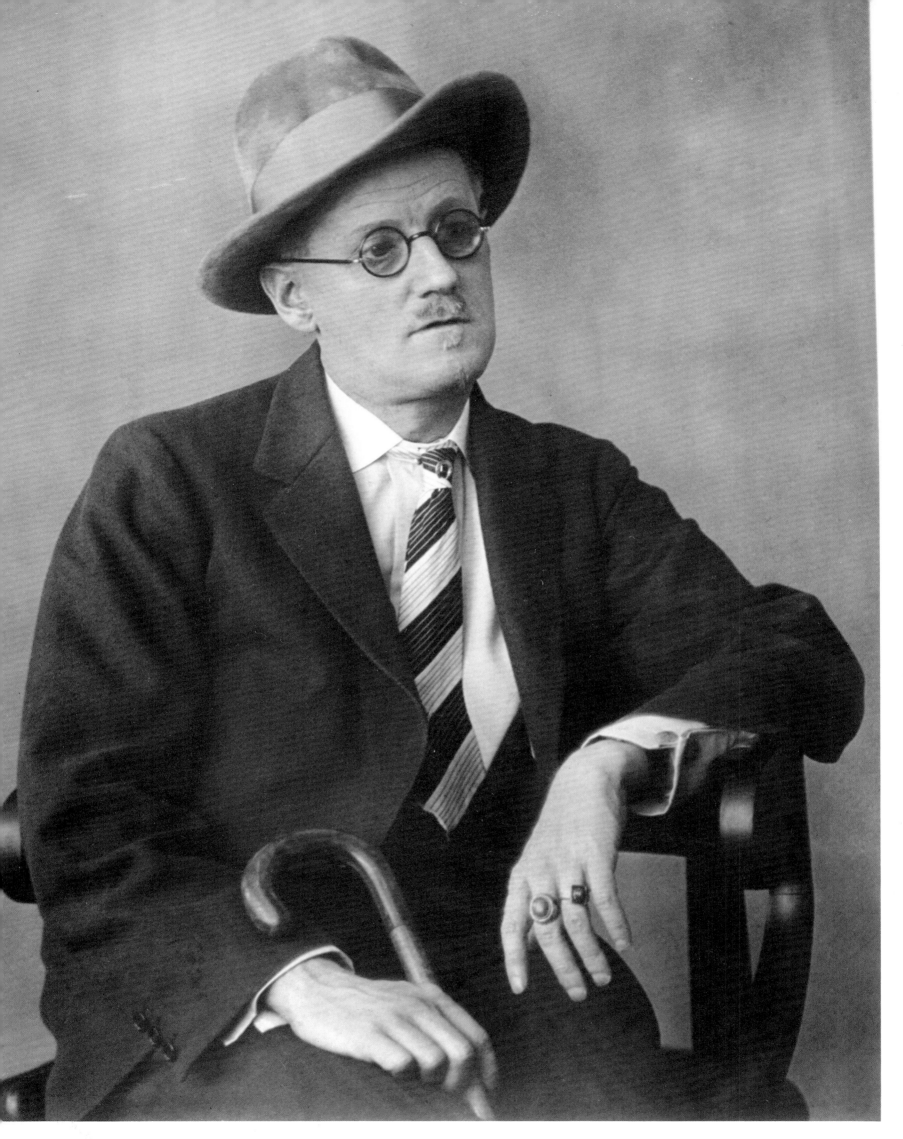

James Joyce

Nora Joyce
She was a wonderful woman and I'm certain a large amount of Joyce's success could be attributed to her. She must have been a marvelous wife; she didn't know much about his writing, and perhaps didn't care, but loved him as a person. The music in her beautiful voice must have constantly pleased him; his style was so dependent on the sound of words and sentences. This sitting was at my studio and was separate from her husband.

Coco Chanel

I don't recall why Chanel came to my studio; perhaps it was because of my brief association with Vogue. *She arrived with someone else and was not particularly well dressed. I do not think this photograph is exceptional; it is printed with a veil. The screen in the background appears to be corrugated cardboard. I tried to vary it as much as possible but I had very little money to spend on fancy props. In the early years my backgrounds were a little small; it took me some time to realize how much was needed to get everything in.*

Djuna Barnes

These were taken at Man Ray's studio, both portraits on the same day; she simply brought a change of clothes. I did her with the light in back of her head because she had such a lovely profile.

I never took two people the same way and often took the same person very different ways. This is why it was so hard, why I didn't take twenty people in one day and make more money. I treated every session as though I had never taken a photograph before in my life, relying on the moment, on my reaction to the sitters, working together with them and thinking of what to do with them and how to see them. It all came spontaneously with each person.

Jane Heap
There are two photographs from the session with Jane Heap, one of the editors, with Margaret Anderson, of The Little Review. *I thought it was foolish to take too many. Usually I'd pretend to do at least four to six,* *but often there was no film (or plates) in the camera. It was just to get the clients to relax a little, to loosen them up in front of the camera. After they were relaxed, I was ready to really get something.*

Margaret Anderson
On my hurried trip to Paris in 1930, I took this photograph in a hotel room, posing Margaret against a window. There are two photographs from this sitting; this is the more spontaneous.

Jean Cocteau

Jean Cocteau

Jean Cocteau
The photograph with the hat and pistol was taken in 1926 at Man Ray's studio. The hands with the mask and Cocteau in bed were done later at my own studio in the rue du Bac, after I had separated from Man Ray. Cocteau brought the mask with him. It was his idea; he was using it in one of his plays, I believe. His hands were extremely expressive; I focused on them in two or three photographs. In the photograph of him reclining with the mask, the hands were incidental.

Sylvia Beach
She came wearing this very photogenic coat to my studio on the rue Servandoni. I don't recall how I got such a white background, perhaps it was just a wall. Many of my photographs hung in her bookshop, Shakespeare and Company, but she must have obtained them from other people. This was the only one Sylvia ever purchased directly from me.

Mme. Guerin with Bulldog
A photograph with a veil over the lens. This woman was the mother of Jean Guerin, the writer, and I took her in the studio with the dog she brought as a prop. I eventually made portraits of the entire family.

André Gide
This photograph was taken in very poor light at the rue du Bac. I recall he had a dreadful headache that day. Gide was a good friend—one of the first people I met when I arrived in Paris—and this is my favorite photograph of him. I made many others that day, but this was the best. In some of the others you could see how much his head hurt; I never showed him these. Normally I'd take the photographs, make proofs, submit the ones I felt to be best to my client and then make final prints. Usually the one I felt was superior was chosen.

François Mauriac

Jules Romains

Romains came to me as a commercial client. I knew he was a respected writer, but I had not read his work and I did not discuss writing with him. Later I read his Death of a Nobody *and was very impressed. This photograph tells a good deal more about the times than one might suspect. He arrived at my studio dressed this way; people dressed formally then, even the men. Dress was as important to them as it was to women. The times were not as casual as they are today.*

55

Mme. Theodore van Rysselberghe

Bronja Perlmutter
Bronja was one of my close friends in Paris, along with her sister, Tylia. When I had first arrived in Paris she was in love with Raymond Radiguet, Cocteau's protégé, and she was crushed when he died in 1923. We were friends because we could be poor together; later she married René Clair, the film director.

Solita Solano
Solita was a good friend of Flanner's. This portrait also indicates the sparseness of my studio; she is sitting on a box, a modest prop. I only made two exposures of Solano, with greatly contrasting moods. This one, somewhat reflective, is superior to the other.

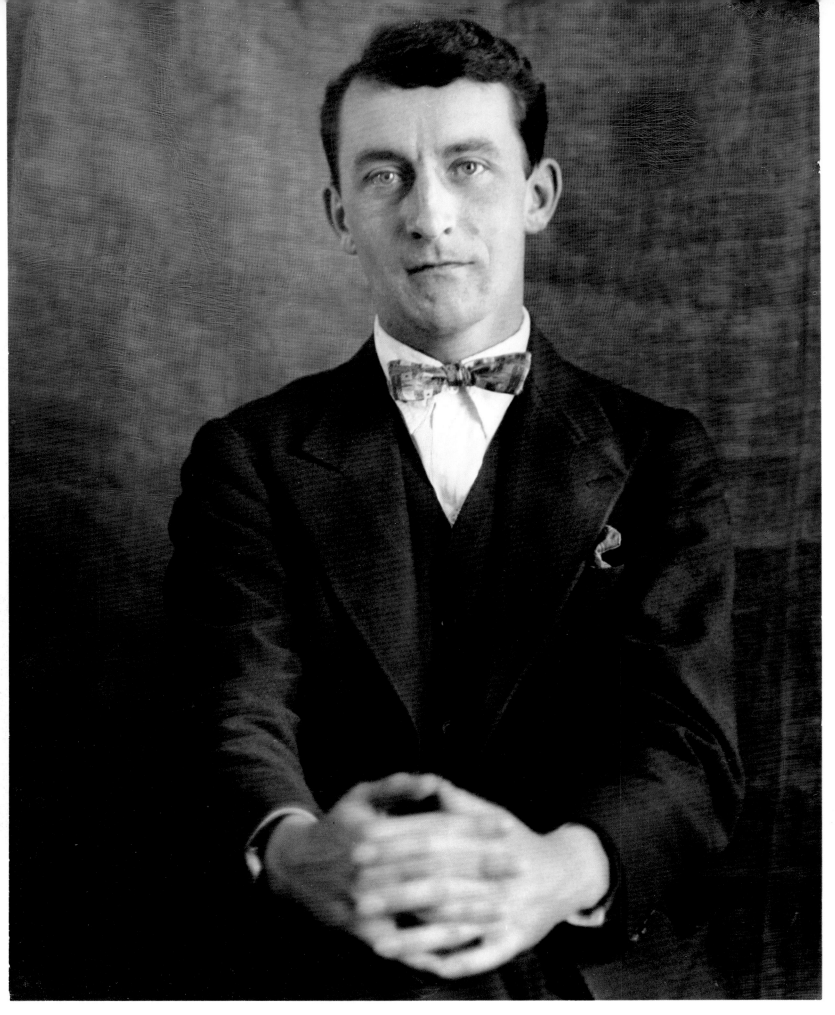

Robert McAlmon

I saw a great deal of Robert McAlmon, but I only photographed him once. This was an early portrait done at the rue du Bac. He had been helpful in lending me money to purchase equipment for my new studio. He was a very enterprising and nice person; he helped many other artists. Bob was a much sounder person than he is given credit for and his book Being Geniuses Together is one of the best books on the 1920s.

This is a very positive photograph, but I did not initially think about it or set it up this way. I relied on my intuition and the timing of the moment and on getting the person involved in an effort to see what they were really like. A sitting with someone like Bob would usually last about one hour. There was no specific time —morning, afternoon, or whenever—they could come. Almost never at night.

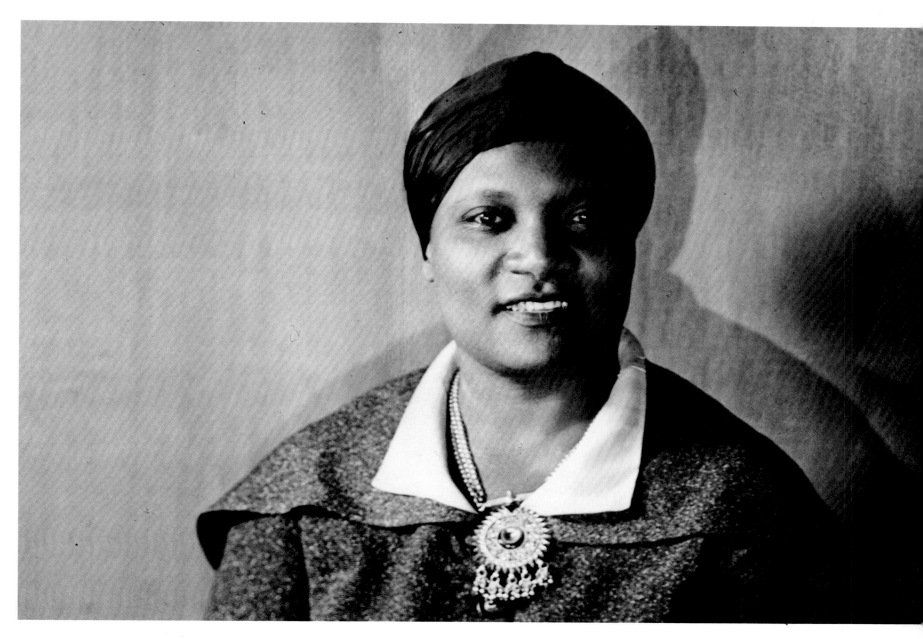

Lelia Walker
This is a New York portrait. Lelia Walker was part of the Harlem elite; she had invented some sort of product for the hair and made a fortune from it. Very often blacks will look blacker because of underexposure and I had to compensate for this. Walker was a delightful woman and I have always liked the expression here very much. It was good so I grabbed it, snatched it out of the air very quickly; the rest of the photograph is not so good and I always crop it just to emphasize the head and the beauty of her expression.

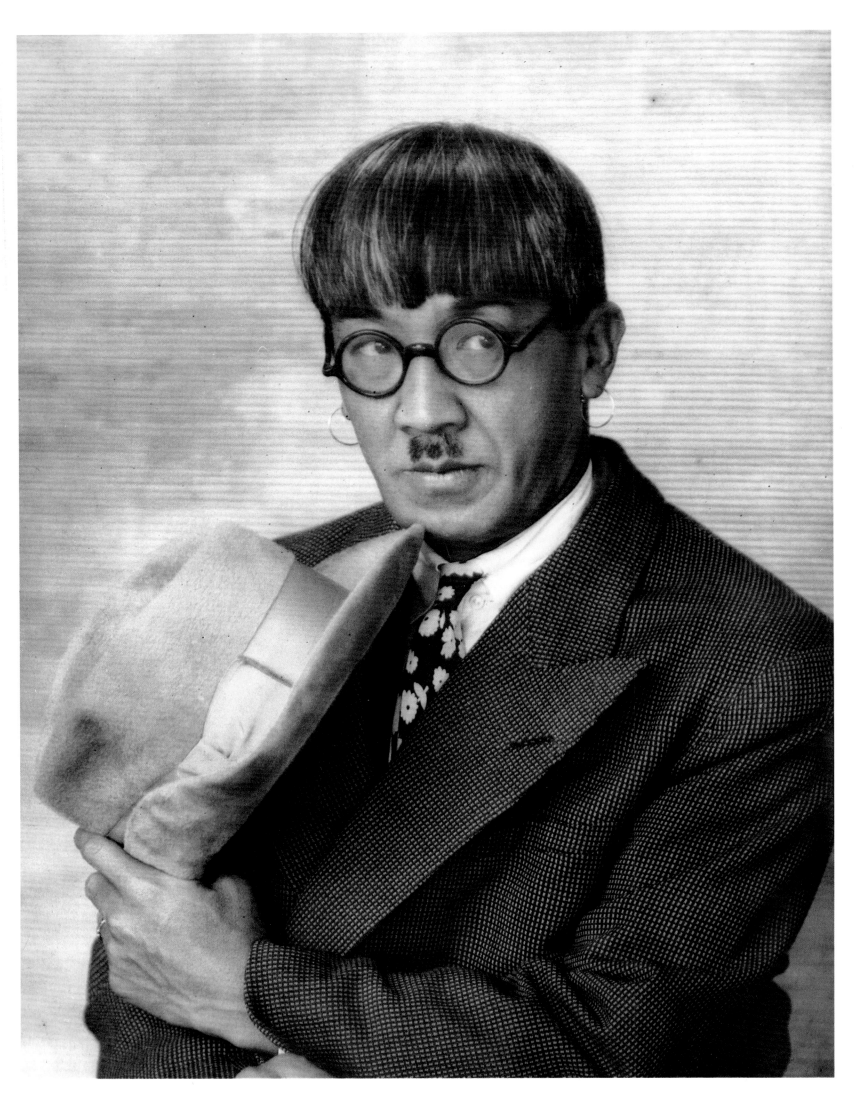

Foujita
*This is the way the artist looked that day. People were
very liberated then, perhaps more so than now. They
worked hard and they were themselves.*

60

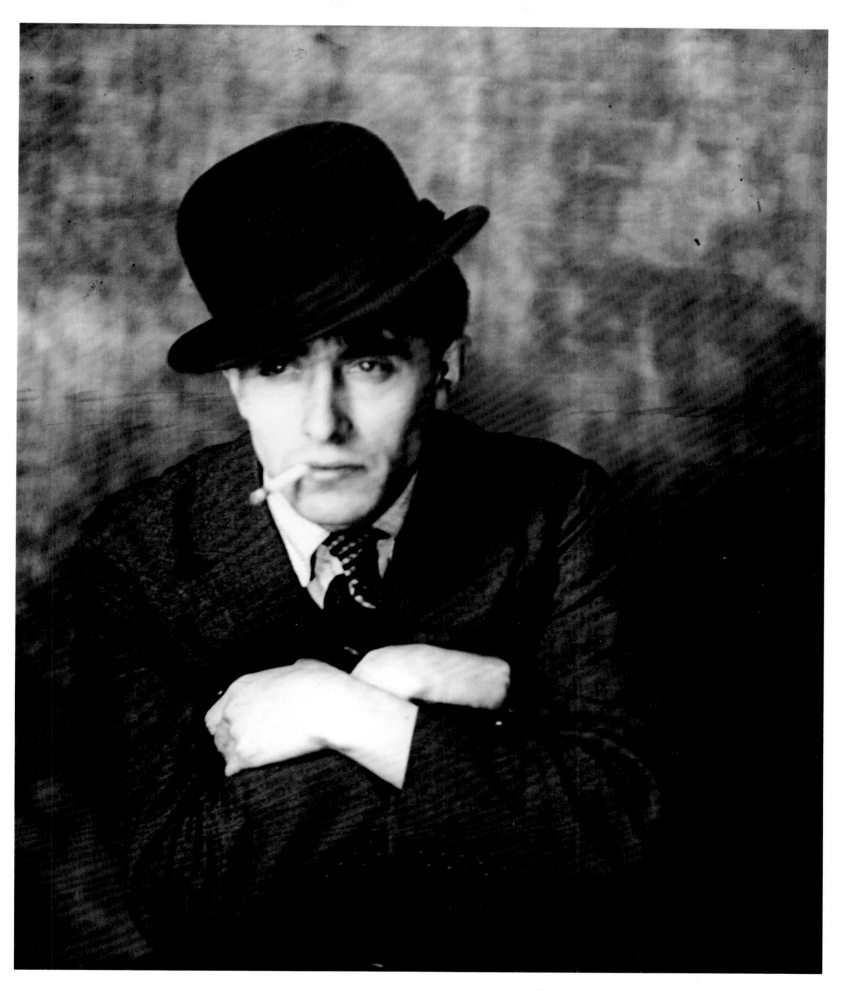

Pierre de Massot
Pierre de Massot was a dear person, trying to look tough here, but he wasn't. A delicate little French writer, he wrote one book entitled Portrait of a Bulldog, *in which one of my photographs appeared. I tried to locate him when I went back to Paris in 1966 but no one had even heard of him.*

Dorothy Whitney
Baroness Elsa von Freytag-Loringhoven used to say that women looked extremely feminine in a tie and collar, and more women wore them then than now. I never told people what to wear; this is simply how she arrived at the studio.

Marie Laurencin
An early portrait of the artist done at Man Ray's studio.
She was already famous when I took this portrait. The
sitting was arranged by Tylia Perlmutter, who often
posed for her. In this case I had nothing to do with the
arrangements, but that was unusual.

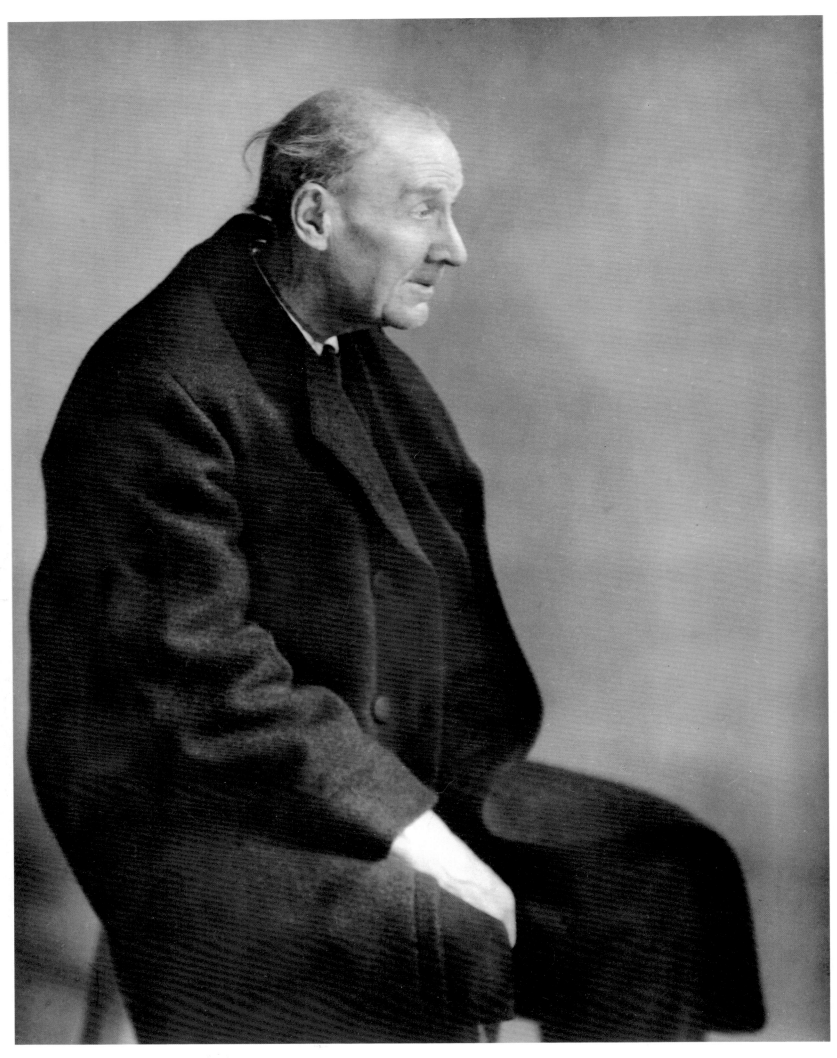

Eugène Atget

I asked Atget to come by and pose for me and he did. I like the side view best; I think he knew I would and I didn't have to do anything with him. He just sat down this way and I took it. That was that. I didn't need to do anything. I had no idea he was so ill; I knew he was very old but I didn't expect him to die so soon. It turned out to be one of my most popular portraits.

Eugène Atget

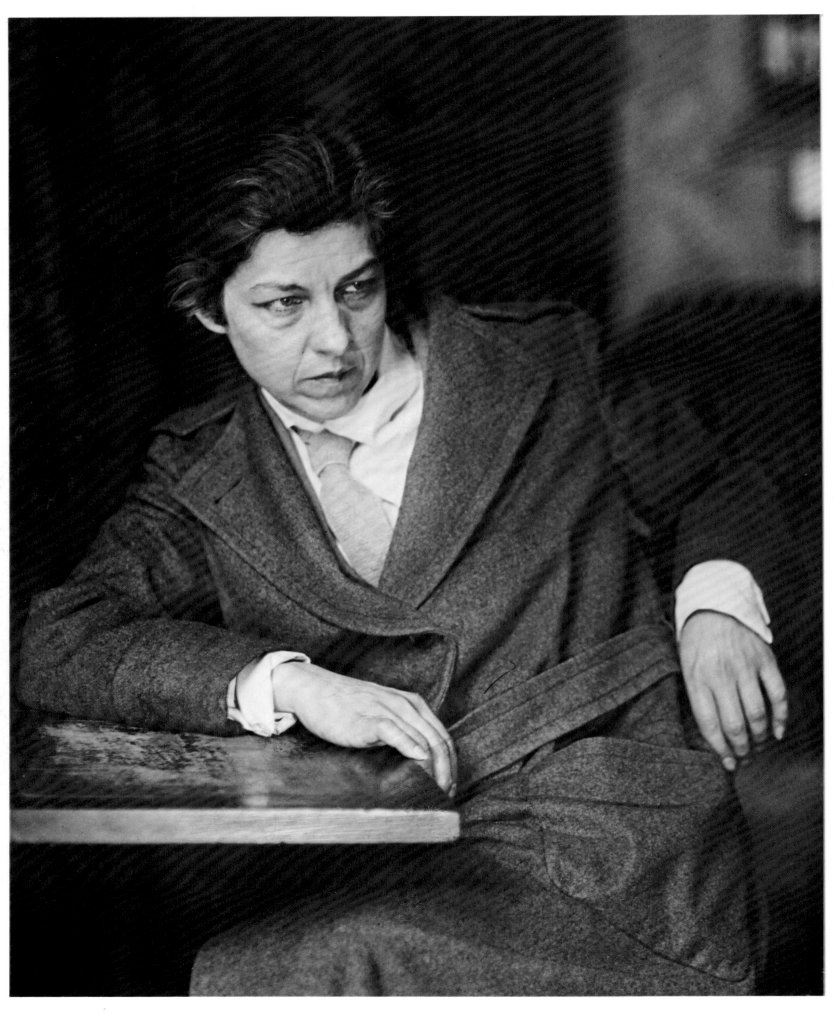

Renée Praha

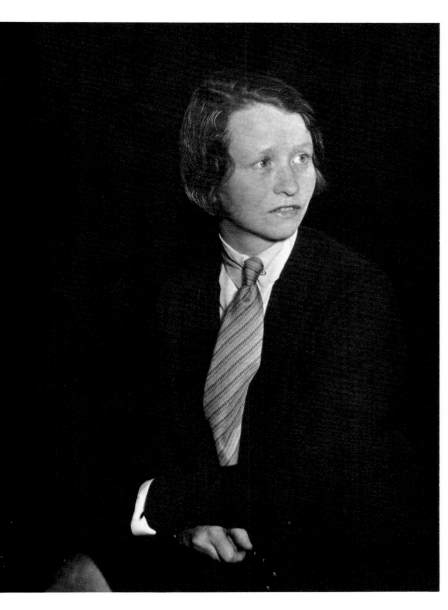

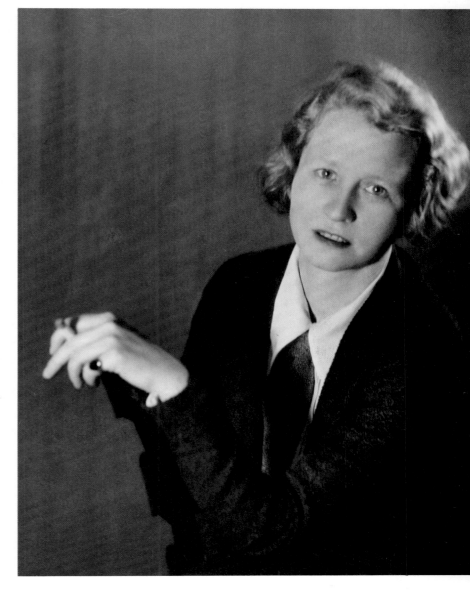

Edna St. Vincent Millay

Edna St. Vincent Millay
All my photographs of Millay were taken at one session. I had known her slightly in New York, but in Paris I saw a good deal more of her socially. This portrait, however, was taken in New York at the Hotel des Artists after I returned. I used light from two different sources; I always used more artificial light in New York. Here, you notice, the hand is not in focus. It would have been nice had it been, but I tried to capture spontaneity and was willing to forego certain things to obtain the best expression possible.

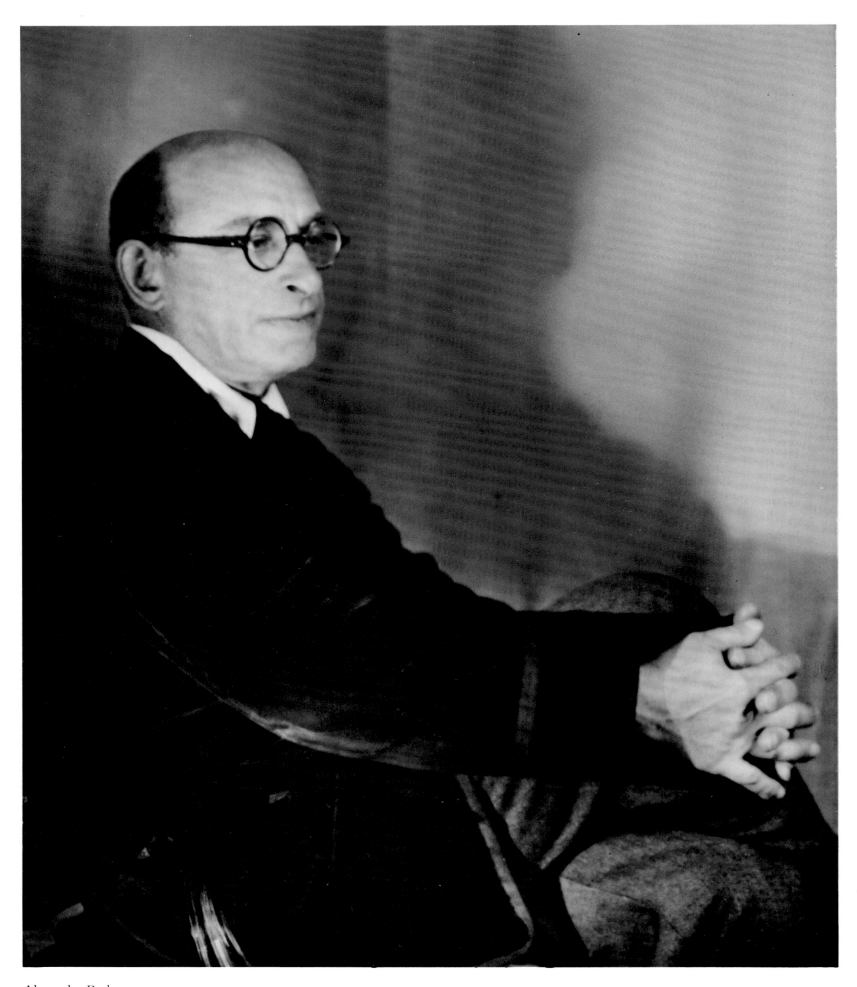

Alexander Berkman
*A portrait taken at the rue Servandoni of a man who
called himself a philosophical anarchist. I'm very sorry
I didn't photograph his friend Emma Goldman, whom
I knew much better. I didn't know Berkman at all.*

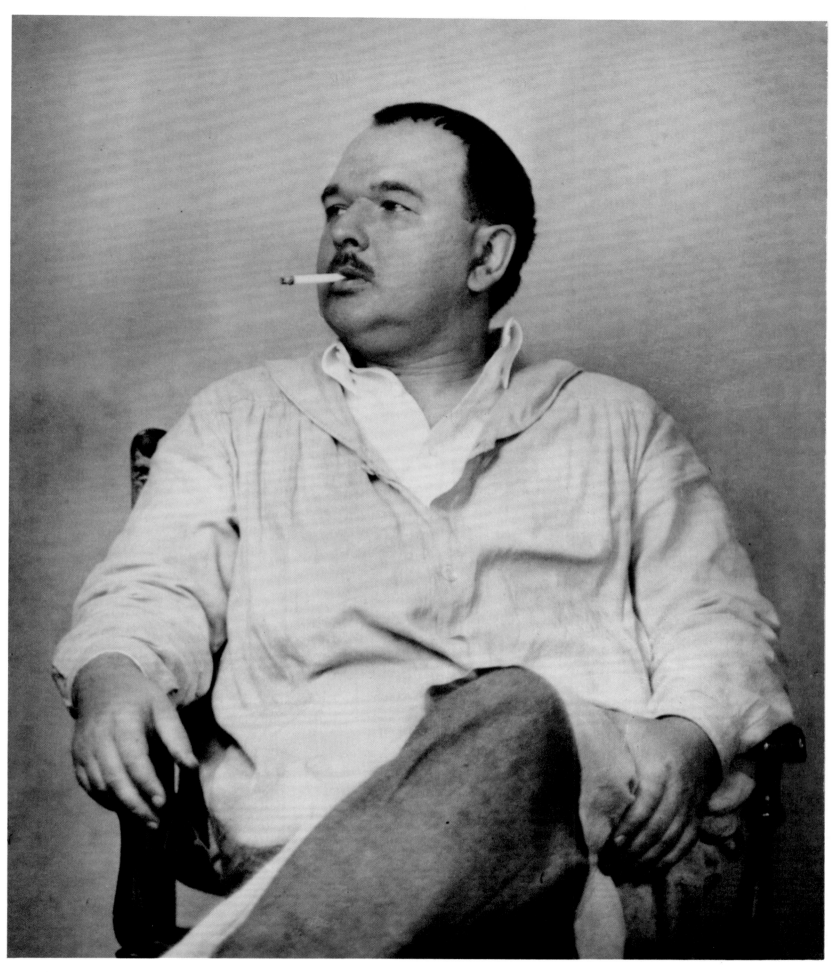

Serge Soudekian
*I took this portrait of the designer in New York at the
Hotel des Artistes. This is typically unposed; no one
wants a posed photograph. I also took a photograph of
his wife, a very fat but handsome woman. One of those
beautiful fat ladies. I have no idea why they sought me
out. I was not particularly well known when I first got
started in New York.*

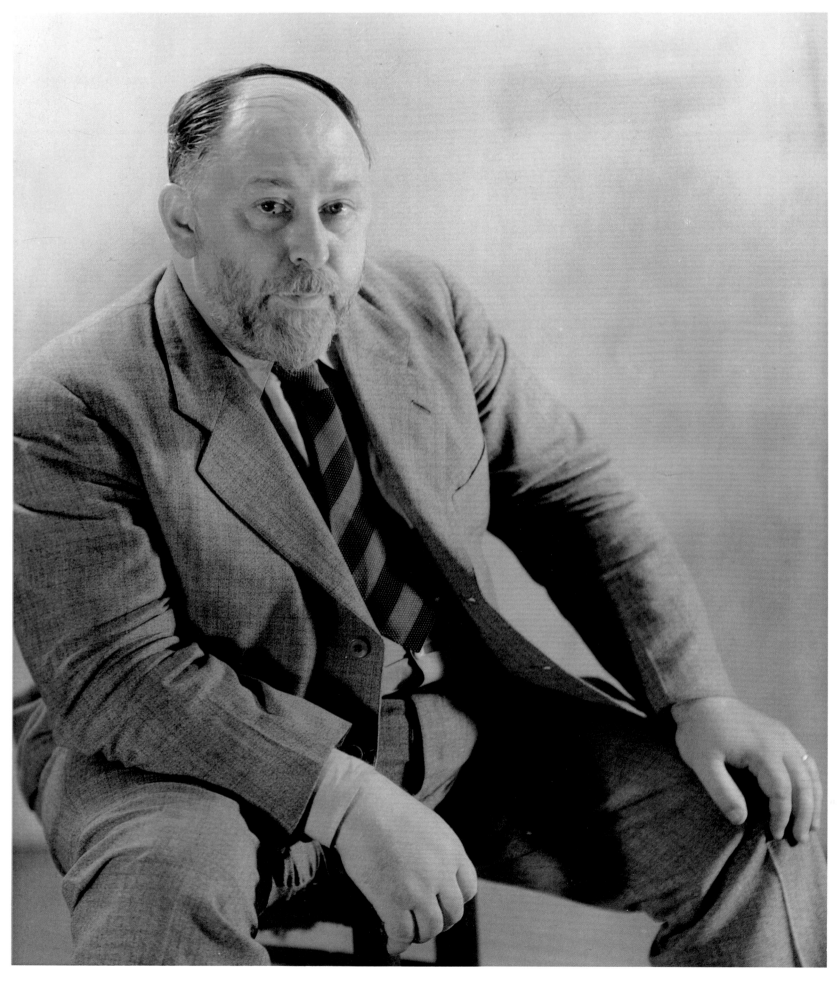

Elliot Paul
A portrait of the American writer, taken in New York.
I had little light then and this complicated everything.
It was hard on the sitter and hard on me.

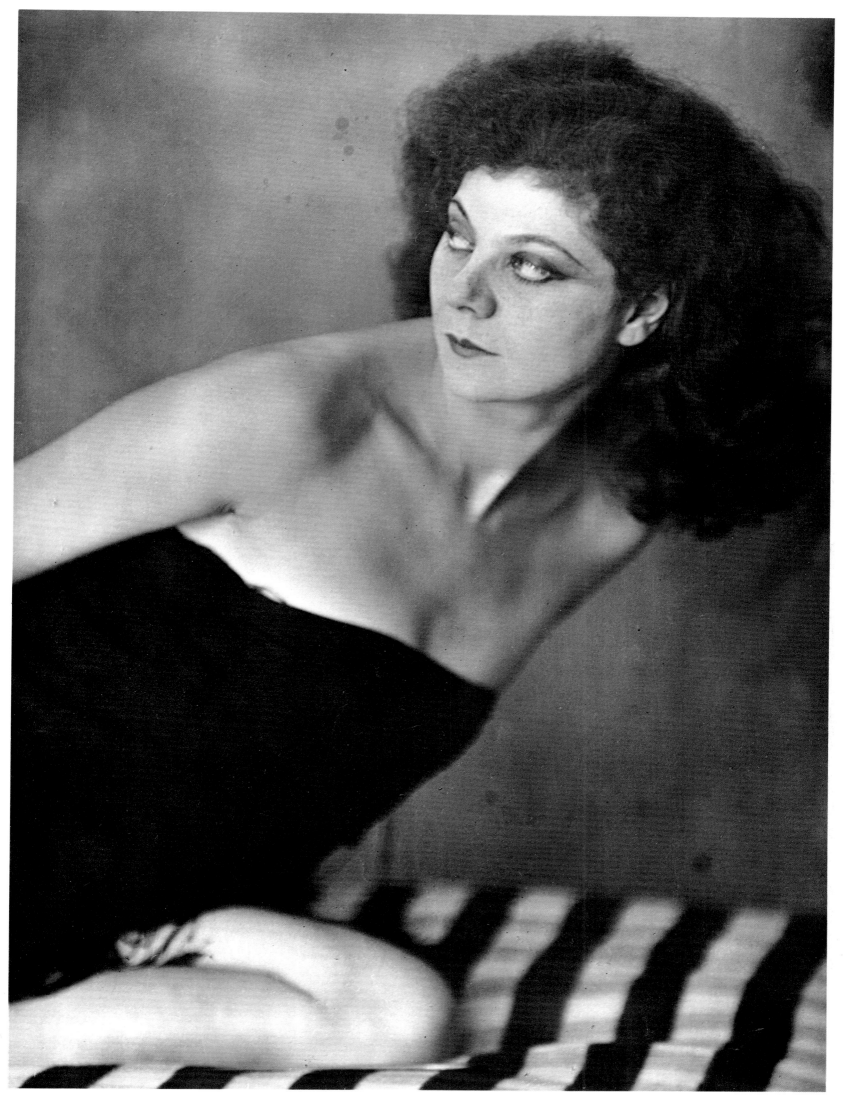

Helen Tamaris

Fratellini Brothers
I have always loved clowns and in Paris in the 1920s the Fratellinis were considered the greatest. I went to their dressing room with my 5" x 7" view camera one night after a performance, but there was much confusion and they were in a hurry. I only took one photograph.

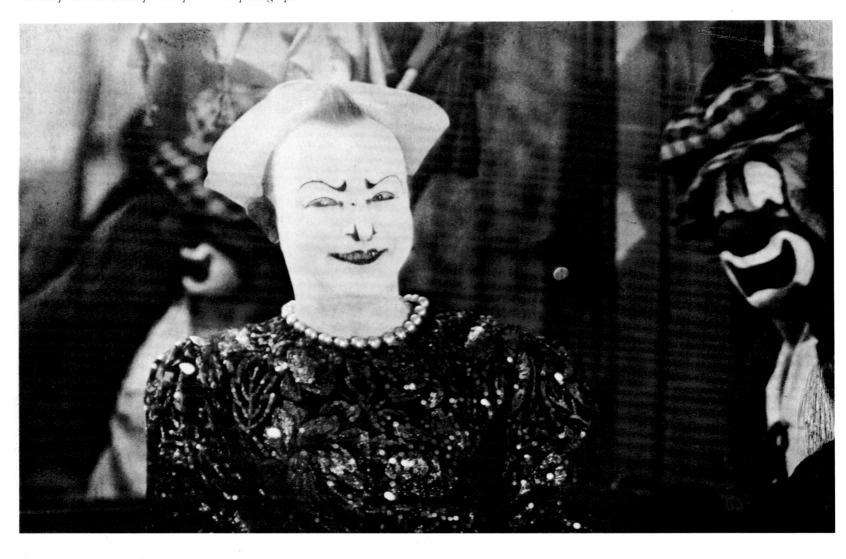

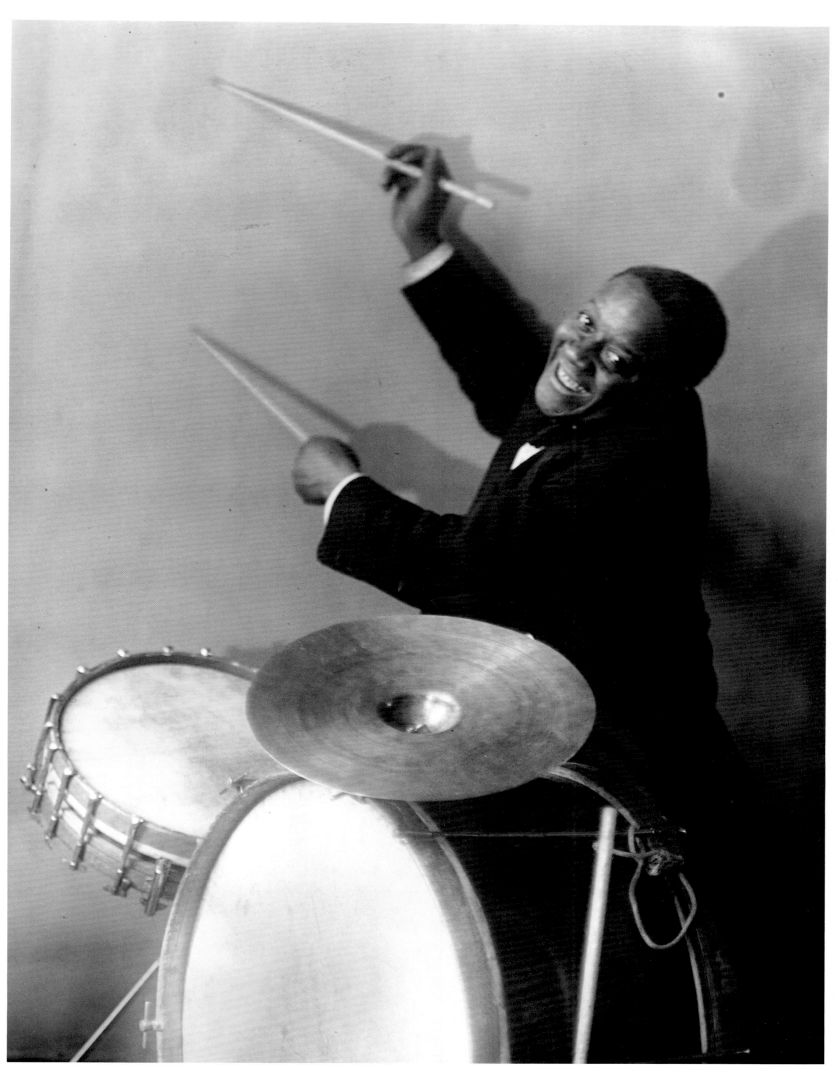

Buddy Gilmore

Buddy Gilmore played the drums at Zelly's with such élan that he simply fascinated me. I asked him to bring his drums to my studio; this, obviously, is a posed photograph. I was simply crazy about his playing.

Berenice Abbott, 1930

Changing New York

Abbott's first major photographic project was documenting New York City. Early in her career she vowed never to take random photographs; she always worked toward a goal, and each photograph had to be part of something greater than itself. Her documentation of this growing and changing but ultimately timeless city is one of Abbott's finest accomplishments. There is little doubt it is the best known.

The New York project began in 1929; it was the reason she returned from Paris. The earliest photographs were simply notes taken with a small camera for future reference. The size of her negatives increased until finally, by 1932, all were made with her 8″ x 10″ Century Universal, except when she was hanging out a window near the top of a skyscraper. The final photographs for Changing New York were made in mid-1939.

Washington in Union Square

Rag Merchant

Storefront

Friedman and Silver

Storefront

El at Columbus Avenue and Broadway

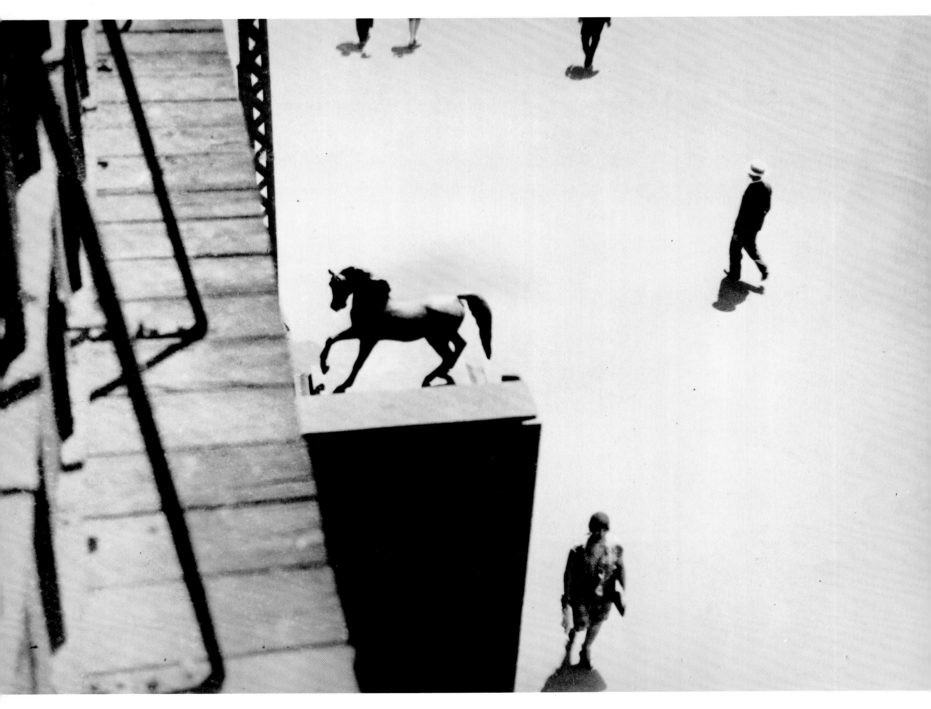

Elevated Railway

Beach Scene

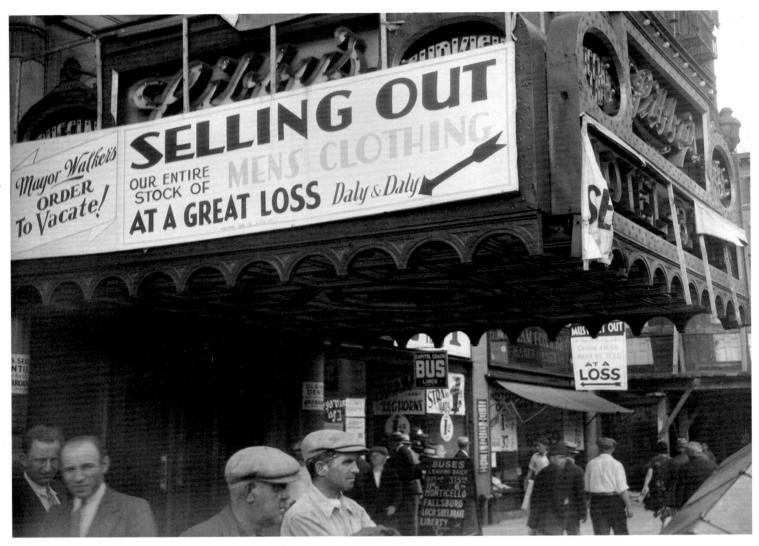

Burlesk Theater

Man on Brooklyn Bridge

Lincoln in Union Square

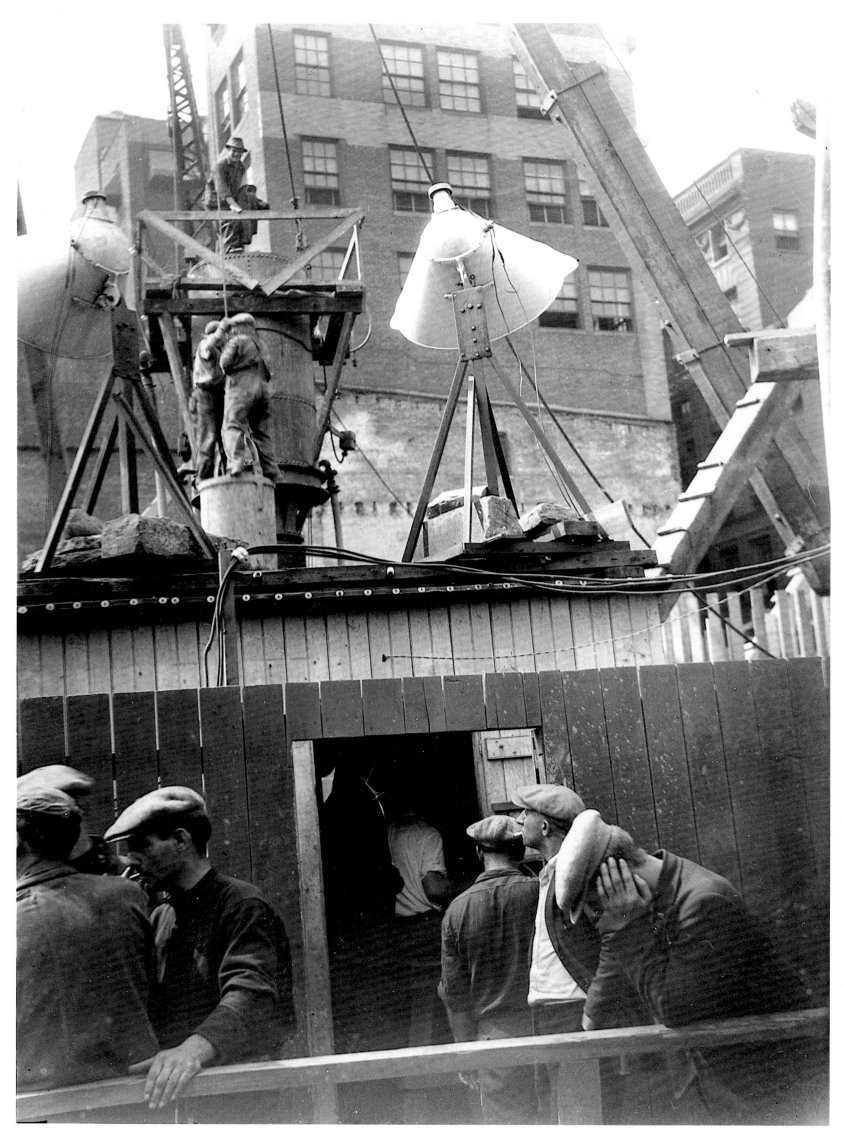

Construction Workers

Building New York

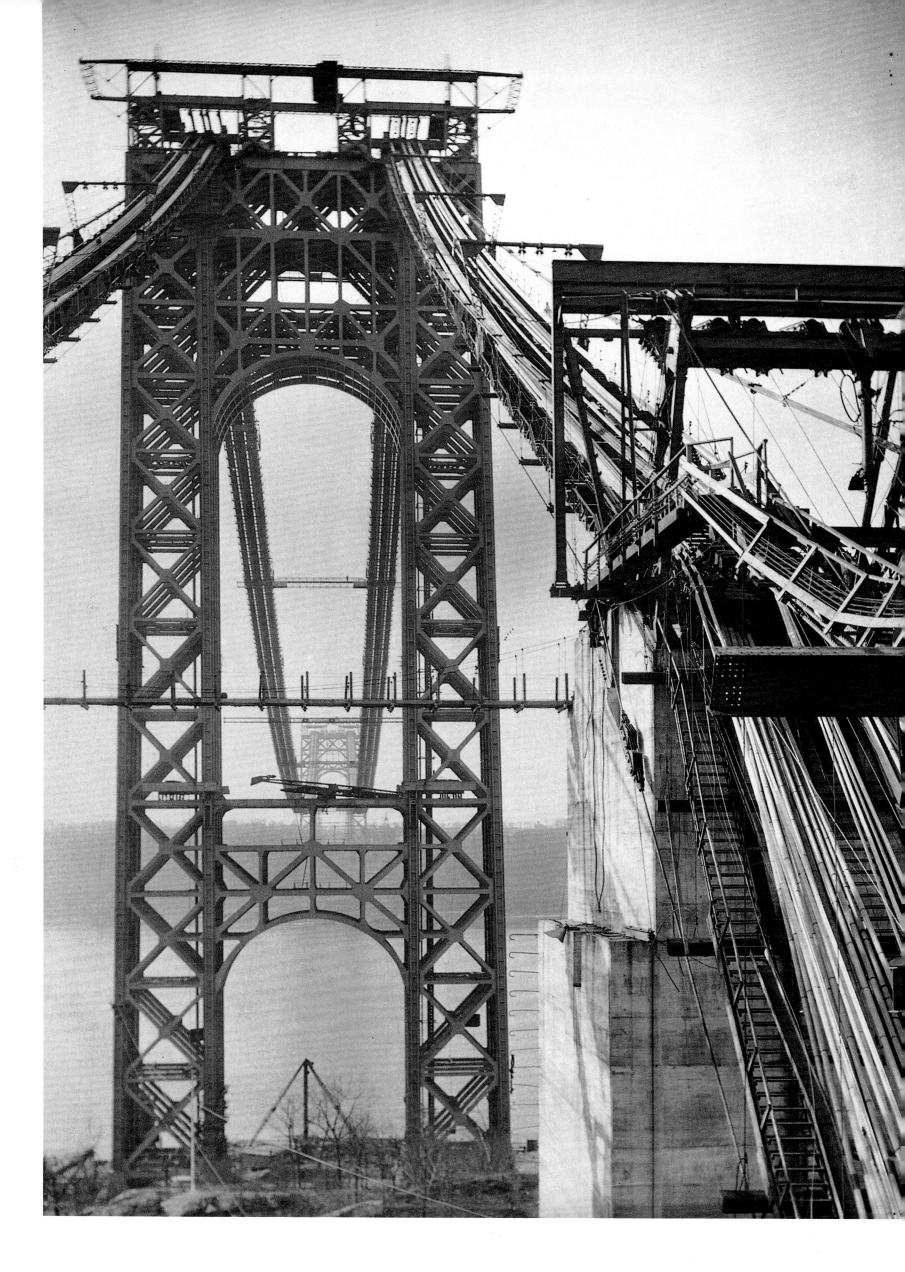

Foundations of Rockefeller Center

George Washington Bridge Under Construction

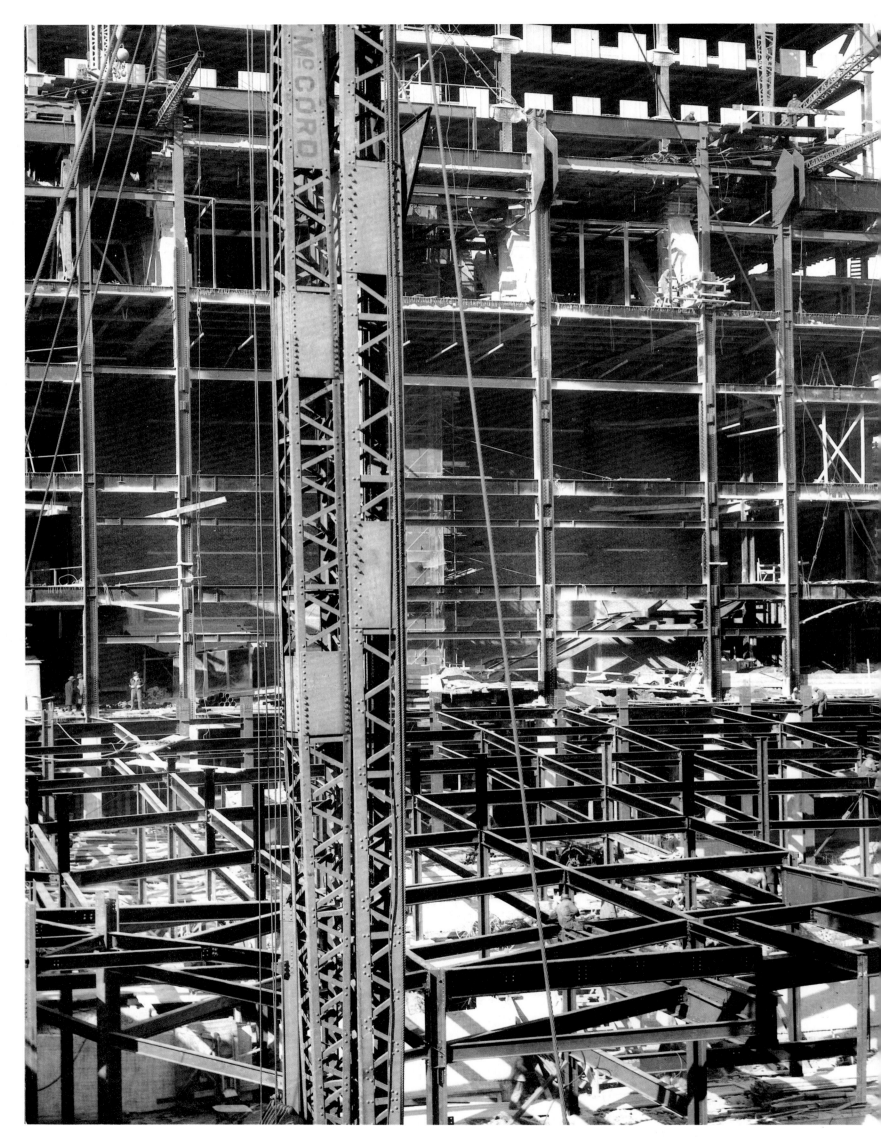

Girders and Derricks (Rockefeller Center)

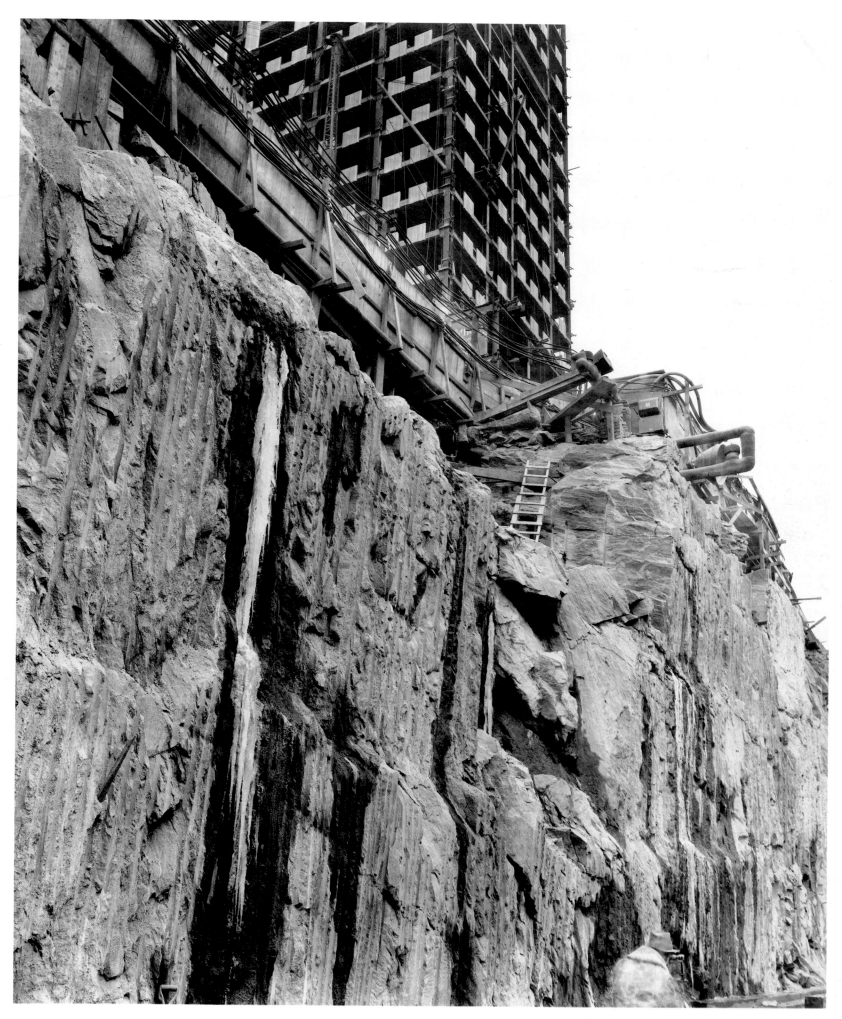

Rockefeller Center

These are from a series of photographs I made documenting the construction of Rockefeller Center. It was one of my first projects requiring more than one day's shooting; I went back many times to do it from many heights, different angles and so forth. It was a very difficult project. There was the problem of gaining permission and the weather was often very cold—and I was looked upon with suspicion. Later I tried to interest the management at Rockefeller Center in the photographs but they said they had enough of their own. Of course what they had were miserable little record photographs.

Under the El at the Battery
This was taken in 1932 down at the Battery. The negative is slightly underexposed. I had to shoot as quickly as I could to stop as much of the action as possible, but the film speed was very slow. I was always fighting existing equipment. I complained to someone at Eastman Kodak about the speed of their film and was told that if I was any good I could take a photograph of anything. I said I couldn't even take a picture of the Brooklyn Bridge because of the depth of focus needed— the speed of the automobiles and people and the vibration of the bridge itself. The fastest film I had access to in those days would correspond to about ASA 50 today.

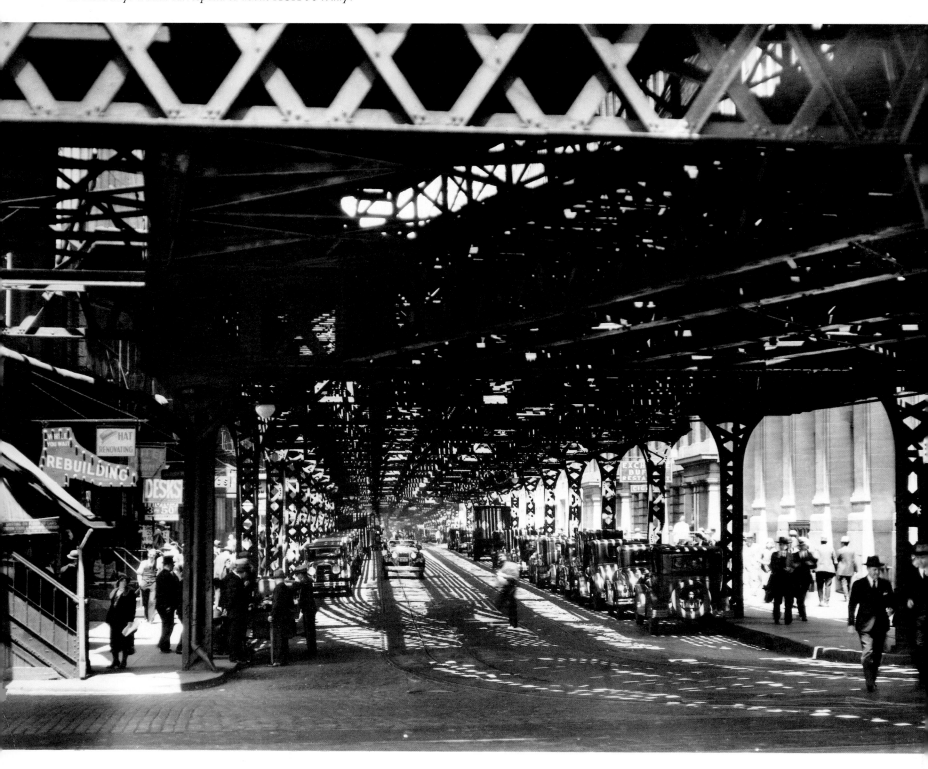

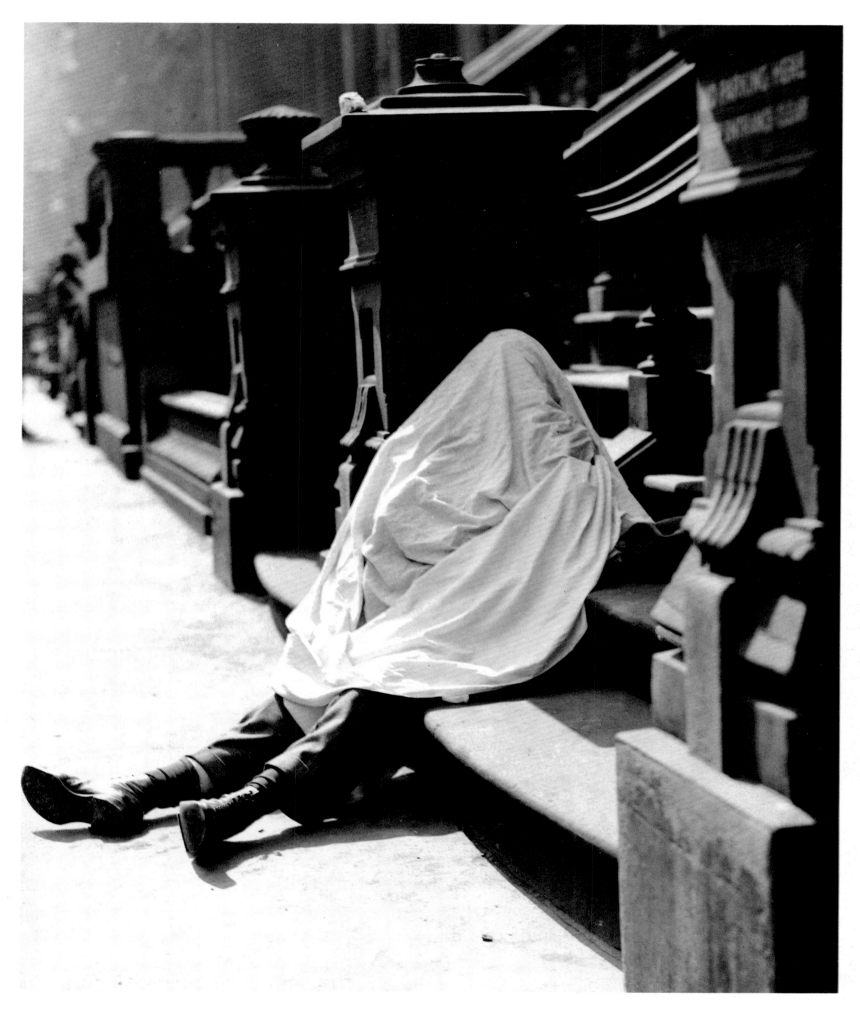

Dead Person

In the early 1930s I had a studio on 53rd Street, right opposite the Museum of Modern Art. One morning I came out and encountered this dead person on the stoop. I hesitated for a moment, wondering whether or not I should make a photograph. This is the result; it has not been shown previously.

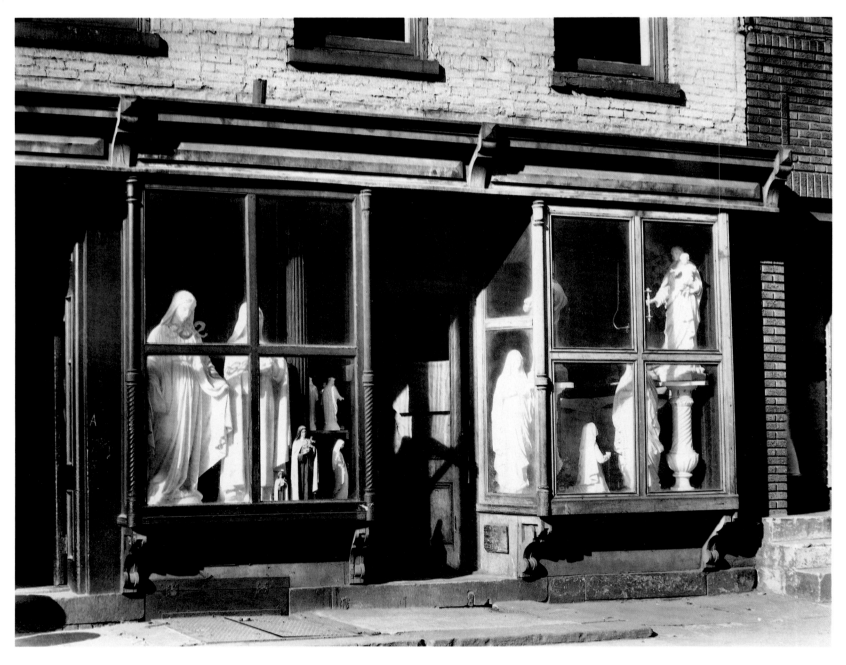

Saints for Sale

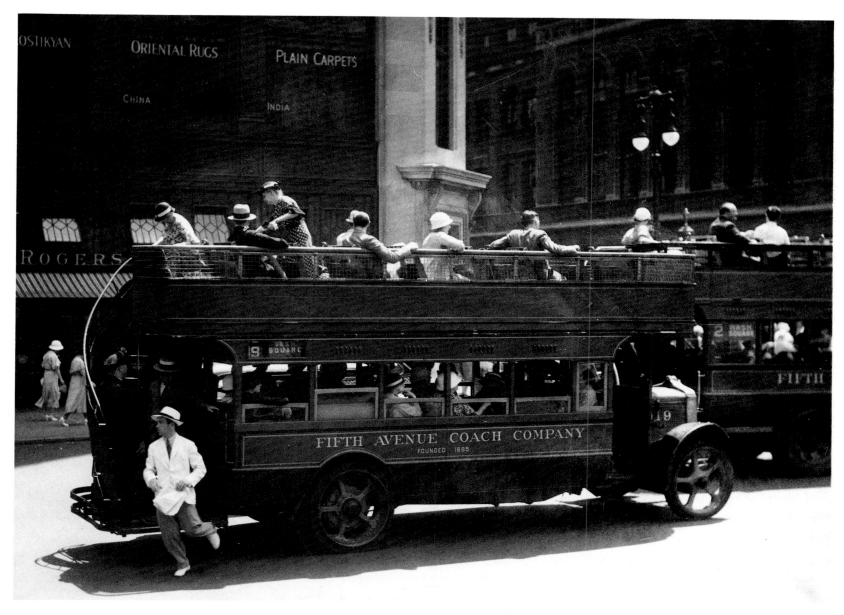

Fifth Avenue Coach Company
This was taken from the steps of the New York Public Library on Fifth Avenue with a small hand-held camera. I was trying to get a good shot of the bus; the spontaneity of the situation helped the composition.

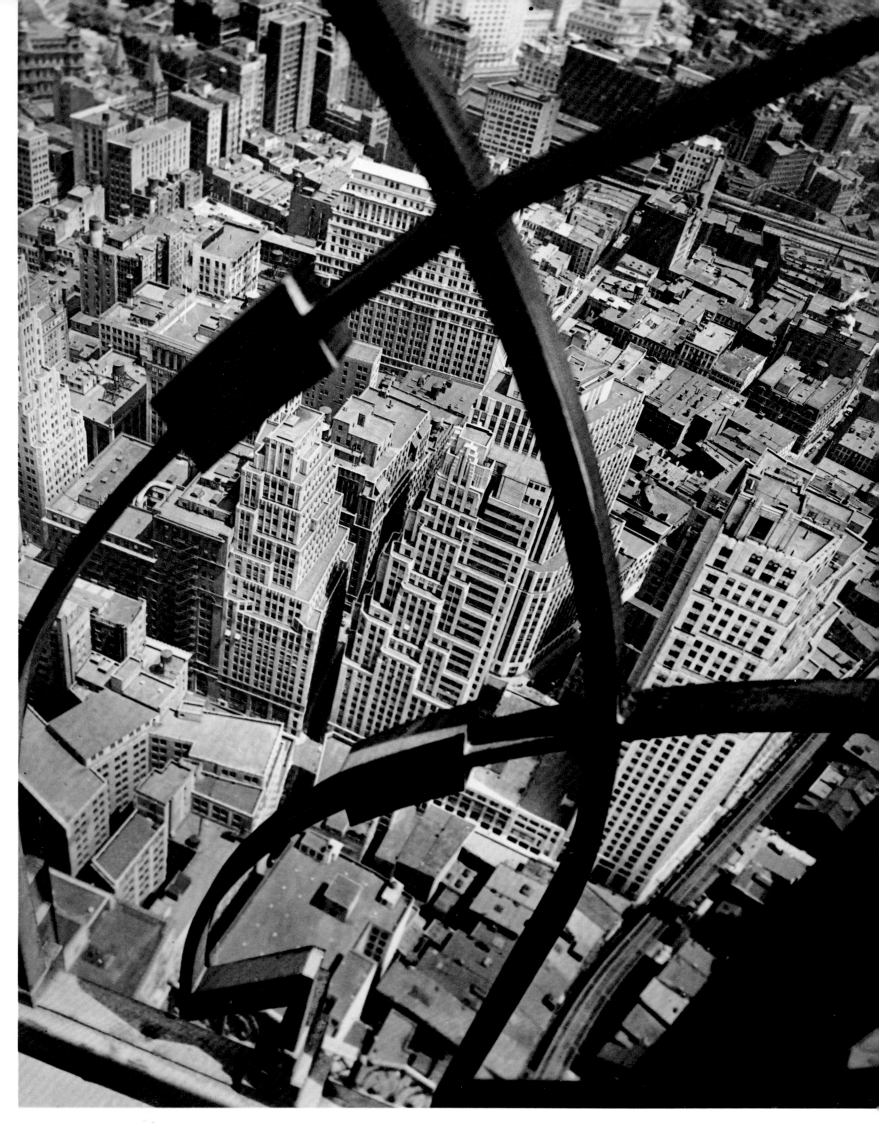

City Arabesque, from the Roof of 60 Wall Tower
I put the grill in because I thought it looked nice. There is no complex idea; the grill simply appealed to me, although it did present some depth-of-field problems. I could have made the grill needle sharp, but I didn't choose to. As with the grillwork on Willow Street (p. 154), I did not want to be too sharp or it would have detracted from the rest of the photograph.

John Watts Statue, from Trinity Church Looking Toward One Wall Street
Taken from Trinity Churchyard with One Wall Street in the background. This is just the way it was; I didn't wait for the shadows to move or anything. If I had I would never have got anything done. This particular photograph looks very good enlarged.

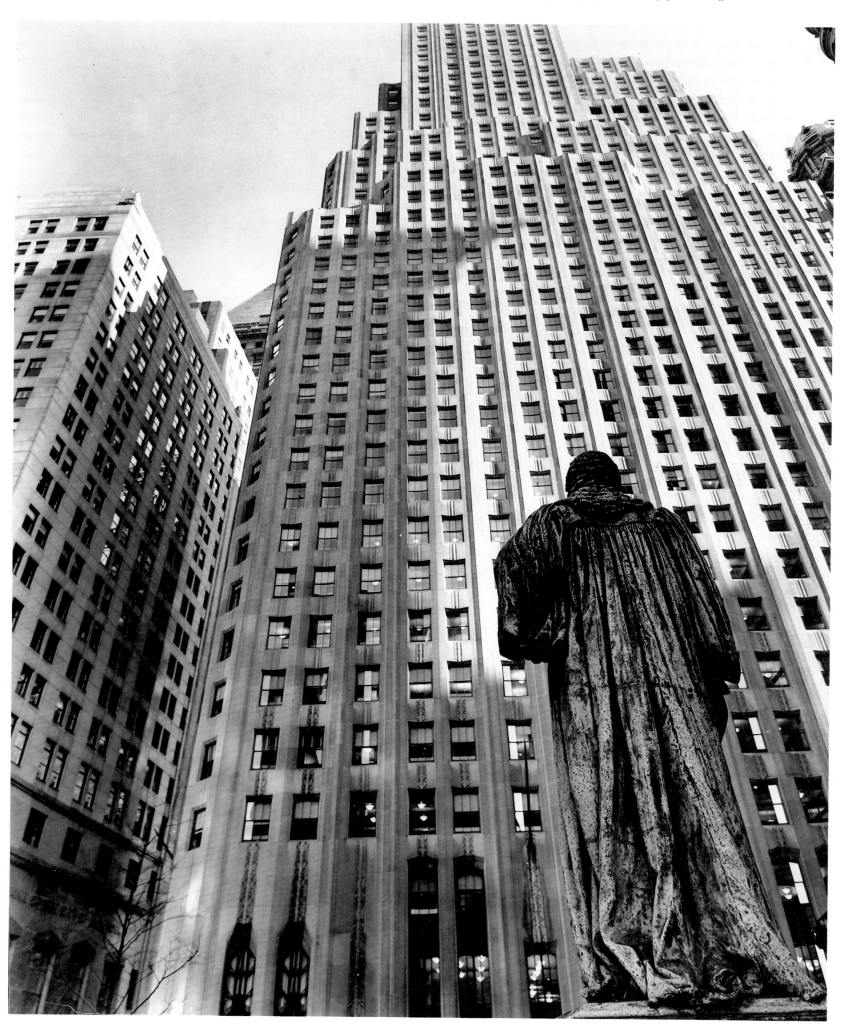

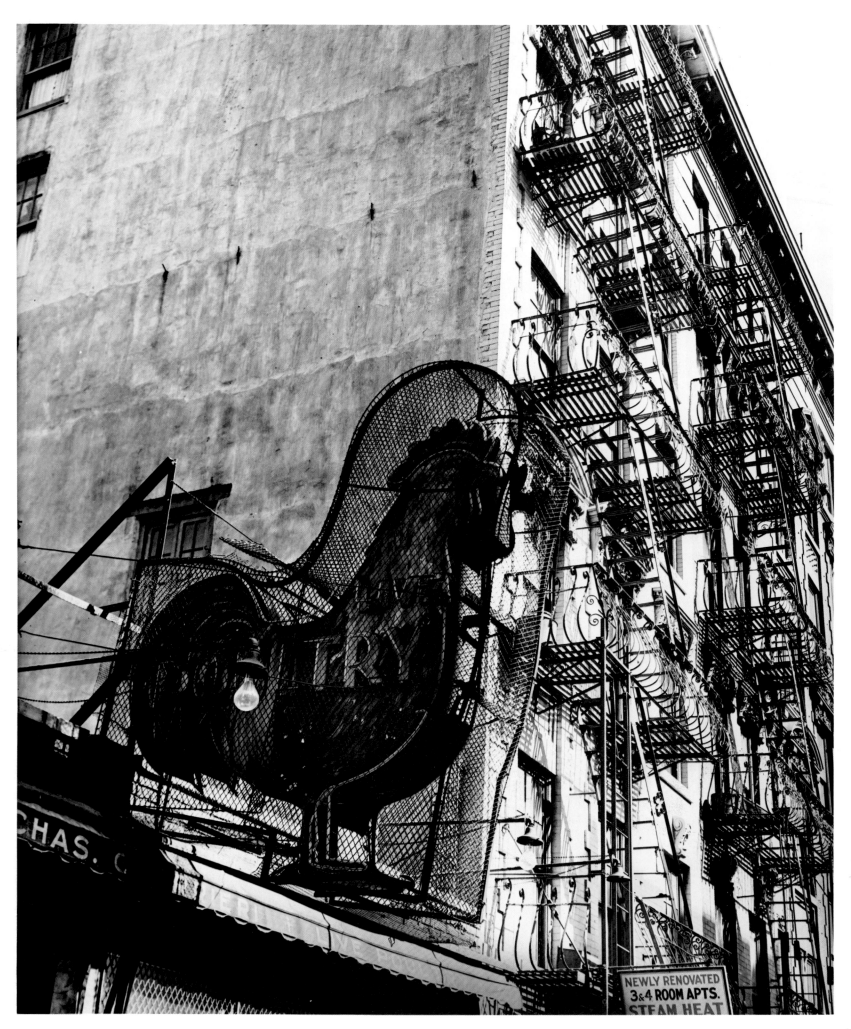

Poultry Shop, East 7th Street
This was on 7th Street. The light was great and the photographic look of the scene was spectacular. I just knew it would make a good photograph. Many people don't understand that there are a lot of good subjects that just don't lend themselves to photography. This one did.

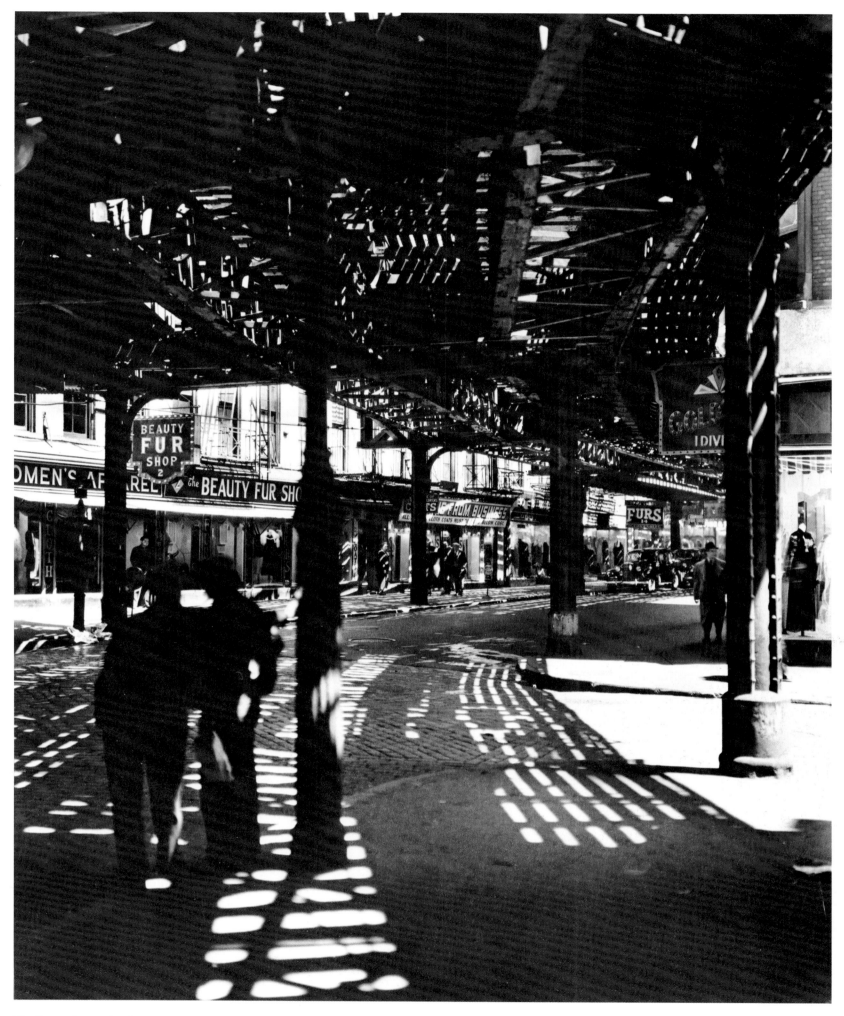

El, Second & Third Avenue Lines, Bowery and
Division Streets
*The two men came along just as I was doing this and it
does not matter that they are out of focus. I was right in
the middle of the street on a little island. This was one
of the occasions when it was downright dangerous to
document New York, with traffic whizzing by on both
sides, but it was very important to get in exactly the
right position to make the photograph work.*

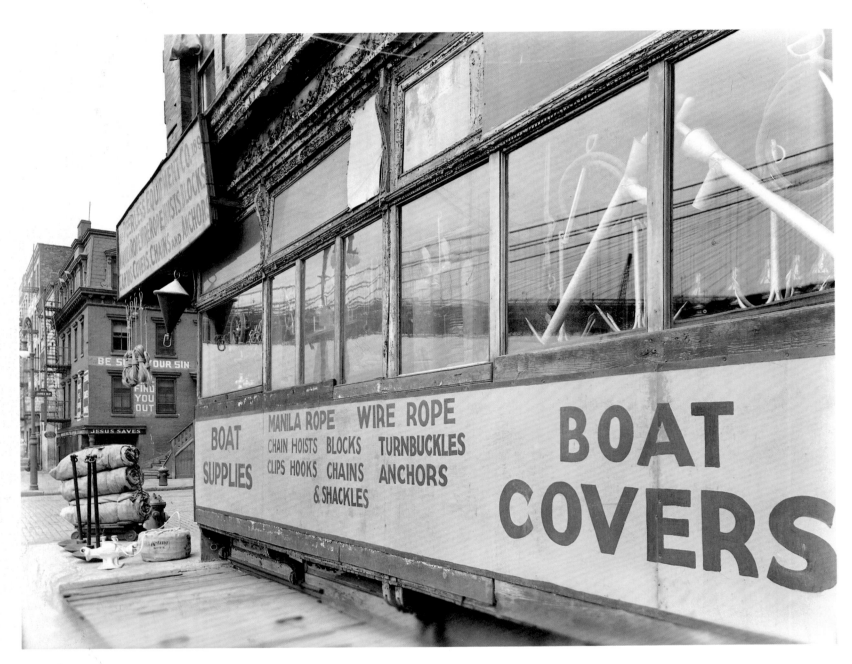

Ropestore: Peerless Equipment Company,
109 South Street
*A waterfront photograph. There was no conscious at-
tempt made to make the place look like a boat; it was
just a good way to get it all in, with the amusing sign
across the street and the reflection of the bridge.*

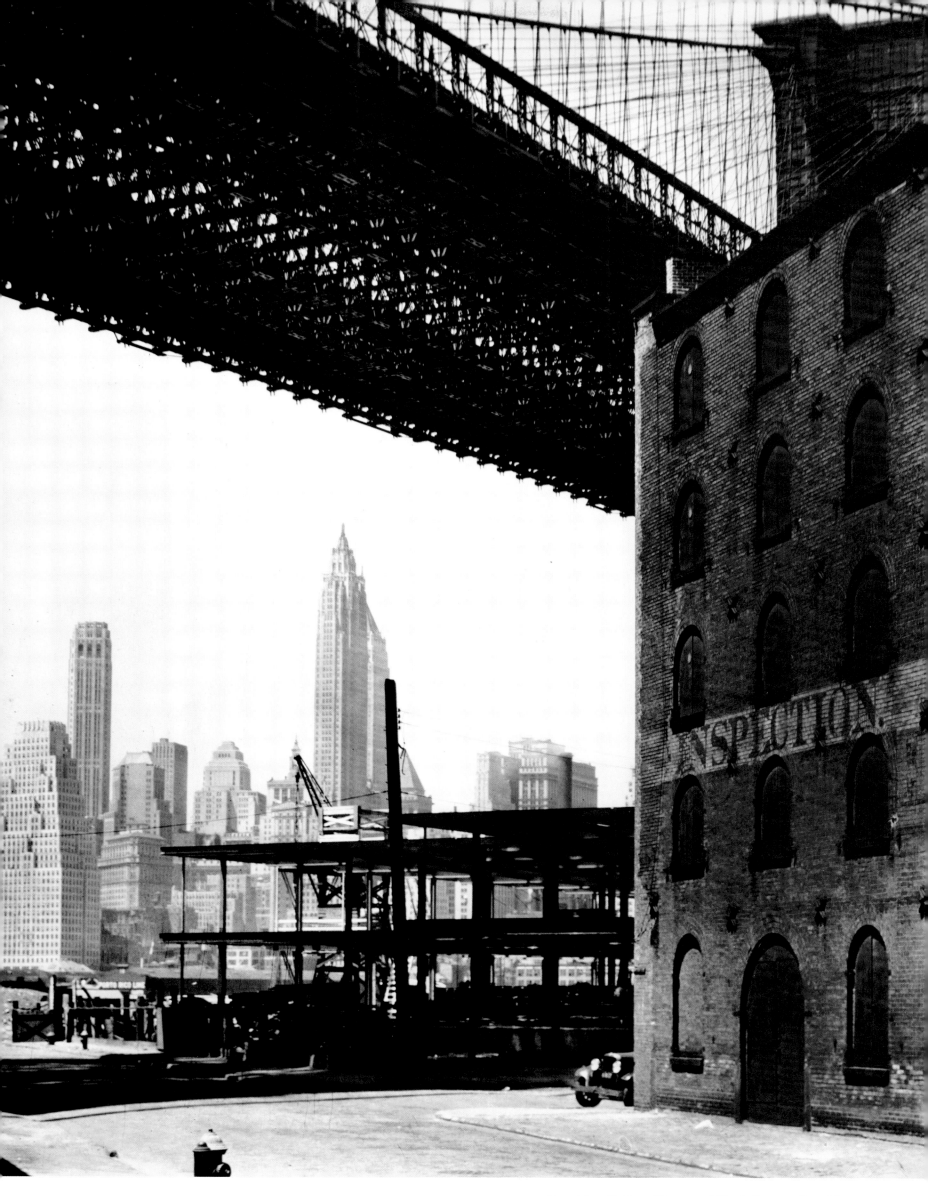

Brooklyn Bridge, Water and Dock Streets, Brooklyn

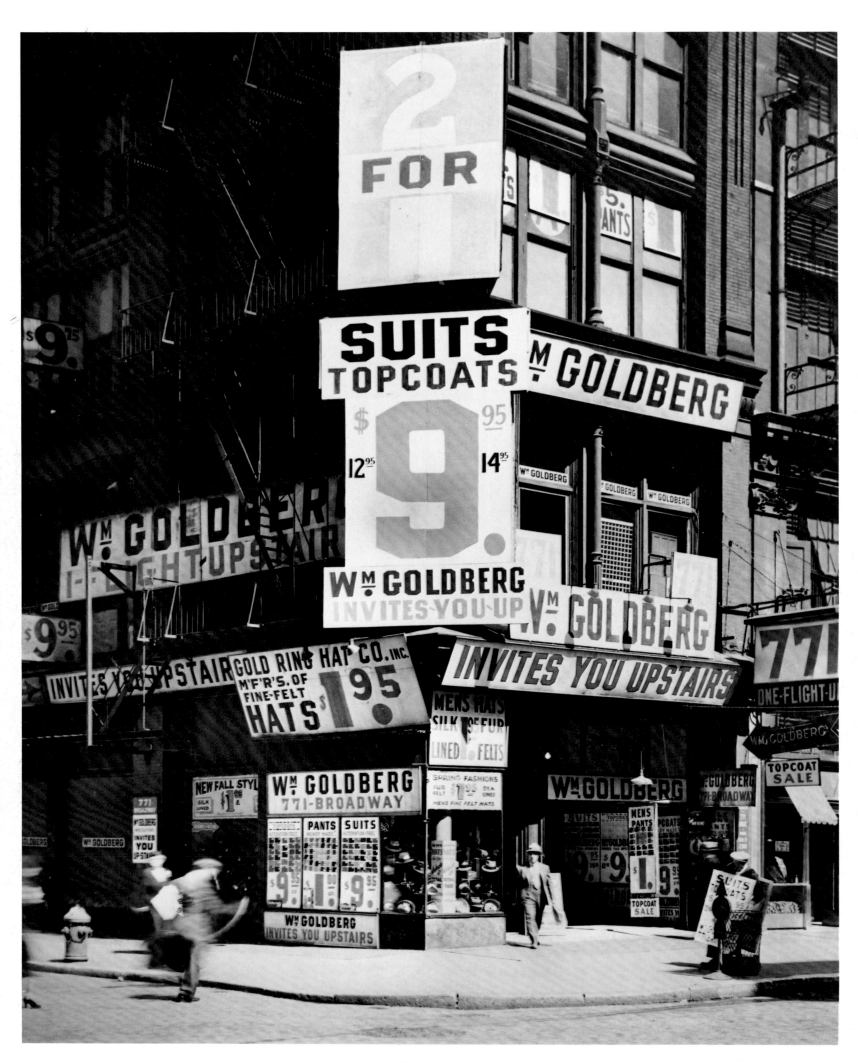

William Goldberg Store, 771 Broadway

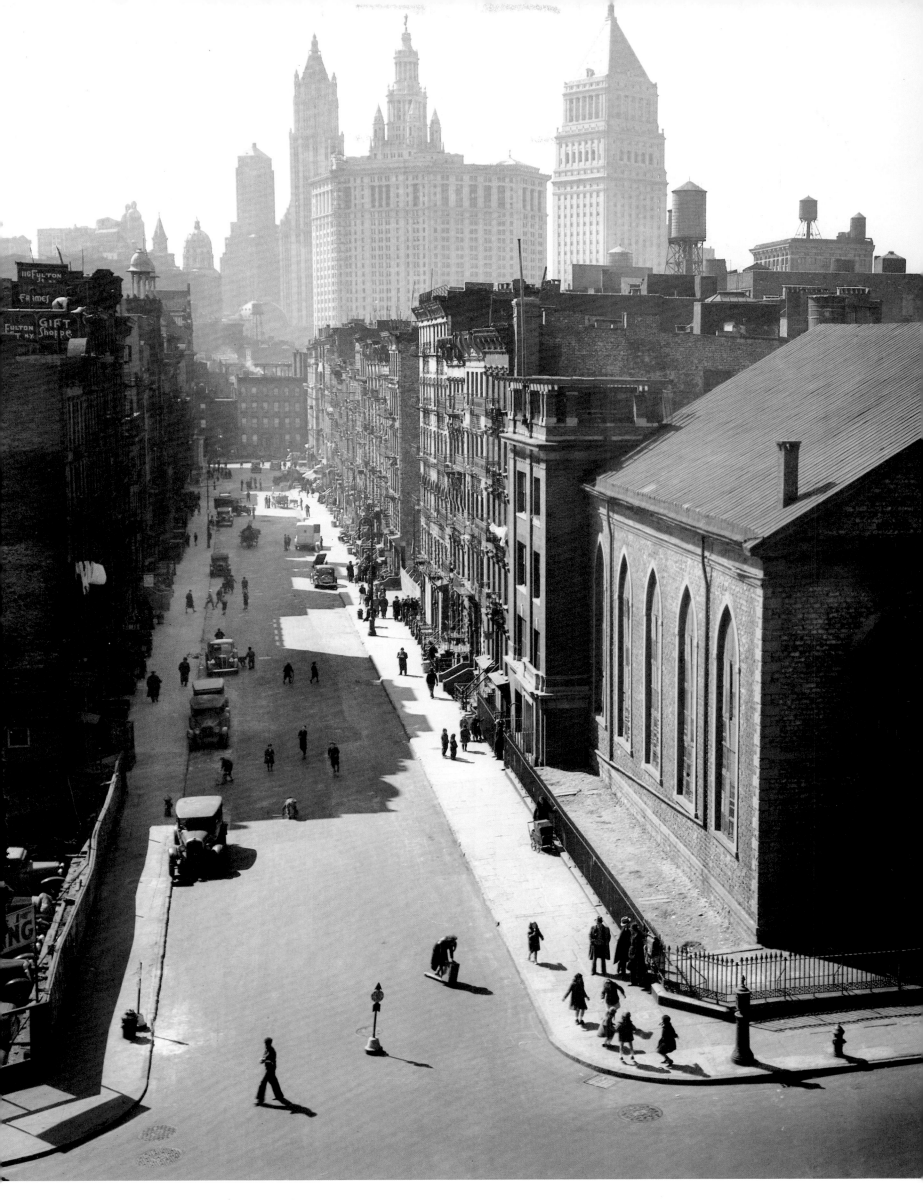

General View Looking Southwest to Manhattan
from Manhattan Bridge

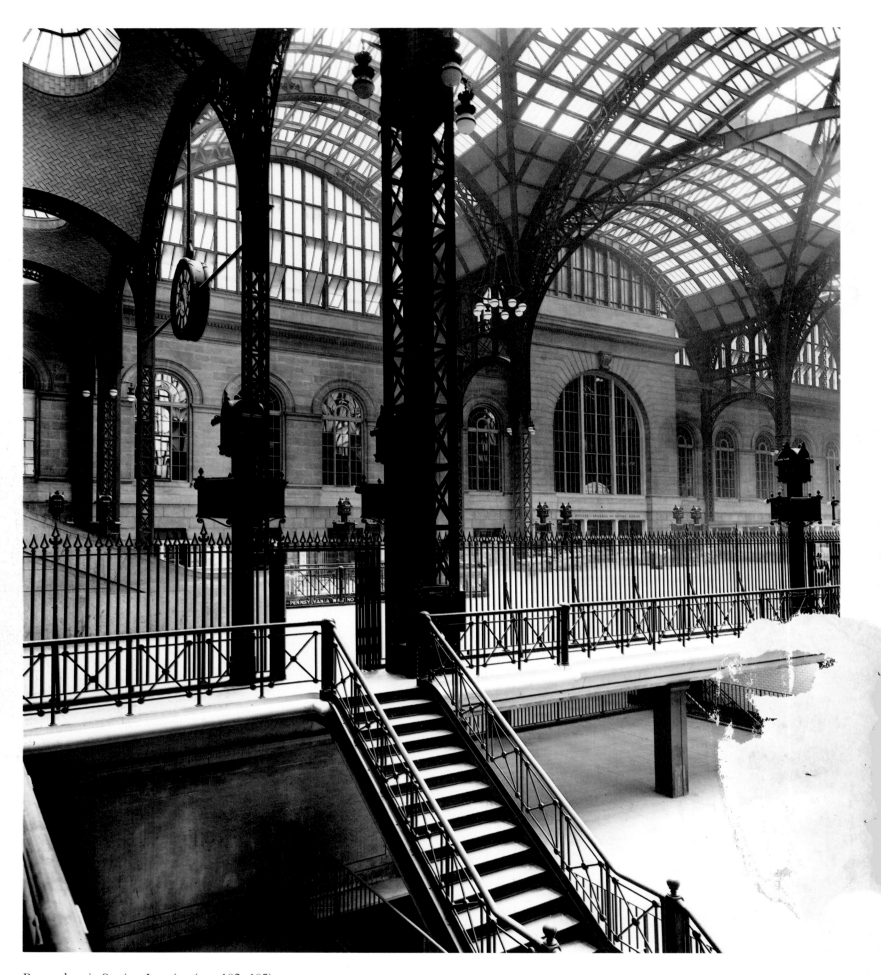

Pennsylvania Station Interior (pp. 102–105)
I had to obtain all sorts of permission to make these photographs, but I knew I had to capture this magnificent building. Even with the big skylights the interior was dark, and there was movement. My film was slow and often I was forced to shoot at 1/10 or 1/25 of a second. It was absolutely wicked to tear the building down; it was cheating America, denying Americans their cultural heritage.

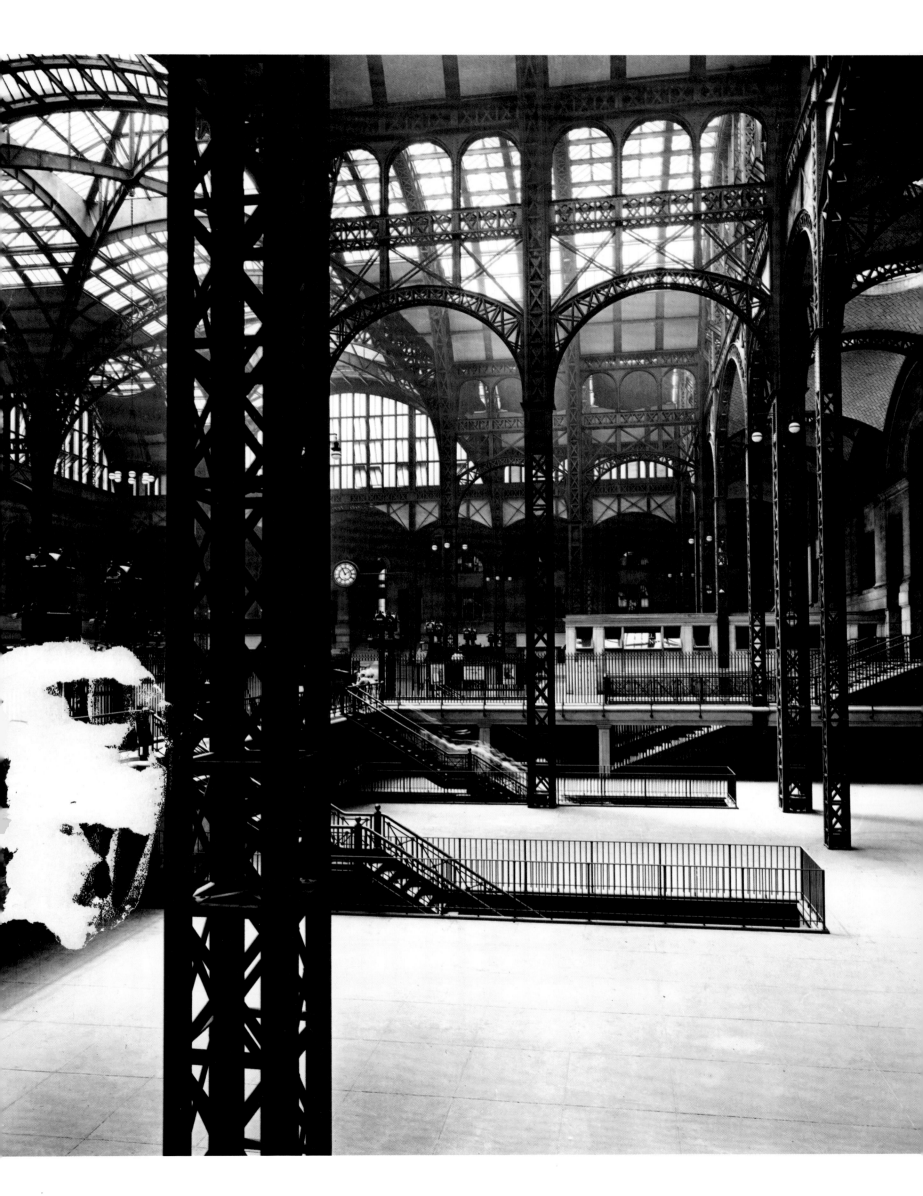

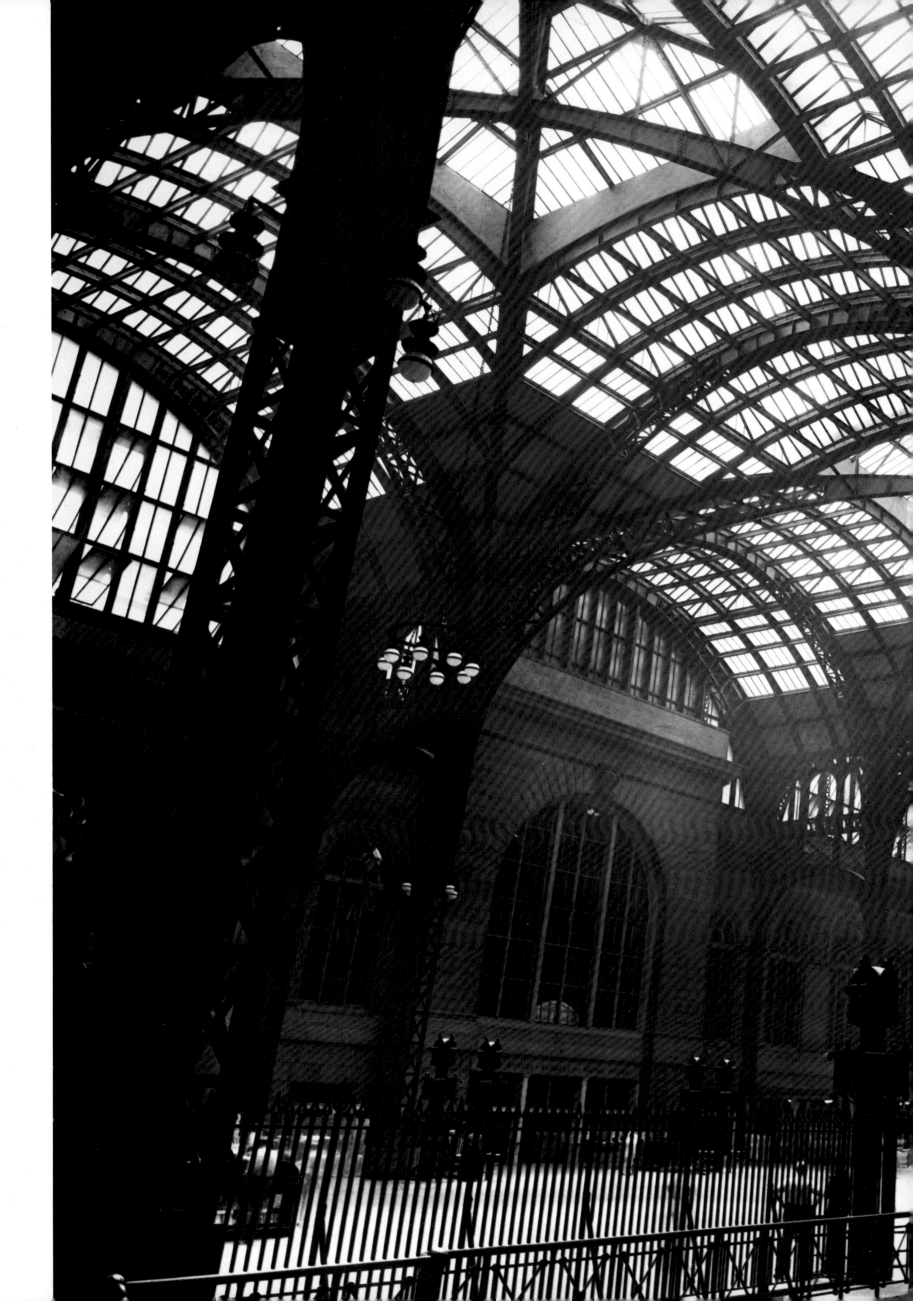

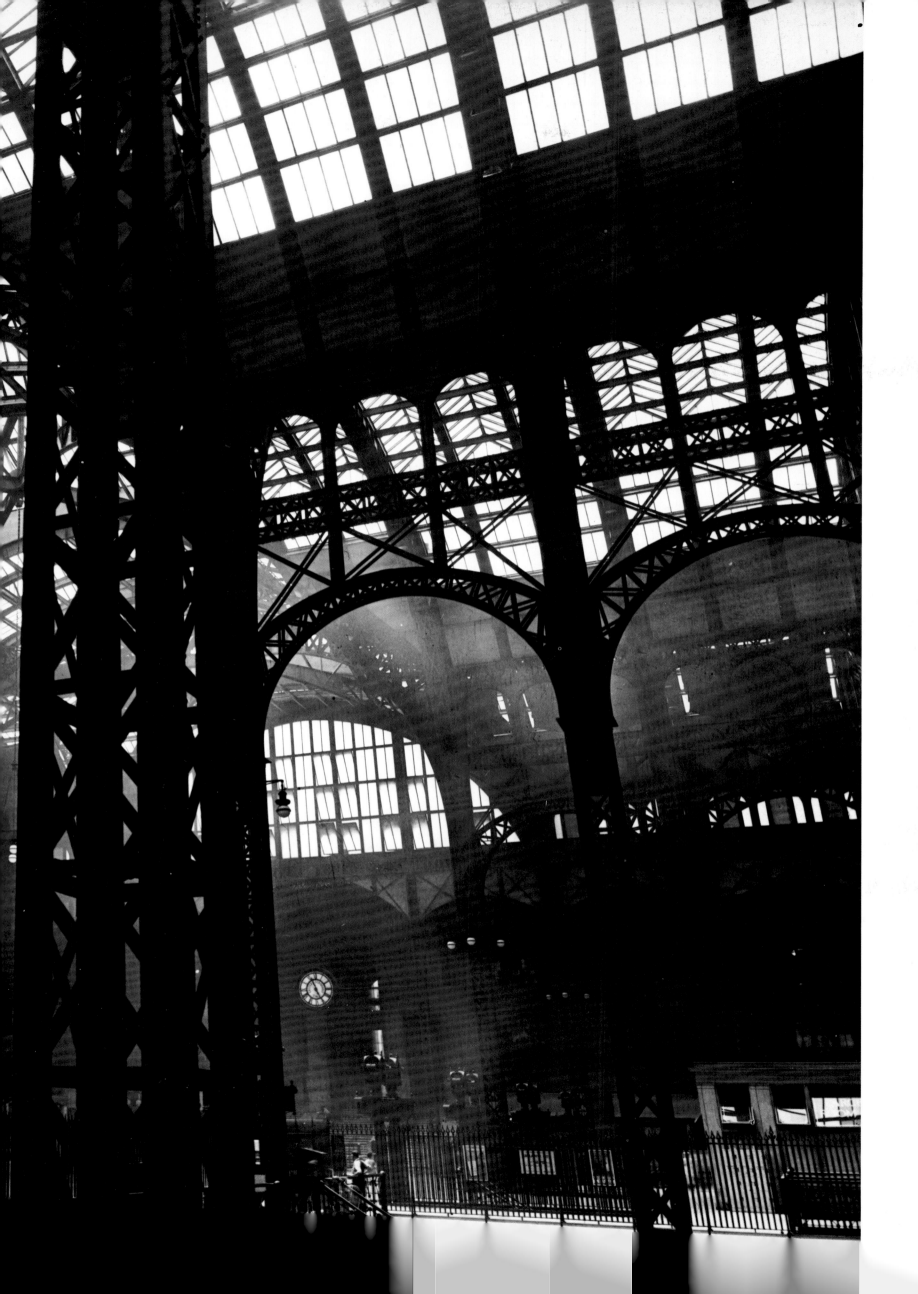

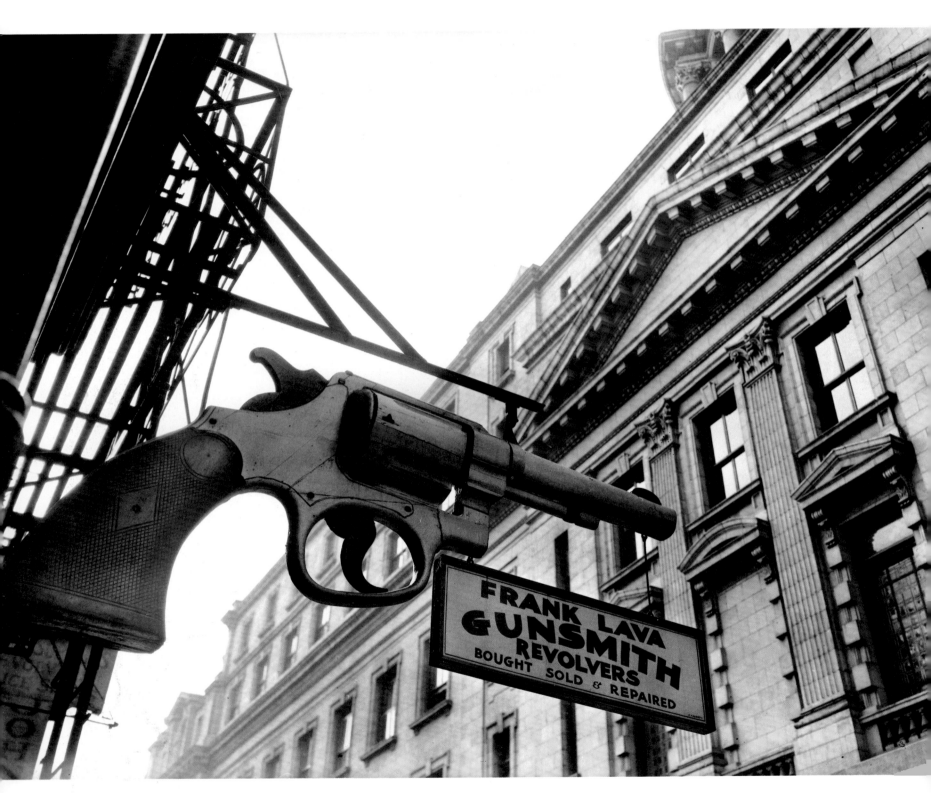

Gunsmith and Police Department,
6 Centre Market Place and 240 Centre Street
*This was difficult to take. The gun was very near me,
everything was at an angle and I didn't want the build-
ing in the background to be perfectly sharp. The gun
was the focal point and I wanted the building to recede
in space and become increasingly diffused. If everything
had been sharp it would not have been nearly so good.*

Murray Hill Hotel, 112 Park Avenue
I always liked the Murray Hill Hotel. I did another photograph of the front of it, with two American flags on either side of the doorway. It had a quality to me that was very American; somehow it couldn't be anywhere else.

107

Fifth Avenue Houses, Nos. 4, 6, 8

*These were very handsome buildings. I had thought
about photographing them for a long time and finally
did it when the time was right, in mid-morning. People
have often talked of this photograph in relation to Ed-
ward Hopper, but I didn't even know Hopper at the
time. As far as I'm concerned you don't think of any-
body when you take a photograph; you simply see the
subject and you take it or you don't. People read all
kinds of things into my work, and what they say makes
me laugh. I like Hopper's work very much and I can
see why people draw the analogy here. He has a picture
of a man walking across the street, which I found out
many years later. But so what? In this case I simply
waited until the man got to where I thought was the
proper place and I snapped the shutter, at about 1/5 of
a second I think. This is why it isn't awfully sharp.*

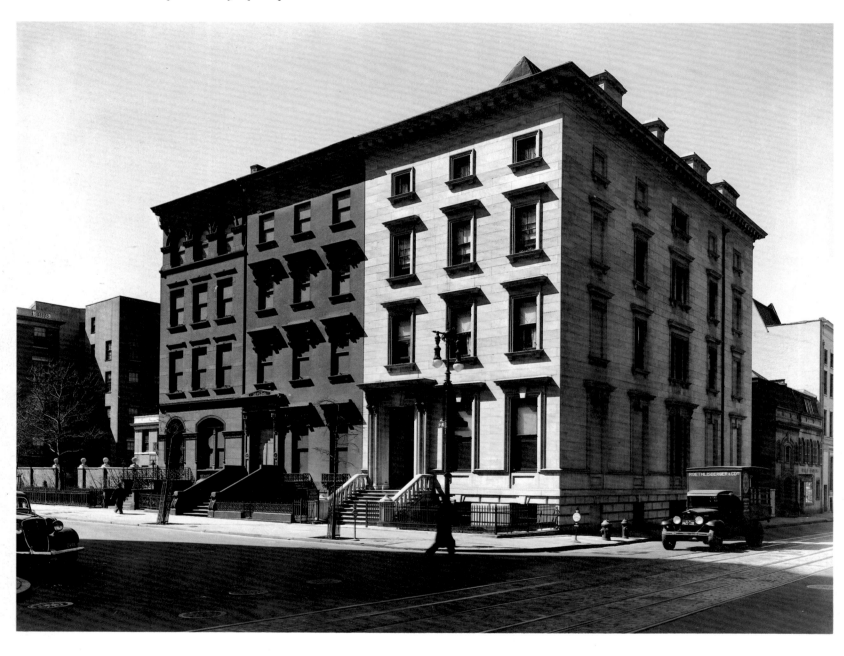

Oldest Frame House in Manhattan, Weehawken
Street
*I took this because it was a very old eighteenth-century
house in New York. It's so plain that it's charming.
Because the buildings on either side were so terrible I
couldn't show the house in relation to anything else and
so I just took it by itself.*

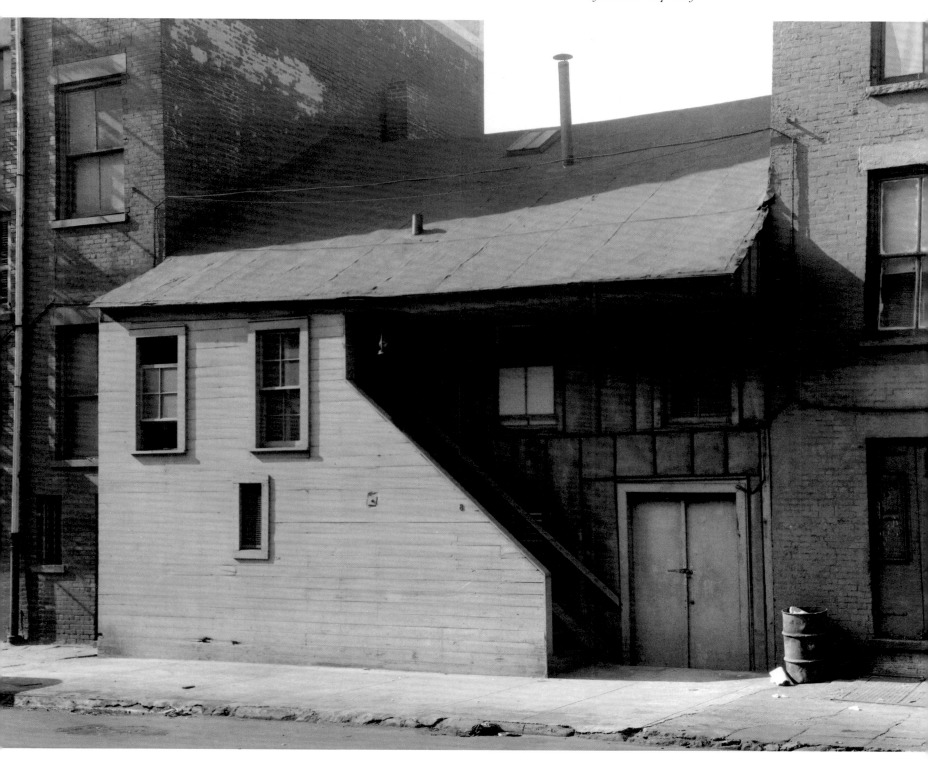

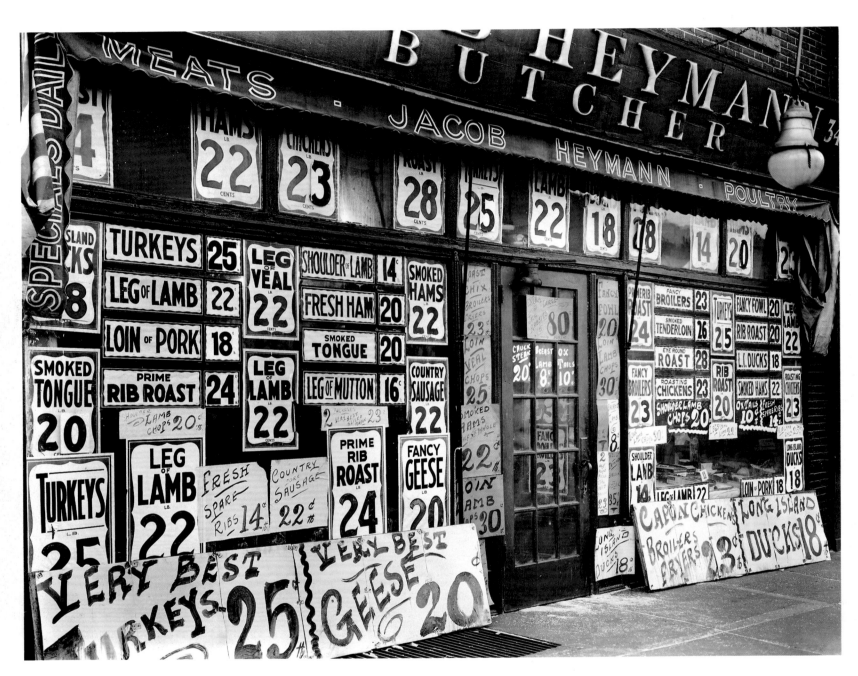

Jacob Heymann Butcher Shop, 345 Sixth Avenue
This storefront fascinated me for a long time before I did it. Unfortunately the first time I tried to take it I made the mistake of using panchromatic film and all the letters, which were red, came out too light. I returned a few days later equipped with orthochromatic film and the letters came out just perfectly; I should have realized this earlier.

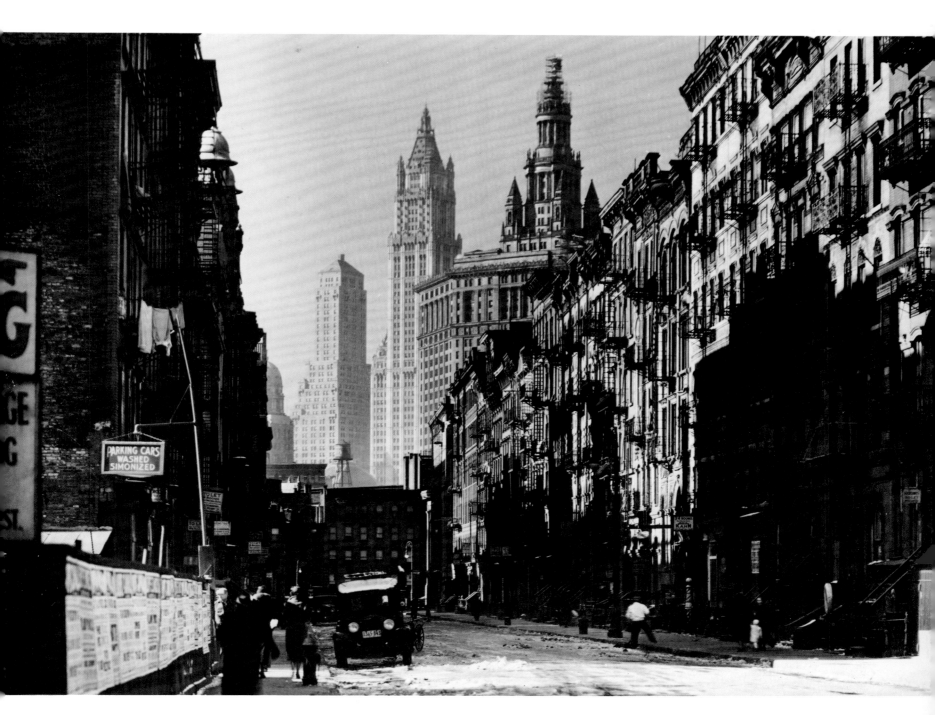

Henry Street, Looking West from Market Street

Trinity Churchyard
Visually this is the most interesting cemetery in the world. It is simply remarkable. Stuck in there with all those skyscrapers, it is absolutely mad. I always wanted to do a little book on this cemetery and I photographed many tombstones for the project, but the negatives were all lost.

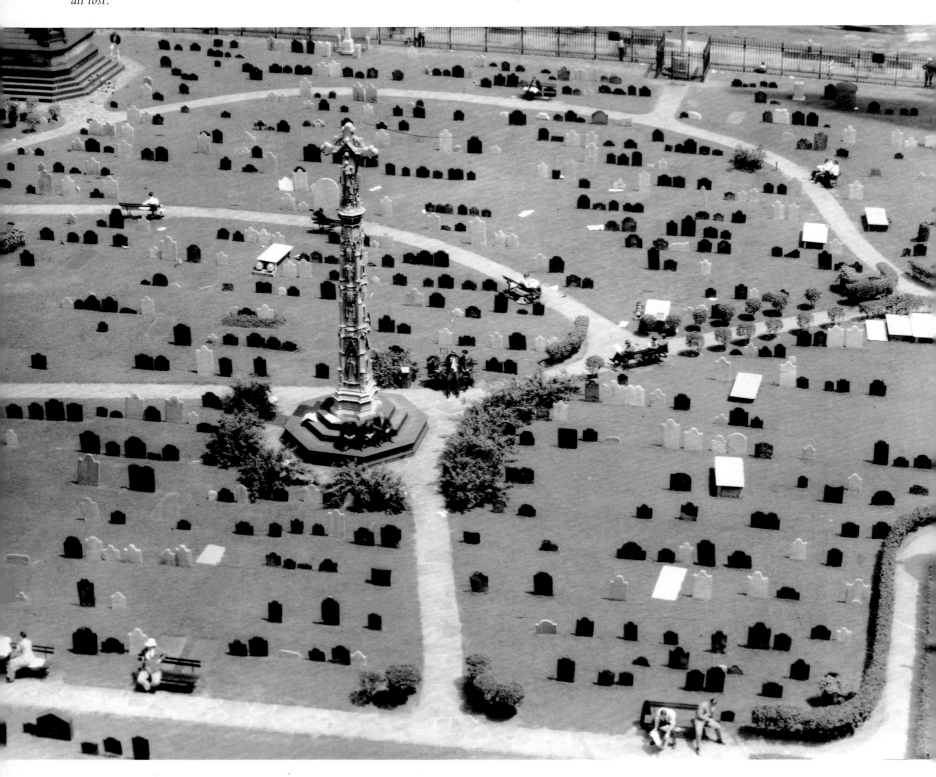

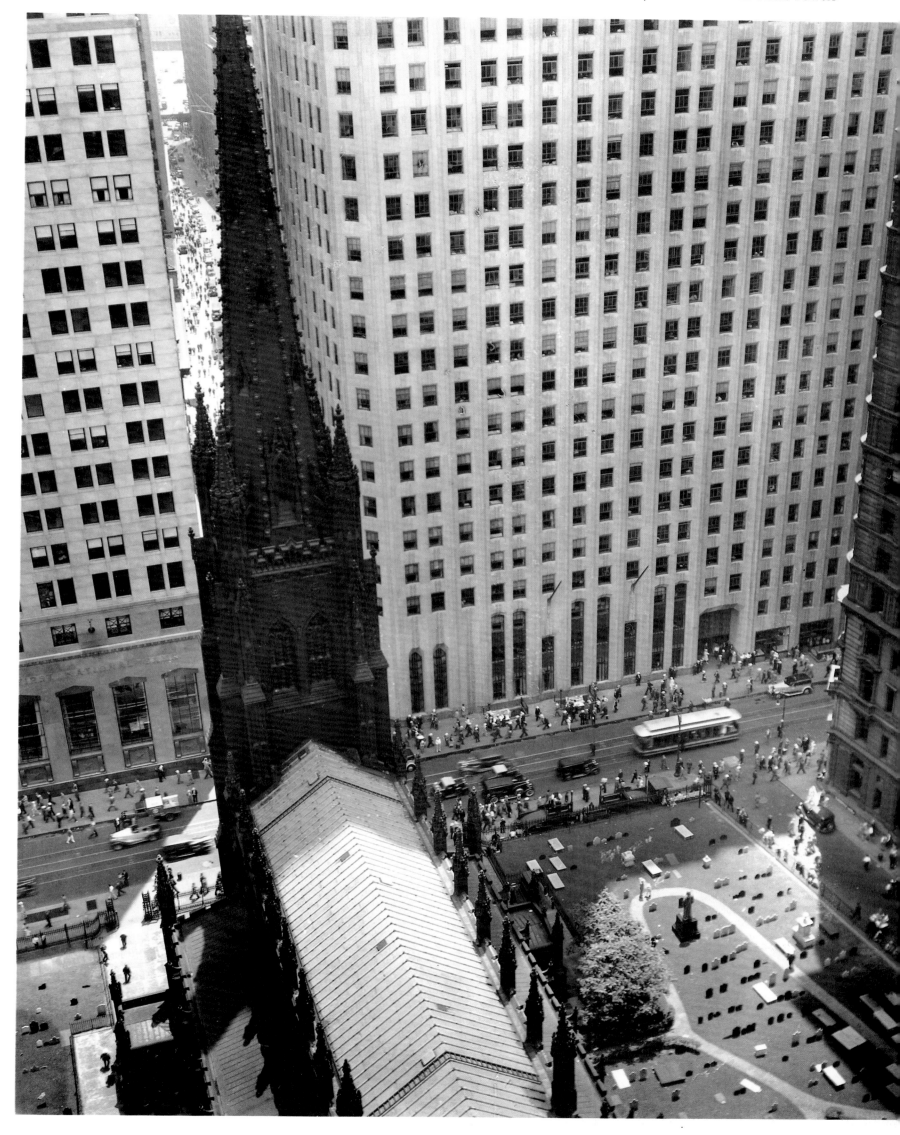

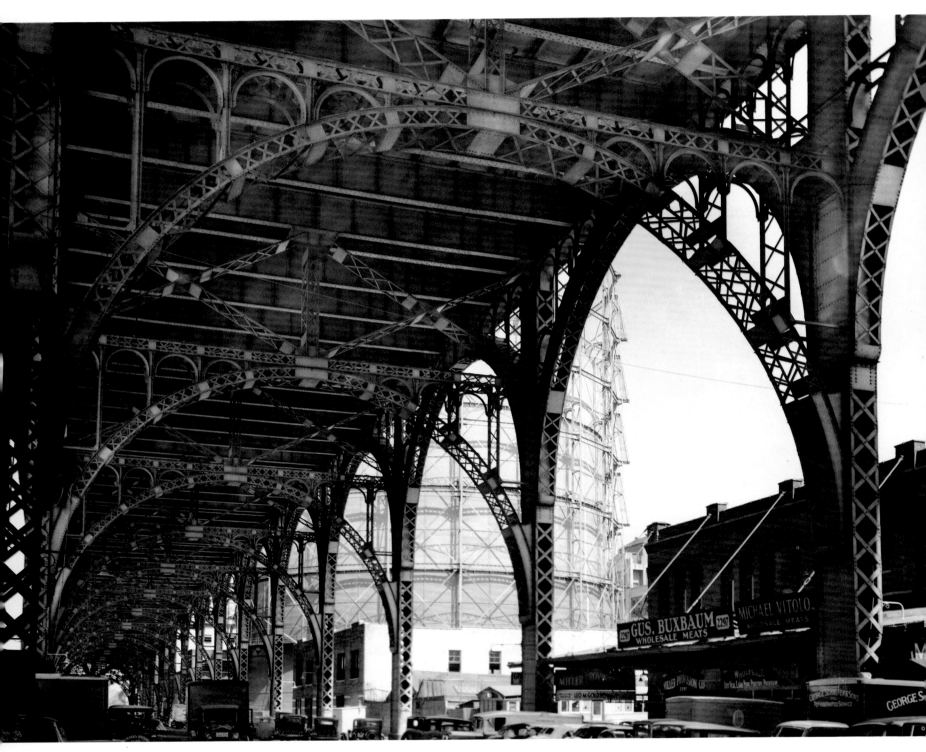

Under Riverside Drive Viaduct at 125th Street and Twelfth Avenue

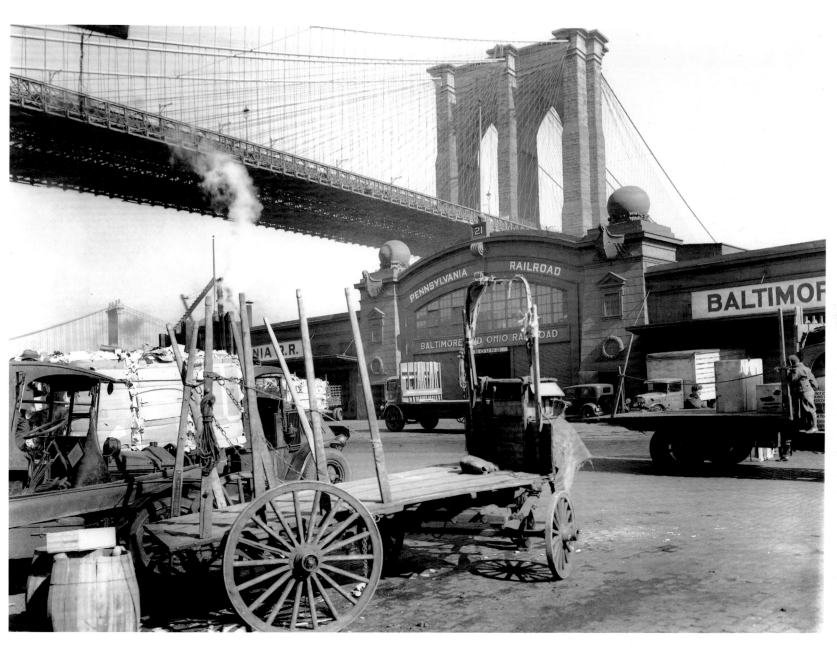

Brooklyn Bridge with Pier 21, Pennsylvania Railroad, East River

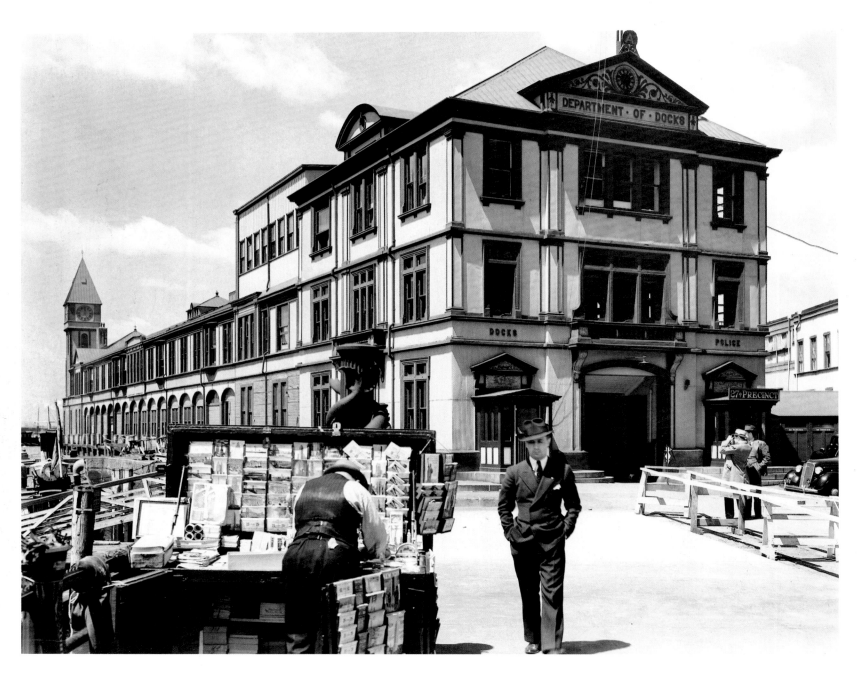

Department of Docks and Police Station, Pier A,
North River
*This is a very American building. It was condemned
years ago but it still survives. The man is an essential
part of the photograph and he was not aware of the
camera. Fortunately he was walking slowly and so I
waited until he had one foot on the ground; he would
then be firm for an instant. I thought he was in the right
relationship to the building. Not too many Europeans
would take this building but it had something that ap-
pealed to me.*

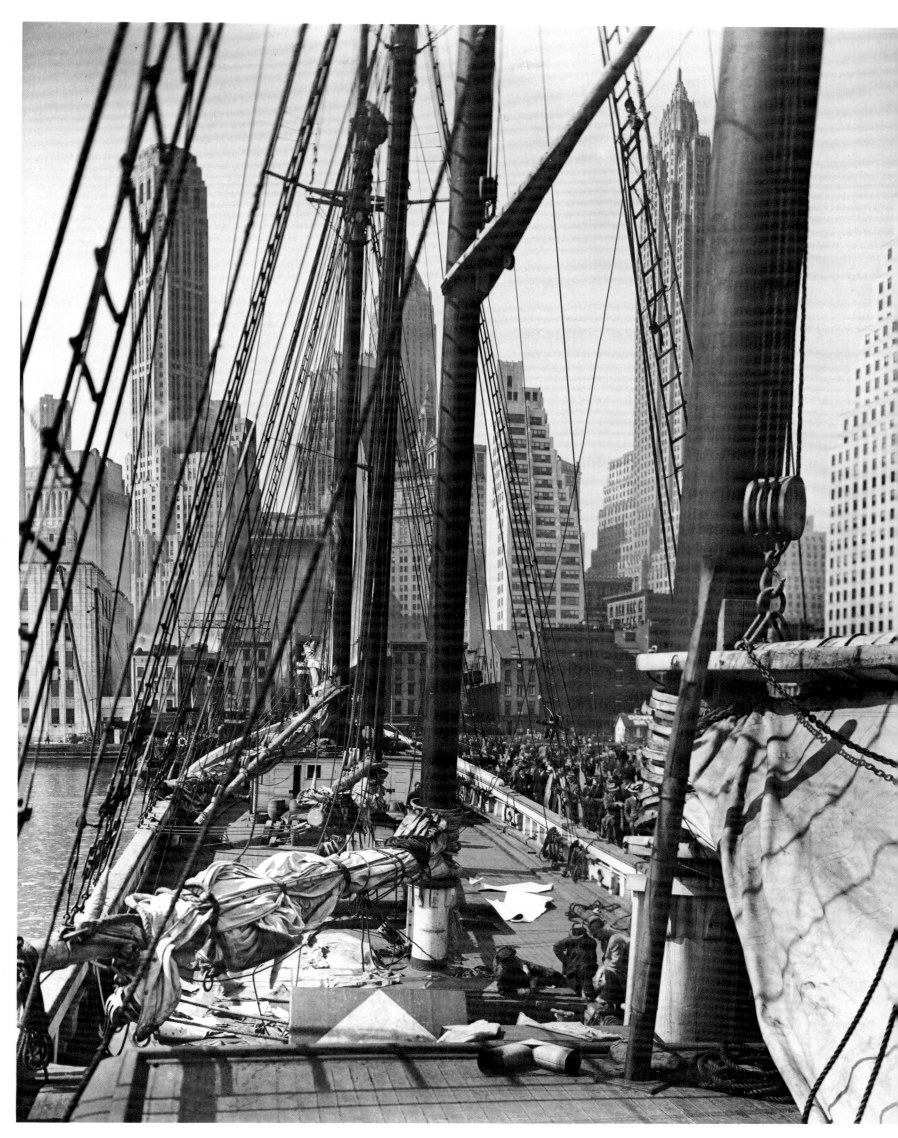

"Theoline," Pier 11, East River

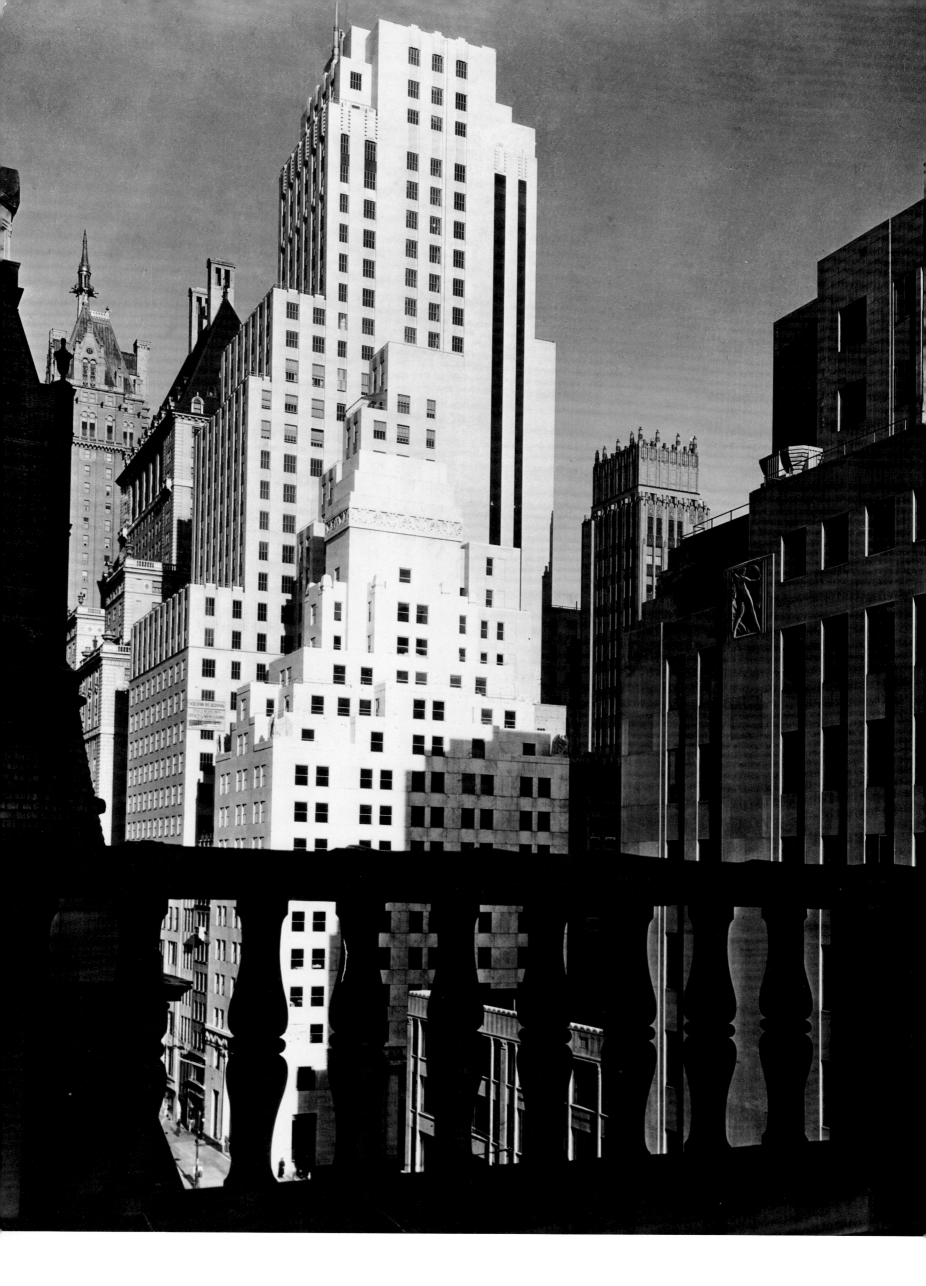

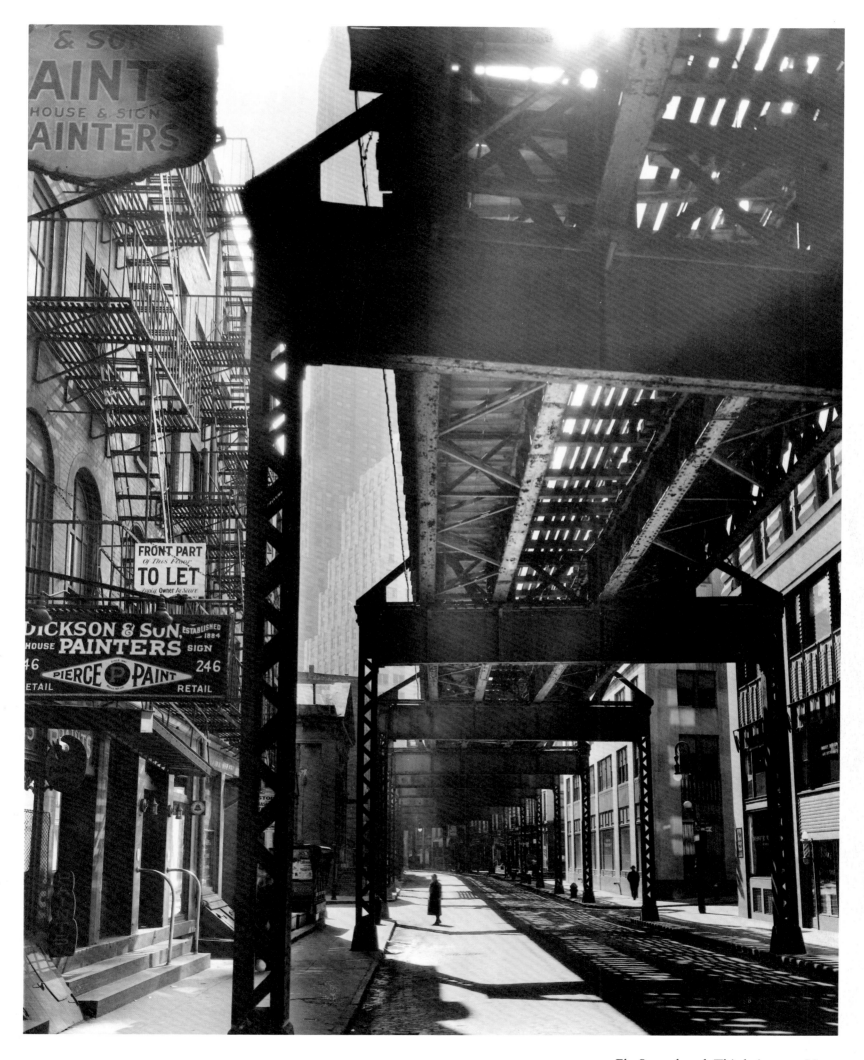

El, Second and Third Avenue Lines,
250 Pearl Street

Squibb Building with Sherry Netherland
in background

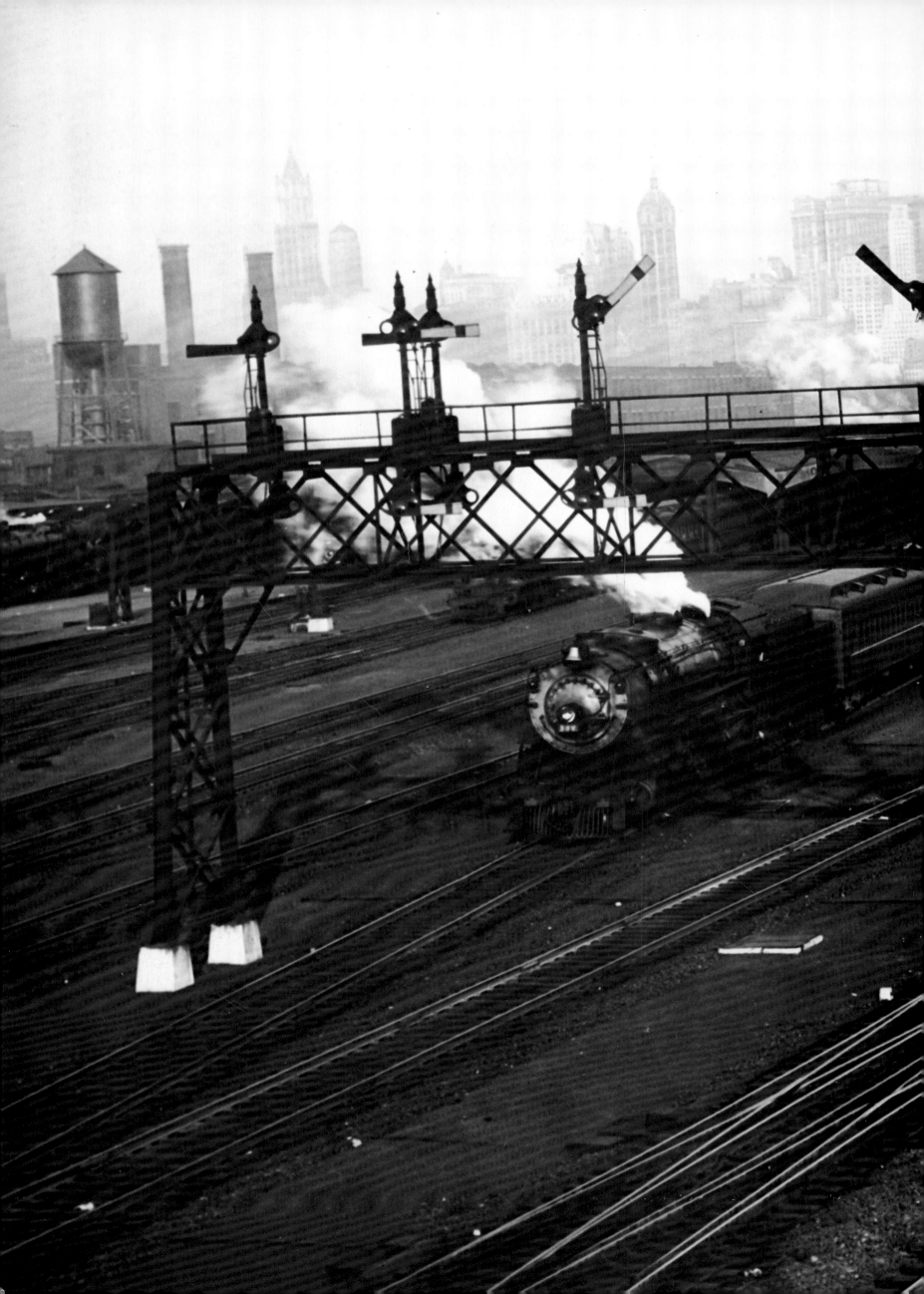

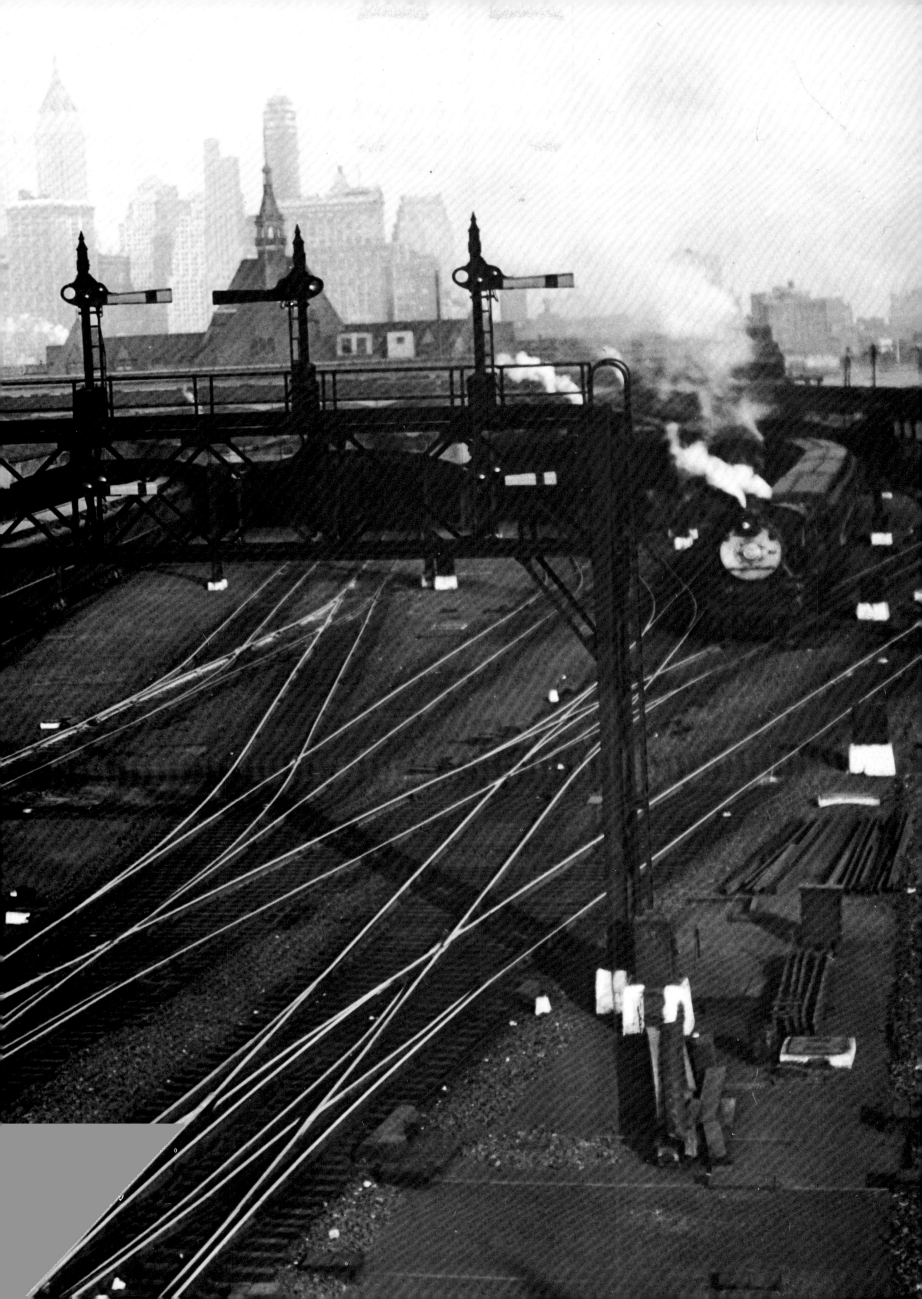

Hoboken Railroad Yards Looking Towards
Manhattan (preceding pages)
*I had had this spot in mind for a long time. I'd often
study a location for some while before I'd take a photo-
graph. This was in Hoboken and the skyline was pur-
posely lined up the way it was. I wanted to show
transportation coming into the city and later I took the
other side—the yards in back of Penn Station—but the
photograph was not nearly as good.*

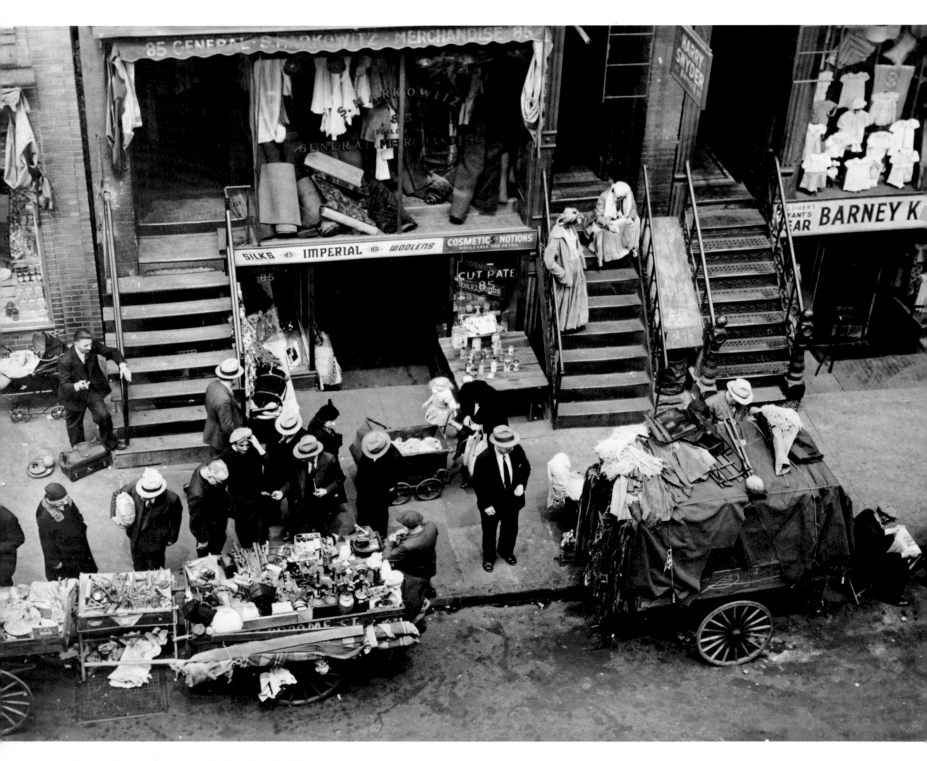

Hester Street, Between Orchard and Allen Streets
*I felt these peddlers should be taken from above so I
asked permission of a lady who ran a grocery store across
the street. I had to talk to her in German but I made
my point and went to the second floor of her building
where I made the photograph from a window. In the
room was the cardplayer, and so I turned my camera
and took his portrait (p. 180).*

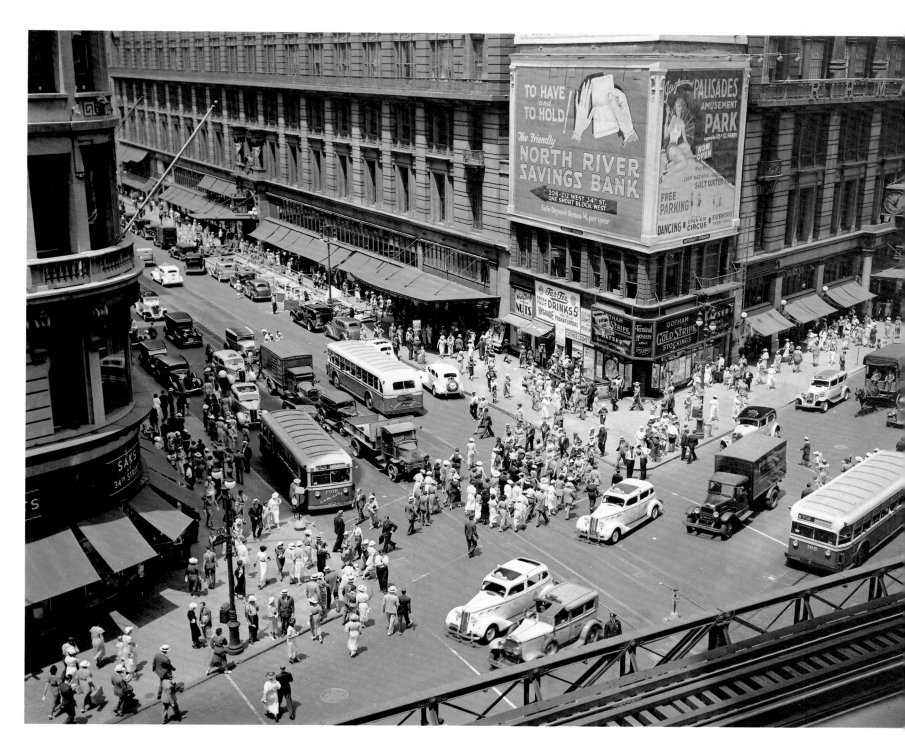

Herald Square

I wanted to get the crowds of the city, and Herald Square was a good place for this. I had to go high up to get the view I wanted—here the McAlpin Hotel across the street. This is perhaps 1/50 of a second; your speed can be better at a distance because your lens isn't as far from the film. You always have that advantage on distant objects. I should have taken more crowds; they are very exciting.

123

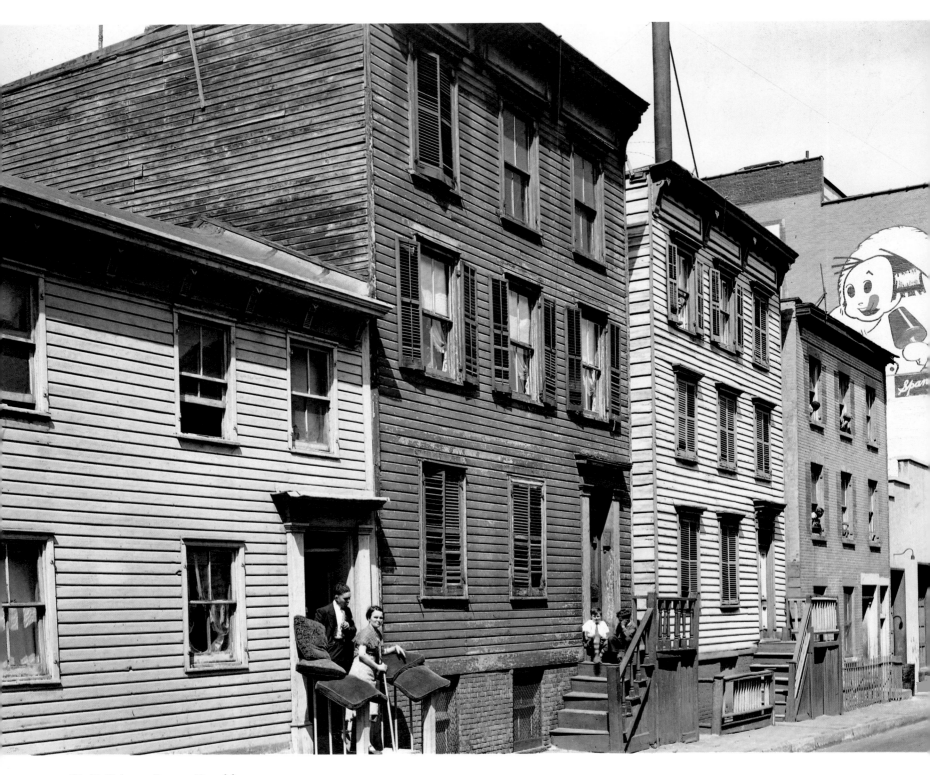

57–61 Talman Street, Brooklyn

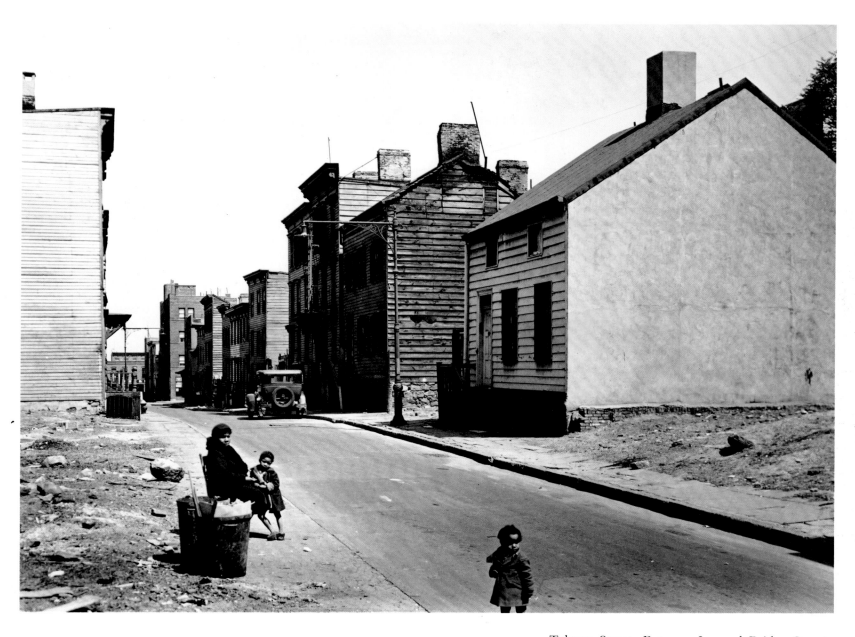

Talman Street, Between Jay and Bridge Streets, Brooklyn
Brooklyn had a lot of charm—wonderful neighborhoods, classical houses. It also had neighborhoods like this. When I set up my camera no one paid any attention to me. I still found it difficult to photograph scenes like this; the poverty distressed me very much.

Hardware Store, 316–318 Bowery
I was trying to show the everyday tools that people use and here was a marvelous spread in a decent light.

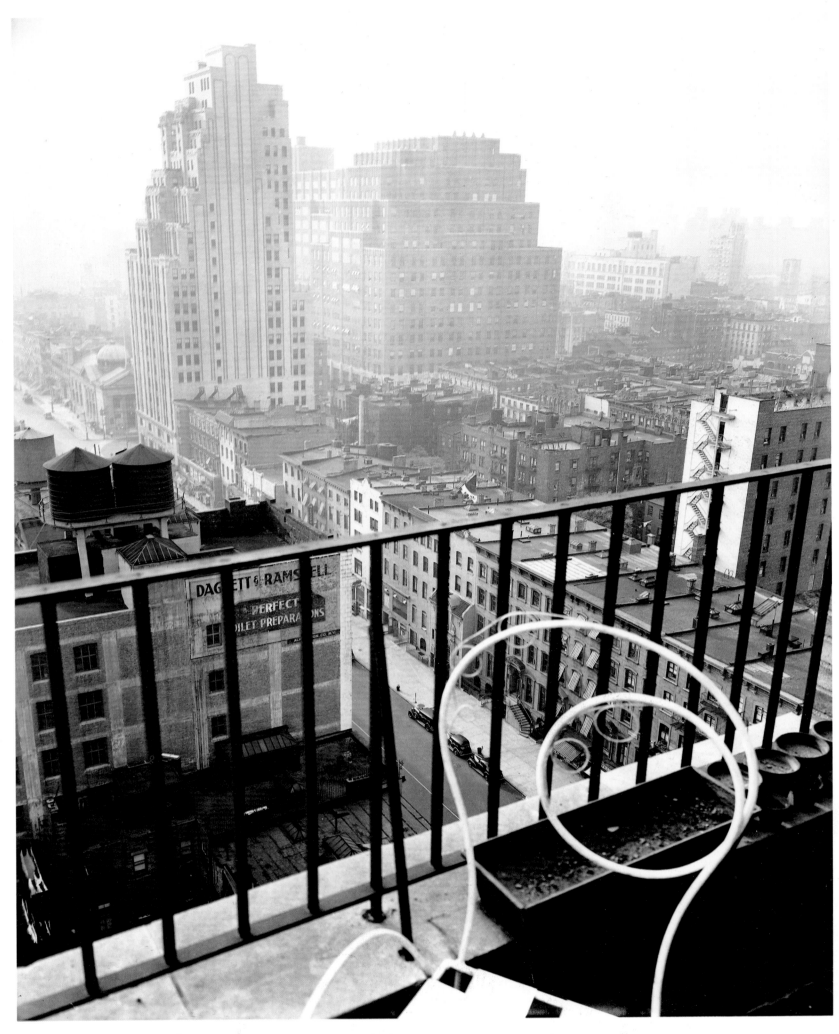

General View from Penthouse at 56 Seventh Avenue

This was taken from a friend's penthouse on Seventh Avenue. There is no mystery here; I thought the chair looked nice and that including it would show the photograph was from a penthouse.

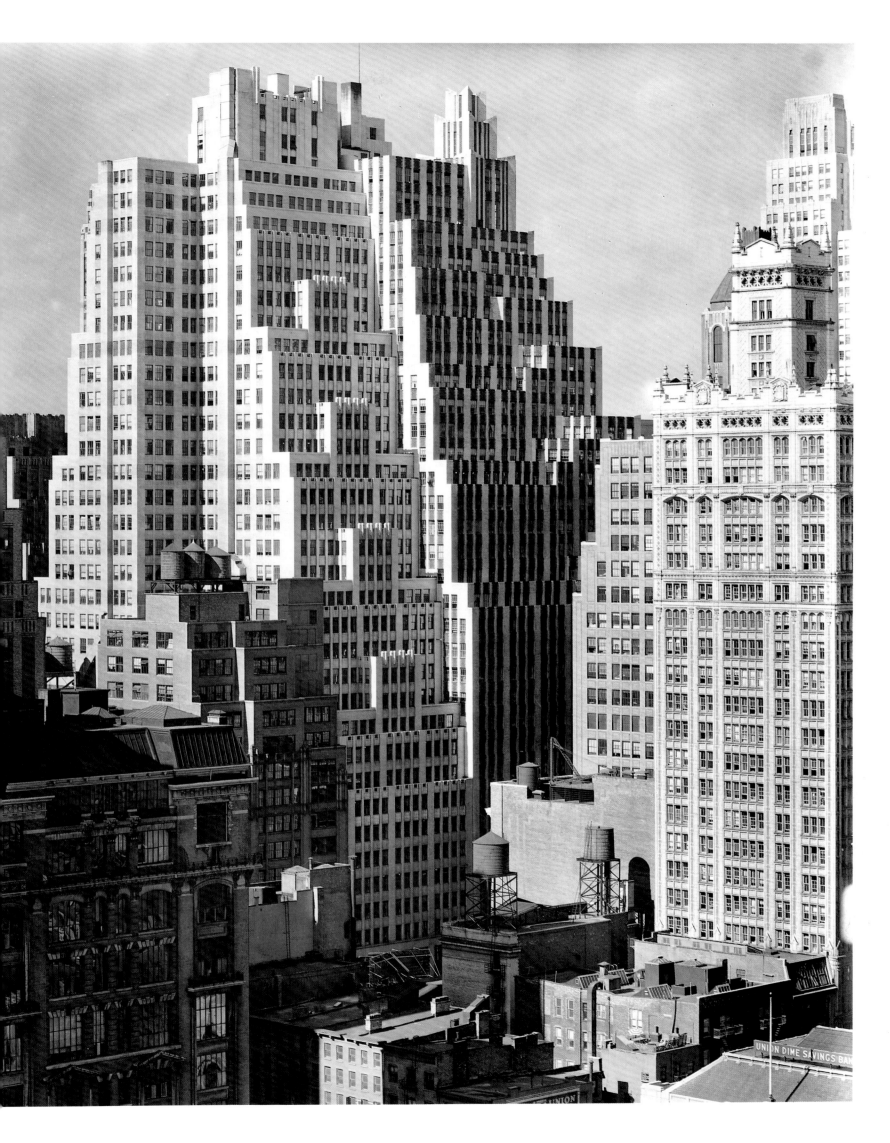

Fortieth Street, Between Sixth and Seventh Avenues
from Salmon Tower, 11 West 42nd Street

View of Exchange Place from Broadway
This photograph has always interested me; it was taken from Broadway, on about the tenth floor of a building that placed me as near as possible to looking straight down the street. I had devised a very low tripod that I used for shooting out of windows; it had adjustable legs and could be used on windowsills, holding my large Century Universal securely. It was used here.

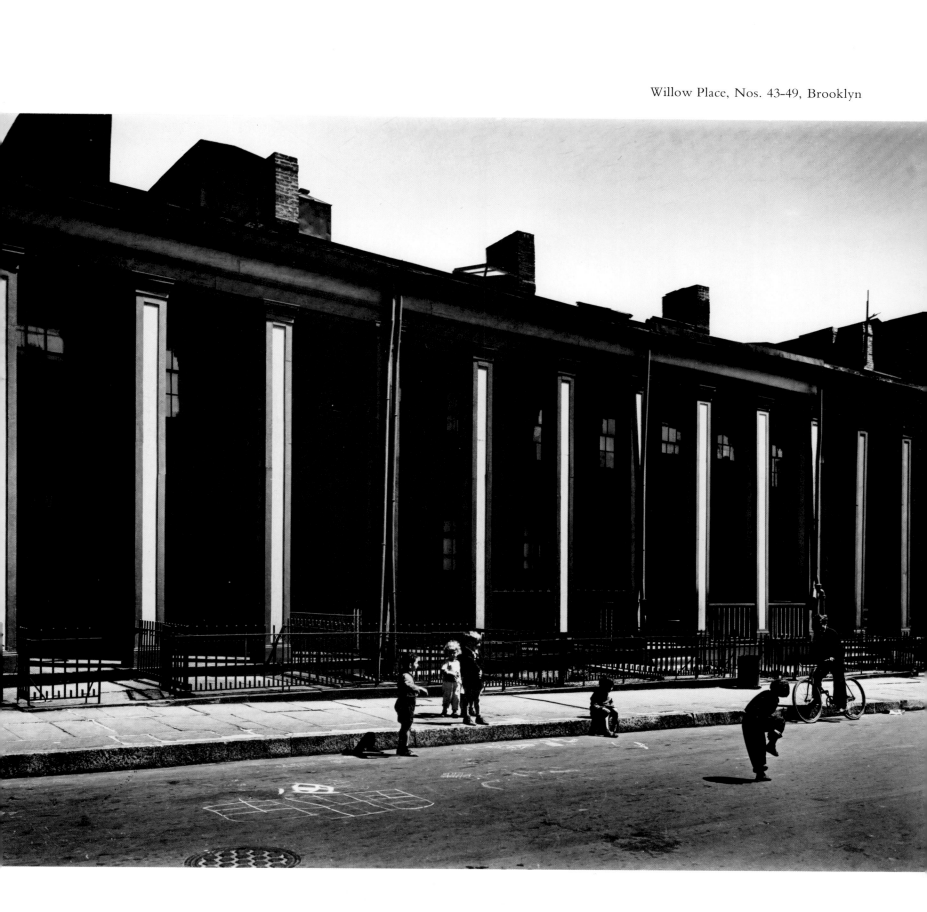

Willow Place, Nos. 43-49, Brooklyn

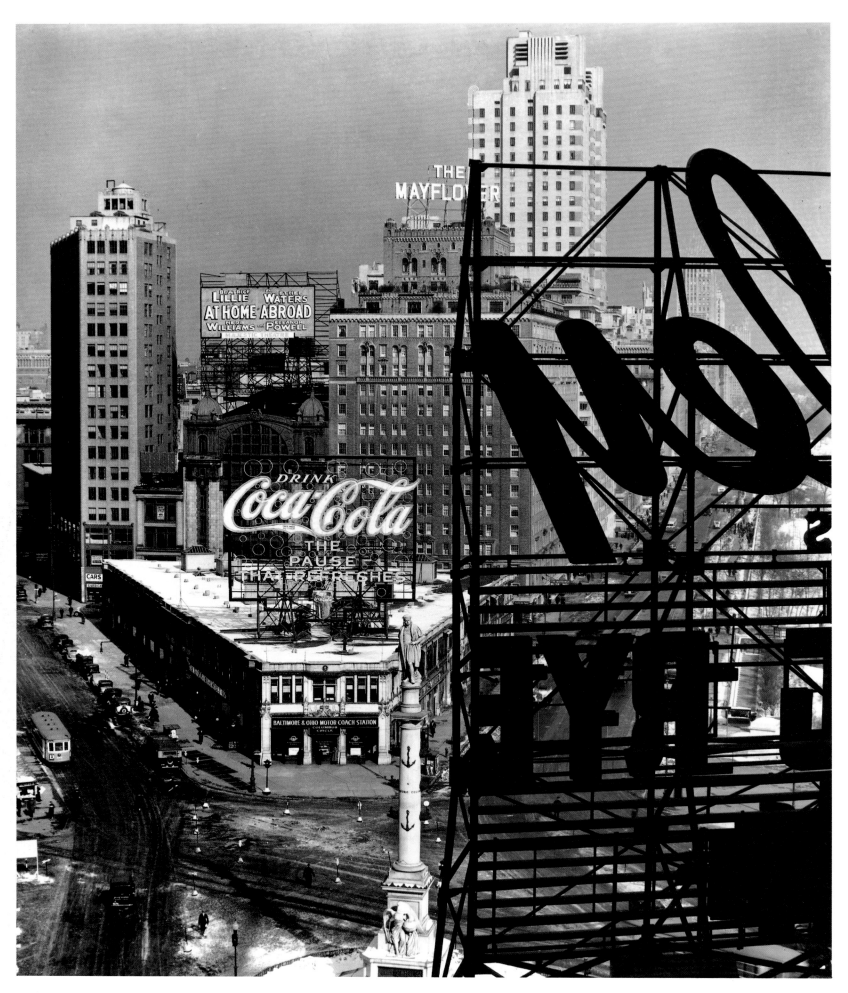

Columbus Circle
In some ways I like the one with more of the sign better, but I have usually stuck with the more conventional version. I'm not sure I'm right. There is also a horizontal version that is interesting. There are different views to everything and I didn't have to move the camera very much to create a completely different image out of the same basic scene.

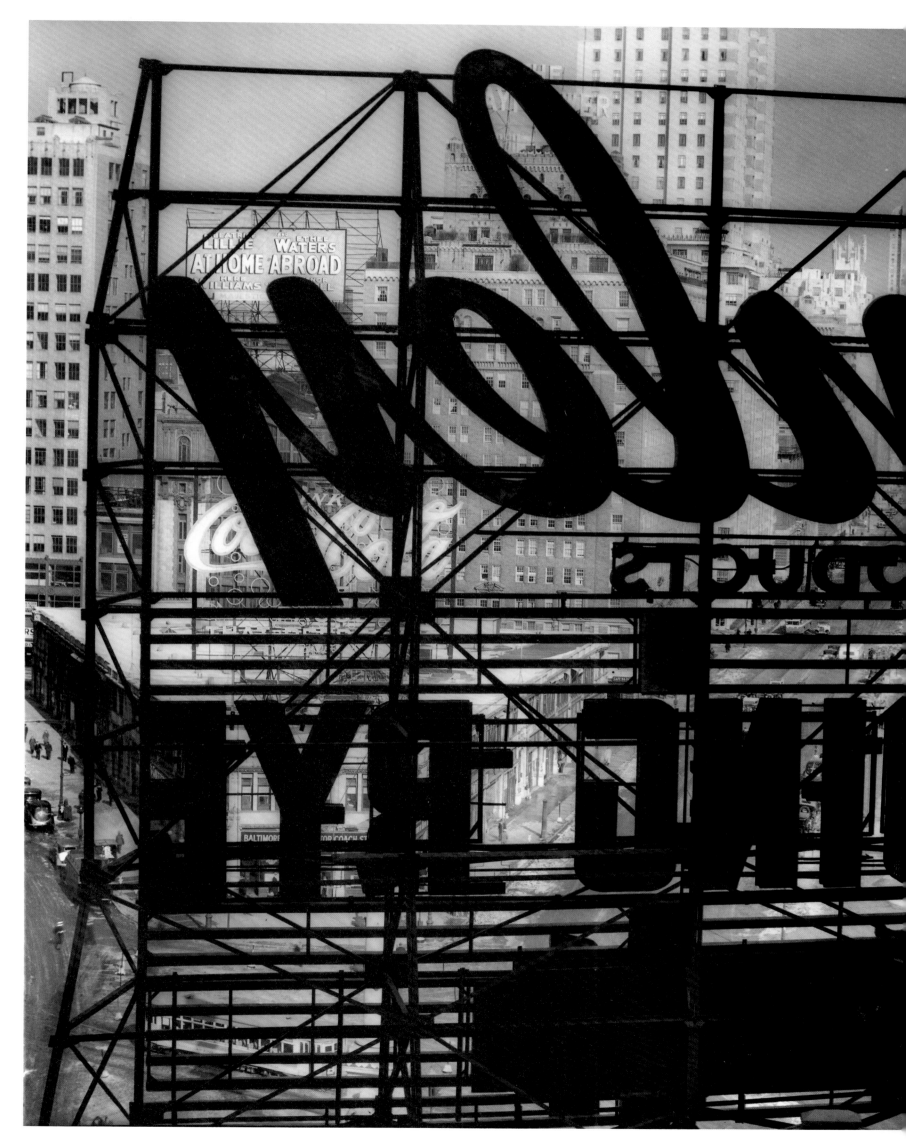

Columbus Circle

Daily News Building, 220 East 42nd Street

This is a spectacular building. I had to go up in the Chanin Building, but was unable to reach the exact height I wanted. I had to settle with an office that would allow me to be present. I set the camera the way I wanted; in this case I did not want the lines to be exactly parallel. I wanted an effect of the building being slightly on an angle. The light was very good; it was mid-afternoon—and just when everything was ready the sun went in, not for just a moment, but for the day. I knew it would be a bad photograph if the light was dull, and so I had to come back another day. I made many exposures the day I came back; I wanted to make sure I got it that time!

Father Duffy, Times Square

The statue was wrapped in a bright blue cloth and I thought it was very funny. As I was setting up in Times Square a crowd quickly gathered. A policeman came and said I was creating a nuisance and suggested I move on. I took one hurried version but was intimidated by the policeman and the crowd. I should have insisted on staying—I wanted to try other angles, showing the signs and background better. But I just packed up my bags and left.

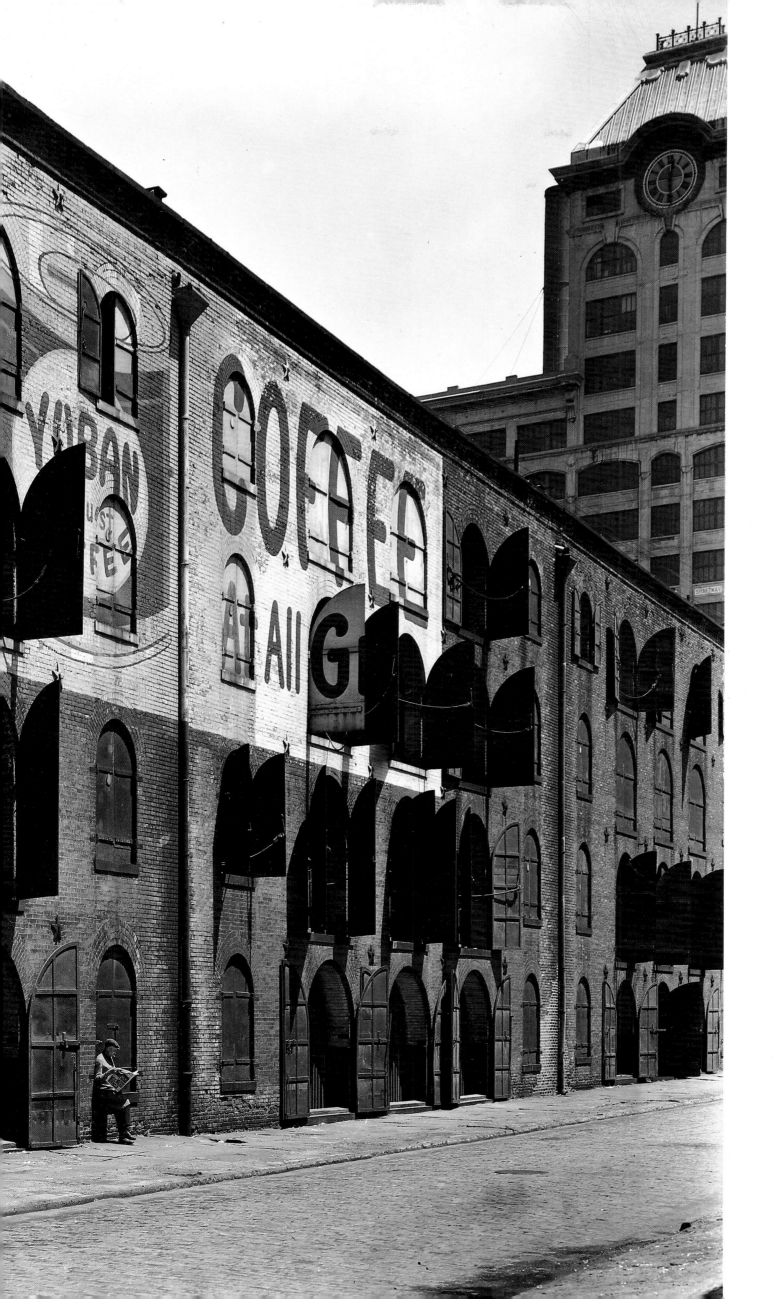

Yuban Warehouse, Water and Dock Streets, Brooklyn (preceding pages)

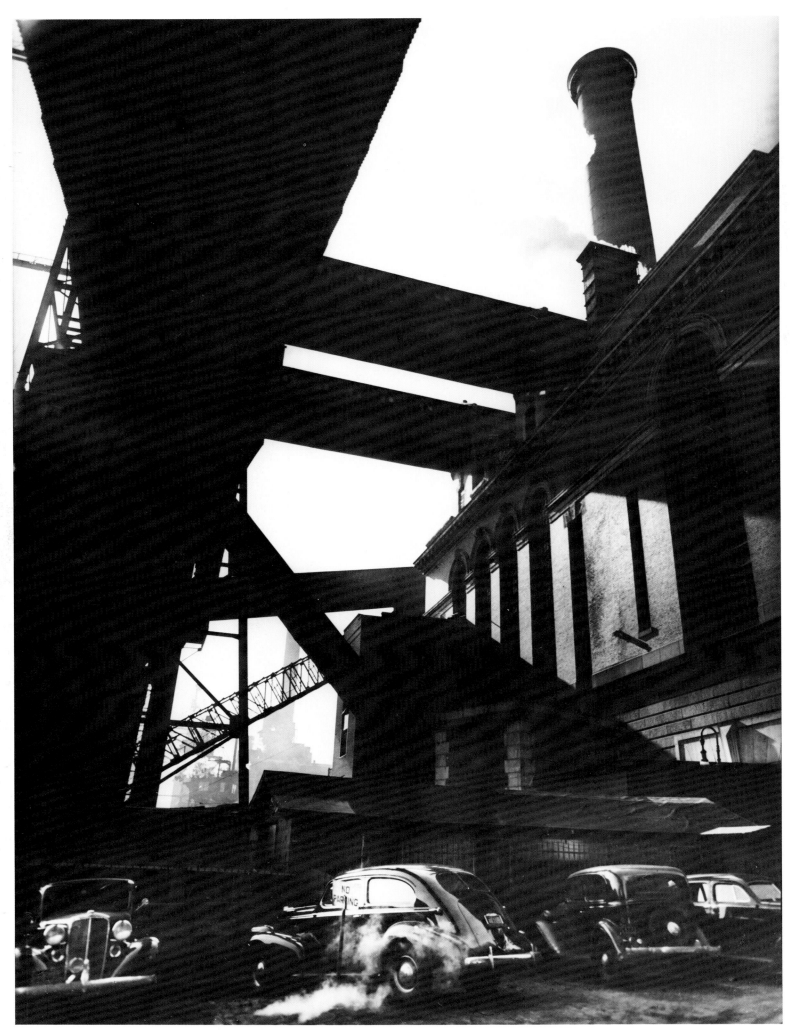

Consolidated Edison Power House, 666 First Avenue

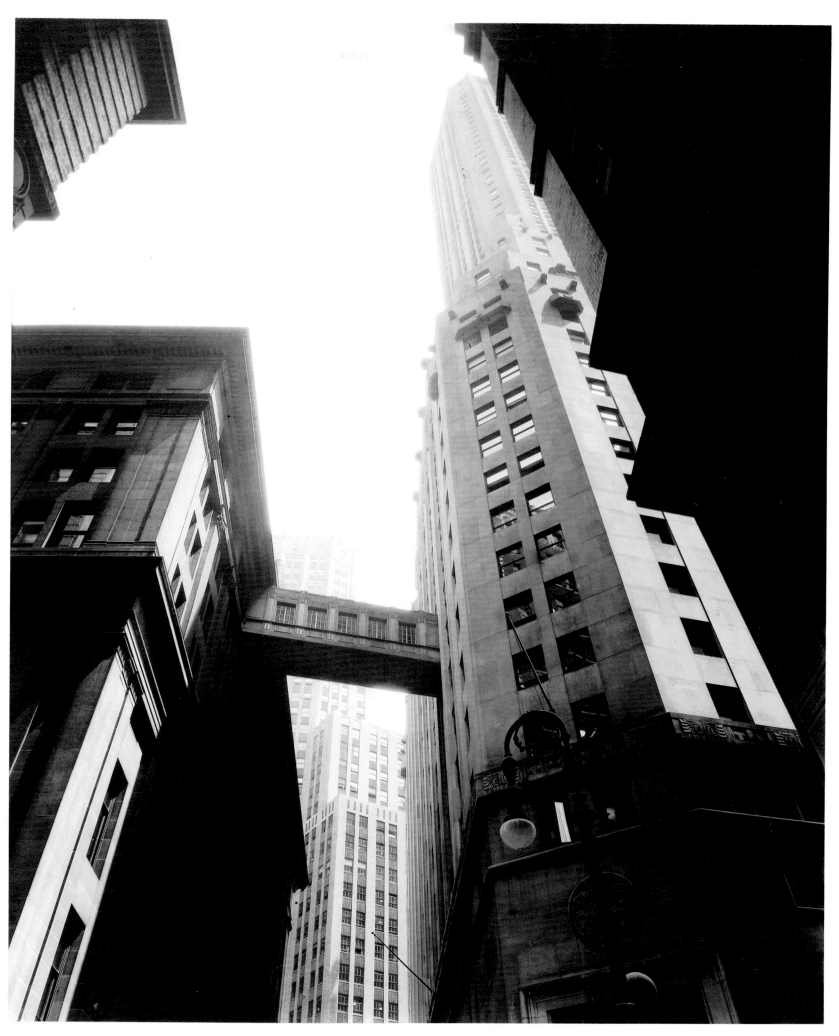

Stone and William Streets

The canyons down at Wall Street seemed have been made so as to be complicated to photograph. It's very difficult to do anything with them, but they present fantastic forms. There was a great deal of camera adjustment needed to capture this photograph, and the extremes in light and dark were almost impossible for the film to register. I don't know if I used a filter or not but I had a rule that if a certain percentage, one third or more, of the photograph was sky then I would use a filter. In this case I'm sure a filter would have helped, along with a very long exposure.

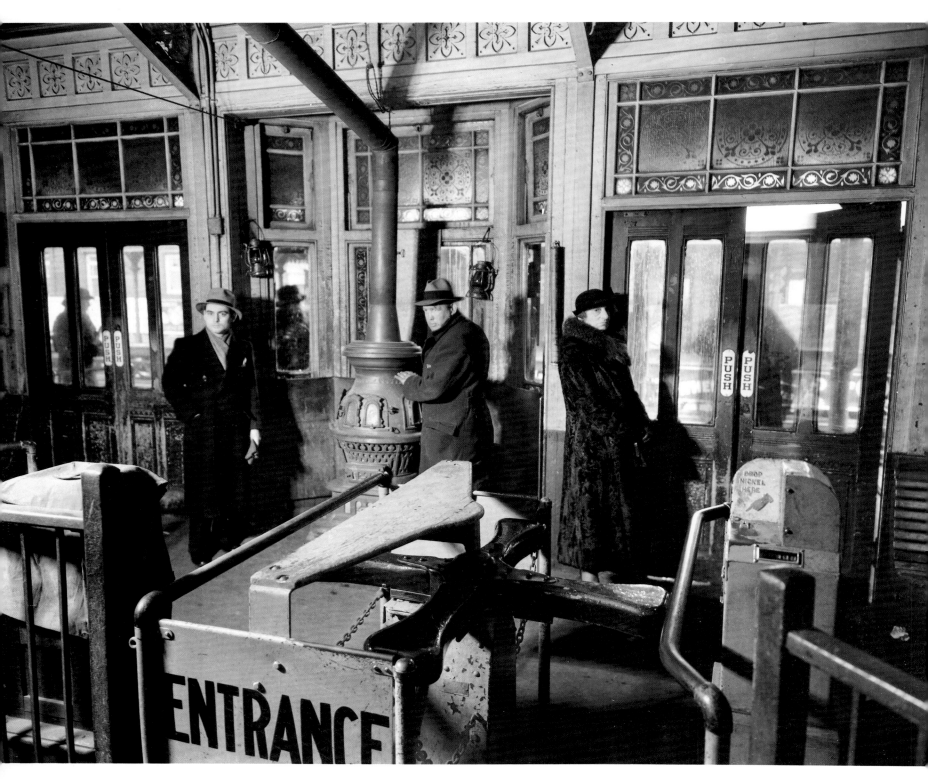

El Station Interior, Sixth and Ninth Avenue Lines,
Columbus Avenue and 72nd Street

*I always felt these elevated stations were designed by
the Swiss; they looked like little chalets. I wanted to
show as much of the interior as possible here, and so I
got up high; the turnstile and the fancy gingerbread are
visible and important to the overall feeling. It was win-
ter and the people were inside keeping warm, waiting
for a train.*

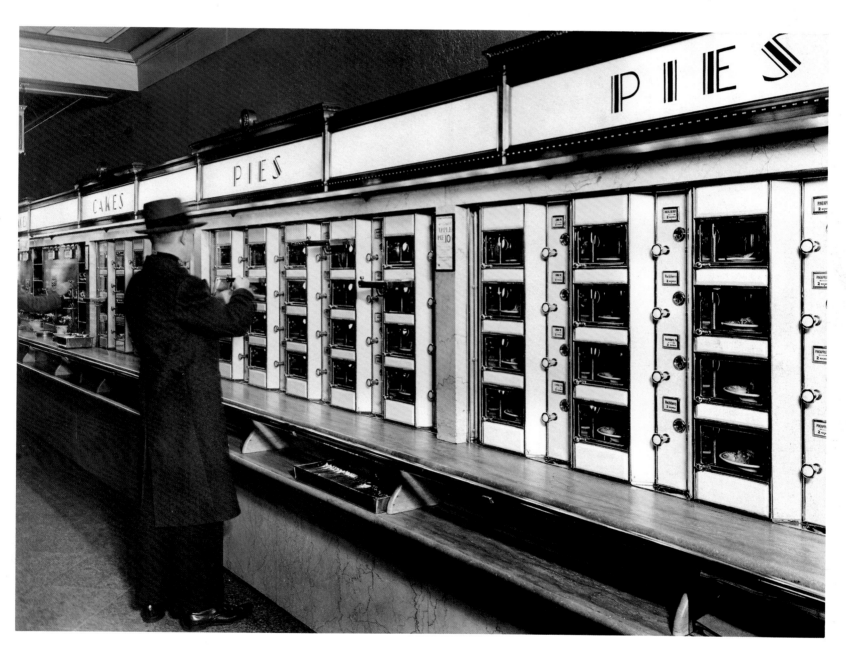

Automat, 977 Eighth Avenue
I always felt the Automat was an extremely American subject; it could not exist anywhere else in the world. Actually, the food was not too bad and it is a pity they have stopped them. I used no artificial light here, the illumination was from the windows in front and it was essential that the entire image be in focus—documenting an extremely American artifact.

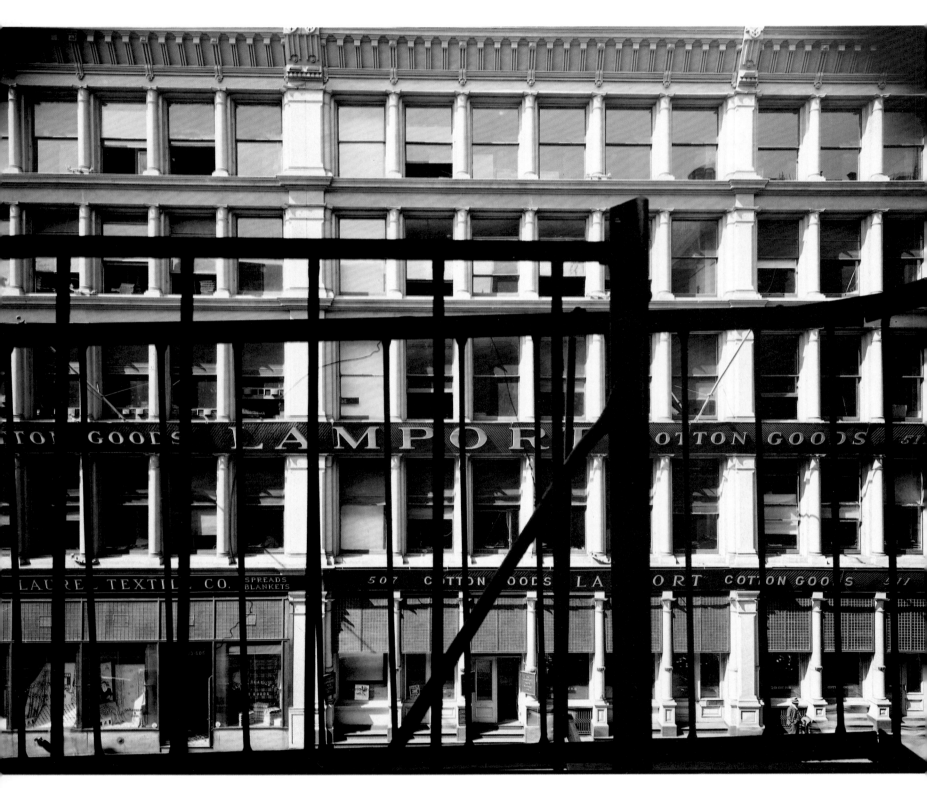

Lamport Export Company, 507–511 Broadway
*I took it through the fire escape purposely; it would
have been easy to raise the camera but it seemed better
through it. This part of lower Broadway is interesting
simply because it is so commercial and nondescript.*

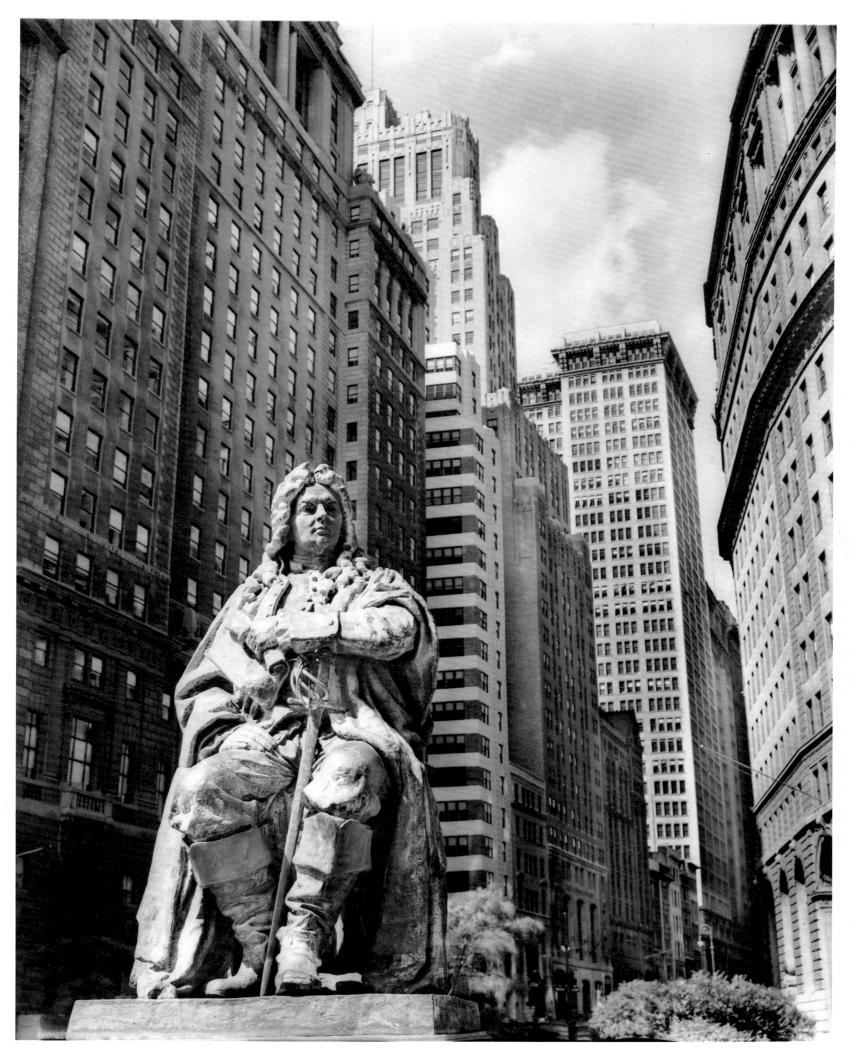

DePeyster Statue, Bowling Green Looking North to Broadway

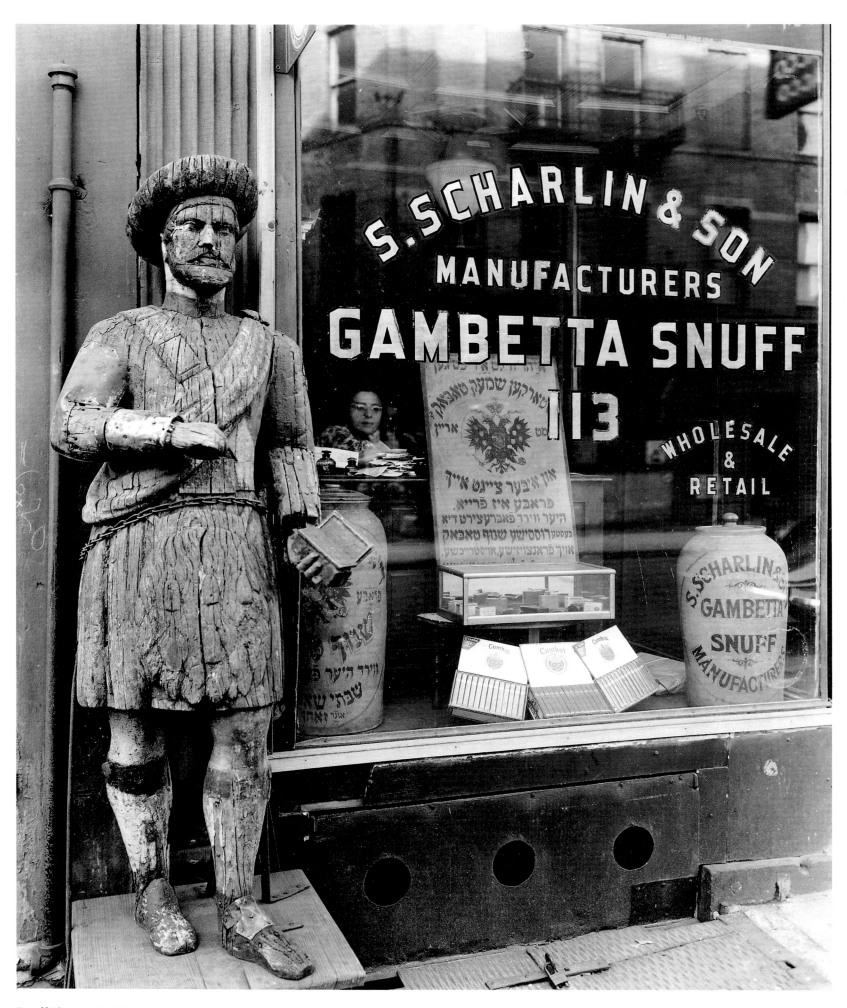

Snuff Shop, 113 Division Street

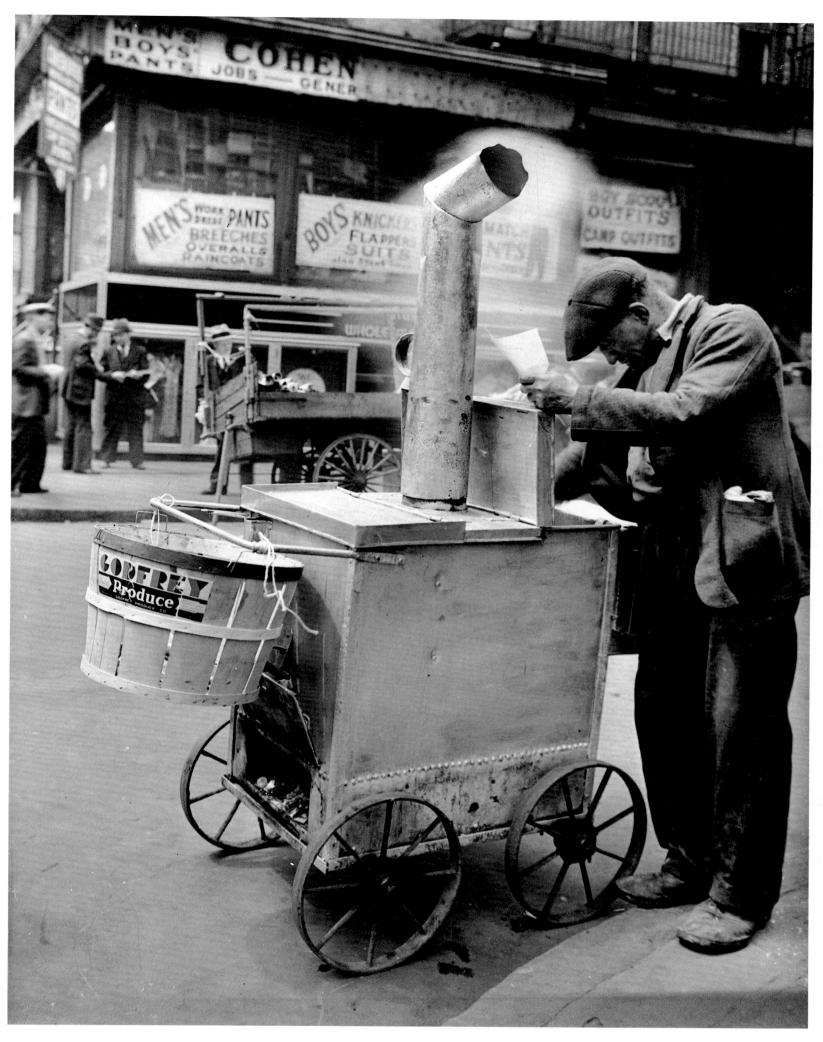

Roast Corn Man, Orchard and Hester Streets

Church of God, 25 West 132nd Street
There were certain things that were characteristic of Harlem and one was its churches. I didn't ask the minister to be in the photograph; I set up and he came out and that was that. I'm glad he did; it helps the photograph a great deal.

Walkway, Manhattan Bridge
I seem to veer toward waterfronts. As Melville wrote in Moby Dick, *the heart of a port city is around its waterfront, and by nature I seem to head right there. Perhaps I should have been a sailor—boats and bridges have always fascinated me. Here I had to use maximum swings and fairly fast shutter speed because of the vibration of the bridge, and I wanted everything sharp.*

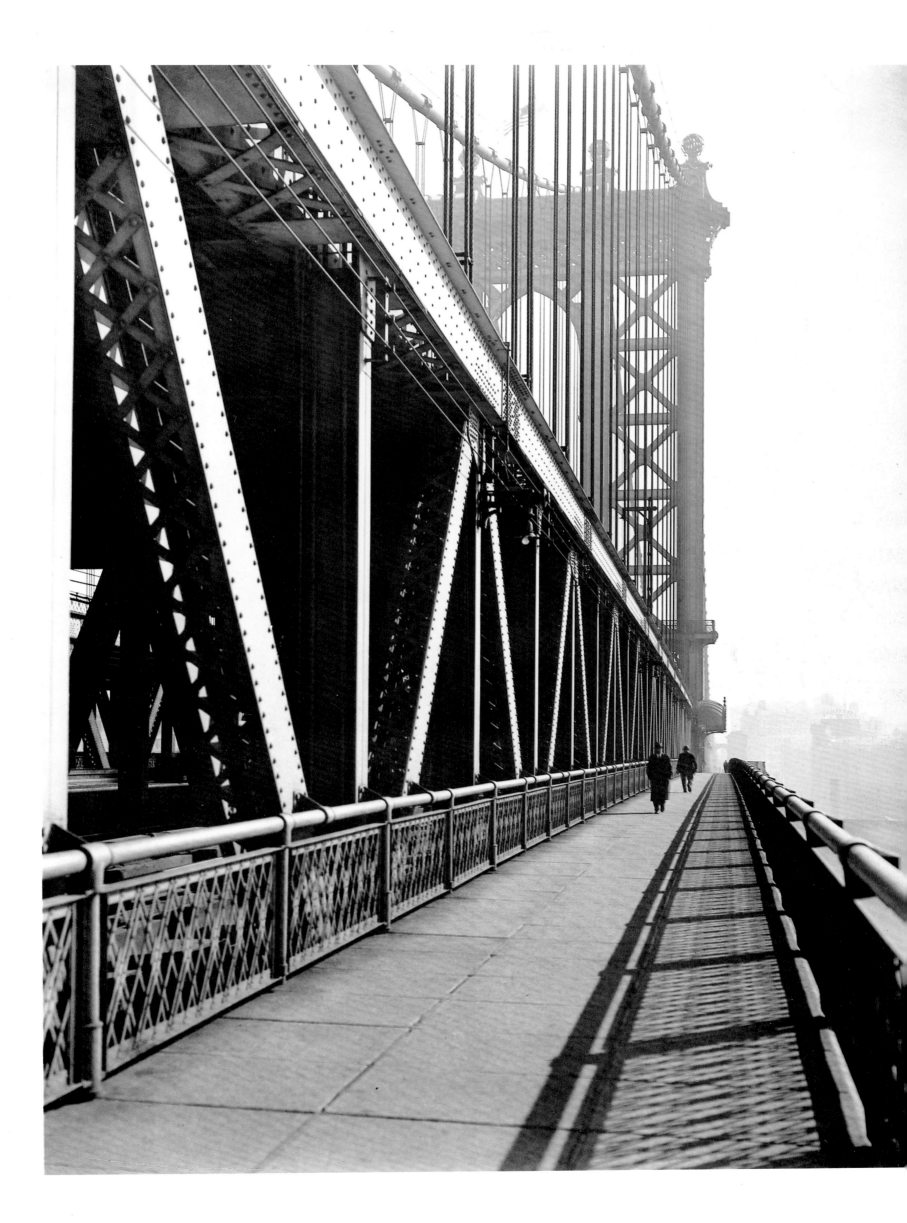

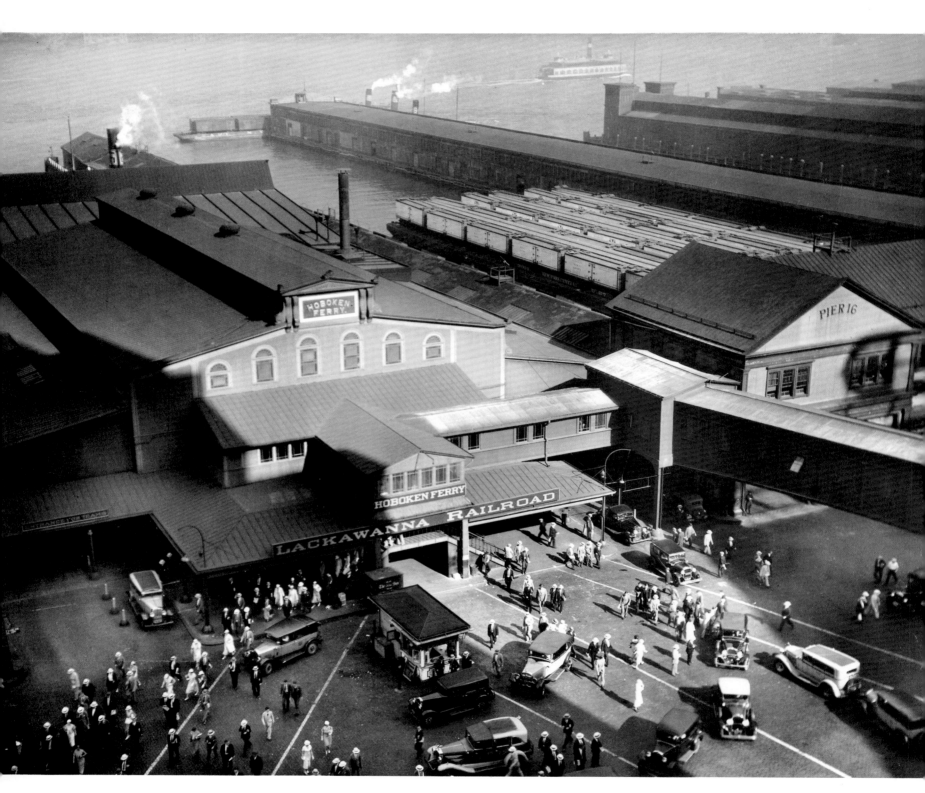

Hoboken Ferry Terminal, Barclay Street

This is a favorite of mine; it was a big frustration at the time. I had to go through all sorts of red tape in order to get into the building to take the picture. I knew the crowds would come off the ferry at a certain time, but I was unable to get in the building early enough to have all the time I needed. I got my camera set up about 9:00 a.m. and one crowd came off and I took this photograph; but this was the peak, there were no more crowds. I would like to have taken more but this was the only chance I had.

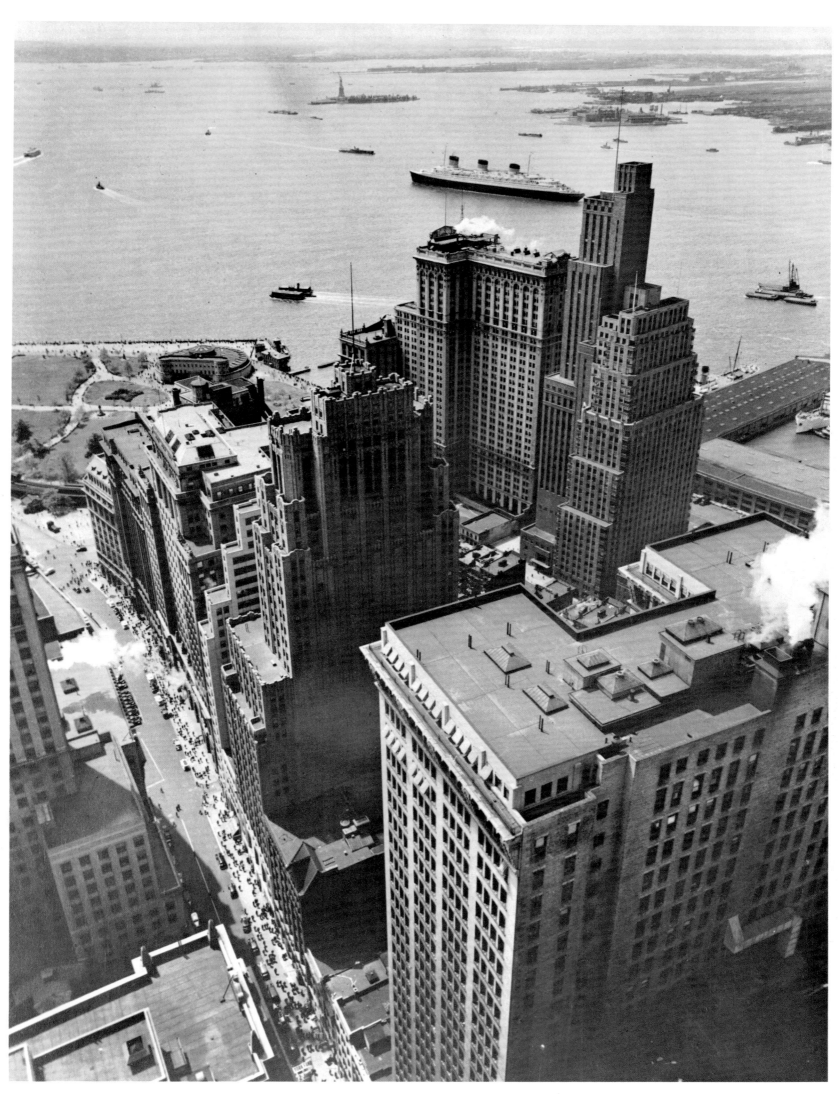

Broadway to the Battery, from Roof of Irving
Trust Company Building, One Wall Street
*I used a 4" x 5" Linhoff, hand held, for this photograph.
I waited for the ship to get to just the right place to*
*make an exposure. I took a second shot but the ship had
moved slightly, which ruined the composition.*

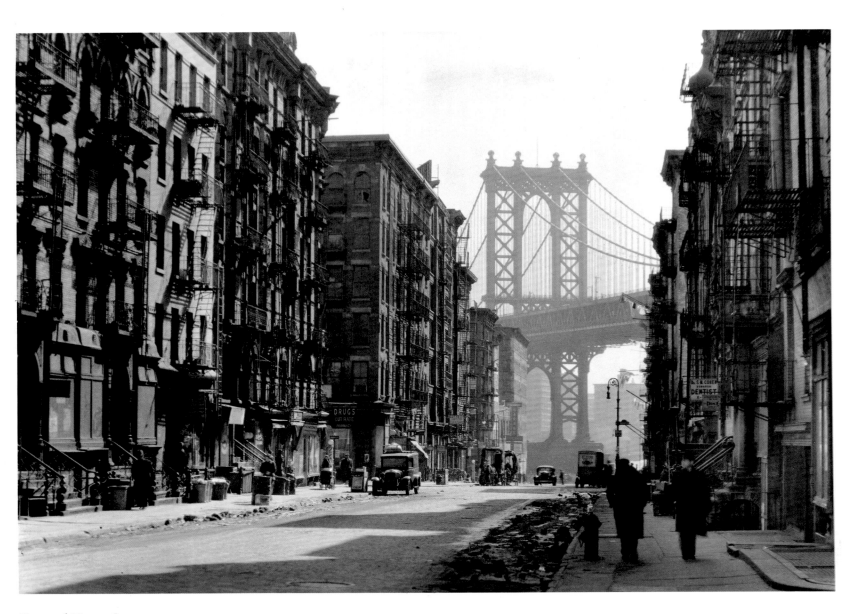

Pine and Henry Streets

Waterfront from Pier 19, East River (overleaf)
I've always liked this photograph. It is typical of the waterfront as it was then and shows the variety of transportation. The train was floating on a barge and gently moving up and down. The man helps the photograph a great deal. It was a great feat to get everything in focus, particularly with the barge moving so much. It was not only moving but could have pulled out at any moment, so, as so often happened, the photograph was done in a great rush.

Queensboro Bridge from Pier at 41st Road, Queens

151

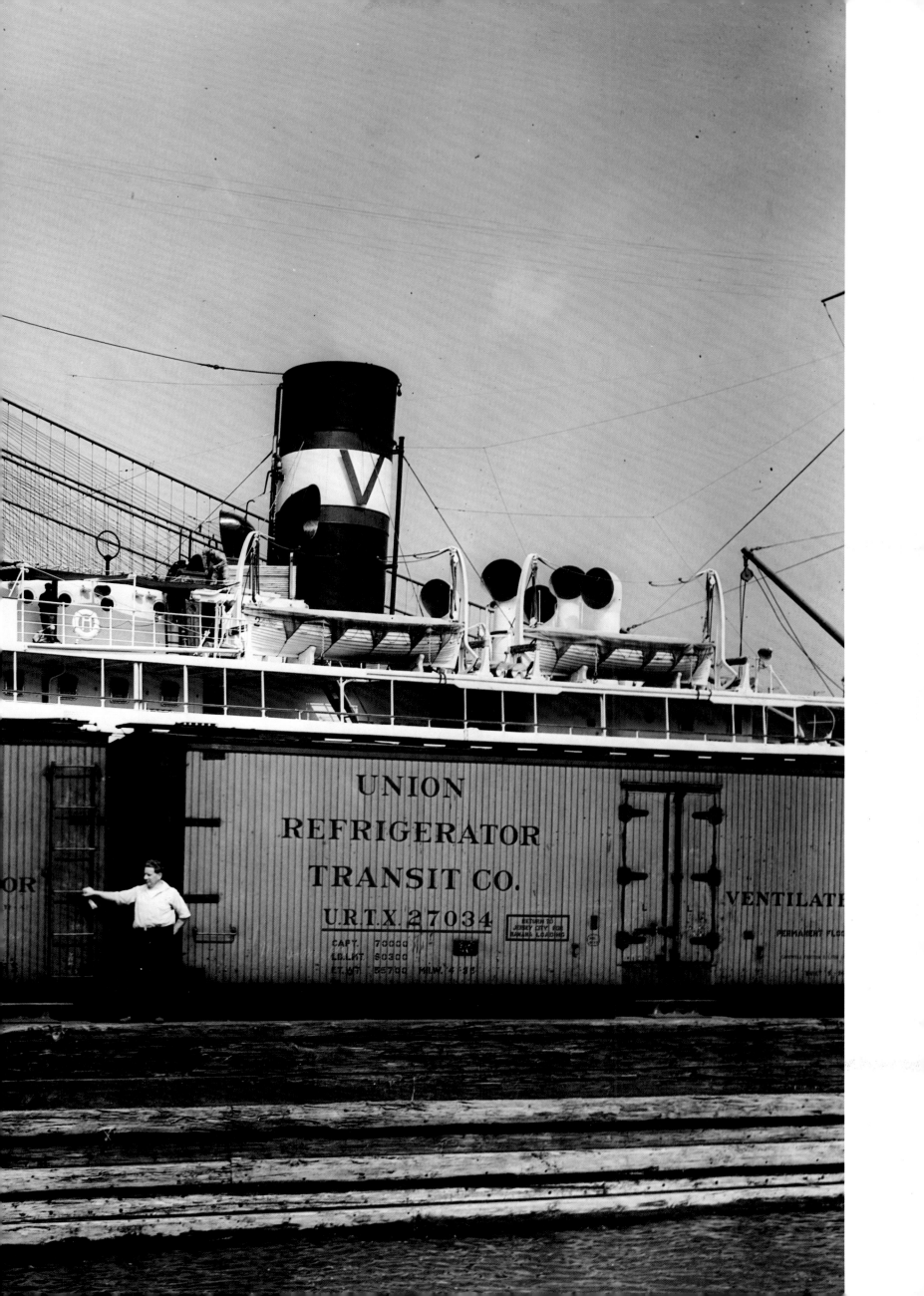

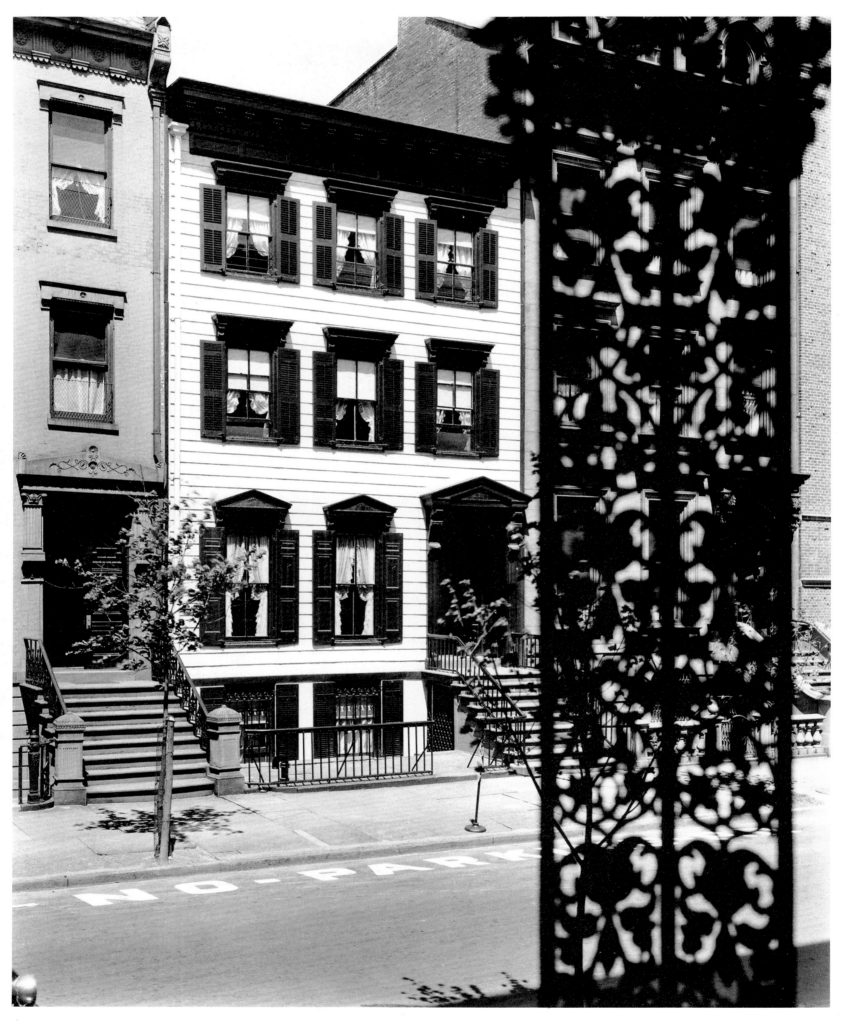

104 Willow Street, Brooklyn

There were nice little homes in Brooklyn. I rather liked the stoop from which I took this photograph and I had the iron grill in there. When Paul Strand saw this one he asked, "Why don't you have the iron grill in focus?" I said I wanted it out of focus to bring attention to the house *and that the black foreground was simply decoration and besides it hid the very dull house next to the white one. It was all very deliberate; I could easily have stood in front of the grill or had it in focus. I chose to have it the way it was.*

154

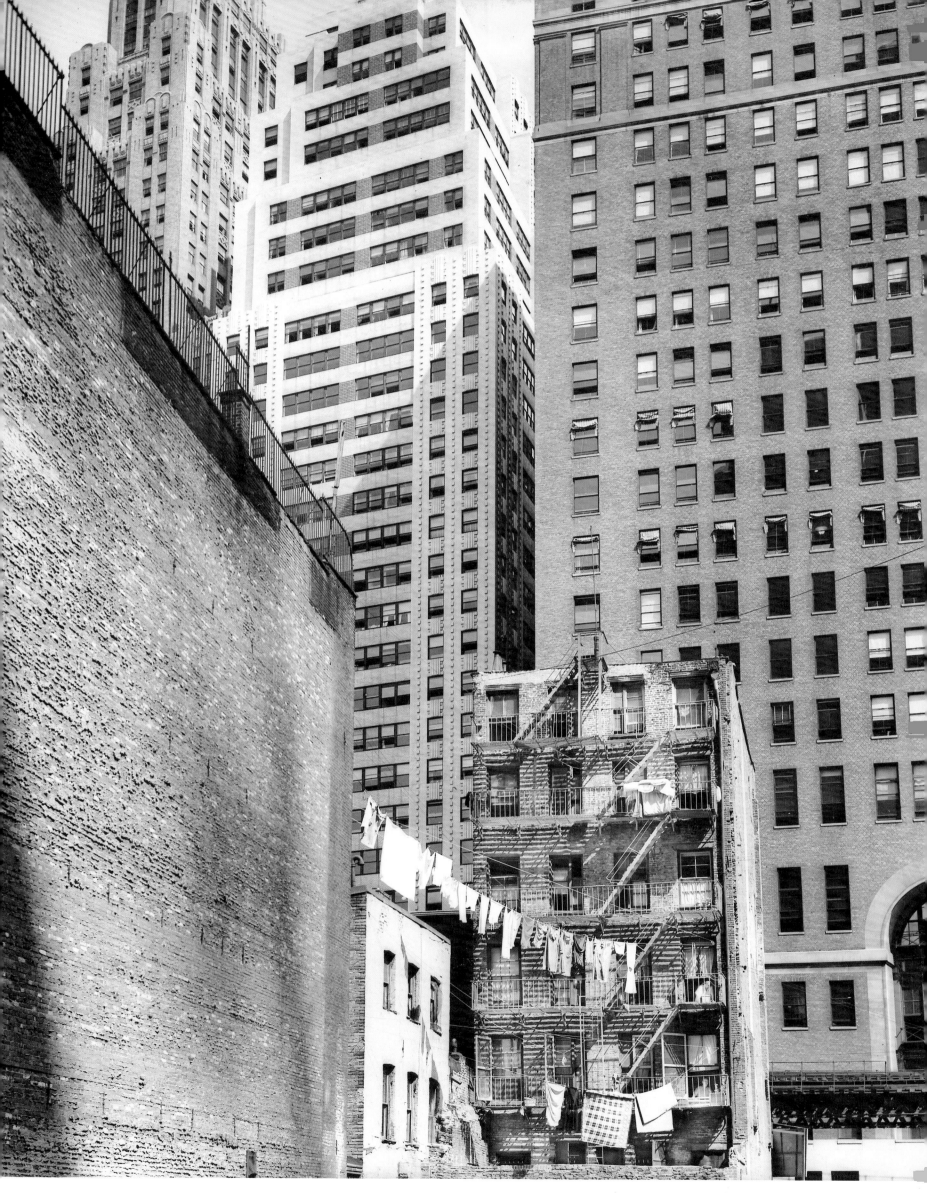

Construction, Old and New, from Washington Street

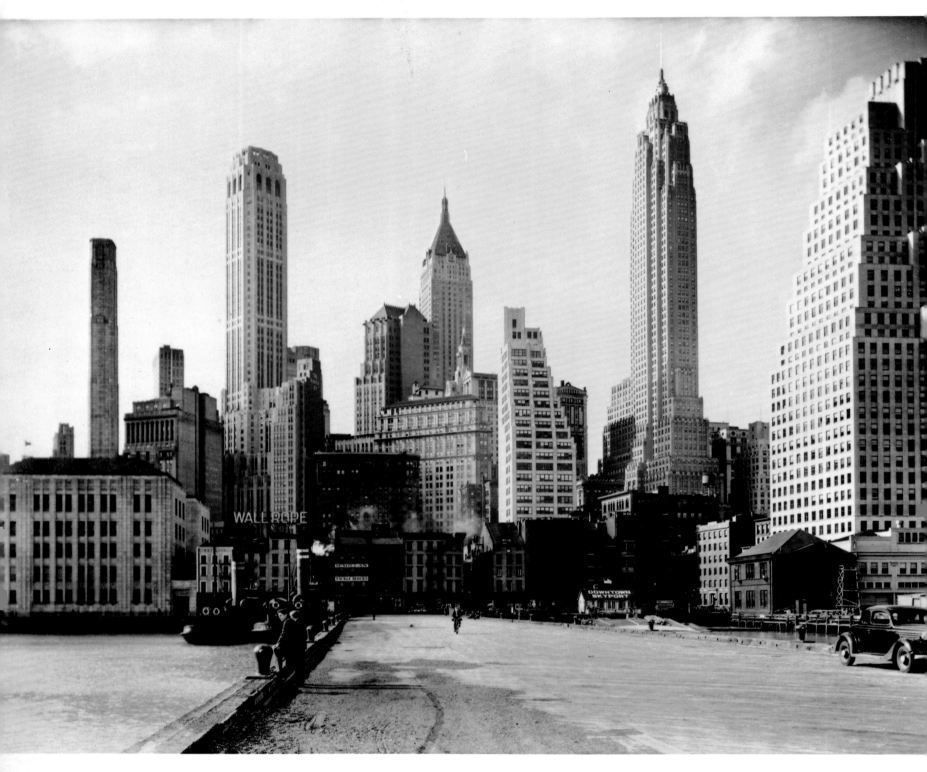

Manhattan from Pier 11, South Street and Jones Lane

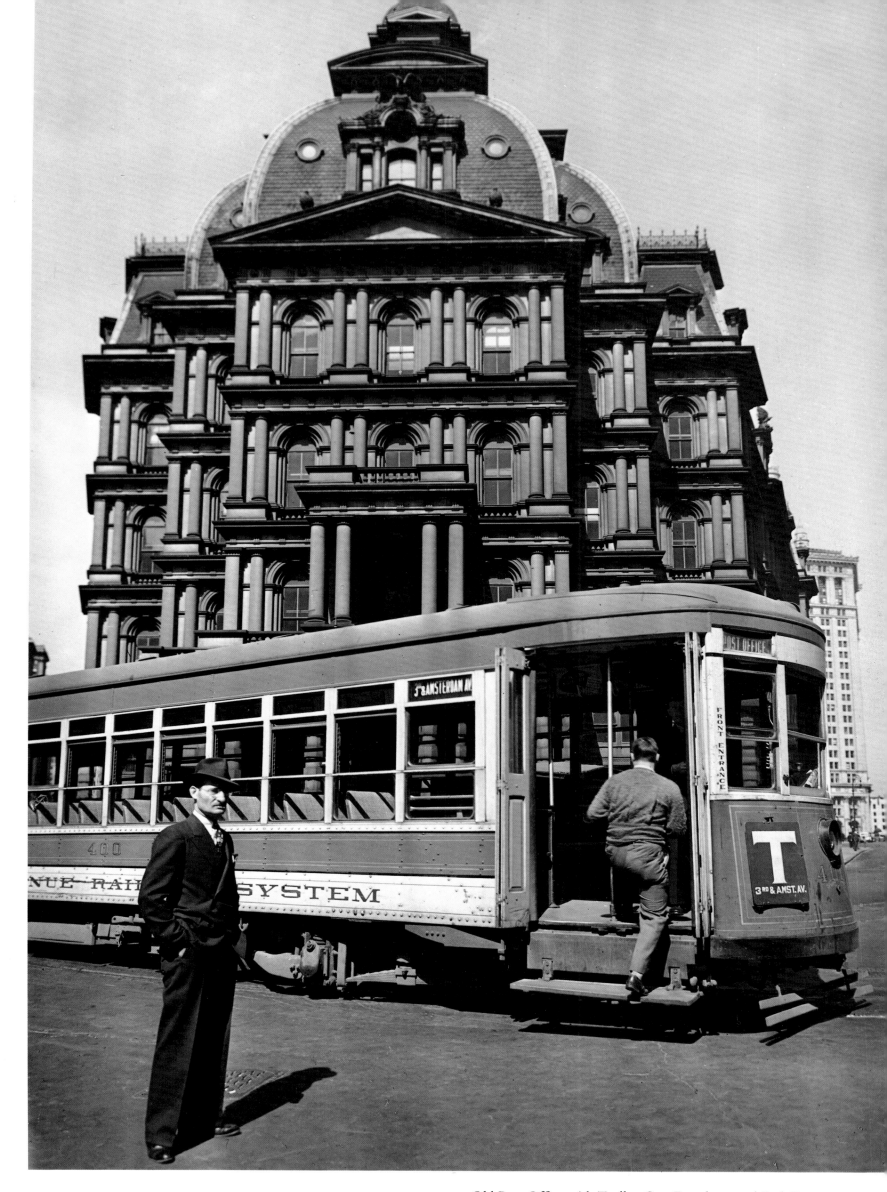

Old Post Office with Trolley Car, Broadway and Park Row

Broadway and Rector Street from above

Old-Law Tenements, Forsythe and East Houston Streets, 35–47½ East 1st Street

The buildings in the foreground were down; a subway line was being constructed and this row of houses was exposed. It would have been a dull photograph without the mailbox, which makes a significant difference. This was taken in the afternoon; in fact, a high percentage of the Changing New York project photographs were taken then. I'd often get up early, but found the morning light to be weaker. It became stronger as the day went by. The early morning light was beautiful but too weak; it took me a while to discover this.

Lyric Theatre, 100 Third Avenue
I wanted to do a movie house, but not one of the glamorous ones. This was of the old-time type—and there weren't many left, even then. There are three versions of this photograph, but this one is preferable.

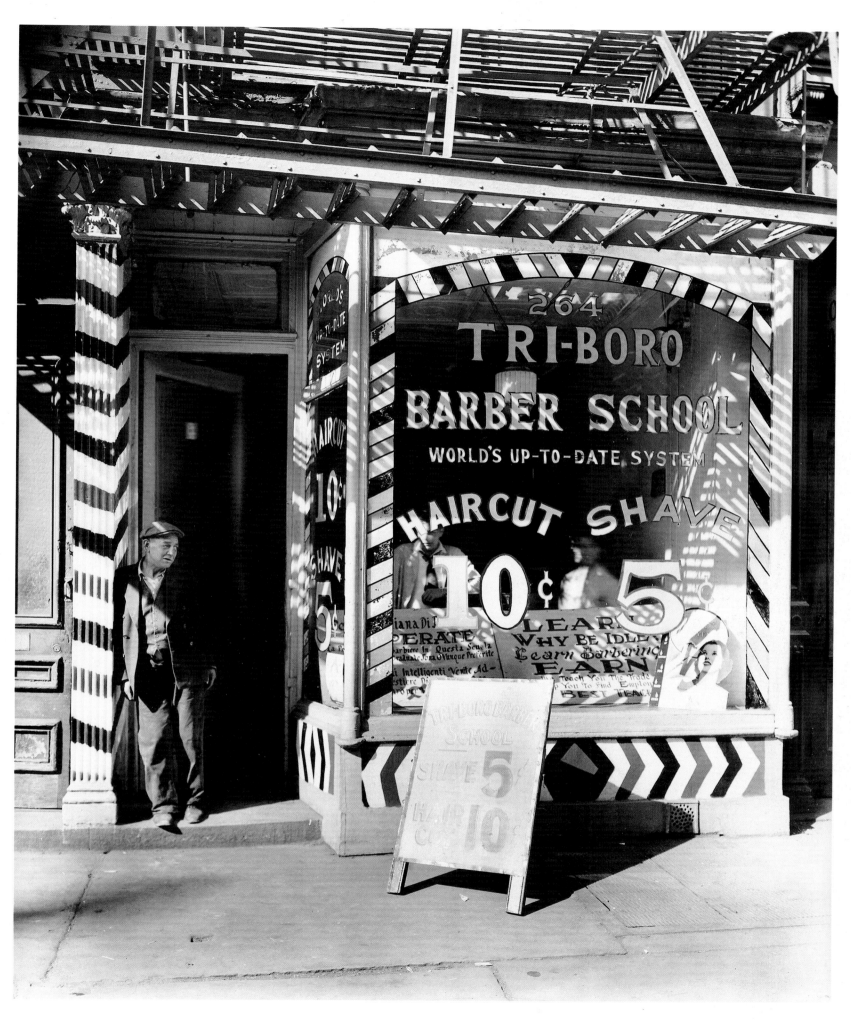

Tri-Boro Barber School, 264 Bowery
It was not unusual to get two good photographs on one day. The barber school was right down from the Blossom Restaurant (see page 167). This particular photograph looks very good enlarged; the shadows are very complex, mixing with the pattern on the building.

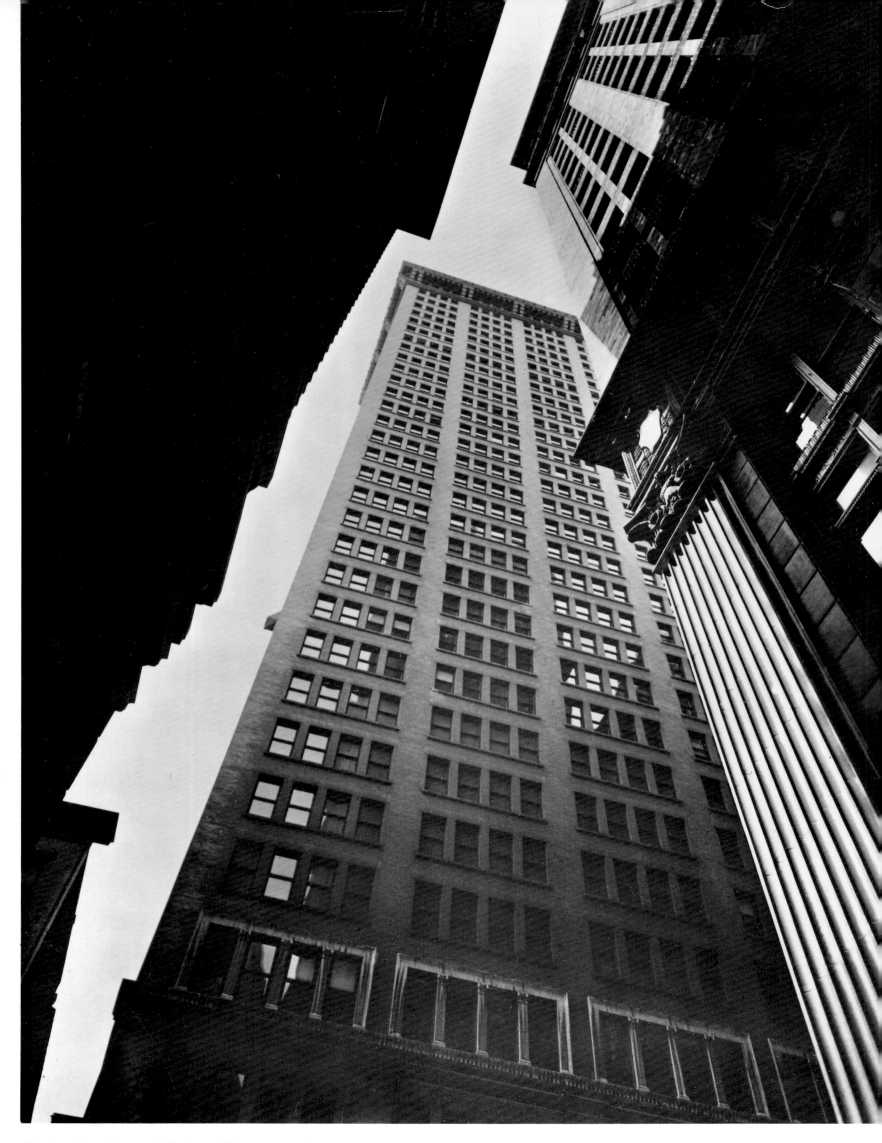

Canyon, Broadway and Exchange Place

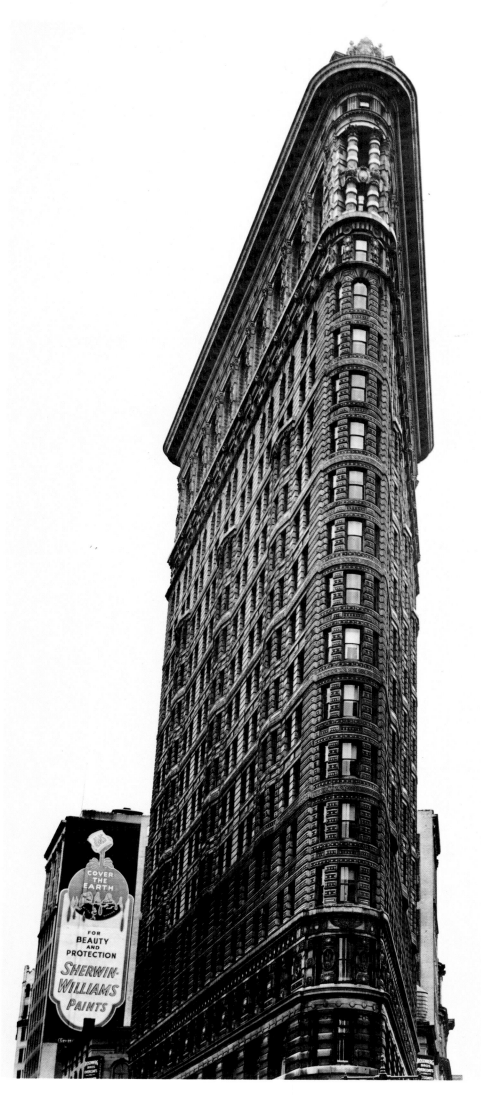

Flatiron Building, Broadway and Fifth Avenue
I did this building two ways. One version was from a height, in a building up the street; this is the better version. There is no doubt in my mind that this building looks better from street level and I was careful in picking the precise location to set my camera.

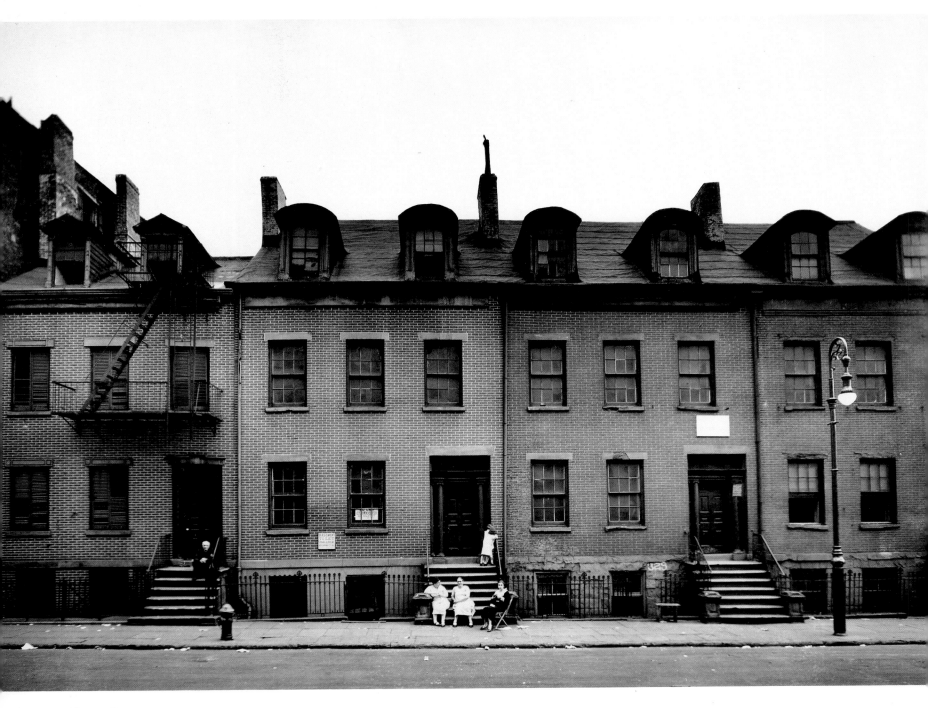

Cherry Street

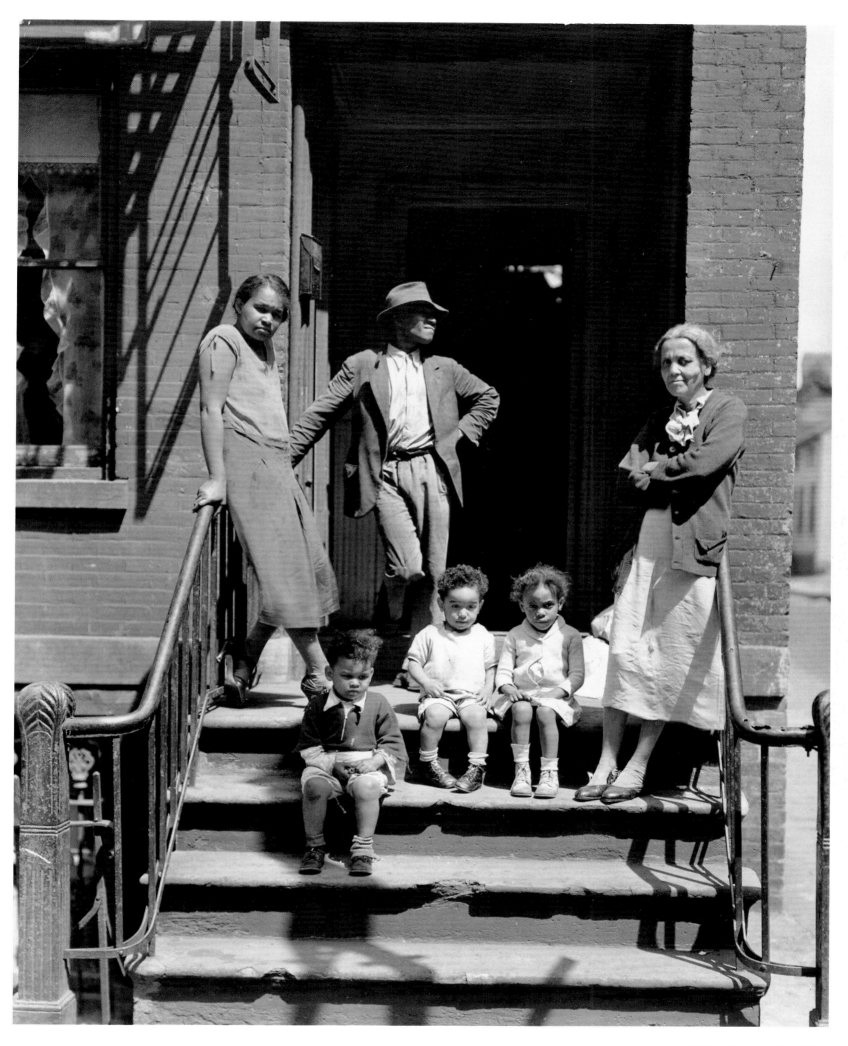

115 Jay Street, Brooklyn

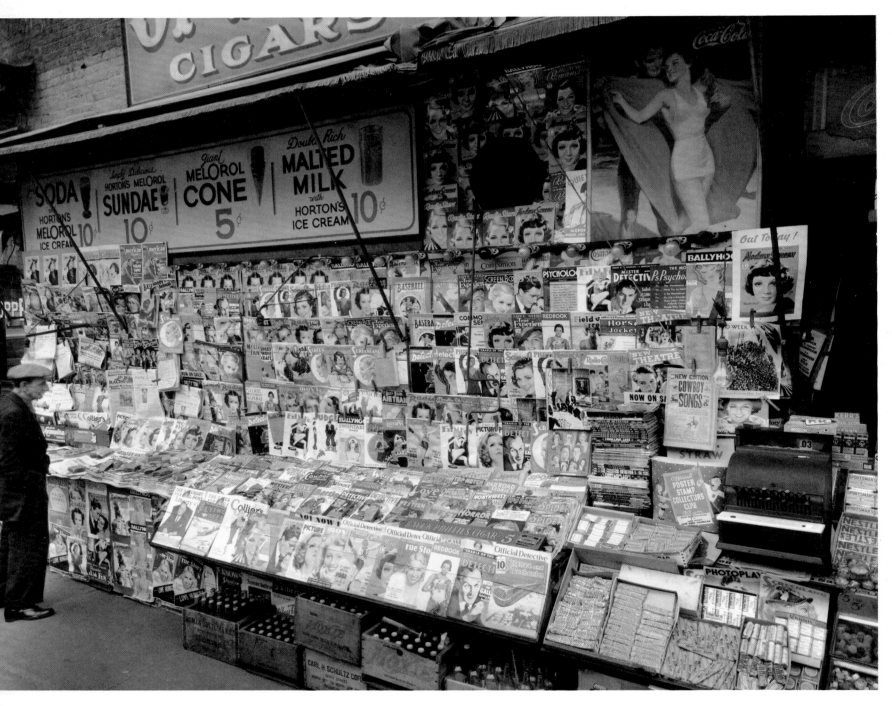

Newsstand, 32nd Street and Third Avenue
This was an exceptional newsstand, all spread out in front of me. An enlargement of just the magazine section might be very interesting. Nearly everything on the Changing New York project was taken with a slightly wide-angle lens, a 9½″ Goertz Dagor, that helped out with this photograph. If I needed a genuine wide angle I'd use a 7″ lens, but then it was not enough to cover the corners of the film unless I was very careful with the camera.

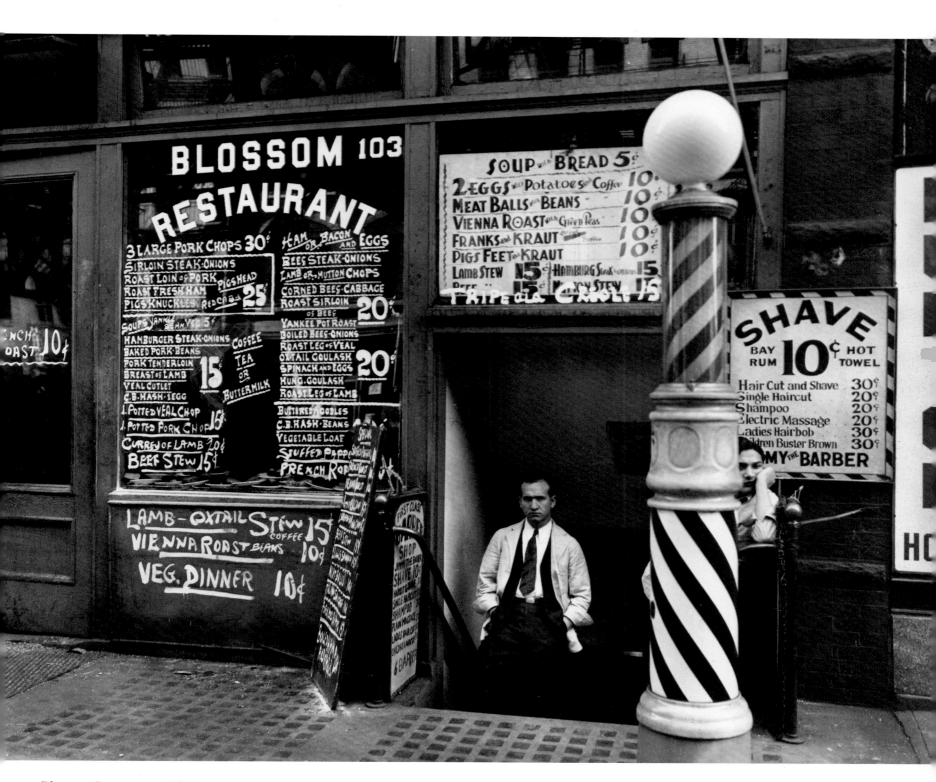

Blossom Restaurant, 103 Bowery

The Bowery was quite colorful. The man came out when he saw me setting up the camera. He stood there not knowing what to do and since I was ready I made the photograph with him in the doorway. He makes it much better.

All the New York photographs took a good while to get set up because it was necessary to select the camera position carefully. These photographs were not done on the spur of the moment. I had to look around a bit; placing the barber pole in the right place was very important. Then I had to square up and level the camera, usually with a spirit level. It always took a long time since my camera was bulky and the tripod was poor. None of it was easy.

167

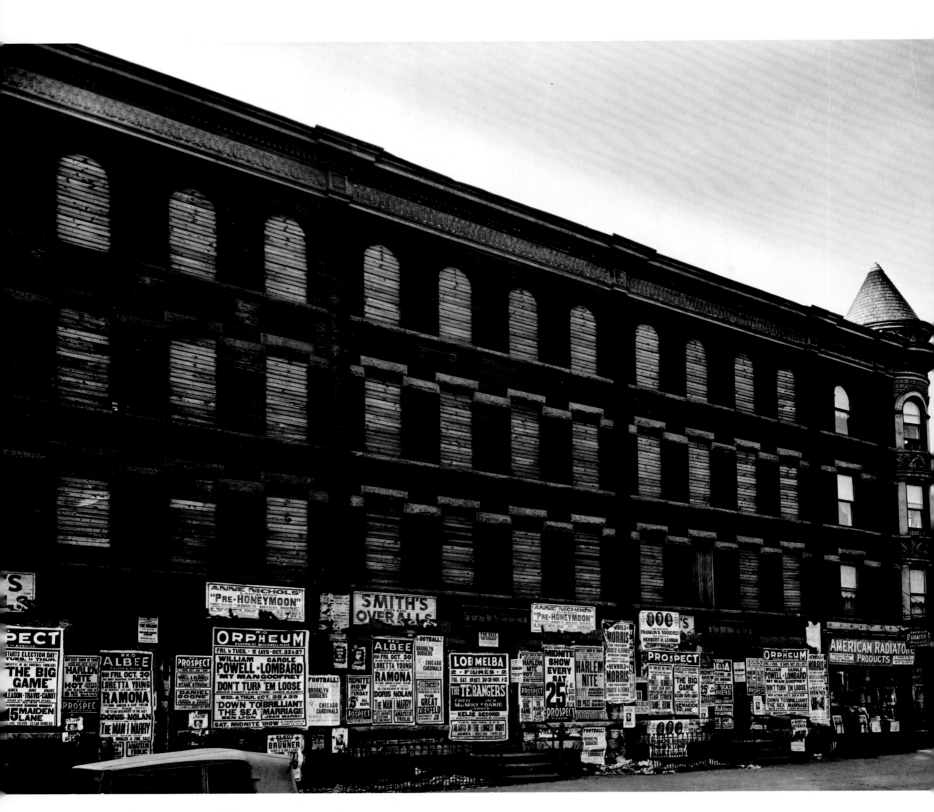

154 Fourth Avenue, Brooklyn

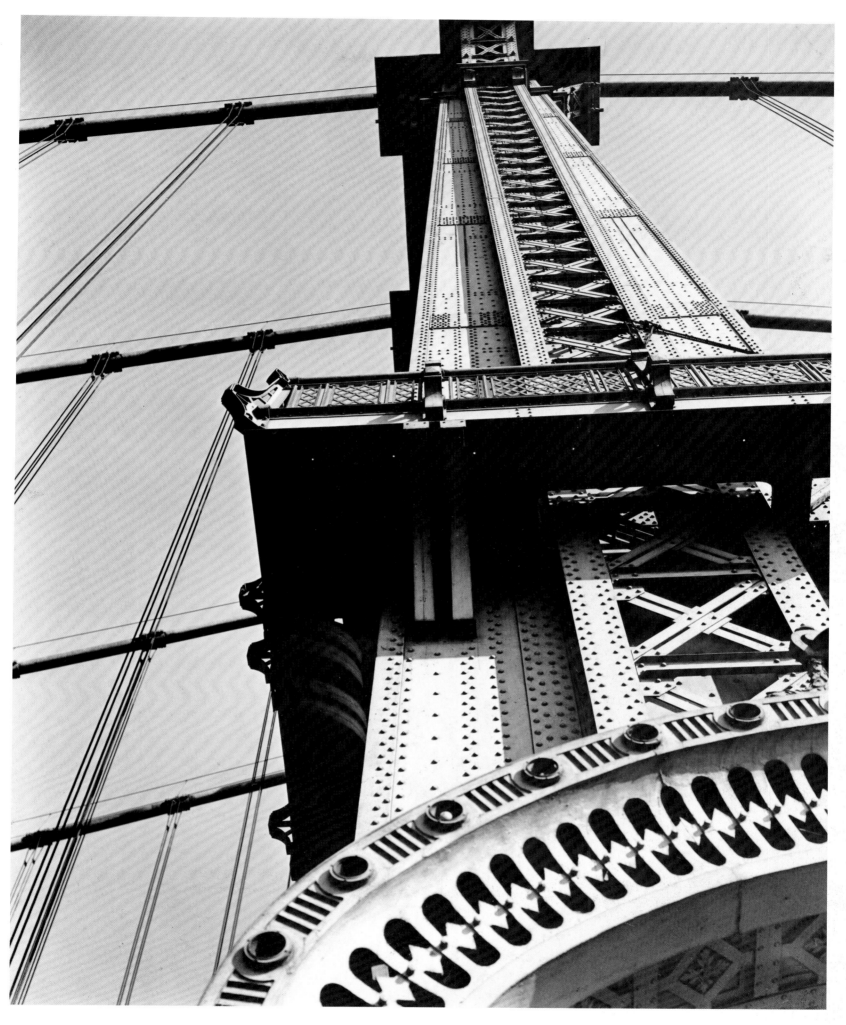

Manhattan Bridge: Looking Up

Berenice Abbott, about 1940

American People and Places

Abbott's involvement with Changing New York and, later, science did not preclude her undertaking other, more modest projects. The first was in the spring and summer of 1935 when she journeyed throughout Ohio, Pennsylvania and the Deep South, producing a number of photographs reminiscent of those made under the auspices of the Farm Security Administration. In 1947–48, working on her book *Greenwich Village Today and Yesterday,* she made her final New York photographs, and in 1953 she made a monumental survey of Route 1 from Fort Kent, Maine, to Key West, Florida, and back, compiling a document of changing America from along this highway. And throughout these years Abbott continued to make occasional portraits of personalities who interested her. Key examples of all these projects present a fascinating cross section of Abbott's talents.

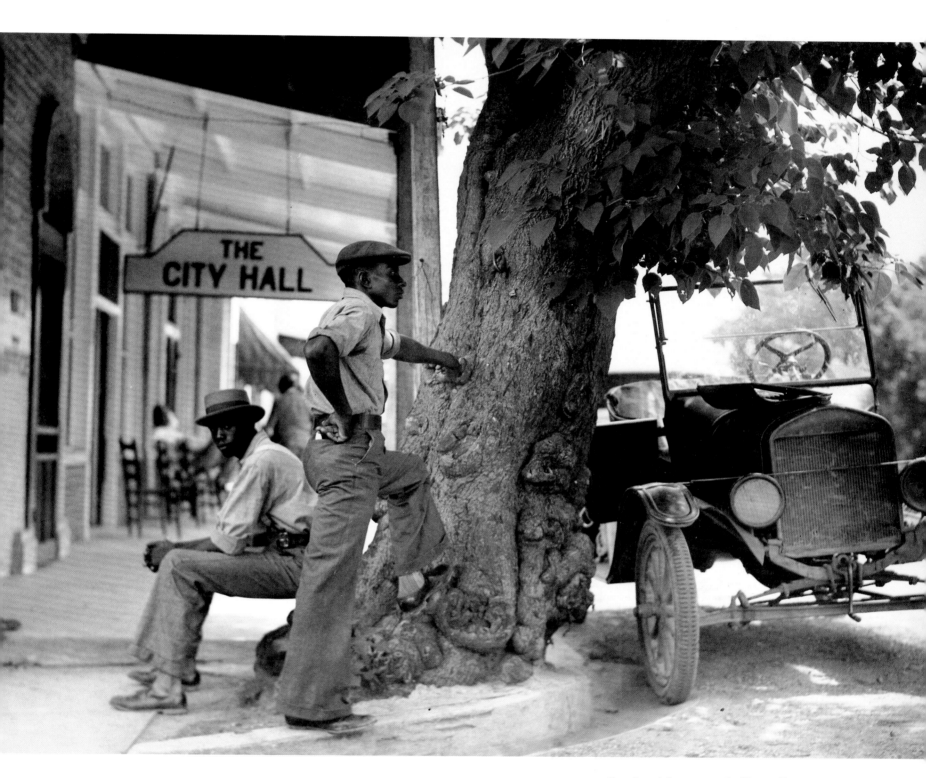

Sunday Afternoon, Colliersville, Tennessee

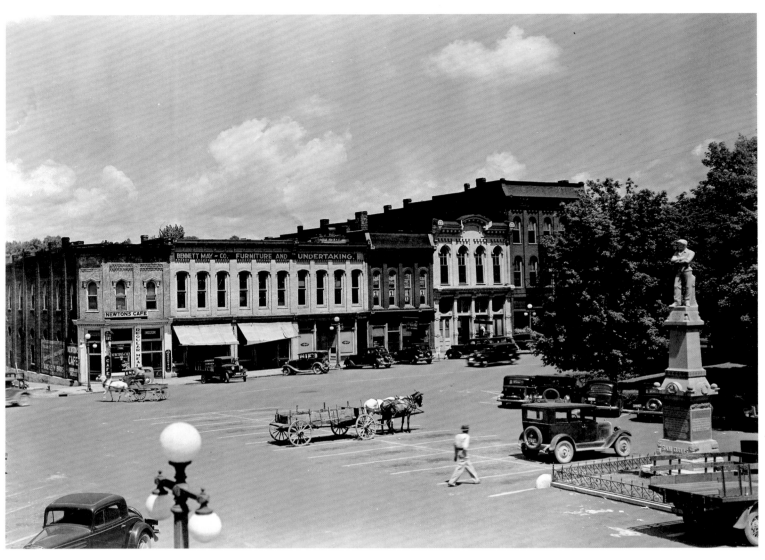

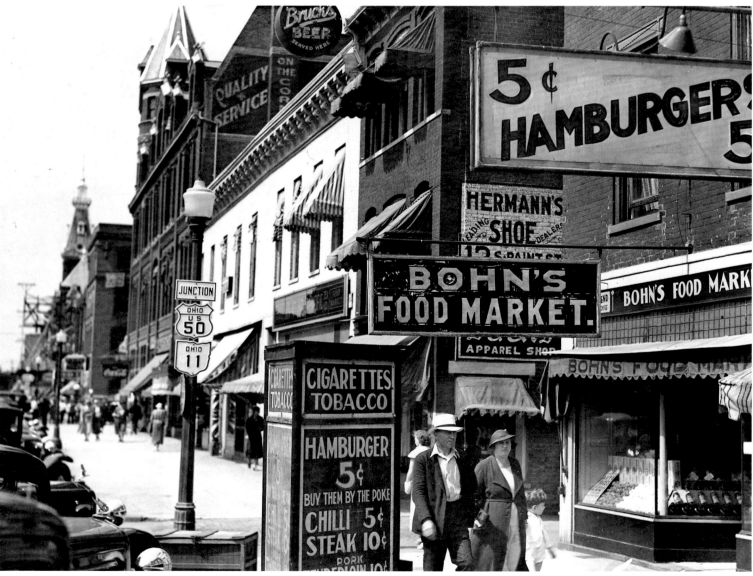

Square, Pulaski, Tennessee

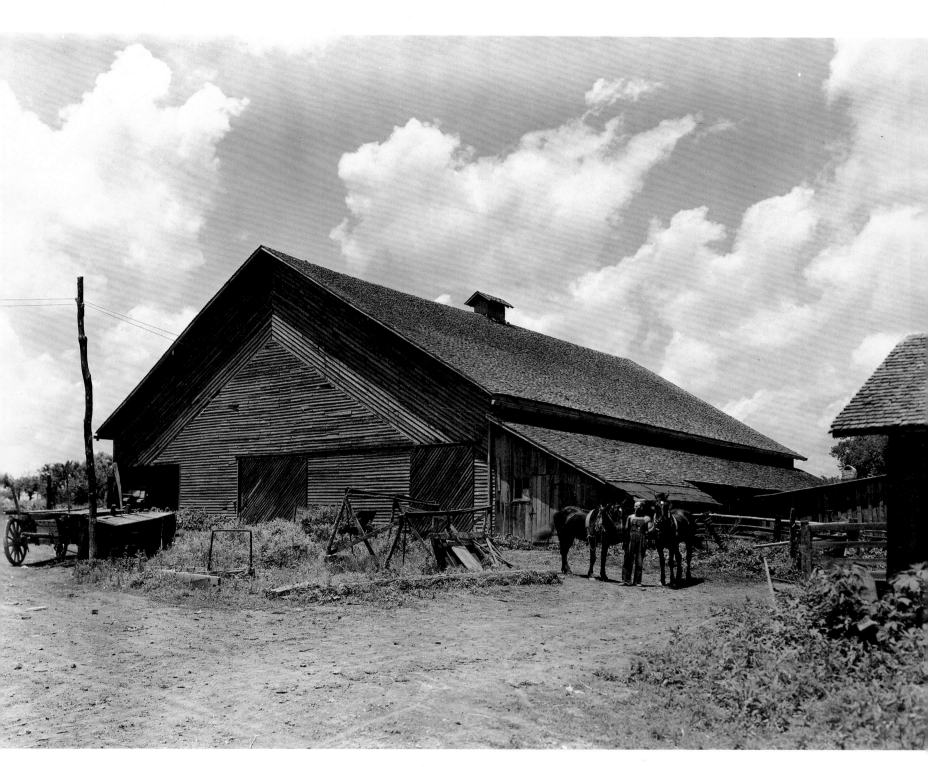

Farm, Pulaski, Tennessee

Main Street, Chillicothe, Ohio

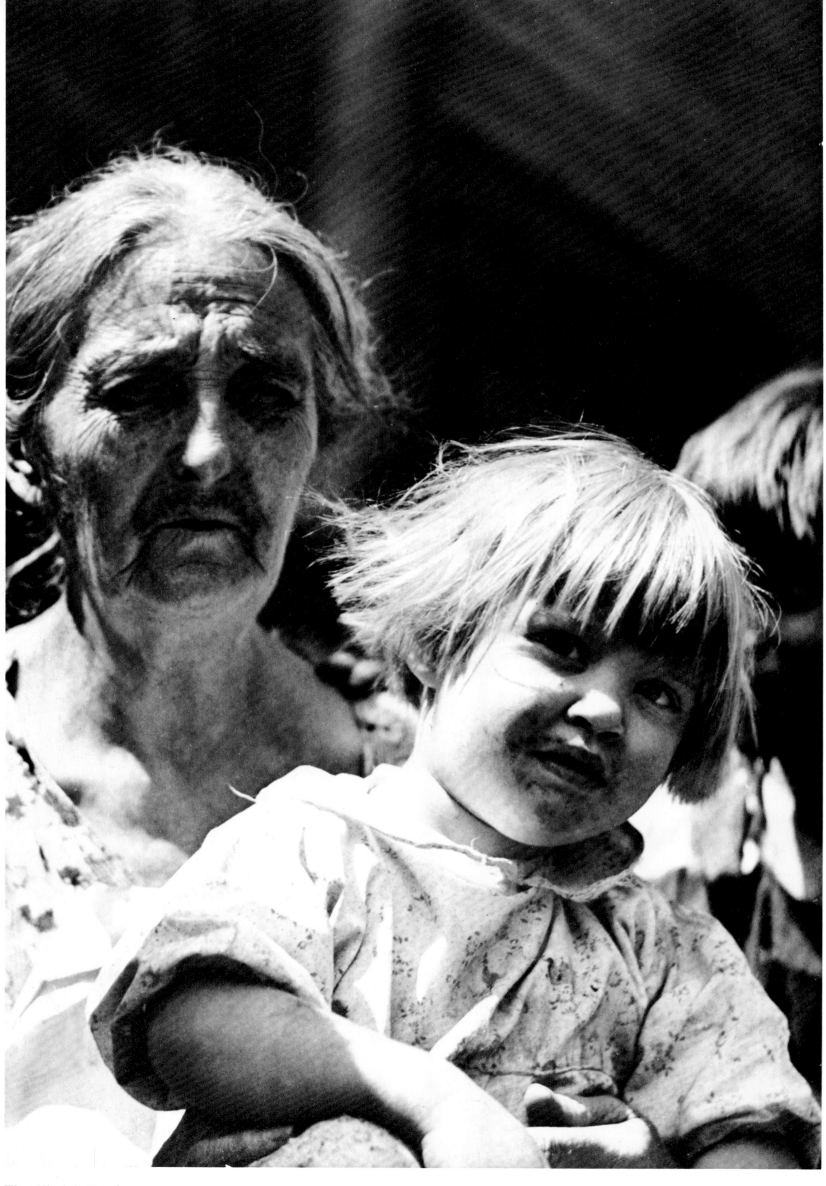

West Virginia Family

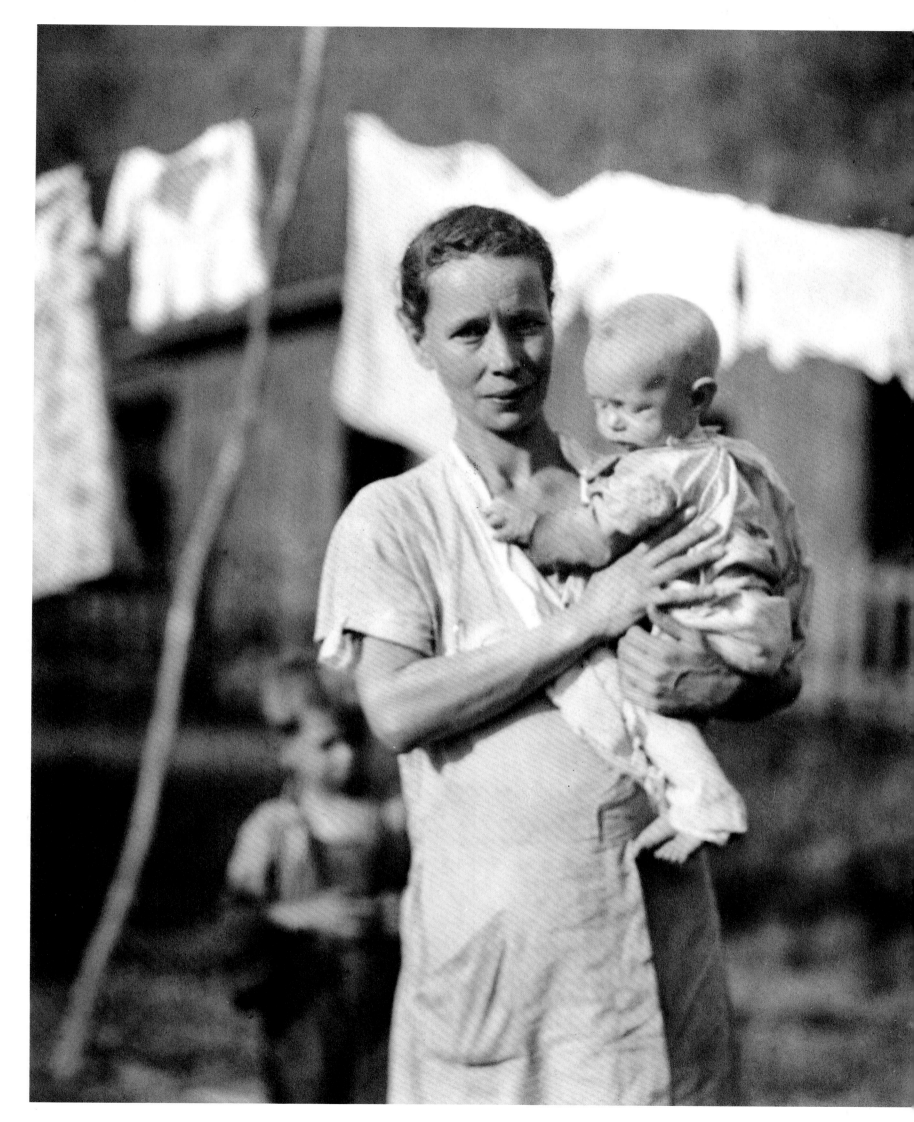

Miner's Wife, Greenview, West Virginia

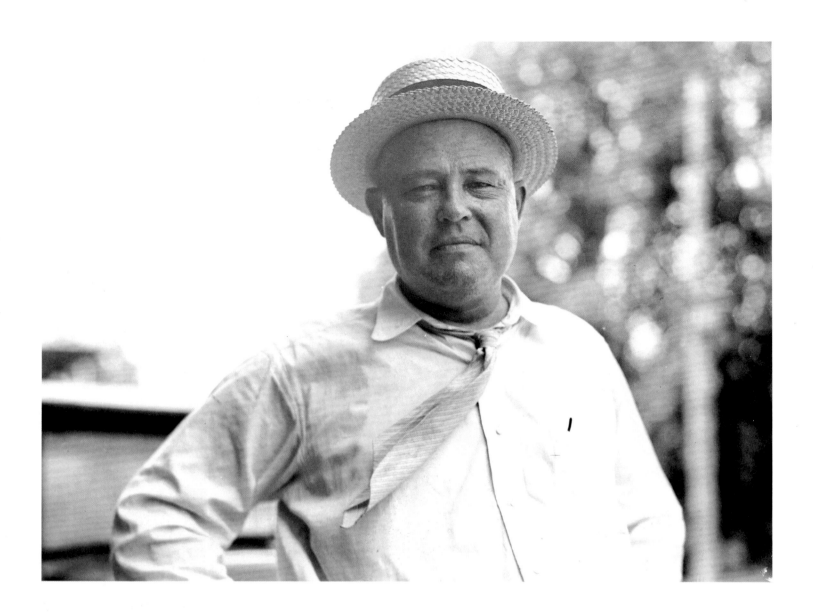

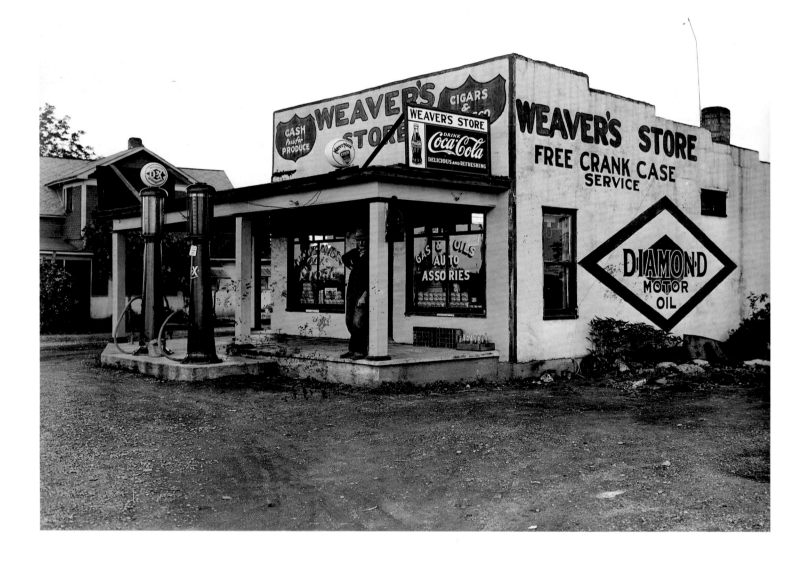

Tennessee Portrait

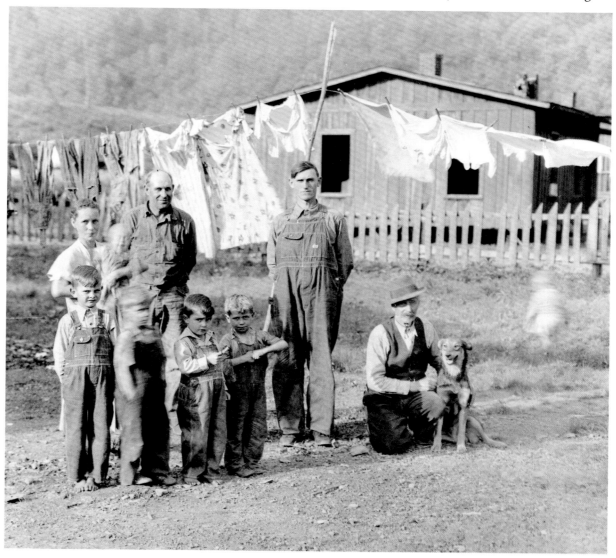

Weaver's Store,
near Marshall, Illinois

Dirt Farmer, Hertzel, West Virginia

Abandoned Fox Farm, near Calfax, Ohio

Norris Dam, Tennessee

East Side Portrait

I wanted to take a photograph of the center of Orchard and Stanton Streets from above and asked permission to go to the second floor of a small restaurant. This man was simply sitting there, quietly playing cards when I arrived upstairs. I was able to speak with him a little because I knew a bit of German. He looked very beautiful to me and I asked if I could take his picture. He agreed and I used the light as it was. I held the shutter open for about ten seconds, as long as he could hold still; when I saw him start to move I shut it.

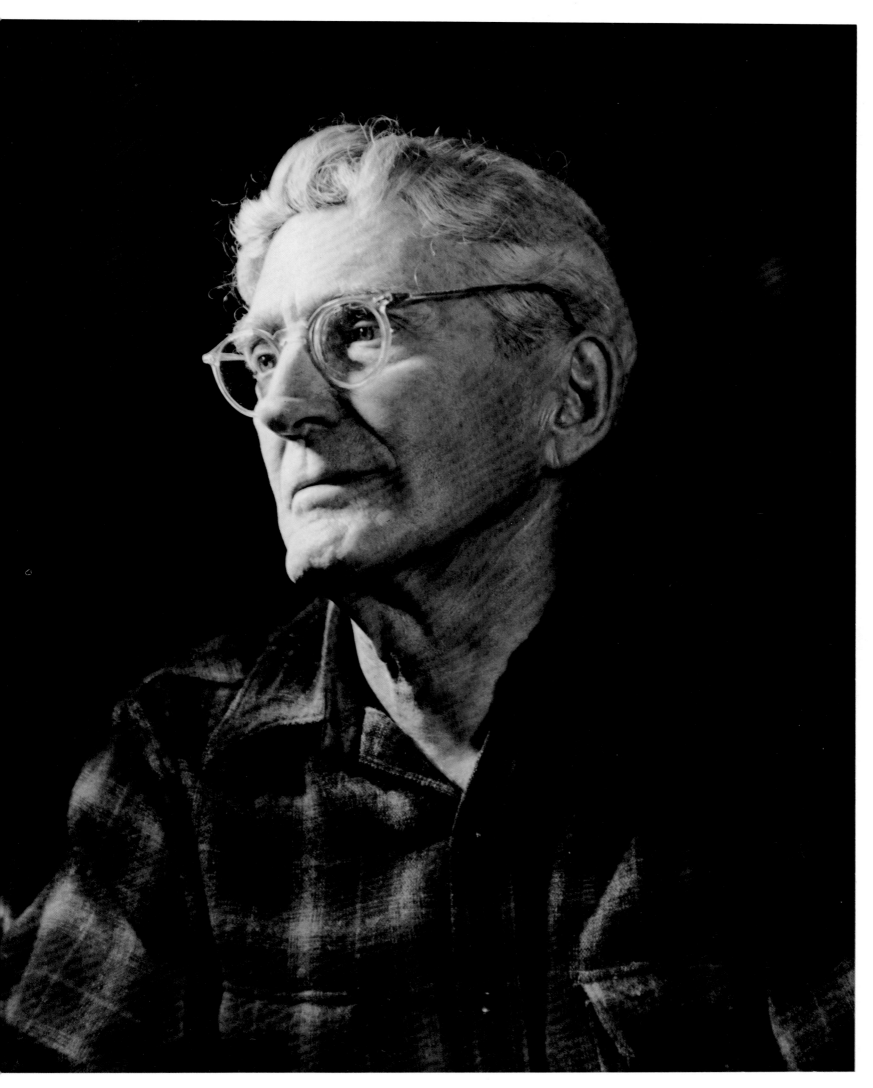

John Sloan

This was taken in the late 1940s for Greenwich Village Today and Yesterday. *Sloan was living at the Chelsea Hotel and was still active; he was in the last* *phase of his work, doing nudes. He died a short time later. There was almost no illumination and I had to set up lights to make the portrait.*

Max Ernst
Max Ernst had just come to the United States and was married to Peggy Guggenheim when this was made. It was taken at Peggy's home in New York. Later I took photographs of Peggy's gallery, Art of This Century, and did some work with Max as well. I have seldom exhibited this photograph, thinking it was too posed. It looks better now.

José Clemente Orozco
Orozco was in New York in the 1930s for a meeting of the Artists' Congress. I saw him and was impressed with the strength in his face and asked to take his portrait. I was living on Fifty-third Street, across from the Museum of Modern Art. He came by and sat for me; it was one of the few times I asked anyone to pose for me after I returned to New York.

Isamu Noguchi

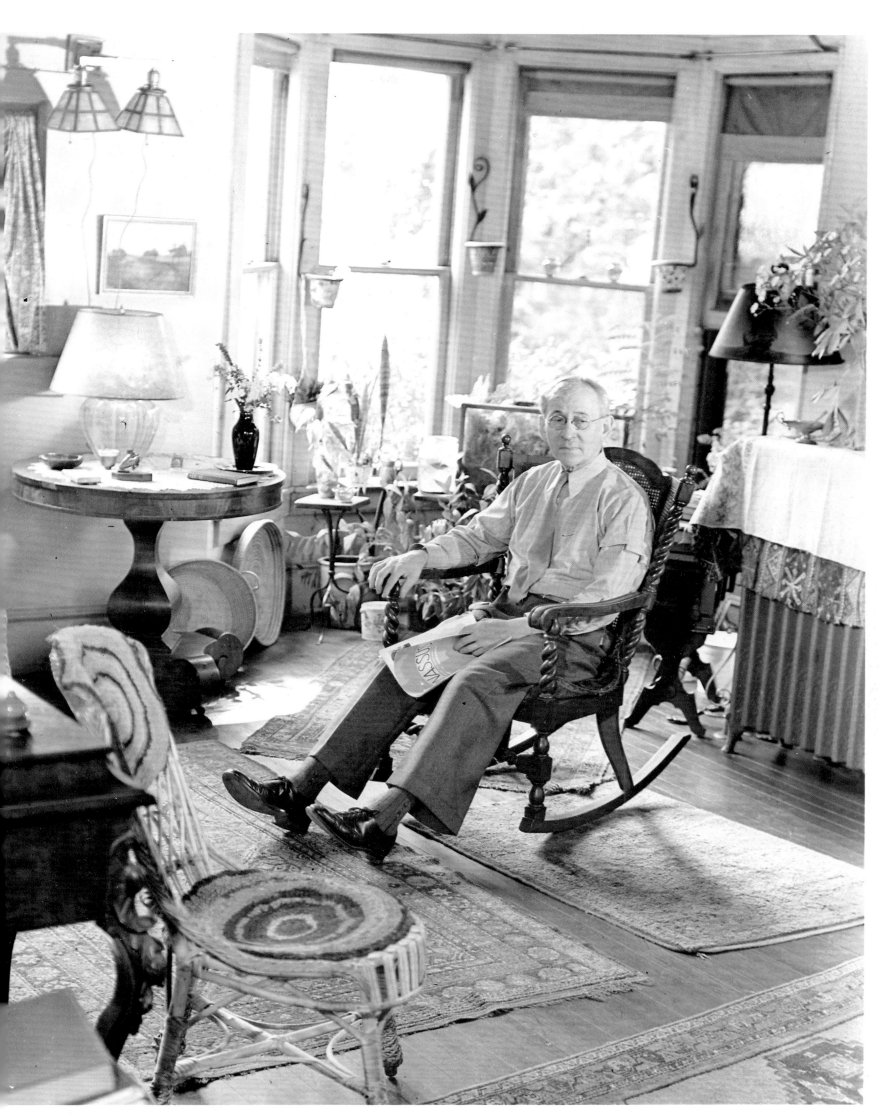

Lewis Hine
When I went to call on Hine I had no intention of photographing him; the series I made was purely an afterthought.

Philip Evergood

Louis Eilshemius
I have no recollection as to why I photographed Eil- *in his house. In fact, it was the only private home left*
shemius, but I remember it was extremely difficult. He *on Fifty-Seventh Street that did not have electricity.*
had palsy and shook a great deal and there was no light *This photograph is something of a miracle.*

Eva Le Gallienne
I took this strictly as a commercial assignment. Le Gal-
lienne was playing Hedda Gabler at the time and wore
a costume from the play. This is an overly theatrical
portrait but she was like that; there was little else to do.

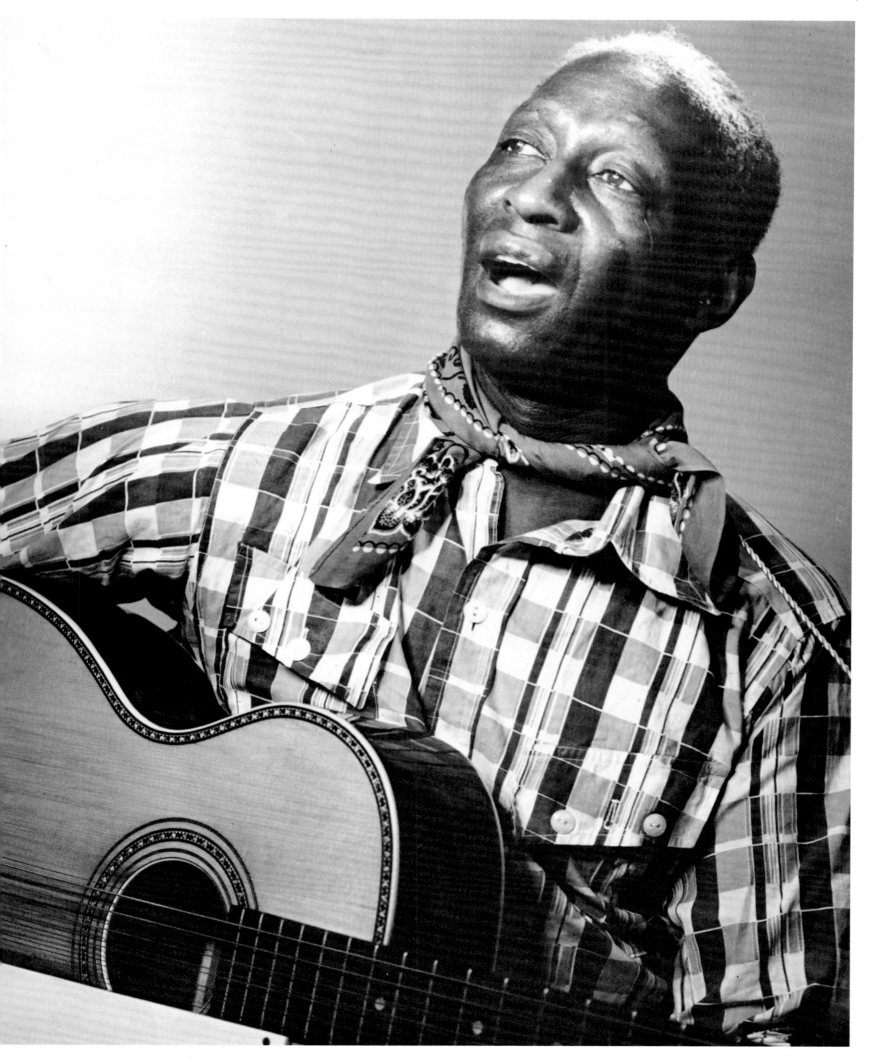

Leadbelly (Huddie Ledbetter)
This was another purely commercial assignment. After I was contacted by a woman who was promoting him, Leadbelly arrived at my Commerce Street studio one afternoon. It was a difficult assignment; I had little electric power and I had to light him with all the lights I owned because he was so dark. At the same time I wanted to capture as much spontaneity as I could. Given the circumstances, the results are satisfactory.

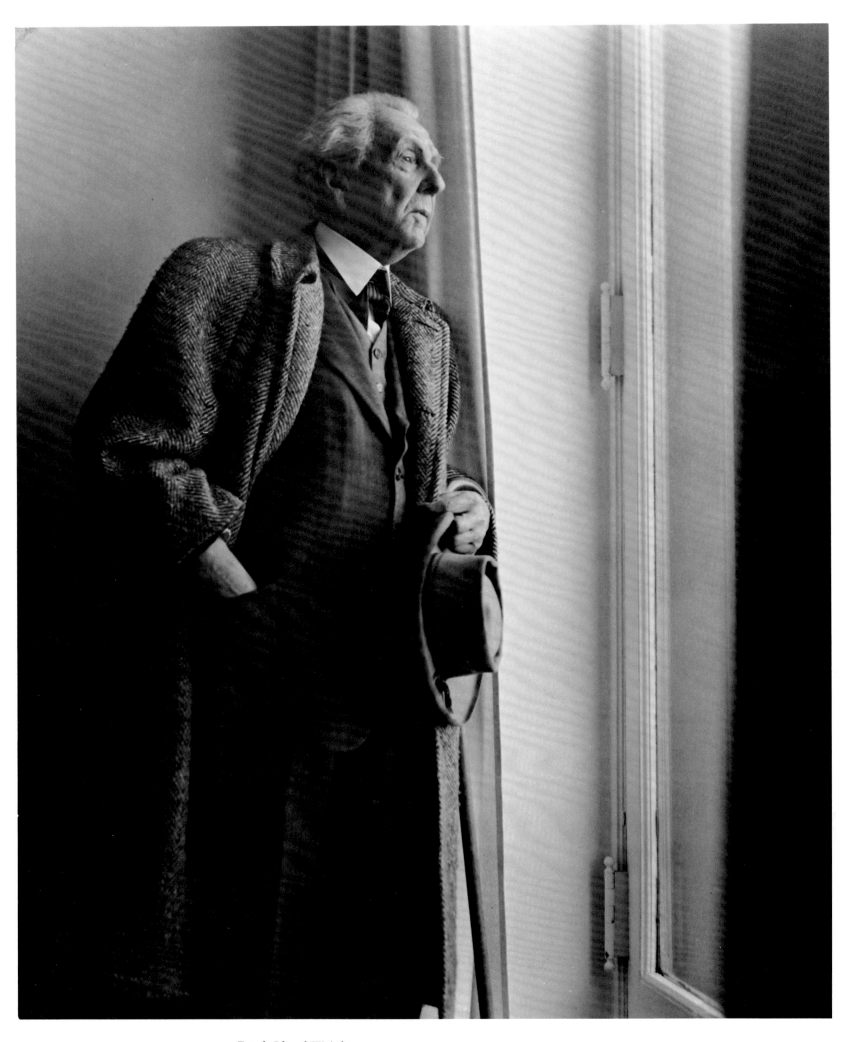

Frank Lloyd Wright
Wright was looking out the window at New York; as I recall he was both angry and sad. This was taken in the early 1950s, before the Guggenheim Museum was built. Earlier, in the late 1930s, he had asked me to photograph some of his buildings but had been unable to pay enough for me to afford to be on the road with him and keep my apartment in New York. It would have been a most interesting challenge. At this meeting, however, he didn't even remember the offer.

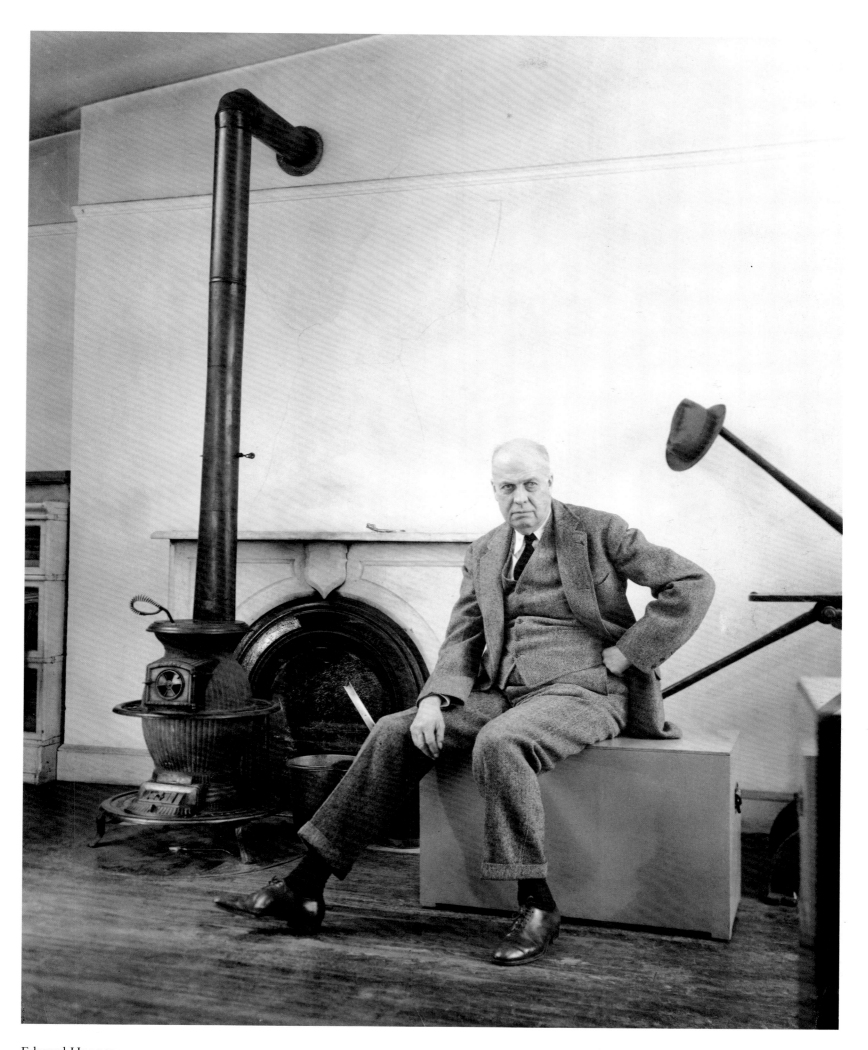

Edward Hopper

It has been said that my Fifth Avenue houses photo-graph looks like a Hopper. I didn't know his work when I took it, but once I became aware of him I liked him very much. I wanted his portrait for my Greenwich Village book and approached his dealer to make the arrangements. This was the best of a series of photo-graphs I made at his apartment on Washington Square.

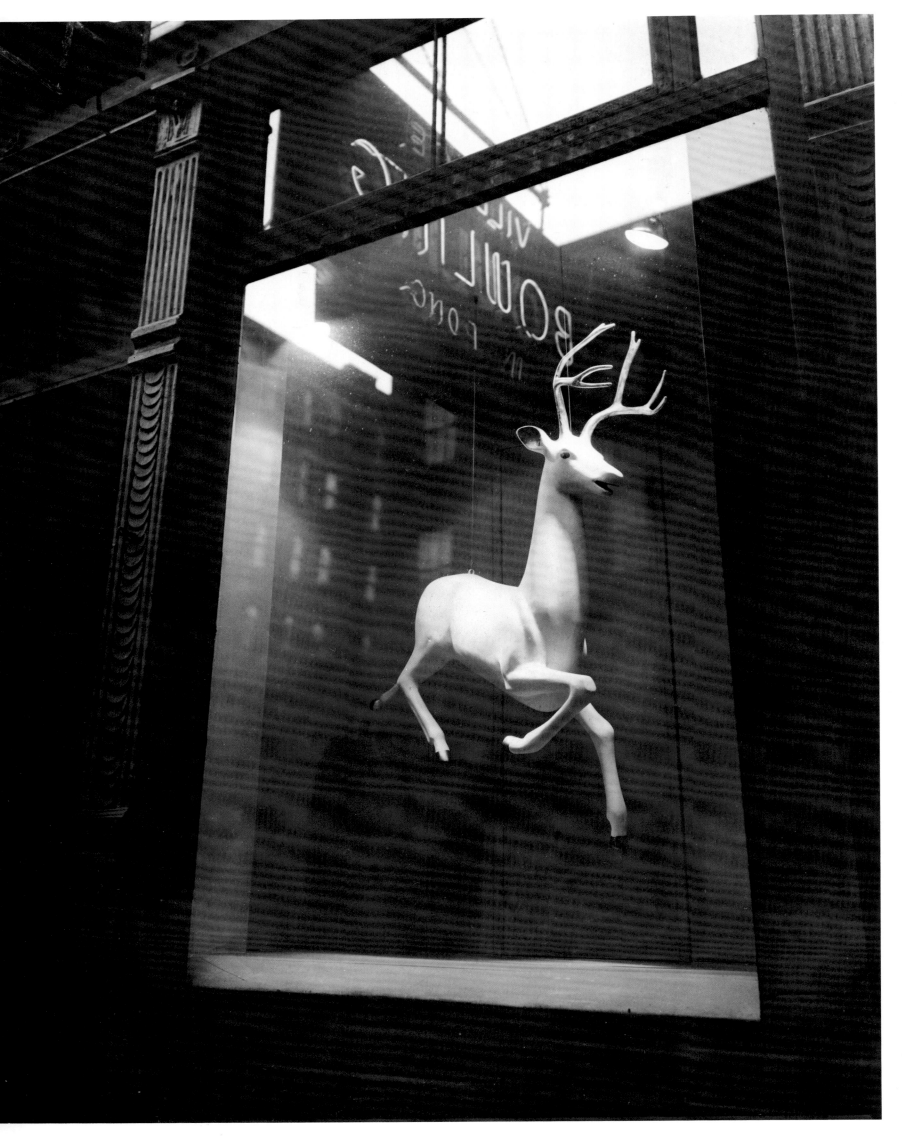

Designer's Window, Bleecker Street

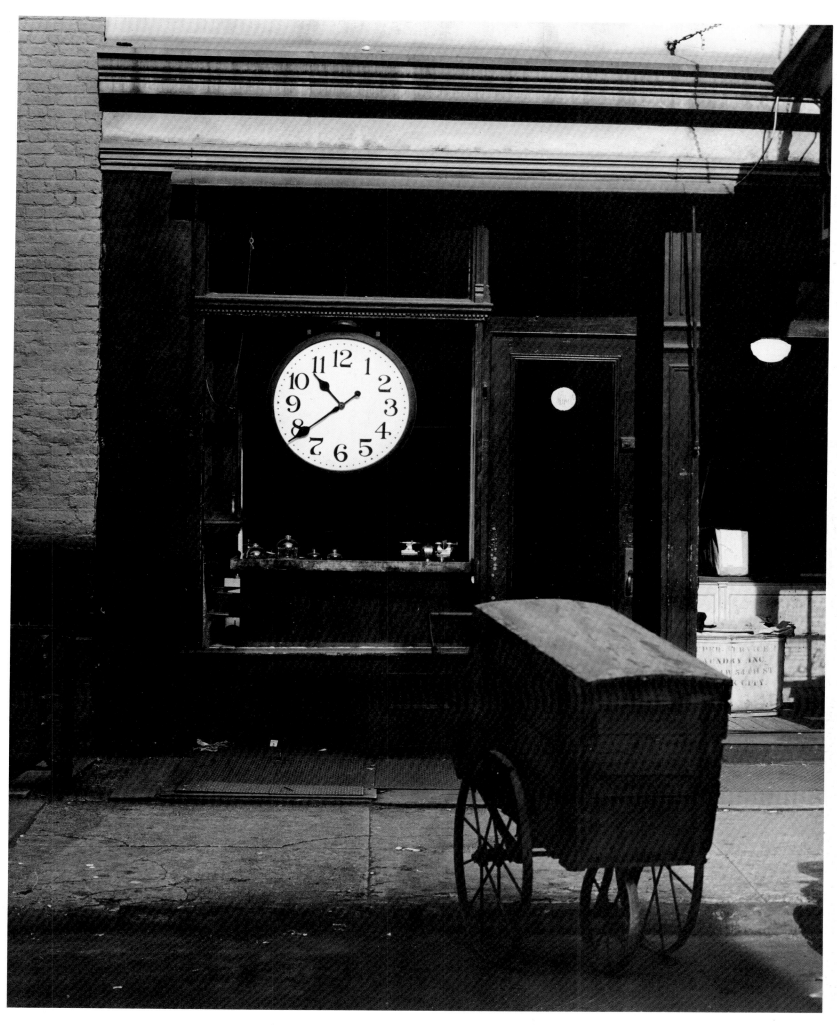

Repair Shop, Christopher Street

I had had my eye on this spot for a long time. I finally got around to taking it in the early 1950s when the old streets, which were once fairly decent, were becoming crowded. There was just enough room between two parked cars to make the photograph, and there were no garbage cans in sight, but just as I get set up a car started to back into the space. My assistant was able to hold the car off long enough for me to get one hurried exposure and as a result this photograph must be carefully cropped, using only part of the negative.

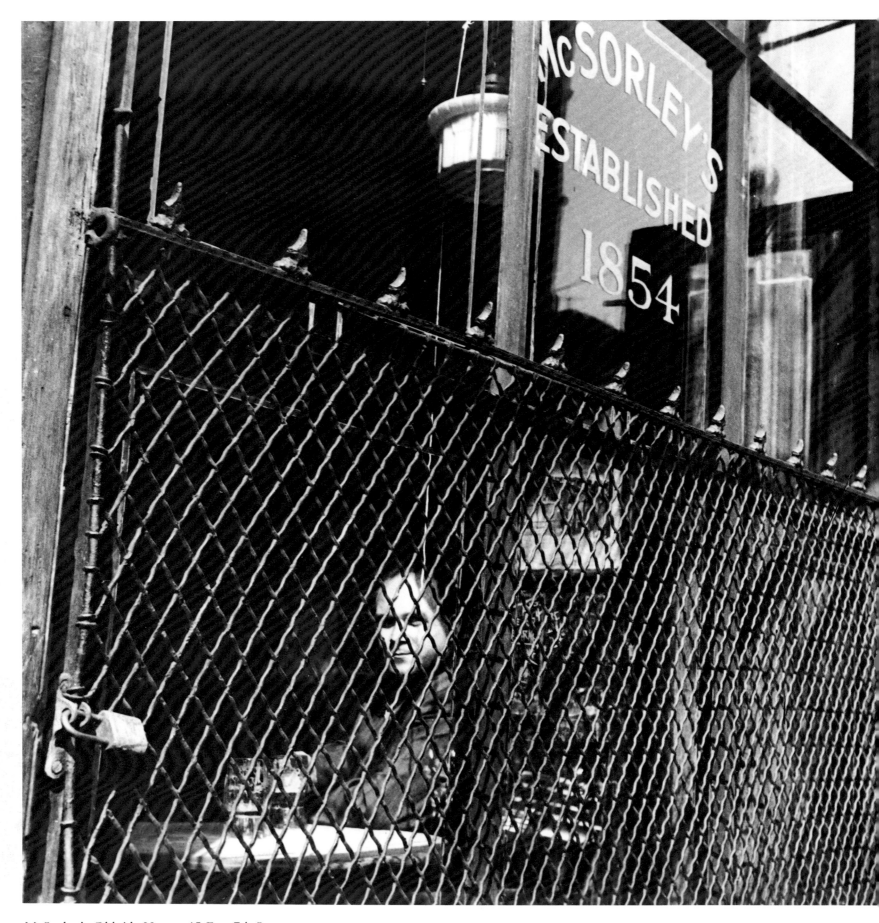

McSorley's Old Ale House, 15 East 7th Street
*I walked by McSorley's one afternoon and here was this
great light and the man sitting in the window. "This is
it," I thought, and just took it. The photograph of the
outside of the place turned out much better than the ones
I had made earlier of the inside, when I had been ner-
vous and the all-male customers had reacted with horror
at my being there.*

Hacker's Art Books

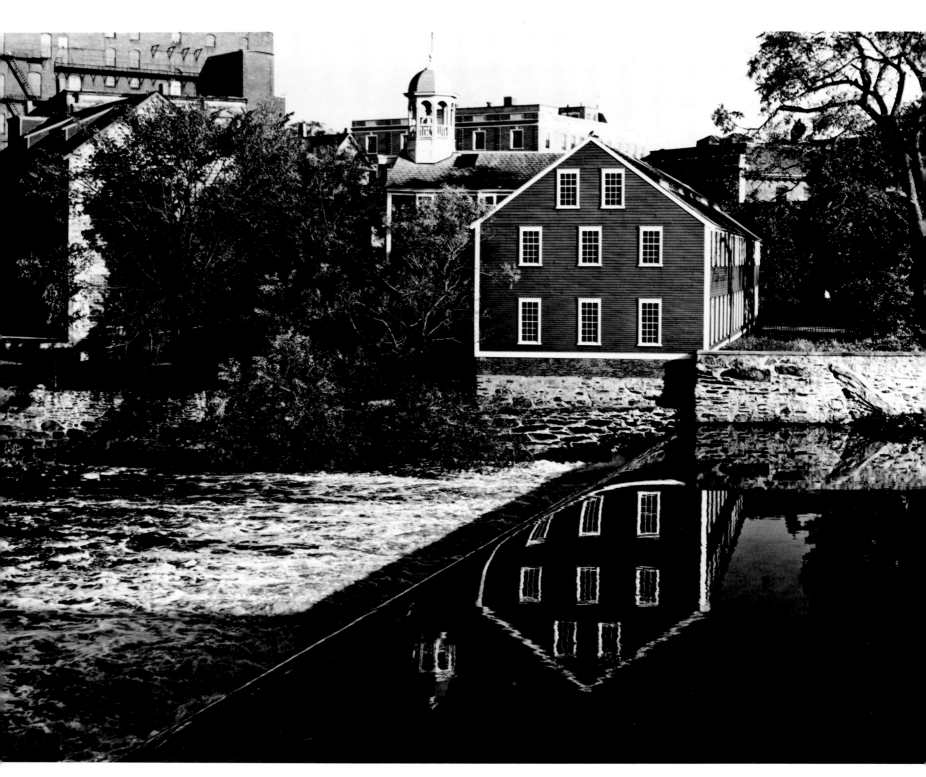

Mill, Pawtucket, Rhode Island

American Shops, New Jersey

Sunoco Station, Trenton, New Jersey
*I thought this scene would make a fine photograph the
moment I saw it, although it turned out to be a very
difficult one to take. It required great depth of focus for
the flapping flags and in order to fill the frame properly.
This was a particularly lively gasoline station, so lively
that I had to underexpose it to get everything: the men,
the flags. I could have exposed it five times as long to
make the negative perfect but then it would not have
been a good photograph.*

Pile of Junked Cars, West Palm Beach, Florida
I don't care about color photography but this pile of rusting cars would have looked very nice in color, if done very carefully. Color crowds the photograph more. In photography three dimensions are reduced to two, and when you add color there is just too much information crowded in for the size of the photograph. Color is only important in science, and there it is not only important but essential. Even so it has to be very good.

Fruit Market, South Dixie Highway, Miami, Florida

Bus Tourist Court, near St. Augustine, Florida
This is a typically American photograph; you would only see this in the United States. There is also something appealing about an old bus. Motels and hotels along the road now are no longer interesting; they have dull, mechanical standards. You can get a bath in one but little else.

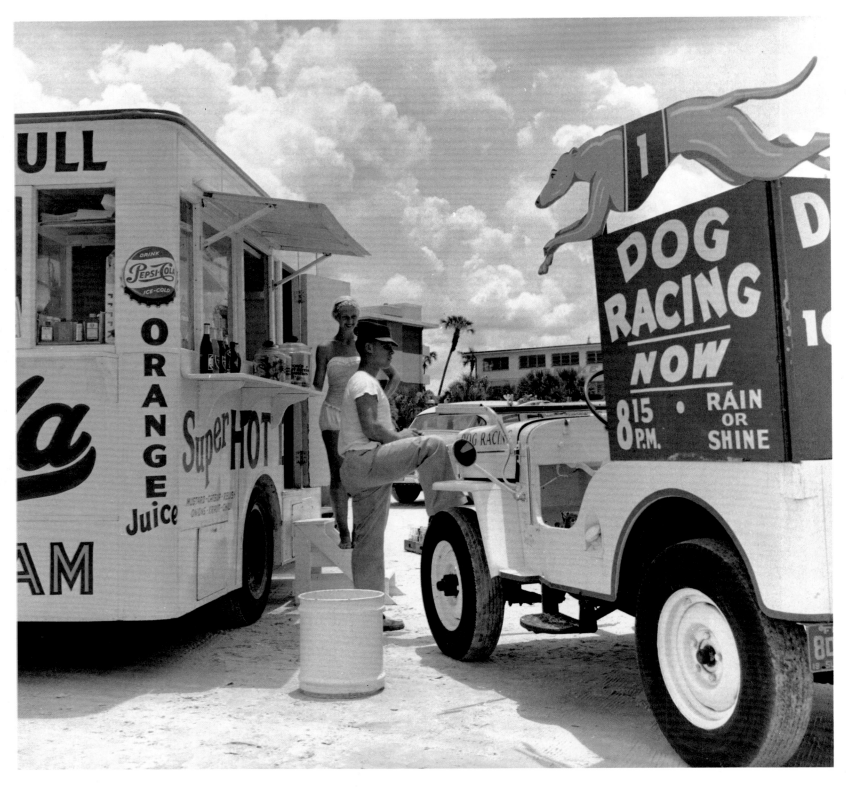

Superhot, Daytona Beach, Florida
Florida is a place where they say people should go to play. So there are all these amusements around to keep the northern visitors occupied. Dog races, amusement parks, the beach, vulgar postcards and so forth. I found much of it appalling but I'm afraid it was typical of what many people wanted.

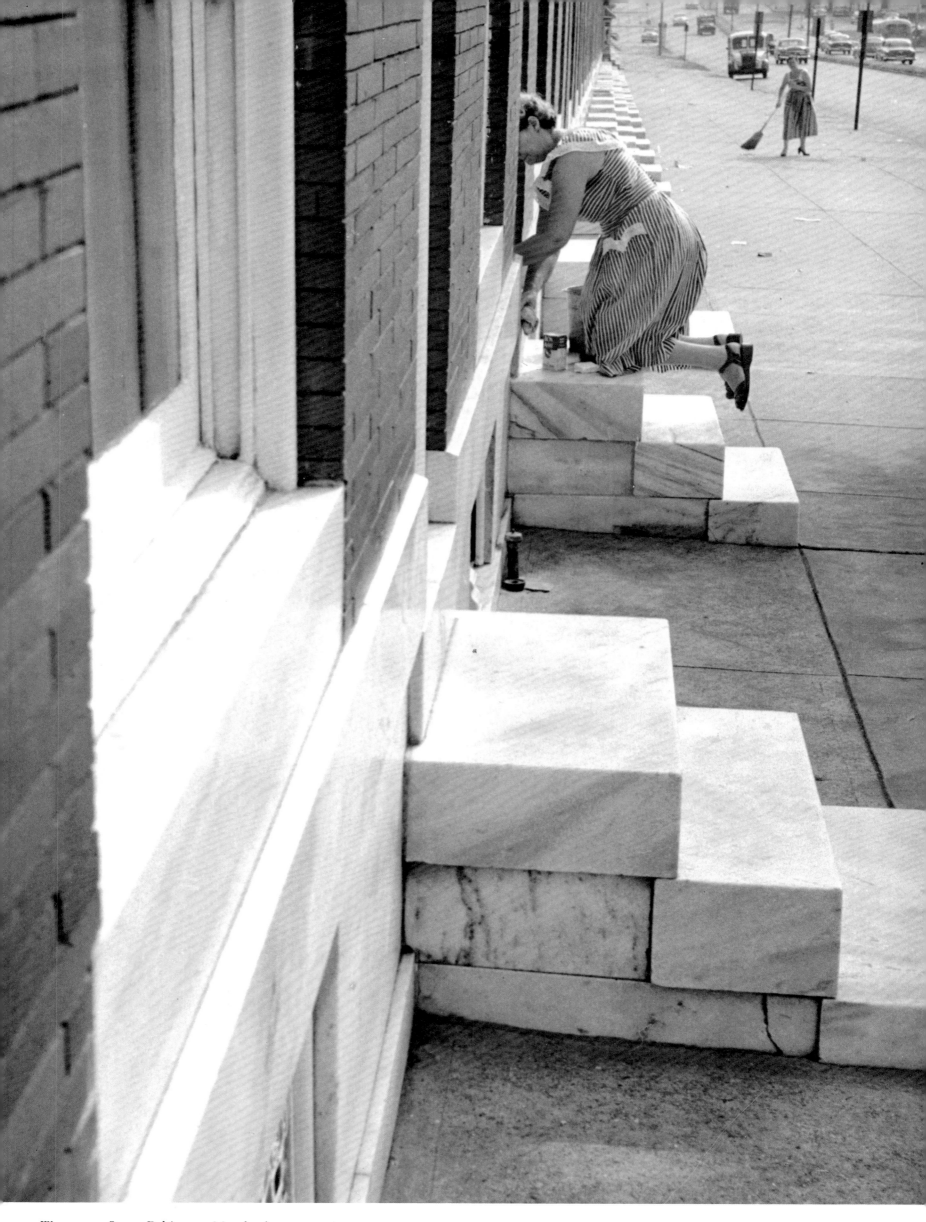

Woman on Steps, Baltimore, Maryland

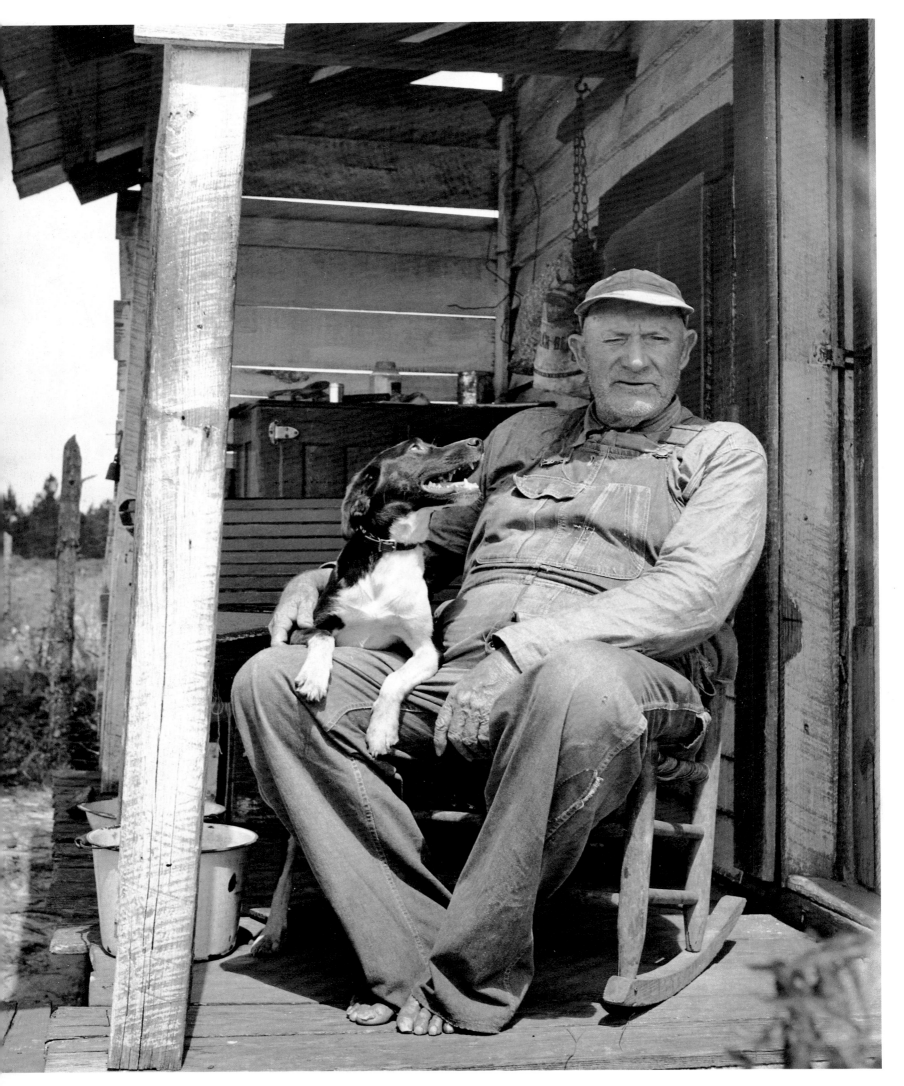

Old Man on Porch
Here is one of the people who made for the tension in the South. He felt vastly superior to any black man out doing all the work, sweating in the sun. It was so dreadful I don't even like to talk about it.

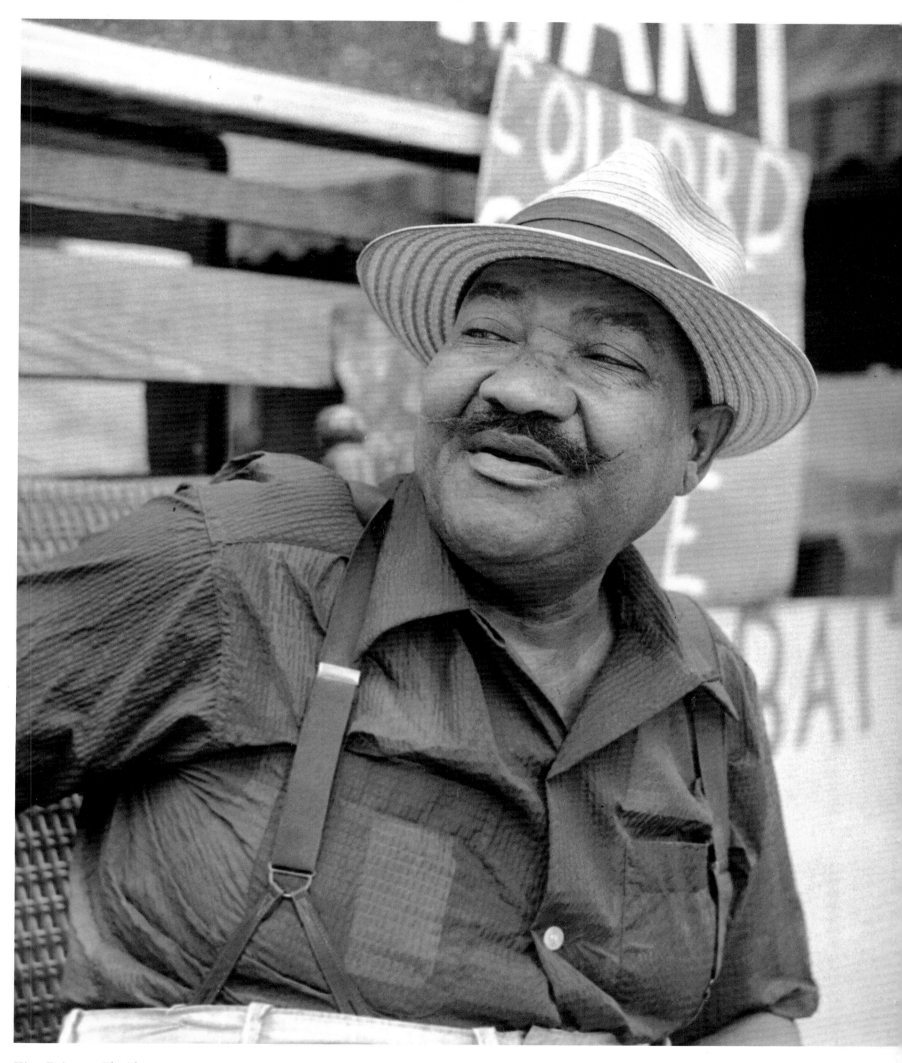

King Baitman, Florida

Postcards, 819 Main Street, Daytona, Florida

Signs Along U.S. Route 1
There was a lot of this along the road. Once I was staying in a motel or trailer camp and next door was one of those preacher things going on with a loudspeaker shouting about God and get right with your sins and everything. I thought it was just dreadful; it made me very nervous and miserable and I got out of there just as fast as I could.

1411 9th Street, Augusta, Georgia

Baptist Church, Augusta, Georgia

Just a little church in Augusta, Georgia, on Route 1. I tried to stick to the plan and not veer off the road. This town was quite a place; there were many things I would have liked to take but I didn't have the nerve. The house was just down the road. A miserable little house, *with the beautiful sunflowers in front. I tried to play them up to give the photograph a little hope. I tried to be friendly with the people, but it was hard; they just distrusted you so much. It was a time of great tension with the school desegregation thing going on.*

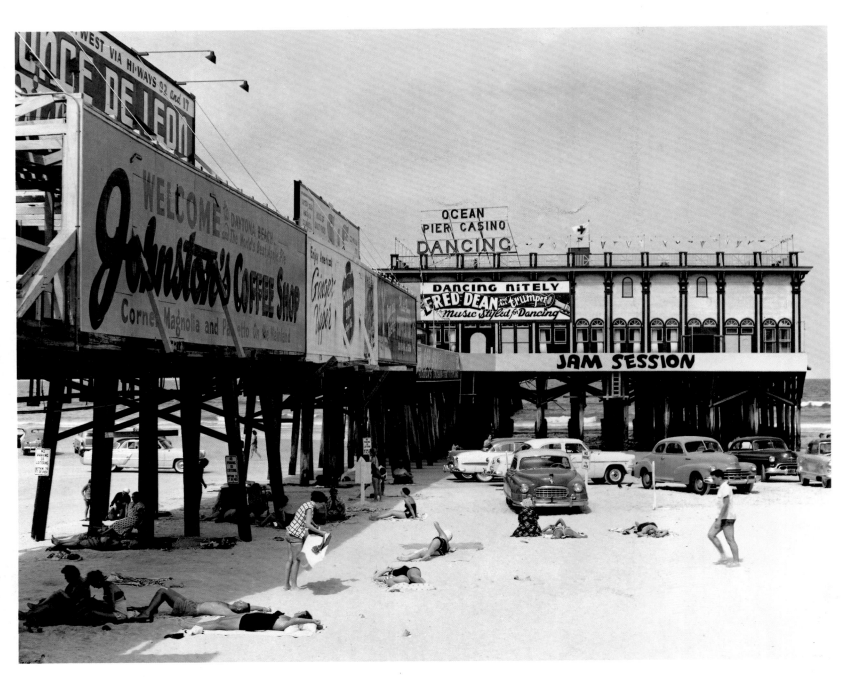

Boardwalk from Beach, Daytona Beach, Florida

Beach from Boardwalk, Daytona Beach, Florida
There is never any one way to take a subject; often there are many. These, like the two views of Columbus Circle in New York (pp. 132–133), amply reveal that by moving the camera a great deal, or even slightly, dramatic results can be achieved.

Berenice Abbott, about 1960

Science

In 1939 Abbott began her most ambitious photographic project. Believing scientific phenomena to be as valid a subject for artistic statements as man and his works, she undertook to prove that photography was the medium uniquely qualified to unite art with science. She labored alone for nearly twenty years with little or no encouragement until finally, in 1958, her work was recognized by the Physical Science Study Committee and she was hired to work with that group at the Massachusetts Institute of Technology for three years.

In this period, spanning twenty-two years, Abbott produced thousands of photographs in formats ranging from 8″ x 10″ to 16″ x 20″ and designed and patented a good deal of scientific equipment, including two cameras. Abbott's scientific photographs are her most significant and in years to come they will perhaps be recognized as her outstanding accomplishment.

Parabolic Mirror

This is one of the most difficult photographs I ever took. Each of the scientific photographs was different, different in its own peculiar way, and there was usually no precedent to go by. The interesting thing about this photograph is the huge background it required—perhaps fifteen feet. First I photographed the eye, enlarged it and mounted it on a piece of cardboard. Then I positioned it so the camera would be at precisely the right angle to catch the reflection of the eye in each of the small mirrors mounted on the concave surface.

A long exposure was necessary because of an additional problem. I was very fond of many of the homely little devices the scientists came up with for my experiments, and so I broke my neck to get the base of the stand in the photograph. I lay awake at night trying to figure out a way to get it in the picture. Finally I did something I never had before and never have since, and used an elaborate raised back swing that enabled me to include the stand, improving the composition.

Cycloid

A rolling cylinder with a lamp on its axis and another lamp on its rim traces the path of light. The horizontal path marks the axis lamp, the curve forms that of the rim lamp. The composition was carefully planned, and I needed two exposures. The spacing was important in making this an intelligent, thoughtful photograph. I also wanted the light to look like a light with a halo and not just a line. The trouble was, the lights had different densities; one moved in a straight line, the other took a much longer path. I finally devised cellophane filters. Later, when the photograph was shown at the MIT Faculty Club, Norbert Wiener told me this was not a perfect cycloid because the light was not exactly at the edge. I knew this but it was impossible to do it any other way. It was gratifying, however, to have someone like that to discuss the work with and help look for accuracy.

Spinning Wrench

We suspended it at its center of gravity on a long piano wire, which would not give or stretch. The center of mass moves in a straight line, even though the wrench appears to travel erratically. The wrench was painted white. I was on a tall ladder, looking down, as near the wrench as possible. The wrench had been wound on the wire so that when it was thrown it would turn. It was very near the floor and I had to have an assistant move the lights with it as it traveled, keeping the light off the background. We had to practice many times before we got this one correct; later we used moving lights on other experiments with good results.

Time Exposure of a Bouncing Ball
The scientific photographs had to be carefully composed, but they could not look that way. I didn't want the composition to be so obvious as to take over. The white ball was thrown with some force to show that the angle of incidence equals the angle of reflection. The composition doesn't take over here; when you look at a photograph and all you can see is composition then you know it is a big flop.

Strobe Photograph of a Bouncing Ball

Collision of a Moving Sphere and a Stationary
Sphere
*This illustrates the conservation of momentum in
spheres of equal mass. After the collision, the spheres
move off with constant velocity.*

Transformation of Energy
*Potential and kinetic energy are shown in the swinging
pendulum. At the top of the swing the pendulum
represents potential energy; when it reaches the perpen-
dicular, energy has become kinetic. I planned this pho-
tograph very carefully to make it balanced; what is more
balanced than science? The photograph had to balance.
It had to be subtle—not just an arty composition. It was
difficult to construct the apparatus; then we had to paint
it correctly. It was important that part of it be gray, not
white. The photograph was a tremendous challenge, but
here I missed just a little. This one should have gone
on 1/30 of a second longer.*

Multiple Exposure of Bouncing Golf Ball
*This shows the decrease of energy in a moving object.
This was one of the early photographs on the PSSC
project. The golf ball was rolled off a platform that was
about six feet high (the relative size is very important
here) and it headed toward a marble surface. I was well
centered and the camera was low, almost on the floor. I
knew as much about lighting this kind of thing as any-
one and I didn't just use a strobe at the camera. This
would have shown the effect but the balls would have
looked flat.*

Multiple Exposure of a Swinging Ball
in an Elliptical Orbit—1 & 2
This was a very interesting experiment. The stationary billiard ball was suspended on a piano wire. We built a scaffold so that I could be above the ball and look right down on top of it, as near to it as possible. The swinging ball was on another wire and was given a whirl. It went in an ellipse, of course, not a circle. The strobe was in front of the lens, whirling about 1/30 of a second. I had to stop at exactly the right second or it would not have looked right, and the balls had to be lit in such a way as to look as round as possible. I wanted them to be beautiful as well as scientifically accurate.

The Pendulum
This was taken with a stroboscopic camera at 1/30 of a second.

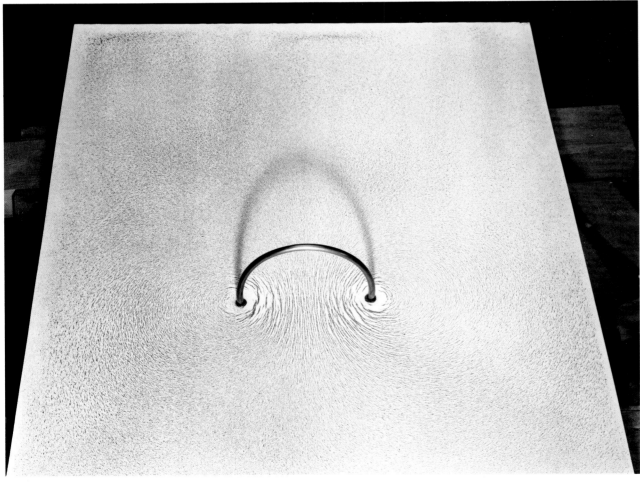

Magnetism and Electricity—1 & 2
In both photographs, steel filings show the magnetic field around a wire carrying an electric current.

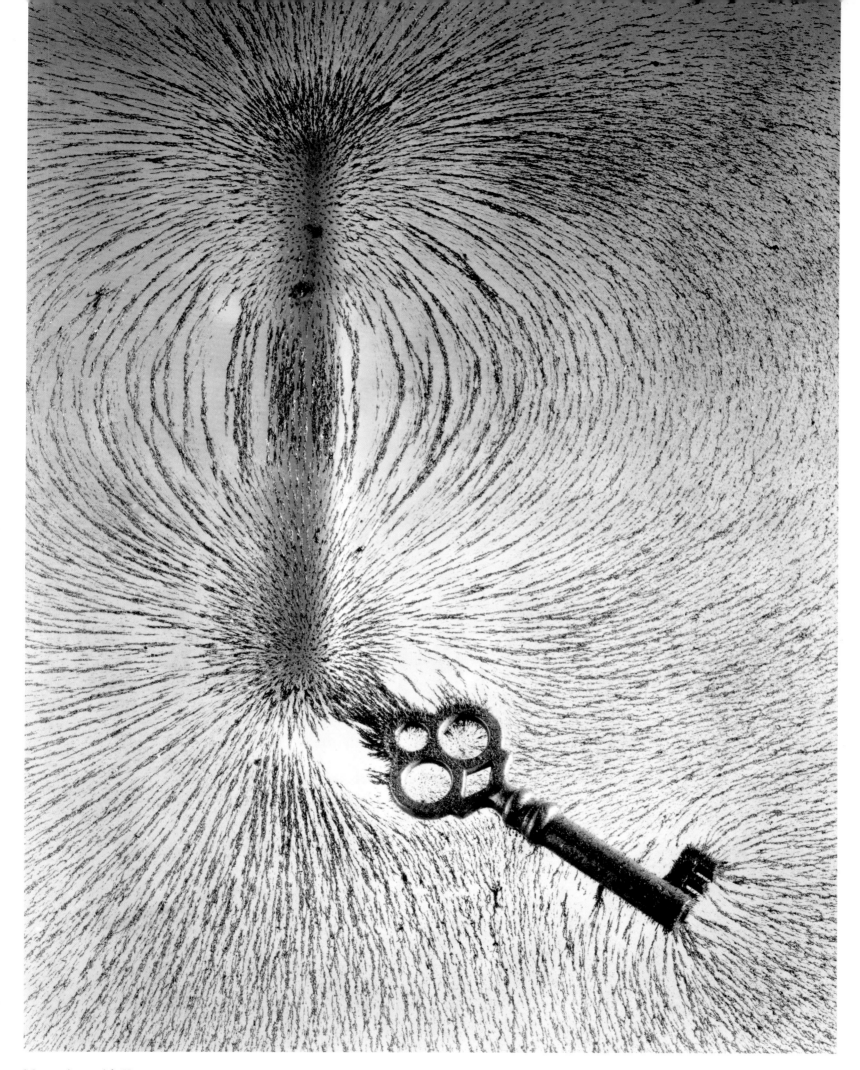

Magnetism with Key

A metal key changes the magnetic pattern of iron filings around a bar magnet. I had done magnet studies on my own long before I joined the PSSC, including the key study. The filings in the key photograph were iron and very crude. Later I used steel and they worked much better to show what I wanted. It was always difficult to space the filings. I finally wound up blowing them on the surface with a straw. The shadows also had to be very precise, otherwise the compositions would have been dull.

Wave-forms

I have always been proud of my wave photographs; as far as I am aware the method I developed had not been used before. The trouble with the photographs was that they were a little too good, people were not used to seeing the waves so clearly. When I did A Guide to Better Photography *I included one experimental wave photograph. My idea was to do a Rayogram in motion. Moholy-Nagy and Man Ray had done pictures by putting objects on sensitized paper but I wanted to do the same thing in motion. I put a piece of sensitized paper in a developing tray, rocked it pretty hard and shot off a flash bulb that was about 1/200 of a second, holding the light source as far away from the tray as possible. It came out very interestingly and I thought I could use the same technique at PSSC with a bigger ripple tank. It didn't work because the waves were too small, and I had to do many tests before I discovered that if I got the paper far enough away from the tray*

the waves would focus themselves, much like a lens, and at a certain distance the waves registered as being very large.

Then I needed a faster strobe. The lights Harold Edgerton had at MIT were very primitive and I needed a very fast light to stop the action; there was no camera, no lens. I finally devised a system of putting a pinhole over the light source. The combination of the point source light and the sensitized paper away from the tray solved the basic problems, but then another one quickly arose. The ripple tank collected dust, bubbles and a host of other impurities. All of these were magnified by the waves, and the water had to be changed constantly. Even so, the photographs that resulted were extremely difficult to retouch. Then there was the question of whether to use a positive or a negative for the illustrations; I chose negatives because they were easier to read.

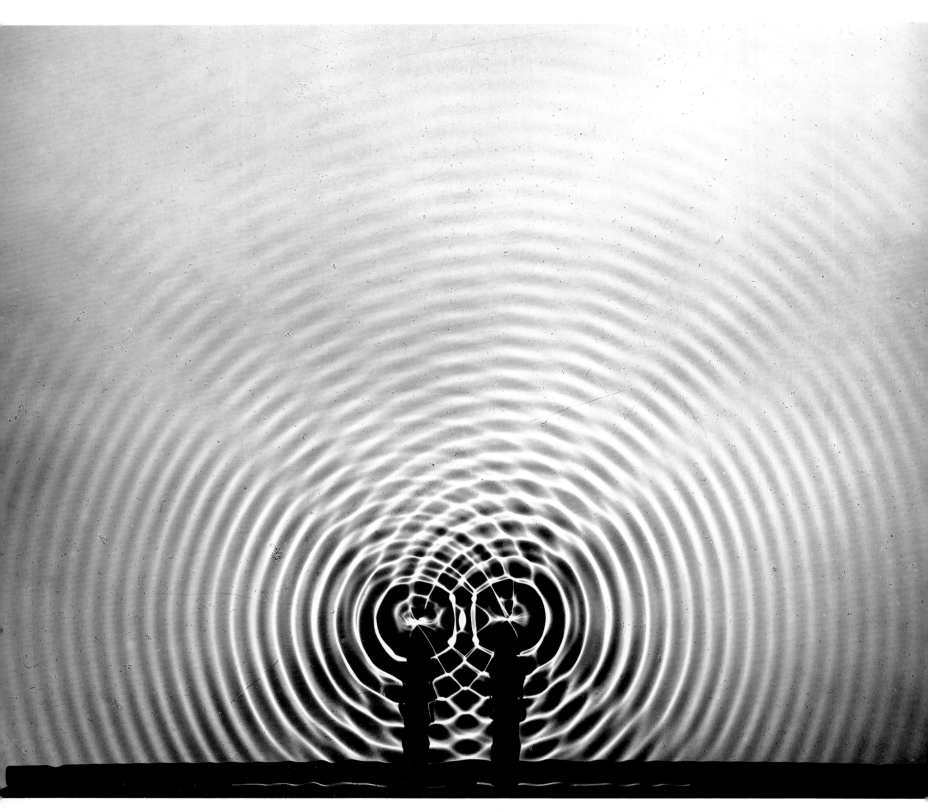

Interference Pattern
This was produced by two interacting sets of circular waves.

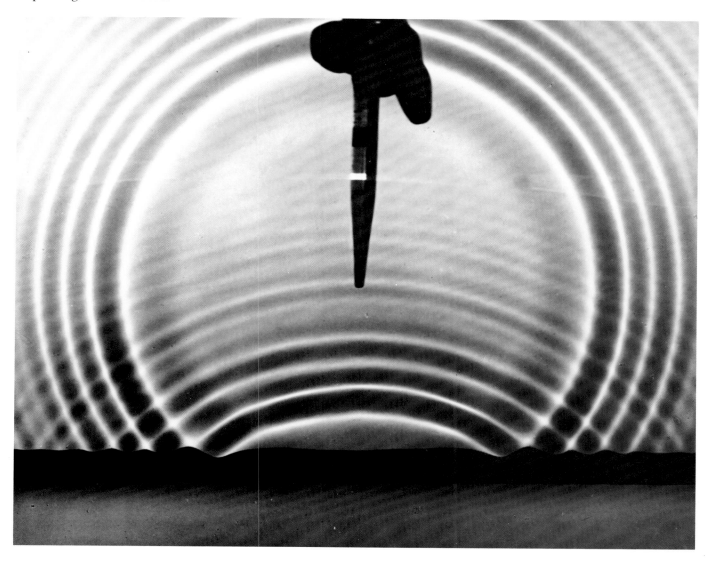

Parabolic Reflection

Periodic Straight Waves
These are caused by a vibrating bar which generates these waves to travel across the tank.

Reflected Water Waves

Like light, these leave the reflecting surface at the same angle at which they approach it. Here are straight waves reflected from a barrier set at an angle of 45 degrees to the wave front.

Focusing Water Waves

To focus water waves as a lens focuses light, a convex piece of plate glass is used in the ripple tank. Straight waves from the bottom of the photograph converge after they have passed over the "lens".

Water Waves Change Direction

Water waves slow down in shallow water. The light changes direction, and the water waves change direction. The experiment shows shallow water over a rectangular glass plate in the ripple tank. The photograph shows that the wave length is shorter.

Water Waves Produce Shadows

Straight waves incident on a round obstacle are seen as the shadow above the obstacle. The shorter the wave length, the sharper is the shadow.

Light Rays
Multiple beams of light from a source change direction when they go into a glass plate and when they emerge. Some waves are reflected inside the glass and then escape. The prism photograph was done very carefully. The prism was filled with water and not one drop of air was inside. The box that held the light source was specially designed and purposely looks as it does to make for a better composition.

Bubbles
This was made for Science Illustrated, *long before the PSSC project. It took at least three days and in a way it is a masterpiece of its kind. The soap bubbles here are very small—actually this is a macrophotograph. I set off a small flash underneath the glass pan holding the suds. I made many exposures and most of them came out mushy. This one finally worked, showing the structure of the suds perfectly.*

Multiple Exposure Showing the Path of a Steel
Ball Ejected Vertically from a Moving Object
*We built a special ramp and track for the toy train. I
painted the wheels and the small ball to be ejected white.
Then I planned the composition. I needed exact spac-
ing; this was not just a record, the composition was
extremely important. It was a time exposure of sorts.
First I photographed the train at the point that was to
be the beginning. Then the train was allowed to roll
down the ramp, and at the exact instant the ball was
ejected I opened the shutter and then closed it down at
the point where I knew the composition would work. It
took three days to get this one right.*

Berenice Abbott, 1980

Maine

Abbott discovered Maine during 1953 while working on the Route 1 project; she bought property there a few years later and settled in Maine permanently in 1966. In 1967 she undertook a documentary study of her adopted state, understanding from the beginning that Maine was more and sometimes less than quaint fishing villages and picture postcard scenes. The state was, in fact, often stark and drab, full of hardworking people who lived off the land and sea and who often had little time to recognize the beauties of nature. The best of her photographs were published in *A Portrait of Maine,* as honest a study of the state as any made.

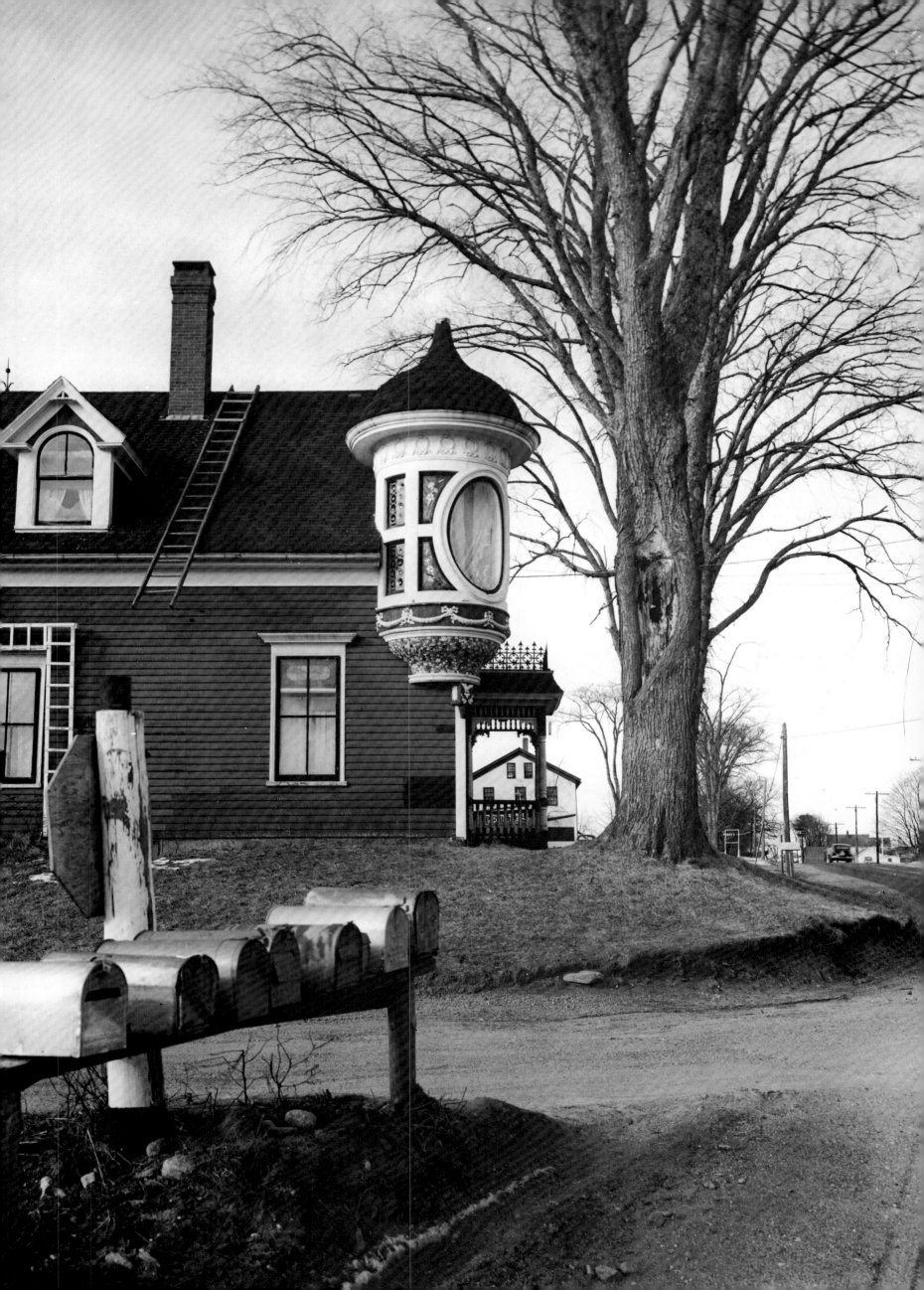

House, Belfast, along Route 1 (preceding page)

Rutted Road, Matinicus Island

Old Man, Spruce Head, near Port Clyde

Lobster Traps and Workmen, Stonington

Mitten Knitting Contest, Sander's Store, Greenville

Pony Endurance Contest

Millikin's General Store on Sunday Morning, Bridgewater

Group of Potato Farmers, Aroostook County

Horse-drawn Sledge

Dog in Bushes by Road, Matinicus Island

Child Gathering Potatoes, Aroostook County

Canoe Tobogganing at Moosehead Lake, Greenville

Acknowledgments

A project such as *Berenice Abbott: American Photographer* requires the cooperation and assistance of many individuals. With thanks and gratitude, we wish to acknowledge the following: Pierre Levai, Marlborough Gallery, Harry H. Lunn Jr., Lunn Graphics, and Lee Witkin, Witkin Gallery, for their contribution of photographs and related material; Liza Stelle, Julie Dean, Chris Haft, and Cheryl Greany for assisting in making prints; A. K. Baragwanath and Steven Miller and the Museum of the City of New York for assisting with captions; Paul Katz, John DeVries, and Fran McCollough; Cornell Capa and his staff at the International Center for Photography for their Berenice Abbott exhibition and their assistance; Kornelia Kurbjuhn for designing this book and Ray F. Patient for supervising its production; Milton Esterow, Chairman, Artpress Books; Brenda Gilchrist for editing the text; and, of course, John L. Hochmann, President, Artpress Books, for having the vision to recognize the merits of the project in the first place and the persistence to see it through to its conclusion.

Hank O'Neal

Notes on the Photographs

2 Nightview (8 x 10)
10 View of Amsterdam
11 Eugène Atget, Paris (3½ x 4½)
12 André Calmettes, Paris (3½ x 4½)
14 Chick Webb's Orchestra, Savoy Ballroom, New York, 1929 (5 x 7)
15 Manhattan Bridge (8 x 10)
17 Doorway, 204 West 13th Street, New York, 1937 (8 x 10)
21 Red River Logging Company project, 1945 (2¼ x 2¼)
30 Houses, Stonington, 1967 (2¼ x 2¼)

Paris Portraits
All portraits were taken in Paris from 1926 to 1930 except as noted below. The New York portraits were taken from 1929 to 1931. All are glass plates except those followed by an asterisk.
35 Janet Flanner (3½ x 4½)
36 René Crevel (3½ x 4½)
37 Isamu Noguchi, New York, 1929 (3¼ x 4¼)
 George Antheil (3½ x 4½)
38 Sophie Victor (3½ x 4½)
39 Princess Eugène Murat, New York (3½ x 4½)
40 Caridad de Laberdeque (3½ x 4½)
41 Peggy Guggenheim and Pegeen (2¼ x 3¼)
42 James Joyce (3½ x 4½)
43 James Joyce (all 3½ x 4½)
44 James Joyce (3½ x 4½)
45 Nora Joyce (3½ x 4½)
46 Coco Chanel (3½ x 4½)
 Djuna Barnes (3½ x 4½)
47 Djuna Barnes (3½ x 4½)
48 Jane Heap (3½ x 4½)
49 Margaret Anderson (3½ x 4½)
50 Jean Cocteau (both 2¼ x 3¼)
51 Jean Cocteau (3½ x 4½)
52 Sylvia Beach (3½ x 4½)
53 Mme. Guerin with Bulldog (2¼ x 3¼)
54 André Gide (3½ x 4½)
55 François Mauriac (2¼ x 3¼)
 Jules Romains (3½ x 4½)
56 Mme. Theodore van Rysselberghe (2¼ x 3¼)
57 Bronja Perlmutter (2¼ x 3¼)
 Solita Solano (3½ x 4½)
58 Robert McAlmon (2¼ x 3¼)
59 Lelia Walker, New York (3½ x 4½)
60 Foujita (3½ x 4½)
61 Pierre de Massot (3½ x 4½)
62 Dorothy Whitney (3½ x 4½)
63 Marie Laurencin (2¼ x 3¼)
64 Eugène Atget (3½ x 4½)
65 Eugène Atget (3½ x 4½)
66 Renée Praha (2¼ x 3¼)
67 Edna St. Vincent Millay, New York (both 3½ x 4½)★
68 Alexander Berkman (3½ x 4½)
69 Serge Soudekian, New York (3½ x 4½)
70 Elliot Paul, New York (5 x 7)★
71 Helen Tamaris (3½ x 4½)
72 Fratellini Brothers (5 x 7)
73 Buddy Gilmore (3½ x 4½)

Changing New York
 These photographs were taken from 1929 to 1939. When a specific date is known, it is given. All photographs in this group were taken with an 8″ x 10″ view camera unless otherwise noted.
75 Washington in Union Square (2¼ x 3¼)
76 Rag Merchant (2¼ x 3¼)
77 Storefront (2¼ x 3¼)
 Friedman and Silver (2¼ x 3¼)
 Storefront (2¼ x 3¼)
78 El at Columbus Avenue and Broadway, 1930 (2¼ x 3¼)
79 Madison Square Park (2¼ x 3¼)
 Elevated Railway (2¼ x 3¼)
80 Beach Scene (2¼ x 3¼)
81 George Washington Bridge Under Construction (2¼ x 3¼)
82 Selling Out Men's Clothing (2¼ x 3¼)
 Burlesk Theater (2¼ x 3¼)
83 Man on Brooklyn Bridge (2¼ x 3¼)
 Lincoln in Union Square (2¼ x 3¼)
84 Construction Workers (2¼ x 3¼)
85 Building New York (2¼ x 3¼)
86 George Washington Bridge Under Construction (5 x 7)
87 Foundations of Rockefeller Center, 1932
88 Girders and Derricks (Rockefeller Center), 1932
89 Rockefeller Center, 1932
90 Under the El at the Battery, 1932
91 Dead Person, 1932 (4 x 5)
92 Saints for Sale, 1932
93 Fifth Avenue Coach Company, 1932 (3½ x 4½)
94 City Arabesque, from the Roof of 60 Wall Tower, June 9, 1938 (4 x 5)
95 John Watts Statue, from Trinity Church Looking Toward One Wall Street, March 1, 1938
96 Poultry Shop, East 7th Street, 1935
97 El, Second & Third Avenue Lines, Bowery and Division Streets, April 24, 1936
98 Ropestore: Peerless Equipment Company, 109 South Street, May 3, 1938
99 Brooklyn Bridge, Water and Dock Streets, Brooklyn, May 22, 1936
100 William Goldberg Store, 771 Broadway, May 7, 1937
101 General View Looking Southwest to Manhattan from Manhattan Bridge, March 30, 1937
102 Pennsylvania Station Interior, July 14, 1936
103 Pennsylvania Station Interior, July 14, 1936
104–105 Pennsylvania Station Interior, July 14, 1936
106 Gunsmith and Police Department, 6 Centre Market Place and 240 Centre Street, February 4, 1937
107 Murray Hill Hotel, 112 Park Avenue, November 19, 1935
108 Fifth Avenue Houses, Nos. 4, 6, 8, March 6, 1936
109 Oldest Frame House in Manhattan, Weehawken Street, 1935

110 Jacob Heymann Butcher Shop, 345 Sixth Avenue, June 13, 1938
111 Henry Street, Looking West from Market Street, November 29, 1935
112 Trinity Churchyard, 1934
113 Trinity Church and Wall Street Towers, 1934
114 Under Riverside Drive Viaduct at 125th Street and Twelfth Avenue, November 10, 1937
115 Brooklyn Bridge with Pier 21, Pennsylvania Railroad, East River, March 30, 1937
116 Department of Docks and Police Station, Pier A, North River, May 5, 1936
117 "Theoline," Pier 11, East River, April 9, 1936
118 Squibb Building with Sherry Netherland in background, November 21, 1935
119 El, Second and Third Avenue Lines, 250 Pearl Street, March 26, 1936
120–121 Hoboken Railroad Yards Looking Towards Manhattan, 1935
122 Hester Street, Between Orchard and Allen Streets, May 3, 1938
123 Herald Square, July 16, 1936
124 57–61 Talman Street, Brooklyn, May 22, 1936
125 Talman Street, Between Jay and Bridge Streets, Brooklyn, May 22, 1936
126 Hardware Store, 316–318 Bowery, January 26, 1938
127 Stuyvesant Curiosity Pawn Shop, 48 Third Avenue, February 4, 1937
128 General View from Penthouse at 56 Seventh Avenue, July 14, 1937
129 Fortieth Street, Between Sixth and Seventh Avenues from Salmon Tower, 11 West 42nd Street, December 8, 1938
130 View of Exchange Place from Broadway
131 Willow Place, Nos. 43–49, Brooklyn, May 14, 1936
132 Columbus Circle, February 10, 1936
133 Columbus Circle, February 10, 1936
134 Daily News Building, 220 East 42nd Street, November 21, 1935
135 Father Duffy, Times Square, April 14, 1937
136–137 Yuban Warehouse, Water and Dock Streets, Brooklyn, May 22, 1936
138 Consolidated Edison Power House, 666 First Avenue, November 14, 1938
139 Stone and William Streets, May 14, 1936
140 El Station Interior, Sixth and Ninth Avenue Lines, Columbus Avenue and 72nd Street, February 6, 1936
141 Automat, 977 Eighth Avenue, February 10, 1936
142 Lamport Export Company, 507–511 Broadway, October 7, 1935
143 DePeyster Statue, Bowling Green Looking North to Broadway, July 23, 1936
144 Snuff Shop, 113 Division Street, January 26, 1938

American People and Places

These photographs were taken from 1935 to 1961. Various cameras were used.

Science

The Science photographs were taken between 1939 and 1961; those on pages 225–229 and 231 were taken in New York, the rest in Cambridge, Massachusetts, from 1959 to 1961. All the photographs were taken with an 8″ x 10″ view camera.

The wave-form photographs are all reproduced in negative; they were originally made directly on paper, rephotographed and extensively retouched to eliminate as many air bubbles as possible. Finally, a copy negative was made to produce the desired print.

Maine

The Maine photographs were made between 1954 and 1967, the great majority for the book *A Portrait of Maine*.

Photo Credits

All photographs are by Berenice Abbott except:

17 right by Walker Evans
31 by Hank O'Neal
32 by Hank O'Neal
34 by Man Ray
74 by Walker Evans
170 by Consuela Kananga
214 Anonymous
234 by Hank O'Neal

List of Exhibitions

A complete list of Abbott exhibitions would be almost as long as a complete bibliography. The following list includes major one-woman exhibitions. An asterisk indicates a catalogue of special interest published in conjunction with the exhibition.

1926 Paris: Au Sacre du Printemps
1930 Cambridge, Massachusetts: Contemporary Art Club, Harvard
1932 New York City: Julien Levy Gallery
Buffalo, New York: Albright Art Gallery
South Orange, New Jersey: Harriet Ach Gallery
1934 New York City: New School for Social Research
Oakland, California: 683 Brockhurst
New York City: Museum of the City of New York
New Haven, Connecticut: Yale University
1935 Northampton, Massachusetts: Smith College
Springfield, Massachusetts: Museum of Fine Arts
Cambridge, Massachusetts: Fine Arts Guild
1937 New York City: Museum of the City of New York
Newark, New Jersey: Cooperative Gallery
New Haven, Connecticut: Yale University
1938 New York City: Hudson D. Walker Gallery
1939 New York City: Federal Art Gallery★
New York City: Museum of Modern Art (one of six photographers represented in "Art in Our Time")
1941 Cambridge, Massachusetts: Massachusetts Institute of Technology
1947 Paris: Galerie l'Époque
1950 Akron, Ohio: Akron Art Institute
1951 Chicago, Illinois: The Art Institute of Chicago
1953 New York City: Caravan Gallery
San Francisco, California: San Francisco Museum of Art
1955 Manchester, New Hampshire: Currier Art Gallery
1956 Toronto, Ontario: Toronto Art Museum
1959 Cambridge, Massachusetts: Faculty Club, Massachusetts Institute of Technology
New York City: New School for Social Research
1960 Washington, D.C.: Smithsonian Institution (widely traveled)
Manchester, New Hampshire: Currier Gallery
1969 Washington, D.C.: Smithsonian Institution
1970 New York City: Museum of Modern Art
1971 Augusta, Maine: University of Maine
1972 Wellesley, Massachusetts: Wellesley College
Skowhegan, Maine: Skowhegan State Fair
1973 New York City: Witkin Gallery
Monson, Maine: Monson Public Library
Portland, Maine: Westbrook Gallery, Westbrook College
Northampton, Massachusetts: Smith College
1974 Keene, New Hampshire: Louise E. Thorne Memorial Art Gallery

1976 New York City: Marlborough Gallery★
Washington, D.C.: Lunn Gallery/Graphics International★
1977 Lewiston, Maine: Treat Gallery, Bates College
1978 Bronxville, New York: Sarah Lawrence College★
1979 Provincetown, Massachusetts: Provincetown Fine Arts Workshop★
New Paltz, New York: College Art Gallery, State University College★
1980 Cleveland, Ohio: New Gallery for Contemporary Art★
1981 New York City: The International Center for Photography
1982 Washington, D.C.: Smithsonian Institution★
Washington, D.C.: Lunn Gallery
Springfield, Ohio: Museum of Art
New York City: Witkin Gallery

Bibliography

Books by Berenice Abbott
Changing New York; photographs by Berenice Abbott, text by Elizabeth McCausland, New York, 1939.
A Guide to Better Photography; New York, 1941.
The View Camera Made Simple; Chicago, 1948.
Greenwich Village Today and Yesterday; photographs by Berenice Abbott, text by Henry Wysham Lanier, New York, 1949.
A New Guide to Better Photography; New York, 1953.
Eugène Atget Portfolio, Twenty Photographic Prints from His Original Glass Negatives; edition of 100 portfolios of prints with an introduction by Berenice Abbott, New York, 1956.
The World of Atget; edited and with an introduction by Berenice Abbott, New York, 1964.
Magnet; photographs by Berenice Abbott, text by E. G. Valens, Cleveland, 1964.
Motion; photographs by Berenice Abbott, text by E. G. Valens, Cleveland, 1965.
A Portrait of Maine; photographs by Berenice Abbott, text by Chenoweth Hall, New York, 1968.
The Attractive Universe; photographs by Berenice Abbott, text by E. G. Valens, Cleveland, 1969.
Berenice Abbott, Photographs; New York, 1970.
New York in the Thirties; photographs by Berenice Abbott, text by Elizabeth McCausland, New York, 1973 (Reprint of *Changing New York*).
Berenice Abbott: The Red River Photographs; photographs by Berenice Abbott, text by Hank O'Neal, Provincetown, 1979.

Selected Articles, Statements, and Introductions by Berenice Abbott
"Eugène Atget," *Creative Art*, September, 1929.
"Photographer as Artist," *Art Front*, Vol. 16, 1936.
"Photography 1839–1937," *Art Front*, Vol. 17, 1937.
"My Ideas on Camera Design," *Popular Photography*, May, 1939.
"The Art of Photography," transcribed interview on WQXR, January 2, 1939.
"My Favorite Picture," *Popular Photography*, February, 1940.
"Eugène Atget," *The Complete Photographer*, No. 6, 1941 (reprinted in the *Encyclopedia of Photography*, Vol. 2, 1963).
"Documenting the City," *The Complete Photographer*, No. 22, 1942 (reprinted in the *Encyclopedia of Photography*, Vol. 7, 1963).
"Nadar: Master Portraitist," *The Complete Photographer*, No. 51, 1943.
"View Cameras," *The Complete Photographer*, No. 53, 1943.
"What the Camera and I See," *ARTnews*, 50:5, 1951.
"It Has to Walk Alone," *Infinity*, 7:11, pp. 6–7, 11, 1951 (an edited version of the statement Berenice Abbott made on October 6, 1951, at the Aspen Conference on Photography).
"Photography at the Crossroads," *Universal Photo Almanac*, pp. 42–47, 1951.
"The Image of Science," *Art in America*, 47:4, 1959.
"Lisette Model," *Camera* (special issue), pp. 4, 21, 1975.

Chansonetta: The Life and Times of Chansonetta Stanley Emmons, 1858–1937; text by Marius B. Peladeau, introduction by Berenice Abbott, Waldoboro, 1977.
Lisette Model; photographs by Lisette Model, introduction by Berenice Abbott, Millerton, 1979.

Portfolios of Photographic Prints by Berenice Abbott
Berenice Abbott: 10 Photographs; edition of 50 portfolios of prints by Berenice Abbott, with an introduction by Hilton Kramer, Witkin-Berley, New York, 1974.
Berenice Abbott's New York; edition of 60 portfolios of 12 prints, Parasol Press, New York, 1978.
Berenice Abbott's New York II; edition of 60 portfolios of 12 prints, Parasol Press, New York, 1979.
Berenice Abbott's New York III; edition of 60 portfolios of 12 prints, Parasol Press, New York, 1979.
Berenice Abbott's New York IV; edition of 60 portfolios of 12 prints, Parasol Press, New York, 1979.
Berenice Abbott's Faces of the '20s; edition of 60 portfolios of 12 prints, Parasol Press, New York, 1981.
Berenice Abbott's Science; edition of 60 portfolios of 12 prints, Parasol Press, New York, 1982.
Berenice Abbott Retrospective; edition of 40 portfolios of 50 prints, Parasol Press, New York, 1982.
Berenice Abbott American Photographer; by Hank O'Neal, introduction by John Canaday, New York, 1982. Limited edition of 400, with 400 prints, 100 each of four subjects.

Articles about Berenice Abbott
Note: So many critical articles about Berenice Abbott have been published since the late 1920s —especially in the last ten years—that a comprehensive listing is beyond the scope of this book. The author respectfully suggests that the following list represents the best of the last fifty years, and particularly recommends those by Elizabeth McCausland.
"The Photography of Berenice Abbott," by Elizabeth McCausland, *Trend*, 3:1 (March-April), 1935.
"Berenice Abbott Photographs the Face of a Changing City," *Life*, January 13, 1938.
"Camera Eye Records Ever 'Changing New York,'" by Elizabeth McCausland, *Springfield Sunday Union and Republican*, October 24, 1938.
"Berenice Abbott," by Ralph Steiner, *PM*, April 19, 1942.
"Berenice Abbott—Realist," by Elizabeth McCausland, *Photo Arts*, 2:1 (Spring), 1948.
"Berenice Abbott—Pioneer, Past and Present," by Julia Newman, *U.S. Camera*, February, 1960.
"Abbott's Non-Abstract Abstracts," *Infinity*, 11:1, 1962.
"Berenice Abbott's Work in the Thirties," by Michael G. Sundell, *Prospects: An Annual of American Cultural Studies 5*, pp. 269–292, 1980.
"Berenice Abbott" by Erwin Leiser, *Du*, pp. 35–38, January, 1981.
"The Unflinching Eye of Berenice Abbott" by Avis Berman, *ARTnews*, pp. 86–93, January, 1981.

An Artpress Book

Chairman: Milton Esterow
President and Editor-in-Chief: John L. Hochmann
Managing Editor: Ray F. Patient
Designer: Kornelia Kurbjuhn
Associate Editor: Brenda Gilchrist
Proofreader: Miriam Hurewitz
Production Assistant: Bonnie Lucas